200

Pennsylvania Academy of the Fine Arts, 1805–2005

200 Years of Excellence

This publication has been generously supported by

INDEPENDENCE FOUNDATION

EUGENE AND MARGARET ORMANDY FUND
OF THE PHILADELPHIA FOUNDATION

THAW CHARITABLE TRUST

Pennsylvania Academy of the Fine Arts, 1805-2005

200 *Years of Excellence*

ESSAYS BY

Mark Hain

Michael J. Lewis

Stephen May

Ronald J. Onorato

Kim Sajet

Peter M. Saylor

CATALOGUE ENTRIES BY

Alex Baker

Mark Hain

Cheryl Leibold

Lynn Marsden-Atlass

Kevin Richards

William Rudolph

Kim Sajet

Published on the occasion of the 200th Anniversary of the Pennsylvania Academy of the Fine Arts, 2005

Copyright © 2005 by
Pennsylvania Academy of the Fine Arts
118 North Broad Street
Philadelphia, Pennsylvania 19102
www.pafa.org

Edited by Jane Watkins
Designed by Phillip Unetic, 3r1 Group.com
Printed by Butler and Tanner, Ltd., Frome, England

Works of art in this publication have been photographed on film by Rick Echelmeyer, or via direct digital capture using a Leaf Scitex camera. Digital photography at the Pennsylvania Academy is conducted by Barbara Katus, Manager of Rights and Reproductions, with equipment provided through a grant from The Henry Luce Foundation. All works of art reproduced in the essays are in the Pennsylvania Academy collection.

ISBN 0-943836-24-7 (hardcover)
ISBN 0-943836-25-5 (softcover)

Frontispiece: Georgia O'Keeffe, *Red Canna*, 1923. The Vivian O. and Meyer P. Potamkin Collection, Bequest of Vivian O. Potamkin (Plate 138).

Cover: Charles Willson Peale, *The Artist in His Museum*, 1822. Gift of Mrs. Sarah Harrison (The Joseph Harrison, Jr., Collection), 1878.1.2 (Plate 27).

Back cover: Academy student working on the second floor of the Samuel M. V. Hamilton Building, 2002 (Floyd Dean Photography).

CONTENTS

CHAIRMAN'S MESSAGE

Donald R. Caldwell

During the Pennsylvania Academy's centennial celebration in 1905, the journals of the day published many articles pertaining to the Pennsylvania Academy of the Fine Arts. On January 1, 1905, *The Philadelphia Press* wrote that as "the eldest arts institution in the United States, its history is at every step interwoven with that of American art; its schools are annually attended by over 300 students, its permanent collection is one of the finest in the country, and finally, there is no famous name in our national artistic annals which, in some capacity—as exhibitor, instructor or student—has not some connection with the familiar building at Broad and Cherry Streets." If we shift forward in years, and add a new building, the statement could apply today, a century later, as we celebrate two hundred years with the same sense of pride and accomplishment.

Academy Charter (Articles of Association) December 26, 1805, Ink on parchment, 33 ½ x 27 inches.

The Academy is the first arts institution to reach its third century, a unique moment in American history. This 200th Anniversary volume celebrates the Academy's commitment to be the recognized leader for American fine arts education, bringing together artists and the public and integrating a world-class collection of American art, major exhibitions, and exceptional teaching programs. The Academy enters its third century better positioned to accomplish its mission than ever before.

The new Samuel M. V. Hamilton Building, named in honor of a distinguished former chair of the Academy Board, leads the urban renewal of North Broad Street. The planned public plaza between the Samuel M. V. Hamilton Building and the Historic Landmark Building is sited above a works-on-paper gallery that will link the two Academy buildings below the street. Their facades will face the front entrance of the Convention Center expansion. The Academy's School of Fine Arts will benefit hugely from the expanded campus, with seven new floors of studio and classrooms, linked to the historic studios from which Thomas Eakins led the academic programs. All of the facilities in this wonderful new addition, including the penthouse student lounge and rooftop painting terrace, help to ensure that the Academy will continue to be one of the premier colleges in the world in which to pursue a career in the fine arts.

Begun with a fifteen million dollar grant from the Commonwealth of Pennsylvania, the Hamilton Building has been supported by many wonderful friends, led by Dorrance H. Hamilton, the Arcadia Foundation, Gerry and Marguerite Lenfest, Stanley and Edna Tuttleman, the Independence Foundation, the Annenberg Foundation, The Pew Charitable Trusts, the Connelly Foundation, the Horace Goldsmith Foundation, the Women's Board of the Pennsylvania Academy of the Fine Arts, and individual members of the board and numerous supporters of the Academy.

All art museums in this country depend for the growth and richness of their holdings on the generosity of regional collectors, and the Academy has been honored to have recently received important gifts of ten masterpieces of American art bequeathed by Meyer P. and Vivian O. Potamkin and the Harold and Anne Sorgenti Collection of African-American art, as well as major gifts and promised gifts from the Pollock-Krasner Foundation, Ann R. Stokes, Dr. Luther Brady, and other generous donors. Excitingly, we now have a satellite at the Curtis Center, adjacent to Independence Hall, where Maxfield Parrish's monumental Tiffany glass mosaic *The Dream Garden* delights the public, a gift made possible by The Pew Charitable Trusts and the other beneficiaries of the John W. Merriam Estate.

On behalf of everyone at the Pennsylvania Academy, I invite you to enjoy the essays and masterpieces from the collection presented in this book.

FOREWORD

Derek A. Gillman

It is perhaps startling to learn that the Pennsylvania Academy of the Fine Arts is one of the oldest continually operating art institutions in the world, founded a little under forty years after the Royal Academy of Arts in London and fifteen years after the Louvre. Its original building on Chestnut Street, designed by John Dorsey and opened in 1806, was probably the first purpose-built museum in any country. The Academy's first honorary member was Philadelphian Benjamin West, who succeeded Sir Joshua Reynolds as second president of the London Royal Academy.

The Academy has transmitted and reinterpreted the disciplines of Western painting, drawing, sculpture, and printmaking to generations of students and has exposed them and the Philadelphia public to exceptional examples of American art. This conversation between working artists, curators, educators, and visitors is now extremely rare, but it seems entirely right for the twenty-first century. We can truly say that we are "home to America's artists."

We move into the new century in great spirits enriched by an experienced faculty and administration soon to be headquartered in the splendid Samuel M. V. Hamilton Building. The facilities there will add a new dimension to the Academy's educational experience with the new Sculpture Study Center, a maturing Graduate Program—now in its second decade—the venerable four-year certificate, and our joint B.F.A. with the University of Pennsylvania.

The Hamilton building triples the existing gallery space and enables the Academy to show all the major paintings in the permanent collection without having to take them down for special loan exhibitions (and to show three times more paintings and sculptures than we have in the past). Thus, for the first time, visitors who come to the annual student exhibition to see the work of our latest generation of artists will also be able to enjoy the depth of our great permanent collection. With the benefit of a generous grant from the Richard C. von Hess Foundation, the Academy has reinstalled the permanent collection for our 200th Anniversary and refurbished the interiors of the Historic Landmark Building.

And so, as we celebrate our two-hundredth birthday, we think it only proper to describe the rich history and many achievements of America's oldest art museum and art school, and to make available in color for the first time a selection of two hundred and twenty works of art from the Academy's collections.

My special thanks go to the many staff members who have helped make this publication possible. Academy Senior Vice-President Kim Sajet guided the entire project, working with individuals across the Academy and beyond. She has undertaken all of this, including authoring her essay on *The Dream Garden* mosaic, while steering other major projects for the 200th Anniversary. Working alongside her, Archivist Cheryl Leibold and Assistant Curator Mark Hain provided in-house editorial expertise for the essays and object entries, respectively. Barbara Katus, Manager of Rights and Reproductions, Lynn Marsden-Atlass, Senior Curator, and Raquel Xamani-Icart, Public Programs Assistant, also provided invaluable assistance. I am grateful to our essay writers Mark Hain, Michael J. Lewis, Stephen May, Ronald J. Onorato, Kim Sajet, and Peter M. Saylor, and to catalogue writers Kevin Richards, William Rudolph and Academy Associate Curator Alex Baker for their fine contributions to the study of the Academy.

The Trustees, staff and faculty thank the Honorable Phyllis W. Beck and Susan E. Sherman of the Independence Foundation, H. Craig Lewis and R. Andrew Swinney of the Philadelphia Foundation, Eugene V. Thaw of the Thaw Charitable Trust, and also Jeffrey P. Orleans of Orleans Homebuilders for their enthusiastic support of the publication of this important volume.

Dagit • Saylor Architects,
Hamilton Building,
Grand Stair Gallery, 2003
(Tom Crane Photography).

As we enter our third century, we do so with renewed vigor under a revitalized Board of Trustees led by Donald R. Caldwell. The energy he has brought to the Academy is infectious and has spread well beyond the walls of the campus. Under his leadership, and that of his fellow officers, Kevin Donohoe, Herbert Riband, Jr., Richard Lieb, and Thomas Pappas, the board set the goal of bringing the institution back to pre-eminence as one of the world's great centers for education in the fine arts. It is a privilege to be here at this momentous time, not only on account of the dedication of the trustees but also because of the presence of fine colleagues and friends dedicated to realizing our common goal.

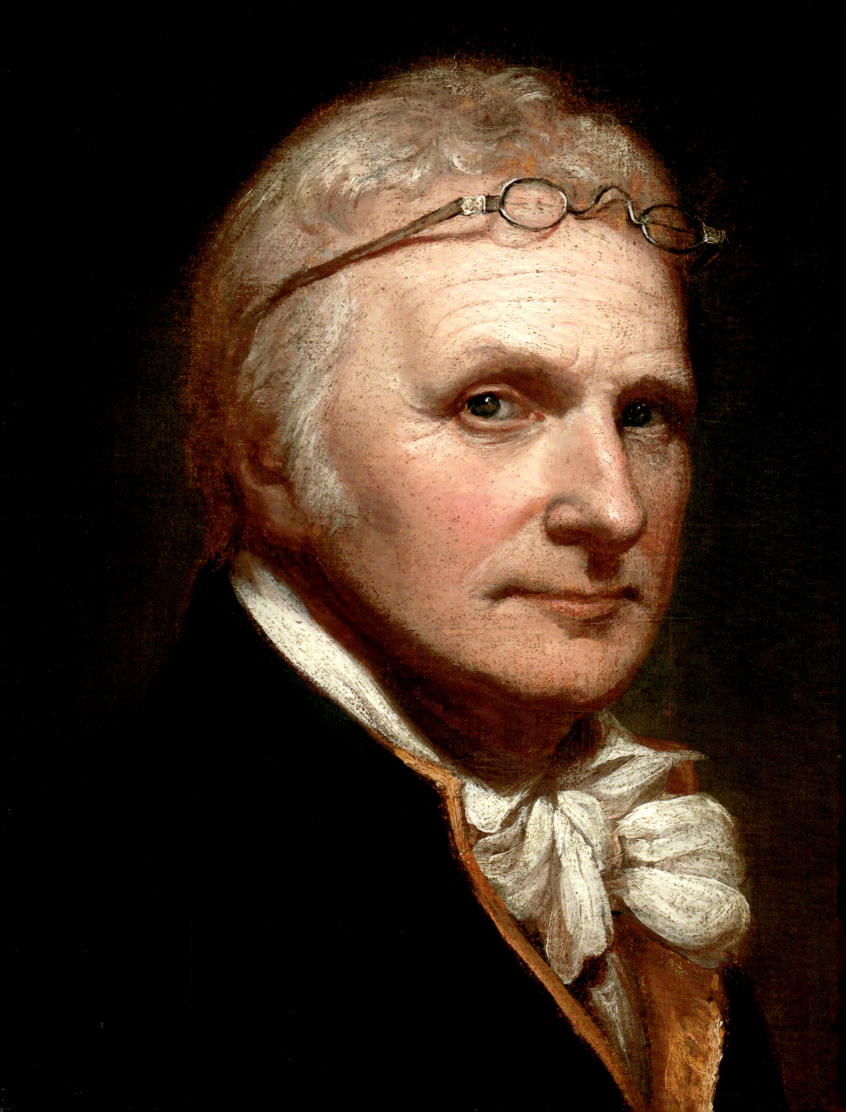

STEPHEN MAY

An Enduring Legacy: The Pennsylvania Academy of the Fine Arts, 1805-2005

The story of the Pennsylvania Academy of the Fine Arts, the oldest art museum and art school in America, is one of vision, ambition, persistence, and adherence to high standards. Founded not long after the establishment of the American Republic, during Thomas Jefferson's second term as president, and while memories of the American Revolution still lingered, the fledgling Academy drew on the example of Britain's Royal Academy and European precedents in forging its own pioneering and enduring American identity.

THE EARLY YEARS, 1805 TO 1869

Fortuitously located in Philadelphia, the nation's capital from 1790 to 1800, the Academy benefited from the city's standing as a cultural and intellectual center and its reputation for supporting the arts. Nevertheless, without the tireless efforts of the irrepressible Charles Willson Peale (1741–1827), the Pennsylvania Academy would never have been established—or survived. Museum pioneer, artist, and patriarch of a large family of important artists, Peale was a man of wide ambitions, far-seeing vision, and energetic purpose (fig. 1). Determined to expand the new nation's cultural horizons and to establish distinctive American artistic traditions, he forged the birth and growth of the Academy. Already well into his sixties, Peale was the driving force behind shaping the new Academy into both a teaching and collecting institution that promptly assumed a role of national importance.

As early as 1771, the precocious Peale was receiving encouragement for his arts advocacy from an exalted source. Writing from London, Benjamin Franklin applauded the thirty-year-old entrepreneur's efforts in Philadelphia, adding: "The Arts have always travelled westward, and there is no doubt of their flourishing hereafter on our side of the Atlantic, as the Number of wealthy Inhabitants shall increase, who may be able and willing suitably to reward them, since from several Instances it appears that our People are not deficient in Genius."[1]

In 1794, Peale had started an art organization, the Columbianum, in Philadelphia, but it failed after a year. His pioneering Peale's Museum, established in 1786, was moved to the second floor of Independence Hall in 1802. It featured portraits of famous Americans as well as habitat groupings of native animals and birds and the skeleton of a prehistoric mastodon. Each facet is recorded visually in Peale's *The Artist in His Museum*, an icon of American art and a special treasure in the Academy's collection (plate 27).

One day after Christmas in 1805, Peale and a group of Philadelphia's leaders met in the signers' chamber in Independence Hall to ratify the articles of association for the Pennsylvania Academy. The seventy-one founders, predominately local businessmen and lawyers, modeled their project on the New York Academy of the Fine Arts, launched in 1802, as well as the venerable Royal Academy in London. Among the founders, only Peale, his gifted son Rembrandt Peale, and William Rush, the country's first sculptor, were artists. The founders chose as the first president George Clymer (1739–1813), a Philadelphia banker who had signed the Declaration of Independence twenty-nine years earlier (fig. 2). Clymer served until his death in 1813. Joseph Hopkinson (1770–1842), a judge of the U.S. District Court and author of *Hail Columbia!*, succeeded Clymer and served as president until 1842.

The lofty purposes and unabashedly nationalistic goals of the founders were reflected in their statement of purpose:

> *The object of this association is to promote the cultivation of the Fine Arts, in the United States of America, by introducing correct and elegant Copies, from works of the first Masters, in Sculpture and Painting, and, by thus facilitating the access to such Standards, and also by occasionally conferring moderate but honorable premiums, and otherwise assisting the Studies and exciting the efforts of the artists, gradually to unfold, enlighten and invigorate the talents of our Countrymen. The name of this Association shall be "The Pennsylvania Academy of the Fine Arts."*[2]

The founders deliberately called the institution an academy, reflecting their vision of a place for educating artists, as well as collecting and exhibiting art for the general public. In the two hundred years since, there have been innumerable changes in styles of art and the role of museums, but the Academy, while changing with the times, has remained true to its original standards and purposes.

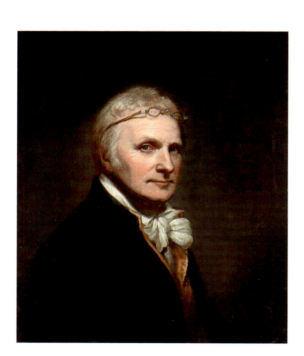

Peale's correspondence with leading figures of the day, such as his friends President Thomas Jefferson, architect Benjamin Latrobe, expatriate painter Benjamin West, and French sculptor Jean-Antoine Houdon, documents his indefatigable efforts on behalf of the Academy and his high hopes for its future. In June 1805, he wrote to Jefferson: "Some Gentlemen have meet [sic] a few times at my House and planed [sic] a design of an Academy for the incouragement [sic] of the fine arts in this City. . . . We hope soon to begin a building for the reception of Casts of Statues, also for a display of Paintings, by the exhibition of which revenue may be had to defray the expence [sic] of a keeper who shall be capable to give instruction to the Pupels [sic]."[3]

In one letter from Latrobe, written in July 1805, the architect expressed support for "a most useful institution," noting with surprise that among the founders were "Names . . . of a Number of Men whom I did not suspect of any taste for, or knowledge for any Arts but that of

bookkeeping or cookery. I am glad however that they have come forward with that most essential support of all Art, Money."[4]

In April 1806, Peale appealed to Jefferson for a donation to help get the Academy off the ground. "As one of the Directors," he wrote, "I think it my duty to mention to you our want of funds to finish this Building, that your aid will be very acceptable in a small sum."[5] In June, Jefferson responded: "I shall cheerfully contribute my mite to your Academy of fine arts by inclosing you 50.D. at my next pay day."[6] Successful fundraising allowed the new directors to construct the Academy's first home, a small classical rotunda on Chestnut Street (see fig. 28).

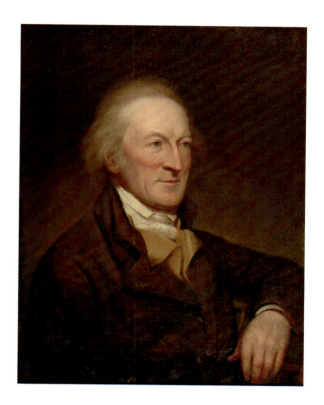

The audacity and significance of the founding of the Academy are suggested by its status as not only the oldest art institution in the United States of America, but also one of the oldest in the world. The Louvre had opened in Paris in 1796, but the Academy is older than the National Gallery in London and the Prado in Madrid. The Metropolitan Museum of Art in New York and the Museum of Fine Arts in Boston were not established until 1870. New York's Art Students League was founded in 1875. The Philadelphia Museum of Art grew out of the Centennial Exhibition of 1876, and the Art Institute of Chicago opened its doors in 1879.

Two notable figures in the early history of the Academy are William Rush (1756–1833) and Thomas Sully (1783–1871). Rush was a native Philadelphian who turned woodcarving into a professional career (plates 13 and 26). He helped to organize the ill-fated Columbianum and, in addition to being an original founder of the Academy, served on its board of directors from 1805 through 1833. Active in civic affairs, he was a key figure in the creation of Fairmount Park. English-born Thomas Sully, master of the aesthetic portrait, served as a board member from 1816 through 1832 (plates 24–25). He was the beneficiary of the Sully Fund, established by the Academy to support him, from 1847 until his death in 1872. Forty-five Sully portraits grace the permanent collection.

Fig. 2
Charles Willson Peale, *George Clymer*, 1807, Oil on canvas, 27 ⅛ x 22 ⅛ inches (68.9 x 56.2 cm), Gift of the artist, 1809.2.

At the outset, the founders sought to build the Academy's prestige by reaching out to England to make Benjamin West (1738–1820) its first honorary member. The American expatriate, born in Swarthmore, Pennsylvania, had, by this time, become an international superstar, serving as Historical Painter to King George III and president of the Royal Academy in London. For a half century, West offered haven, advice, and encouragement to many young American painters including Sully, Washington Allston, Charles Willson Peale, and Gilbert Stuart. In keeping with his generous assistance to American painters, West enthusiastically accepted the Academy's invitation. "That the youth of America have talents for the fine arts (in particular painting) is acknowledged by all the civilized nations," he wrote in September 1805. "I will venture to predict," he added, "that the next great school of the fine arts after Greece, Italy, and Flanders, will be in the United States of America." The new Academy, West said, should make Philadelphia "the Athens of the Western World in all that can give polish to the human mind."[7]

As early as 1810, Joseph Hopkinson expressed the view that the Academy "may now be considered completely formed and established," with no chance of failure.[8] In spite of such confidence, the institution was always pressed for money. Fortunately, the directors, usually numbering eight, managed its funds wisely while raising money through admission fees, sales of stock in the Academy, and

substantial contributions of their own. Board members in this era were closely involved in the day-to-day operation of the Academy, and under their close guidance the institution steadily flourished.

One of the new board's first acts was to begin acquiring objects to enhance and fill its galleries. Plaster casts, then considered objects of virtue in their own right, were purchased to be on hand even before the new building opened in December of 1806. In its early years, the Academy directors, reflecting the prevailing taste of the period, favored history and religious paintings for both exhibitions and acquisitions. The two most notable purchases of these years are Washington Allston's *The Dead Man Restored to Life by Touching the Bones of the Prophet Elisha* (plate 16), acquired in 1816, and West's *Death on the Pale Horse* (plate 6). Both purchases entailed mortgaging the building to defray costs, and both are today among the best-known and most important works of art in the collection.

In 1807, barely a year after opening its doors, the Academy mounted its first exhibition. It was unlike anything America had seen before. Combining plaster casts, selections from the collection of artist-inventor Robert Fulton, and strategic loans, the show featured paintings by West and the Peales, along with examples of contemporary British art. While topical or thematic exhibitions were mounted often, the institution's European models prompted the inauguration of an annual group exhibition in 1811. The board stated that "Paintings by American & living Artists shall always have a preference over those by European or Antient [*sic*] Artists."[9] Thus, from the outset, young American artists had the opportunity to display their work alongside that of counterparts from around the nation and across the Atlantic.

The first annual exhibition featured just over five hundred works, of which nearly half were by American artists. There were paintings by the Peales, Stuart, Sully, and Thomas Birch, the Academy's first keeper (curator), and sculpture by Rush. Highlights included Charles Willson Peale's likeness of Clymer and Stuart's famous "Lansdowne" portrait of Washington.

The annual, which lasted until 1969, soon became a major event in the American art world. Awards and prizes given out during the annuals carried great prestige and significantly encouraged the development of American painting and sculpture. Moreover, the Academy's collection was immeasurably enriched through purchase awards associated with the annuals. "The cumulative effect of these exhibitions on American arts, artists, and public taste was colossal," observed former Academy Curator and President Frank H. Goodyear, Jr.[10]

The year after the first annual exhibition, the young art institution made another mark on the art world by contributing to a precedent in international law during the War of 1812. A ship flying the American flag and carrying twenty-one paintings and fifty-two engravings by Italian artists bound for the Academy was captured by a British man-of-war and taken to the port of Halifax, Nova Scotia. The Academy's directors appealed to officials in Nova Scotia for release of the art treasures, prompting Sir Alexander Croke of the admiralty court in Halifax to reply: "Heaven forbid that such an application to the generosity of Great Britain should ever be ineffectual. . . . With real sensations of pleasure. . . I decree the restitution of the property."[11] The works arrived at the Academy, and the principle of free trade for artwork in times of war was established.

During much of the Academy's first half century, the Pennsylvania Academicians, a group of painters, sculptors, engravers, and architects of recognized merit, played a key role in selecting professors and keepers of the institution, as well as in mounting the exhibitions. The original members, elected by the board of directors in 1812, included the cream of American artists. Among those artists who served at the outset were Washington Allston, Thomas Birch, John Wesley Jarvis, Charles Bird King, Charles Willson Peale, James Peale, Rembrandt Peale, William Rush, Gilbert Stuart, Thomas Sully, and John Vanderlyn. Off and on until about 1870, the Academicians provided vital leadership to the fledgling Academy. While the Academy occupied its Chestnut Street building, the board of

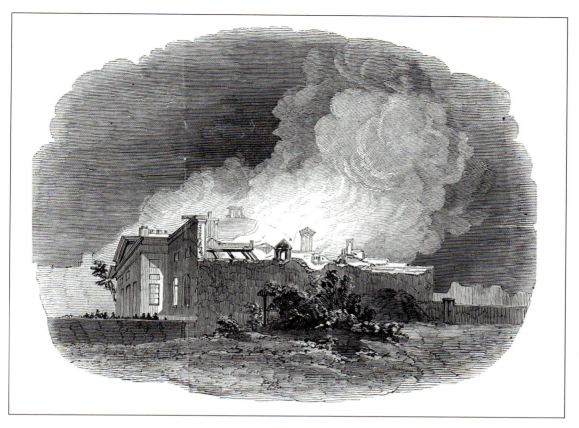

Fig. 3
"Destruction of the Academy
of Fine Arts, Philadelphia,"
The Illustrated London News,
July 19, 1845.

directors ran the Academy, assisted by the Academicians, without the services of a paid administrator. More artists served on the board in this era than at any other time.

In 1845, a disastrous fire ignited by a deranged nephew of the janitress devastated the Academy building on Chestnut Street (fig. 3). Flames engulfed the east and north wings, destroying most of the cast collection and many valuable paintings. Volunteer firefighters heroically rescued West's huge canvas *Death on the Pale Horse* by cutting it from its signed frame, rolling it up, and dragging it out to the street. *The Illustrated London News* reported in detail on the objects lost in the conflagration, adding that Stuart's portrait of Washington was saved with its "canvas being torn and frayed." When it was carried out to the street, "a gladsome shout from the crowd around the burning building, rent the air. It showed, indeed, that he was first in the hearts of his countrymen."[12]

Supporters rallied around the wounded institution, raising substantial funds for its resurrection. The largest sum came from the Ladies Bazaar and Ball, through which the generous sum of ten thousand dollars was raised. A new structure with capacious galleries and a new facade was constructed, opening in 1847. New casts were acquired from Europe, and school facilities were improved.

By the middle of the nineteenth century, the Academy was a focal point of Philadelphia's cultural life and a major force on the American art scene, mounting important exhibitions and quality annual shows, with increased attendance, and a thriving school. The Academy consistently embraced contemporary art, exhibiting works by almost every significant American artist of the time, either in temporary exhibitions or in special displays. Among the exhibitions shown in the newly reconstructed building were Thomas Cole's famous allegorical series *The Voyage of Life* (1844) and *The Course of Empire* (1852); Hiram Powers's controversial *Greek Slave* (1848); English Pre-Raphaelite art (1858); Frederic E. Church's celebrated *Heart of the Andes* (1860); and Albert Bierstadt's *Domes of the Yosemite* (1867). Asher B. Durand and Daniel Huntington were elected Honorary Professional Members around mid-century. Church, Cole, Jasper F. Cropsey, and John F. Kensett were honored by the Academy well before they had gained national acclaim.

After 1850, the Academy, like the entire nation, faced a changing society, particularly following the Civil War. The pervading sense of prudery that defined moral standards in America was apparent in Philadelphia. The problematic issue of male nude statuary, in particular, was especially controversial. At the opening of the first building in 1807, one day a week was set aside for women's classes only. In 1844, recognizing the growing interest of women in studying at the museum, the Academy decided that the sculpture gallery would be open on Monday, Wednesday, and Friday mornings to women artists who wanted to copy antique casts. These special hours were abolished in 1856, when the Academy board, continuing to fret about "nude statuary," decreed "a close fitting, but inconspicuous fig-leaf be attached to the Apollo Belvedere, Laocoon, Fighting Gladiator, and other figures as are similarly in need of it."[13] Such puritanical attitudes prevailed late into the nineteenth century, as Thomas Eakins learned, to his dismay, in 1886.

Like much of American society, the Academy has wrestled with issues of race and equality throughout its history. In 1857, for example, the Reverend William H. Furness wrote the board on behalf of an African-American man whom he described as dignified, neat in appearance, and respectful, who "informed me that he had been refused tickets of admission [to an exhibition] unless he had an express order of the Board of Directors." According to his letter and board minutes, the minister asked the board to admit to Academy shows "decent and respectable colored persons upon the same terms with decent and respectable white persons." The board, after considering the matter, resolved to inform Reverend Furness that "it has always been the Custom of the Academy to admit decent and respectable colored persons making application therefore, and who may desire either to view the works of art or study them at times deemed suitable by the Committee in attendance or by the members of the Board, and that such still continues to be the practice."[14]

The fiftieth anniversary of the Academy was celebrated quietly at the stockholders' meeting on June 2, 1856. Rembrandt Peale, one of six surviving signers of the 1805 charter, chaired the meeting. Several addresses were presented, informing the stockholders that twelve thousand visitors had been counted in the previous year, sixty-four students were enrolled in the school, the library housed one hundred fifty books, no serious financial encumbrance was suffered, and there was a pressing need to enlarge the building for more space. Toward the end of the 1860s, the growing permanent collection, the temporary and annual exhibitions, and the desire to accommodate more students led to the recognition that the building was simply too small. In 1869, the decision was made to replace the Chestnut Street building with a new structure at a different location.

The board was divided over the choice of a new site. Joseph Harrison, Jr., advocated a Fairmount Park location, while board president Caleb Cope felt that such a site was too remote, and he favored a center city site. After intense debate, the board purchased property at the corner of Broad and Cherry Streets. Harrison, who had served on the board for fifteen years, resigned in protest, certain that any lot north of City Hall was doomed to become a backwater. Later, however, Harrison's widow gave the Academy part of his fine collection of American paintings.

THE MIDDLE YEARS, 1876 TO 1905

The gala opening of the new building, designed by the architects Frank Furness and George W. Hewitt, highlighted the city's celebration of the nation's centennial in 1876. Among the speakers at the dedication ceremony, presided over by Cope's successor, James L. Claghorn, was Reverend Furness, the father of the architect. He saluted "the Rejuvenance of our venerable Academy" and hailed "the new day that now dawns upon the Beautiful Arts, that help so powerfully to gladden and refine and elevate the life of man."[15]

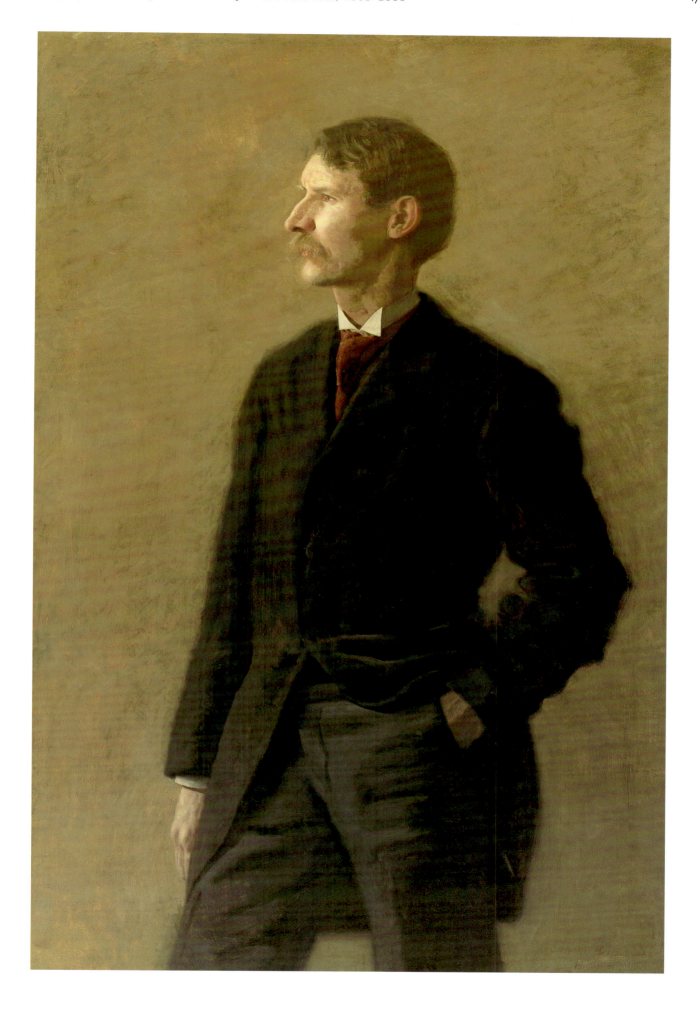

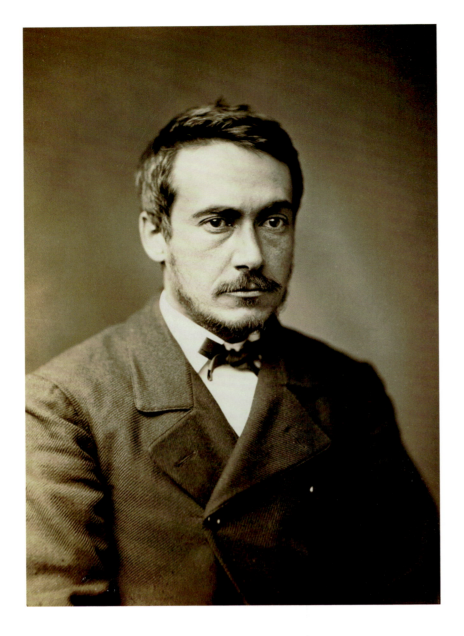

Fig. 5
Frederick Gutekunst,
*Thomas Eakins at about age
thirty-five*, 1879. Silver print,
5 ½ x 3 ¹³⁄₁₆ inches (14 x 9.7 cm).
Charles Bregler's Thomas Eakins
Collection. Purchased with the
partial support of the Pew
Memorial Trust, 1985.68.2.19.

Inspired by the magnificent new building (see fig. 30), appreciation for the Academy's historic importance was renewed, and an ambitious board launched a forty-year period of unparalleled achievements for the institution. Among the most influential directors were Claghorn, Edward H. Coates, Henry C. Gibson, Edward T. Stotesbury, and Joseph E. Temple. The permanent collection grew by leaps and bounds, highlighted by the donation of four important art collections—from Philadelphians Joseph Harrison, Jr., Henry C. Gibson, Edward L. Carey, and John S. Phillips—that vastly expanded the Academy's trove of American and European works. The Academy board hired its first administrator to assist in the running of the institution. The first so-called secretary of the Academy was George Corliss. With the appointment in 1892 of Harrison S. Morris (1856–1948), the nation's first professional arts administrator (fig. 4), the title of the position was changed to secretary and managing director, and duties were expanded beyond secretarial tasks. Since 1983, a president has served as chief executive officer of the institution.

In spite of all its successes, when Morris assumed his duties as managing director in 1892, he found the place "a heavy tomb. . . a deep and chilling recess, a prematurely old ruin."[16] He set out to reinvigorate the venerable institution, launching a period of enlightened collecting and exhibitions. This former magazine editor was, fortuitously, a knowledgeable connoisseur, especially of modern American art. Morris cultivated friendships with contemporary American artists to attract outstanding works to the annuals. "The annual exhibitions began to respond, after a while, by taking on a national appeal," he recalled in his somewhat bitter memoir. "The notices by critics became numerous and friendly. They spread farther through the country."[17] Just before Morris's arrival, the Academy was the recipient of the Joseph E. Temple Fund, the first endowed fund for acquisitions, which enabled Morris to engineer some of the greatest acquisitions in its history. The Temple Fund also provided for a series of gold medals to be awarded for the annual exhibitions.[18]

At the same time that the annuals were attracting sizeable crowds, the special exhibitions also appealed to a large national audience. Temporary loan shows ran the gamut from architectural drawings, art posters, and photography to historical and contemporary art. Shows included American colonial portraits (1887–88); the Thomas B. Clarke Collection of American painting (1891); English Pre-Raphaelite art (1892); and a selection of American works headed for the World's Columbian Exposition (1893). The poster exhibition of 1896, with an announcement designed by Academy alumnus Maxfield Parrish, showcased works by such American artists as Edwin Austin Abbey, Will

Bradley, Edward Penfield, and John Sloan, and by Europeans such as Aubrey Beardsley, Pierre Bonnard, and Henri de Toulouse-Lautrec. The success of these exhibitions and the Academy's flourishing reputation helped the Academy's finances to prosper. An endowment fund was begun in the mid-1880s, and the City of Philadelphia appropriated funds annually in return for school scholarships and free days in the museum.

About 1880, the Academy school underwent an important change, converting its curriculum from the European-inspired atelier system to a more modern studio-oriented model. Instrumental in this change was Thomas Eakins (1844–1916). With the backing of influential board member Fairman Rogers, Eakins (fig. 5) introduced more progressive ideas about teaching art. Eakins's forceful, blunt personality, his insistence upon using nude models, and his unwillingness to respond to the board's demands for less innovative teaching methods eventually put him at odds with his overseers. Things came to a head in 1886 when, contrary to warnings from the board, he removed the loincloth from a male model in a women's life class. For this indiscretion, he was forced to resign, amidst considerable anger and resentment on both sides. In hindsight, it is the view of Kathleen A. Foster, a former Academy curator and an Eakins scholar, that the artist-instructor was "insubordinate" in flouting the board's instructions. She sees Eakins as a fascinating combination of an intentional "provocateur" who was "looking for a fight" and a naif who did not recognize how offensive his methods were in the context of Victorian propriety.[19] In his memoir, Morris described Eakins as "innocent of sexual wickedness. It would never occur to him that the human body had any other purpose than that of plastic beauty."[20]

Eakins went on to paint deeply insightful, realistic portraits (plates 76–77) that were scorned by some and admired by others. Although something of a pariah to segments of Philadelphia society and some at the Academy, he continued to exhibit in the annuals. In spite of his earlier estrangement from the Academy, in 1904 the jury for the 73rd annual awarded Eakins the Temple Gold Medal for outstanding work. After riding his bicycle to the Academy to accept the honor, he told board president Coates: "I think you've got a heap of impudence to give me a medal." Eakins then rode to the United States Mint, handed over the medal and pocketed seventy-three dollars in return.[21]

In 1985, the Academy purchased an invaluable cache of Eakins material from the widow of Eakins student and acolyte Charles Bregler. In his modest Philadelphia home, Bregler had hoarded a huge trove of drawings, oil sketches, photographs, and manuscript items. With the acquisition of these Eakins treasures, the Academy became a major center for study of this titan of American art. Since then, numerous exhibitions and publications have underscored the Academy's prominent role in all things Eakins.

Perhaps the finest woman artist closely associated with the Academy, indeed one of America's greatest female artists, Philadelphia native Cecilia Beaux (1855–1942) also taught in the school. She is represented in the collection by eleven paintings, forty oil sketches, and significant manuscript materials (plates 66–67). Recalling the successes of Beaux's paintings, Managing Director Morris—not one given to hyperbole—gushed about "the sensation aroused by her successive portraits as they appeared in the annual shows." Reflecting the high esteem in which she was held around the Academy, Morris continued: "there is. . . a kind of halo about her and her work; she was liked so well, she was so rarely talented, so unaffected, so simple, so winning and, if I may say it, so beautiful, that everybody was eager to give her the praise which she so richly deserved."[22] In 1899, when her lush double portrait *Mother and Daughter* (fig. 6), now in the Academy's collection, was awarded a first-class Gold Medal at the Carnegie Art Institute's international exhibition, William Merritt Chase pronounced Beaux "the greatest woman painter of modern times."[23]

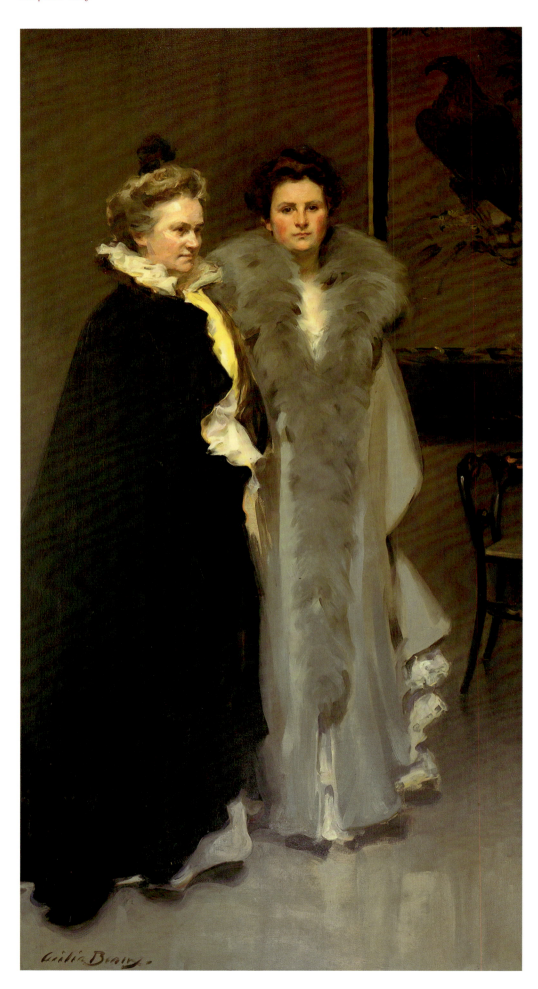

Fig. 6
Cecilia Beaux, *Mother and
Daughter* (Mrs. Clement Acton
Griscom and Frances C.
Griscom), 1898. Oil on canvas,
83 x 44 inches (210.8 x 111.8 cm).
Gift of Frances C. Griscom,
1950.15.

Chase and especially Beaux introduced Impressionist technique to the painting classes at the Academy. As early as 1892, the institution had begun to lead the way in showcasing the work of American Impressionists, just emerging as a popular and enduring style. The advertisement for that year's annual proclaimed "The Dawn of New American Art: Impressionism!" The acceptance of Impressionism in this country was further advanced by the Academy's embrace of the oeuvre of ex-student and expatriate painter Mary Cassatt (plates 54–55) and the faculty presence of Beaux, Chase, Daniel Garber (plates 126–27), and, briefly, Robert Vonnoh and Theodore Robinson. Garber joined with Edward Redfield, an Academy alumnus, and other Bucks County artists to put Pennsylvania Impressionism on the map. With the popularity of Impressionism, outdoor landscape painting was added to the instructional program. Between 1917 and 1952, a hugely popular summer school was conducted in Chester Springs, Pennsylvania.

In the mid-1890s, the father of American illustration, Howard Pyle (1853–1911), offered to teach his specialty at the Academy, but the board was not interested in instruction in practical art. By the time the school's curriculum was broadened to include mural painting and illustration in 1900, Pyle was firmly ensconced at Drexel Institute and turned down the offer of a position at the Academy. Among the famous illustrators who studied at the Academy were John Sloan, Violet Oakley, Parrish, and Jessie Willcox Smith. Illustration courses continued to be offered until 1958.

By the time of its centennial in 1905, the Academy was esteemed nationally and internationally, with talented teachers, students and alumni, and collections, exhibitions, and annuals that attracted wide attention. But the focus of art-making and the art market had begun to shift to New York, where Philadelphia-born artists such as Robert Henri and other members of The Eight had moved to pursue success. A festive one-hundredth anniversary banquet was held in the Academy building on February 23, 1905 (fig. 7). The theme of the evening was pride in the institution's history and confidence about its ability to maintain its preeminence in the American art world, but many had their doubts. Recalling the occasion in his memoir, Managing Director Morris lamented the relative lack of support for the Academy from wealthy Philadelphians: "The structure we had built of friendship and patronage," he recalled, "was not any too strong. . . . There was little money to go on."[24]

More than two hundred fifty guests dined on deep-sea oysters, Philadelphia-style terrapin, quail on toast, and Nesselrode pudding, accompanied by a Pol Roger '95 and Veuve Clicqot champagne. Morris recalled that the guests represented "the cream of American Art, the quintessence of our creative life." He observed that: "Everybody known in the United States for original work in the Fine Arts was there. The names at the tables duplicated those on the surrounding pictures. . . . No recollection of mine recalls any such inclusive gathering of American artists in the annals of our art."[25]

Fig. 7

Invitation to the Pennsylvania Academy's centennial banquet, 1905.

The celebratory tone was established by Academy President Edward Horner Coates (1846–1921). "It would seem," he said, "that the grandeur that was of Greece, and the glory that was of Rome, were in the souls of the men who in 1805 met in Independence Hall to found the first American Art Institution."[26] The Academy moved "steadily forward," Coates continued. "If there had been periods when the torch was slowly passed from hand to hand, the fire upon the sacred altar of art has never been extinguished, its votaries still believing that in this world we are only concerned with the superlative, and that only the excellent can continue to exist."[27] His remarks were followed

by those of Dr. Horace Howard Furness, brother of the building's architect and a noted Shakespearean scholar, who delivered a suitably lofty address. Witty remarks by lawyer Charles Biddle, descendant of two Academy founders, were followed by comments from Sir Caspar Purdon Clark, director of the Metropolitan Museum of Art, and Talcott Williams, editor of *The Philadelphia Press*. The Academy Gold Medal was awarded to seventy-two-year-old William Trost Richards, and a special centennial year Gold Medal was given to Violet Oakley.

A high point of the evening came when Coates introduced Chase as "a great painter of men, of women, and . . . of fishes . . . one who has done much for the cause of American artists."[28] Greeted with applause, cheers, and chants of "Chase! Chase!," the teacher-painter declared that the Academy "is the most important art institution in this country today." Chase went on to discuss the value of the Academy's instructional program, opportunities for students to travel and study abroad, and the difficulty of becoming a professional artist in America. "I seek to inspire my students . . . with the thought that they have entered a magnificently noble profession," he continued, to applause. After observing that "the artist, in every other part of the world that I know of, England, France, Germany, yes, even in Japan, is respected very highly," Chase bemoaned the lack of appreciation for artists in America and urged support for their efforts in this country.[29] It was an appropriate coda to an upbeat, optimistic commemoration of an institution that still regarded itself as the lynchpin of America's artistic expression.

THE TWENTIETH CENTURY, 1906 TO 2000

As the Academy moved into its second century, the venerable institution failed to respond to new art movements and, as a result, lost contact with the contemporary art world. The Academy's reputation for being a stodgy, conservative place was shaped largely by the profile of its annual and special exhibitions, the content of its permanent collection, and the traditional teaching methods of its school. There was serious outside competition from the Philadelphia Museum of Art, the Metropolitan Museum of Art, the Whitney Museum of American Art, the Museum of Modern Art in New York, and the Museum of Fine Arts in Boston, which among others, attracted avant-garde artists who, in earlier eras, might have gravitated to the Academy.

In the years after 1905, the Academy's record of exhibitions was a mix of the daring and the conservative. In 1908, immediately after an exhibition by The Eight at the Macbeth Gallery stunned the New York art world with its gritty scenes of urban life, the same show opened at the Academy. Five of The Eight had studied at the Academy—Henri, Sloan, George Luks, Everett Shinn, and William Glackens. Bound together by styles and friendships developed in Philadelphia, they paved the way for modernism in America.

The 1913 Armory Show in New York introduced the country to works of the European avant-garde and to American modernists such as Arthur B. Carles, Stuart Davis, and Marsden Hartley. The Academy followed with forays into the new styles. While the Academy's commitment to modernism was more tentative and less pronounced than its interest in Impressionism, the presence on the faculty of avant-garde stalwarts such as Carles, Hugh Breckenridge, and Henry McCarter signaled interest in fresh styles. Carles (1882–1952), a gifted avant-garde painter and a brilliant colorist, was a particularly influential advocate for modernism during his tenure as an instructor from 1917 to 1925 (plates 120–21).

Although many students tended to work in representational styles attuned to the conservative leanings of Philadelphians, some real stars of early American modernism emerged from the Academy. As former Academy curator Sylvia Yount observed, artists such as Davis, Charles Demuth, John Marin, Morton Schamberg, and Charles Sheeler proved that "sometimes, in spite of itself, the Academy has cultivated the more progressive impulses of its student body."[30]

In the wake of World War I, the Academy hosted three modernist exhibitions that helped to promote popular appreciation for the new styles. In 1920, Academy instructors Breckenridge, McCarter, and Carles, assisted by local artist and collector Carroll S. Tyson, Jr., and Academy alumnus and modernist convert William H. Yarrow, organized the exhibition *Paintings and Drawings by Representative Modern Masters.* Most of its two hundred fifty-four works were by European artists, such as Cézanne, Degas, Gauguin, and Manet, and early avant-gardists Braque, Derain, Matisse, and Picasso. The only Americans included in the exhibition, which drew forty-five thousand visitors, were Cassatt, Stanton MacDonald-Wright, and James McNeill Whistler.

The *Modern Masters* catalogue foreword was written by conductor Leopold Stokowski, who, once he had taken over the Philadelphia Orchestra in 1912, had successfully educated conservative Philadelphians about the merits of progressive composers such as Claude Debussy, Igor Stravinsky, and Arnold Schoenberg. He urged viewers to accept with equal enthusiasm styles advanced by modern painters such as Cézanne, Degas, and Matisse.

A year later, in 1921, an even bolder exhibition of avant-garde art, *Exhibition of Paintings and Drawings Showing the Later Tendencies in Art,* opened at the Academy. A committee headed by Yarrow and including Thomas Hart Benton, Arthur B. Carles, Joseph Stella, and Alfred Stieglitz limited the exhibition to work by Americans, choosing two hundred eighty paintings and works on paper by eighty-eight artists. It featured diverse art ranging from figurative painters such as Arthur B. Davies, William Glackens, and John Sloan to European-inspired modernists such as Carles, MacDonald-Wright, Stella, Alfred Maurer, Man Ray, and Max Weber. Distinctively American progressives on view included Benton (then a modernist), Carles, Hartley, Marin, Demuth, Arthur G. Dove, Georgia O'Keeffe, Schamberg, Sheeler, and Florine Stettheimer. *Later Tendencies in Art* "marked the first comprehensive display of American modernist works in an American

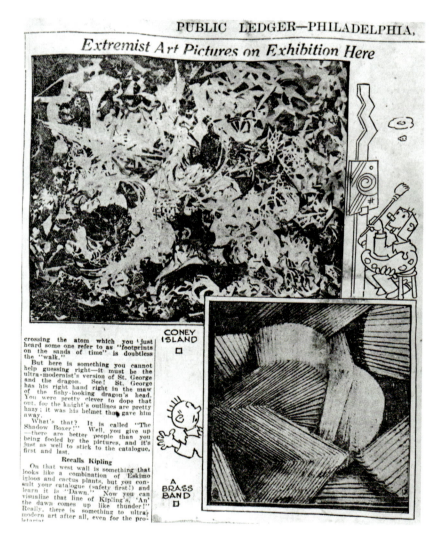

Fig. 8

"Extremist Art Pictures on Exhibition Here," *Philadelphia Public Ledger*, April 17, 1921.

museum."[31] The show drew large crowds and earned favorable reviews from such respected critics as Thomas Craven, who praised the "conservative" Academy for its "new vision" and said that it had performed an "immense service" to modernism by opening its hallowed galleries to such an array of talented American artists.[32] A few critics responded negatively to the show, attacking it as representing the work of radicals, even madmen (fig. 8). Nonetheless, the Academy's example advanced popular acceptance of an unfamiliar art and encouraged other museums to mount modernist exhibitions. The Academy followed this forward-thinking show with a third modern display, the 1923 exhibition of the collection of Albert C. Barnes. Critics vilified the works, especially those by Chaim Soutine, rehashing the uproar of 1921.

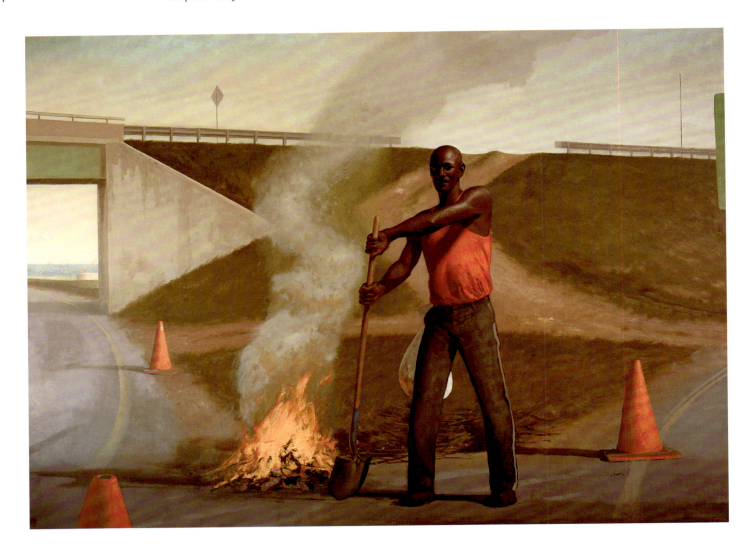

After the modernist shows, the Academy annuals, which continued in a fairly formulaic manner until 1969, became the main focus of the exhibition program. The rise of nationalist sentiment and the trauma of the Great Depression brought work by the then-progressive regionalist and social realist artists to the Academy. But even with these current trends reflected, the annuals became increasingly conventional. For years, little abstract or Expressionist art was shown, reflecting the sense of conservatism and insularity surrounding the Academy. After World War II, when New York had replaced Paris as the center of world art and Abstract Expressionism became the rage, it was represented in annuals, but rarely was added to the collection. Realism dominated the Academy's acquisitions. The school, anchored by such teachers as Hobson Pittman and Franklin Watkins, maintained its figurative tradition, offering a strong academic, studio-based curriculum, with emphasis on drawing from casts and live models.

The stolid and essentially old-fashioned profile of the Academy before and after the middle of the twentieth century was solidified under the conservative leadership of Joseph Fraser (1898–1989), who served as director from 1936 to 1969. Trained as an architect, he ran the Academy's summer school in Chester Springs before becoming head of the Academy. Fraser "provided continuity, but comparatively little growth," according to Frank H. Goodyear, Jr. "The Academy had become a 'slumbering giant,' a reference to the widely held recognition of its tremendous assets."[33]

The Academy's one hundred fiftieth anniversary in 1955 featured numerous events, the issuance of a commemorative postage stamp, and the *One Hundred and Fiftieth Anniversary Exhibition.* The show comprised more than three hundred works by twenty-five artists, both histori-

cal and contemporary, with ties to the Academy. Hailed by critics as a comprehensive reflection of the American spirit, it drew large crowds on a tour of six European cities.

The influence of renowned art historian and board member Edgar P. Richardson in the late 1960s, and the brief tenure of Thomas B. Armstrong as director in the early 1970s, ignited a new era at the Academy. In addition, the first full-time professional curator, Frank H. Goodyear, Jr., joined the staff. Increasingly adventurous exhibitions of nontraditional artists, as well as shows devoted to historical American art were shown. After the annual exhibitions ended in 1969, the Academy encouraged trends in contemporary art through special exhibitions by alumni such as Raymond Saunders and by artists from outside the region such as Richard Diebenkorn (plate 186). Some examples of newer, more abstract art were added to the collection. "The Academy collection," Richardson observed in 1974, "is not a world-encompassing museum, like the Metropolitan or the Louvre, but it is, like the city in which it was created and established, symbolic of the traditions and heritage upon which the present and future will build."[34]

In 1978, at the behest of Goodyear, the Morris Gallery was established to exhibit contemporary work by artists with Philadelphia ties, including site-specific installations and performance art. In addition, more conventional exhibitions focusing on art associated with the Academy or its traditions helped spread knowledge of the institution's heritage and collections. Richard J. Boyle, a respected art historian, came from the Cincinnati Art Museum to serve as director of the Academy from 1973 to 1982. He and then board president Charles E. Mather III spearheaded the careful, historically accurate restoration of the century-old building, completed in 1976. The project confirmed, he stated, that the building is "itself a work of art." He regards it as "an extraordinary place. . . . One of the great places in the art world."[35]

Building the collection was emphasized following the restoration of the Academy. Initial acquisitions emphasized contemporary American realism, consistent with the institution's traditions. Works by realist painters William Bailey, Rackstraw Downes, Alex Katz, Philip Pearlstein, and Neil Welliver were acquired. As a new century approached, efforts to show and collect a variety of contemporary art accelerated. In recent years, the Academy has expanded the scope of its permanent trove by acquiring works by such diverse artists as Red Grooms, Jacob Lawrence, Robert Motherwell, Louis Nevelson, Frank Stella, David Smith, and Jack Tworkov. The museum has yet to represent the twentieth and twenty-first centuries as comprehensively as it does the nineteenth.

Over the last half century, the Academy school has broadened its curriculum, offering printmaking, new sculpture techniques, and experimental multimedia options. In 1988, the purchase and reconfiguration of the 1301 Cherry Street property provided the school with an up-to-date instructional facility. The reemergence of representational art—the New Realism—in the closing decades of the twentieth century found many adherents among the school's faculty and students. "The Academy has come back into fashion by remaining what it was all the time," says artist and veteran instructor Peter Paone.[36] Jeffrey Carr, Dean of Academic Affairs at the Academy, put it thus: "We're mainly a painting school. Painting's not dead. We're in terrific shape as representational painting has come back with a vengeance."[37] Among recent alumni who have made their mark in the art world are such varied talents as Bo Bartlett (fig. 9), Brett Bigbee, Moe Booker, Vincent Desiderio, Renée P. Foulks, Sarah McEneaney, Douglas E. Martenson, and Jody Pinto.

As its third century approached, the Academy expanded its facilities, opening the Samuel M. V. Hamilton building across the street on the northeast corner of Broad and Cherry Streets. It houses seven floors of school classrooms and studios and offers an outdoor painting terrace, library, student lounge, café, and galleries. An underground concourse will connect the Furness and Hamilton buildings, creating a single campus for the first time in forty years. In consolidating the museum and school,

the Academy enters a new era with increased exhibition space to accommodate major loan shows and state-of-the-art facilities for staff, faculty, students, and visitors. The 1876 structure, a National Historic Landmark, continues to provide a venue for the display of the permanent collection.

THE ACADEMY'S THIRD CENTURY, 2005 AND BEYOND

As the Academy celebrates its two-hundredth anniversary, Derek A. Gillman, who became the President and Edna S. Tuttleman Director in 2001, observed that "Museums and schools go through cycles, moving in and out of fashion, and need to be judged over long periods of time." The Academy, he says, "doesn't have to follow fashion, but must know what is going on in the world."[38] Gillman acknowledges significant gaps in the Academy's collection, leading to a selective "wish list" of desired acquisitions. But a de Kooning or a Pollock is simply too expensive for the Academy to purchase; it has to rely on donations. On the other hand, Gillman points out, we "try not to miss good works [by contemporary artists] now on the market."[39]

Seventy-five years ago, Harrison Morris observed that on its one-hundredth anniversary, the Academy was "at the topmost reach of its history." He went on to speculate about its "possibilities for the future, for culture in beauty and taste, for the education of rising talent; for gathering into knowledge of the best things the tragic masses of ignorance—all these uses [the Academy might serve] with growing power."[40] Morris's vision of the Academy's mission remains relevant to this day. A forum for diverse ideas, it looks toward a future in which a multiplicity of artists, styles, methodologies, and cultures engage in a lively dialogue with each other and the public.

Looking to the future, President Gillman says that he wants the "Academy to be seen as a place where intelligent art is made. It should be thought of again as a place where things are going on of importance to the nation and the world."[41] An enduring fusion of past, present, and future, the Pennsylvania Academy of the Fine Arts, on its two-hundredth anniversary, is poised to carry on its mission to develop American artists and to enhance appreciation for their work, and to continue its contributions to the national and international art worlds.

Notes

Unless otherwise noted, the primary sources cited below are in the archives of the Pennsylvania Academy of the Fine Arts, Philadelphia.

1. Benjamin Franklin to Charles Willson Peale, July 4, 1771, in *The Selected Papers of Charles Willson Peale and His Family*, 4 vols., ed. Lillian B. Miller (New Haven, Connecticut: Yale University Press, 1992), vol. 1, pp. 99–100.

2. *Articles of Association, Dec. 26, 1805, of the Pennsylvania Academy of the Fine Arts.*

3. Charles Willson Peale to Thomas Jefferson, June 13, 1805, in Miller, ed., 1992, vol. 2, part 2, pp. 850–52.

4. Benjamin Henry Latrobe to Charles Willson Peale, July 17, 1805, *ibid.*, p. 866. In reference to this letter, the editors of the Peale papers note that "cookery meant the practice of falsifying."

5. Charles Willson Peale to Thomas Jefferson, *ibid.*, p. 953.

6. Thomas Jefferson to Charles Willson Peale, *ibid.*, p. 970. There is no evidence in the Pennsylvania Academy Archives that Jefferson ever sent his contribution.

7. Benjamin West to the Pennsylvania Academy, September 18, 1805.

8. Joseph Hopkinson, *The First Annual Discourse*, 1810, p. 6.

9. Resolutions of [the] Committee of Arrangements and Inspection [for the Annual Exhibition], April 22, 1811. Reproduced in Miller, ed., 1992, vol. 3, pp. 89–90.

10. Frank H. Goodyear, Jr., "A History of the Pennsylvania Academy of the Fine Arts, 1805–1976," in *In This Academy: The Pennsylvania Academy of the Fine Arts, 1805–1976* (Philadelphia: Pennsylvania Academy of the Fine Arts, 1976), p. 25.

11. John Merryman, "Case Notes: The Marquis de Somerueles," *International Journal of Cultural Property*, vol. 5, no. 2 (1996), pp. 319–21.

12. "Destruction of the Academy of Fine Arts, Philadelphia," *The Illustrated London News*, July 19, 1845, pp. 37–38.

13. See Christine Jones Huber, *The Pennsylvania Academy and Its Women*, 1850–1920 (Philadelphia: Pennsylvania Academy of the Fine Arts, 1974), p. 12.

14. The Reverend William H. Furness to the Pennsylvania Academy, May 4, 1857, and Academy board minutes of April 13, 1857.

15. Quoted in Goodyear, 1976, p. 33.

16. Harrison S. Morris, *Confessions in Art* (New York: Sears Publishing Company, 1930), p. 59.

17. *Ibid.*

18. For a list of recipients of the Temple Medal, see *The Annual Exhibition Record of the Pennsylvania Academy of the Fine Arts*, 3 vols., ed. Peter Hastings Falk (Madison, Connecticut: Sound View Press, 1989), vol. 1, p. 36, and vol. 2, p. 31.

19. Interview with author, February 11, 2004.

20. Morris, 1930, p. 31.

21. Lloyd Goodrich, *Thomas Eakins*, 2 vols. (Cambridge, Massachusetts: Harvard University Press for the National Gallery of Art, 1982), vol. 2, p. 201.

22. Morris, 1930, p. 196.

23. See Nancy Mowl Mathews, " 'The Greatest Woman Painter': Cecilia Beaux, Mary Cassatt, and Issues of Female Fame," in *The Pennsylvania Magazine of History and Biography* (special issue), vol. 124, no. 3 (July 2000), p. 308.

24. Morris, 1930, p. 219.

25. *Ibid.*, p. 220.

26. *Report of Addresses at the Banquet Given in Celebration of the One-Hundredth Anniversary of the Founding of the Academy of Fine Arts*, p. 2.

27. *Ibid.*

28. *Ibid.*, p. 26.

29. *Ibid.*, p. 29.

30. Sylvia Yount, "The Academy Legacy," in *The Unbroken Line: A Suite of Exhibitions Celebrating the Centennial of the Fellowship of the Pennsylvania Academy of the Fine Arts* (Philadelphia: Pennsylvania Academy of the Fine Arts, 1997), p. 19.

31. In 1996, the Academy recreated *Later Tendencies in Art* in the exhibition *To Be Modern: American Encounters with Cézanne and Company*, featuring more than fifty works shown in 1921, along with pertinent art from the Academy's collection. See Sylvia Yount and Elizabeth Johns, *To Be Modern: American Encounters with Cézanne and Company* (Philadelphia: Pennsylvania Academy of the Fine Arts in association with the University of Pennsylvania Press, 1996).

32. Thomas Jewell Craven, "The Awakening of the Academy," *Dial*, vol. 70 (June 1921), pp. 673–78.

33. Goodyear, 1976, p. 46.

34. Edgar P. Richardson, "Introduction," *Pennsylvania Academy of the Fine Arts Appointment Calendar*, 1974, n.p.

35. Telephone interview with the author, February 23, 2004.

36. *Ibid.*

37. Interview with the author, February 10, 2004.

38. Telephone interview with the author, February 23, 2004.

39. *Ibid.*

40. Morris, 1930, p. 220.

41. Telephone interview with the author, February 23, 2004.

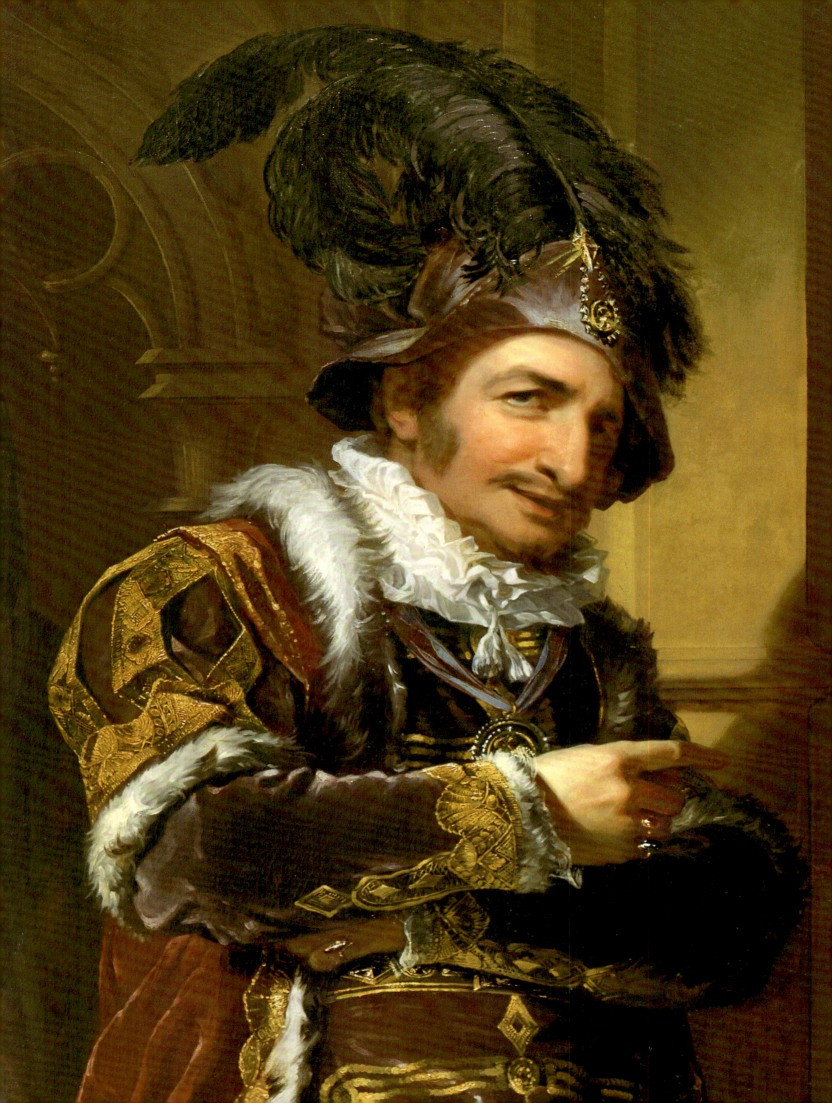

MARK HAIN

Coming into Focus:
Two Hundred Years of Building a Collection

On December 26, 1805, the founders of the Pennsylvania Academy of the Fine Arts signed their Articles of Association with the implicit belief that fostering the visual arts was in the trust of the City of Philadelphia, the cultural hub of the young nation. Predominant among the founders' noble intentions were both the training of American artists and the cultivation of art appreciation among the general populace. Over the two centuries of the Pennsylvania Academy's existence, these goals have been interdependent in a way that is unique in American art institutions, with the founders' original intentions still guiding the Academy's teaching, exhibiting, and collecting practices.

As stated in the Articles of Association, the founders emphasized the acquisition of plaster reproductions of historic sculptural works. This decision was strongly influenced by Benjamin West, who was revered as the first native artist to earn acclaim outside America. West had reached heights previously undreamed of by American artists, receiving an appointment as Historical Painter to the court of England's King George III. The Academy's board of directors sought and followed his advice eagerly. In emulation of London's Royal Academy of Arts, of which he was president, West convinced the Academy's board that copying from master works was crucial to art instruction. The directors immediately commissioned a selection of plaster casts of Greek and Roman statuary from an atelier at the Louvre in Paris. The casts were purchased through the Academy's agent Nicholas Biddle, who compiled a list of about fifty impressive pieces to be shipped to the Academy, including the *Medici Venus*, *Laocoön*, *Cupid and Psyche*, the Borghese gladiator, the torso Belvedere, and an *écorché* (anatomical model of a flayed man) by the French artist Jean-Antoine Houdon.[1] These casts arrived in 1806, along with a handful of paintings copied after various old masters, all meant to inspire original works by

fledgling American artists. Thus the nucleus of the Academy's collection was formed, and an uninterrupted process of collecting was instigated.

Throughout most of the nineteenth century, the Academy's slowly growing collection was dependent primarily on donations from private collectors. The first objects donated to the young Academy were a selection of fifteen hundred small plaster impressions of antique medals, coins, and gems given by Joseph Allen Smith in 1807. Two years later, Charles Willson Peale, one of the three artists involved in the founding of the Academy, donated his portrait of the Academy's first president George Clymer, likely the first American painting in the collection (see fig. 2). Among other donations in the Academy's earliest years was a large gift, also by Smith, of European paintings as well as a painting by Angelica Kauffmann, anticipating the Academy's progressive stance toward women artists, and a twenty-four-volume set of prints by Giovanni Battista Piranesi received, indirectly, from Napoleon Bonaparte. This unregulated trickle of donations resulted in some significant coups, such as Gilbert Stuart's famous "Lansdowne" portrait of George Washington (plate 10), given by William Bingham in 1811, and Thomas Sully's portrait *George Frederick Cooke as Richard III*, donated by "friends and admirers of the artist" in 1812 (fig. 10), but, for the most part, such random acts of kindness produced an unfocused collection reflective of local taste more than American art as a whole. Philadelphia taste tended to be simultaneously sophisticated and conservative, with both a lingering appreciation for formal portraiture, as typified by colonial New England painting, and a love for the dramatic Continental style known as history painting, or the Grand Manner, which emphasized heroic scale, multiple figures in action, and a moralizing theme based on mythological, biblical, literary, or historical narrative.

The taste for the Grand Manner is exemplified by the Academy's first major purchase in 1816. Washington Allston had developed a reputation almost as lofty as West's, and the Academy engaged the financial support of forty-six stockholders, or "subscribers," to assist in the purchase of his large canvas *The Dead Man Restored to Life by Touching the Bones of the Prophet Elisha* (plate 16). Despite such support, the Academy was forced to mortgage its building to cover the cost of the acquisition. The Academy found itself in a similar position upon purchasing West's massive and frightening painting *Death on the Pale Horse* from the artist's son Raphael in 1836 (plate 6). Acquiring and exhibiting such grand history paintings were seen as the highest priority, instructive to students in the "correct" method of painting and morally and aesthetically uplifting to the public. Fortunately, however, early donations of such paintings as Charles R. Leslie's *The Murder of Rutland by Lord Clifford* (plate 18) and John Neagle's *Pat Lyon at the Forge* (plate 31) expanded the collection and satisfied the taste for the Grand Manner without any further mortgages.

Limited funds had been set aside by the board for the purchase of American art since 1814, but at this time American works were still regarded as less desirable than European, which comprised the focus of the collection. Nevertheless, the Academy's board of directors devised means of obtaining American works at little or no cost. Members of the Pennsylvania Academicians, a group of artists who advised the Academy, were, in theory, required to donate an example of their art to the collection.[2] Despite the almost complete failure of this tactic, the Academy board proposed a similar

endeavor in 1851, offering artists the opportunity to become Academy stockholders by donating a work of art valued over thirty dollars.

In 1845, the Academy's collection was dealt a major blow when a fire devastated the original building at Tenth and Chestnut Streets, destroying many European paintings and probably all of the casts.[3] West's *Death on the Pale Horse*, which had caused such a financial strain for the institution, was saved by resourceful firemen who sliced the huge canvas from its stretcher and carried it out of harm's way. In the aftermath, a number of damaged works were repaired, and as citizens of Philadelphia rallied to aid the devastated art institution, the collection rebounded by 1855 to one hundred thirty-five paintings (mainly European) and sculptures (mainly copies after originals).[4]

While the Academy had, by this point, established itself as vital to Philadelphia's cultural life, the limited scope of its instruction and collection was typical nationwide. The Academy's opportunities to collect original sculptural works were hindered by insufficient availability, expense, and the complex logistics of transport. An 1851 assessment of the Academy's scanty collection of busts and small works as "not aspiring to the higher efforts of the sculptor's art"[5] was honest, although the inclusion of works by William Rush (plate 26), another artist connected with the Academy's founding, and Horatio Greenough prefigured triumphs to come.

Throughout the 1850s and 1860s, the prestige of the Academy's school grew, as did the acclaim for its annual exhibitions. An integral feature of the Academy's program since 1811, the annuals increasingly became a source of acquisitions for the collection, developing from displays of miscellaneous borrowed and permanent collection items to eagerly anticipated exhibitions of new pieces by working artists. Throughout the nineteenth century, the Academy's prominence in the training of Philadelphia artists, who would then sell their works back to the Academy in its annuals, was arguably a case of the institution perpetuating its own artistic agenda. As the reputation for the annuals grew stronger nationally, however, and began attracting artists beyond the borders of the city, the exhibitions became a venue not only for Philadelphians to see beyond local endeavors but also as a means of diversifying the Academy's holdings (fig. 11).

Fig. 11
63rd Annual Exhibition, 1893,
Pennsylvania Academy of the
Fine Arts, Philadelphia, showing
Winslow Homer's Fox Hunt.
Albumen print, 6 x 8 ½ inches.

With such collecting practices in place by the late 1860s, the Academy building was growing ever more cramped, and plans were underway to relocate the school and museum. The new building at Broad and Cherry Streets quickly became a Philadelphia landmark. Flamboyantly eclectic in color and ornamentation, the Academy's new home reflected the grandeur of the art collection inside as well as the rather hodge-podge nature of its acquisitions. Academy board members touted the modernity of the new structure as a means of soliciting donations; apparently this tactic worked, for the inauguration of the building anticipated some of the most important gifts in the Academy's history.

Within months of the new building's opening, the Academy received a bequest of sixty thousand prints and drawings, mostly European, from John S. Phillips (1800–1876). Phillips, who had made and lost fortunes through a cotton power-loom factory and a sugar refinery, was a strong supporter of Philadelphia's cultural institutions. A passionate collector of etchings and engravings, Phillips donated twelve thousand dollars to supplement the Academy's holdings along with his massive print collection.[6] Two years later, some of the most important paintings in the collection arrived with a bequest from Joseph Harrison, Jr. (1810–1874). Harrison's innovative locomotive designs had earned him a considerable fortune, and he eventually became one of the most insightful collectors of American art. Although Harrison's long-term involvement with the Academy ended in 1870, his widow Sarah (1817–1906) oversaw the donation of eleven key works from his collection, including West's *Christ Rejected, Penn's Treaty with the Indians* (plate 5), and John Vanderlyn's *Ariadne Asleep on the Island of Naxos* (plate 15), a painting deemed so risqué at the time that it required strictly scheduled viewing times, segregated by gender. Three works by Charles Willson Peale in the bequest, portraits of George Washington and Benjamin Franklin, in addition to what is perhaps the Academy's trademark image, Peale's self-portrait *The Artist in His Museum* (plate 27), had been purchased by Harrison in 1854 at the dissolution of Peale's Philadelphia Museum.[7] After Sarah Harrison's death, six additional works entered the collection. Unfortunately, these did not include Gilbert Stuart's "Vaughn" portrait of Washington, purchased by Harrison from William Vaughn himself, which was sold at public auction, where the Academy was outbid by a private collector.[8]

In 1879, scarcely a year after the initial Harrison gift, the Academy received another treasure in the bequest of Edward L. Carey (1806–1845), the son of a prosperous Philadelphia bookseller and publisher. Carey was a major patron of the arts in America who had amassed a bold collection of contemporary British and American works (fig. 12) and commissioned some of the most ambitious works by American artists, from the first of Thomas Sully's portraits of the British actress Fanny Kemble (in character as Beatrice from *Much Ado About Nothing*, plate 25) to a series of grand-scale canvases by Daniel Huntington based on John Bunyan's *The Pilgrim's Progress* (plate 33). Carey's affection for humorous or sentimental genre scenes is particularly well represented in the Academy's collection, with works by William Sydney Mount, John Inman, James Clonney (plates 35, 36, 34), and William Page.[9]

The 1892 gift of Henry C. Gibson's collection was hailed as the most valuable to date. Gibson (1830–1891) was the heir to John Gibson & Son, a whiskey distillery and wine importer in Pittsburgh, and his fortune allowed him to become a great patron to many of Philadelphia's cultural institutions. He was especially generous to the Academy, where he served on the board from 1870 until his death.[10] Gibson's bequest, however, represented a growing quandary for the Academy: of just over one hundred works donated, a mere ten were by American artists, including the sculptural treasures *Paradise Lost* (plate 45) and *First Prayer* by Joseph A. Bailly, *Hero* by William Henry Rinehart, *Eleänore* by Howard Roberts, and three paintings by Academy instructor Peter Frederick Rothermel. After about 1880, the Academy effectively stopped collecting European works, save for donations, and focused instead on building a preeminent collection of American art. A policy of giving preference to

Fig. 12
George Bacon Wood, *Interior
of the Library of Henry C. Carey*,
1879. Oil on canvas, 14 x 20¼
inches (35.6 x 51.4 cm).
Gift of the artist, 1880.1.

American artists for exhibitions had existed, theoretically, as early as 1811.[11] As American art matured throughout the nineteenth century and became notable for its own sake, the Academy's resolve to limit the collection to American works strengthened. There were certainly also practical and economic implications for collecting American works exclusively, including those of worthy Academy instructors and alumni, a trend that seems to have gained the support of local critics. Beginning in the 1890s, the European works in the collection, including objects from the Phillips, Carey, and Gibson bequests, have been traded or sold, the proceeds earmarked specifically for purchase of work by American artists.

These first instances of deaccessioning European works, which still comprised the bulk of the museum's collection in the 1880s, signaled an important change in the museum's practices. From the 1890s until the outbreak of World War I, the Academy enjoyed some of the most important, profitable, and forward-thinking years of its collecting endeavors. New administration by Academy president Edward H. Coates (1846–1921) and managing director Harrison S. Morris (1856–1948), the institution's first professional administrator (see fig. 4), signaled an increased interest in innovative art. Prior to Morris's tenure, the Academy's collection reflected the conservative tastes of its board of directors; works were acquired randomly, with little thought given to cohesiveness and great favoritism given to local artists, regardless of merit. Morris's forceful personality and strong opinions alienated some of the more conventional board members, who were opposed to his passion for bold new trends in art and his determination to add such works to the collection. Morris developed strong connections with artists and benefactors alike, successfully orchestrating major new donations to the Academy's holdings. Prime among his accomplishments was a degree of reparation with Thomas Eakins, who was still resentful after his forced resignation from the Academy faculty in 1886. It was under Morris's influence that Eakins's *The Cello Player* (plate 77) entered the collection in 1897, marking the Academy as among the first museums to collect his work.

The funds that enabled the purchase of *The Cello Player* were provided by one of the greatest benefactors in the Academy's history, Joseph E. Temple (fig. 13). Temple (1811–1886), a wealthy dry-goods merchant, collector, and major philanthropist, had no immediate family and used his consid-

erable fortune to support Philadelphia's cultural life. While Temple donated a few paintings to the Academy outright, including Charles Sprague Pearce's *Fantasie* (plate 61) and Burr Nicholls's *Sunlight Effect*, his greatest gift was an extremely magnanimous fund given in 1880: fifty-one thousand dollars, a princely sum he increased to sixty thousand by 1883.[12] Temple requested that a significant portion of the income be used for new acquisitions and the awarding of gold and silver medals at the Academy's annuals.

Prior to the Temple gift, most of the Academy's acquisitions were still donations, hobbling ambitions to build a cohesive collection. Temple's gift was the major impetus for the board to begin purchasing with confidence, and serendipitously coincided with the annuals becoming increasingly prestigious as cosmopolitan showcases for the best works by American artists active both at home and abroad. The increasing sophistication of the annuals is reflected by the staggering number of major works purchased for the collection with Temple funding, spanning such nineteenth-century figurative painters as Eakins, Cecilia Beaux, and William Merritt Chase, American Impressionists such as Childe Hassam and John Twachtman, and Ashcan School painters such as Robert Henri and George Bellows. If one work might be singled out, the honor would go to Winslow Homer's haunting analysis of "survival of the fittest," *Fox Hunt* (fig. 11 and plate 86). Purchased with Temple funding from the 1893 annual exhibition, *Fox Hunt* was, unbelievably, the first work by Homer to enter a museum collection. It is also worth noting that, contrary to earlier published accounts, the Academy did not fumble the opportunity to purchase James McNeill Whistler's famed *Arrangement in Grey and Black No. 1: Portrait of the Artist's Mother*. When the work was shown at the Academy as part of a special exhibition in 1881, it was not for sale.[13]

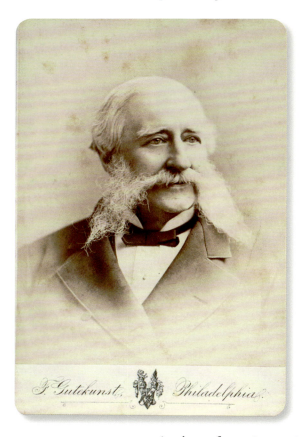

Fig. 13
Frederick Gutekunst,
Joseph E. Temple, 1883. Albumen
print, 5¾ x 4¼ inches.
Provenance unknown.

In addition to the great boon of the Temple Fund, the Academy also received funds from the estate of Henry D. Gilpin (1801–1860), although complicated litigation had delayed it for many years. Gilpin, an attorney, author, and editor, had served as the sixth president of the Academy, from 1852 to 1859, after his retirement from political life. By today's standards, his politics rather vilify Gilpin, since he supported the government's removal of Native Americans, and, as U.S. Attorney General, he argued against defender John Quincy Adams in the 1841 Supreme Court case on the slave rebellion aboard the *Amistad*. Politics aside, Gilpin's funding has accounted for major additions to the Academy's collection, ranging from works by Charles Willson Peale and James Peale to major twentieth-century painters such as Guy Pène du Bois, Lyonel Feininger, William Gropper, Reginald Marsh, Isabel Bishop, Raphael Soyer, and Fairfield Porter. Sculpture purchased through the Gilpin Fund includes that of Academy instructor Charles Grafly (1862–1929). Grafly's carefully realized, unidealized figures in bronze (plate 97) exemplify the growing importance of sculptural instruction at the Academy in the late nineteenth and early twentieth centuries, and the attendant increase in sculpture collecting, with important additions by Alexander Stirling Calder, Bessie Potter Vonnoh, and Alfred Laessle.

The turn of the century brought with it an increasing divide between progressive forces at the Academy and those whose tastes remained attuned to older traditions in art. With great animosity toward the Academy's board of directors, Morris resigned in 1905, and his successors showed greater willingness to support the popular taste for unchallenging academic works in both exhibitions and

collecting. At the same time, the works of long-standing faculty artists such as Beaux, Grafly, Chase, and Thomas Anshutz, who had been innovators a decade earlier, were joined by younger artists Hugh Breckenridge, Henry McCarter, and Arthur B. Carles, American pioneers in modernist concepts and abstraction. As such, the Academy was a microcosm of growing tensions in the larger art world, and the institution already had a history—from Eakins to the American Impressionists to the student days of members of The Eight—of teaching practices and student-art production that tended to be several steps ahead of the museum's collecting insight.

 Even when intentions were good, the outcome was frequently mixed. A 1907 bequest of fifty thousand dollars from John Lambert (1861–1907), a former Academy student, came with the stipulation that the money be used to purchase works by emerging artists. Unfortunately, the majority of selections purchased with Lambert's funding reflected the inability of the board to appreciate innovation or recognize work of lasting significance: of the more than three hundred works purchased with Lambert funds from the annual exhibitions, most are indifferent works by artists of no historical consequence. When the selections were on target, however, the Lambert Fund provided the collection with some strong works by important artists including Carles, Violet Oakley, Preston Dickinson, Edward Hopper, George Ault, Earl Horter, Abraham Rattner, Mark Tobey, and Red Grooms. Even a few of the works purchased with Lambert funding by lesser-known artists, such as Hilda Belcher, Hubert Davis, Lilian Westcott Hale, Lee Gatch, Morris Hall Pancoast, Marianna Sloan (fig. 14), and Walter Stuempfig, are exceptional.

Fig. 14
Marianna Sloan, *A Rocky Beach*, ca. 1914. Oil on canvas, 26 ³⁄₁₆ x 33 ³⁄₁₆ inches (66.5 x 84.3 cm). John Lambert Fund, 1915.6.

The schism between conservative and progressive interests at the Academy was a fixed pattern throughout the first half of the twentieth century, each side able to claim victories as American art simultaneously increased in its inventiveness and its potential to alienate. The annuals continued to be a source of acquisitions; yet innovative artists, even those with Academy connections such as Carles, Robert Henri, John Sloan, William Glackens, Everett Shinn, John Marin, and Charles Demuth, were infrequently purchased. To some degree, this decision was purely economic. The Academy, which retained a small commission on sales from the annuals, had long recognized that Philadelphia audiences did not respond to "new" art; the frequent focus by such artists on images of New York further distanced local buyers. Many of the works purchased in this era are of significantly lesser interest.

In the 1920s, the Academy compensated for the timidity of its annuals with groundbreaking special exhibitions of modern art, such as the 1920 exhibition of European avant-garde works *Paintings and Drawings by Representative Modern Masters*. A year later, the Academy exhibited work by young American modernists in *Paintings and Drawings Showing the Later Tendencies in Art*, and in 1923 presented, with a surprising amount of negative criticism, works from the famed Philadelphia collector Albert C. Barnes. While the Academy purchased nothing from the 1921 exhibition, Barnes bought no fewer than eight works.[14]

As its contemporary collecting continued with provincial inclinations, the Academy received a large gift of historic works, which turned out to be a mixed blessing. In 1933, John Frederick Lewis, Sr. (1860–1932), who had served for twenty-four years as president of the Academy board, bequeathed one hundred twenty-seven portraits and a collection of engravings. As the Lewis works were assessed, it was determined that many of the works were "over-attributed" inferior copies. Once the collection was weeded, however, some true gems emerged—a unique overview of figuration in Philadelphia from West's colonial-era portrait *Elizabeth Peel* to Mary Cassatt's pre-Impressionist painting *Bacchante* (plate 54). A short time later, Lewis's widow added significant works to the gift, including several striking canvases by two masters of early nineteenth-century portraiture: Jacob Eichholtz and John Neagle.

Many on the Academy's board of directors were content to see the collection grow in this direction, building on existing strengths in historical holdings and turning a blind eye to modern works. In a sense, this was beneficial to the Academy's status, as it perpetuated a vision of historical significance by collecting and exhibiting works that embodied its instructional focus on academic figuration; on the other hand, amid a maelstrom of ever more advanced contemporary art, the institution was in imminent danger of becoming a dinosaur.

After World War II, the United States ascended to the forefront of the international avant-garde, and, as with most of the nation, Philadelphia was reluctant to accept Abstract Expressionism and other New York-centered art movements, which the Academy's board tended to dismiss as fads. After 1950, the Academy's annual exhibitions became more inclusive and reflective of national trends but were still an uneasy mix of pedestrian, retrograde works and daring choices. Although many innovative artists won major awards at the annuals, the Academy was not especially forward thinking in its collecting practices, with purchases from the annuals controlled by lay members of the Committee on Exhibitions. Hindsight reveals a particularly galling instance: the Academy's failure to purchase Jackson Pollock's *Convergence*, priced at six thousand dollars, from its 1956 annual.[15] However, the occasions on which important works in the annuals were recognized and purchased were surprisingly impressive; in passing on the Pollock, for example, the Academy instead acquired Jack Levine's *Medicine Show* (plate 172) and Rico Lebrun's *Buchenwald Cart*.[16] In the last two decades

of the annuals, the Academy also obtained paintings and sculptures by such artists as Yves Tanguy, Saul Baizerman, Isamu Noguchi, Harry Bertoia, and Richard Diebenkorn (through the Gilpin Fund); Stuart Davis and Richard Anuszkiewicz (through the Lambert Fund); and Philip Evergood, Lee Bontecou, and another Stuart Davis (through the Temple Fund).

In 1975, the Academy's first full-time professional curator, Frank H. Goodyear, Jr., cognizant of the institution's holdings as "more an assemblage of objects than a self-conscious collection," prepared a detailed collection analysis as an initial step in developing what was perhaps the institution's first directed acquisitions plan. Not surprisingly, Goodyear found the weakest area of the collection (and top priority for redress) to be modern and contemporary art but also mentioned nineteenth-century landscapes, particularly of the Hudson River School. In addressing the collection's strengths, Goodyear acknowledged the representation of eighteenth- and nineteenth-century American paintings to be among the finest in the nation, citing the Academy's holdings by members of the Peale family to be its greatest strength.[17] With seventeen paintings by Charles Willson Peale, thirteen by James Peale, nineteen by Rembrandt Peale, two each by Raphaelle Peale and Charles Peale Polk, one each by Margaretta Angelica Peale, Rubens Peale, and Sarah Miriam Peale, plus five miniatures by James Peale and two attributed to Anna Claypoole Peale, the selection is not only impressive but also presents a fascinating picture of Philadelphia taste of the late eighteenth and early nineteenth centuries.

Most of these works by the Peale family, along with the Academy's twenty-nine works by Gilbert Stuart and forty-four canvases by Thomas Sully, comprise the core of its important portrait collection. In keeping with the Academy's tradition as principally a school of figurative art, much attention has been paid over the years to collecting portraiture, not least because of its great instructive value to students who would find portrait commissions the most available means of making a living. The Academy's portrait collection, particularly works by Stuart, was such a source of pride throughout the late nineteenth century that proposals were regularly made to inaugurate a gallery of national portraiture at the Academy. The idea emerged as early as the 1882–84 annual report, with a rather shameless pitch to bolster the collection through donations and long-term loans from individuals, soliciting "ancestral portraits" by the likes of Gustavus Hesselius, Robert Feke, John Singleton Copley, John Trumbull, Mathew Pratt, Gilbert Stuart, and John Neagle and assuring potential donors that placing the works "in the fire-proof galleries of the Academy, would provide against all chances of their destruction, and at the same time leave them open to the view of posterity, for all time to come."[18] As if to chastise such boldness, yet another fire struck the building on April 8, 1886, destroying nearly fifty paintings and parts of the roof. Fortunately, the "fireproof" nature of the building's construction did indeed keep the blaze from spreading farther. Undaunted, the Academy's desire for the portrait gallery persisted, culminating in an exhibition in 1905. The installation was probably intended to be permanent, but seems to have lasted only about a decade. The wish to expand the holdings in portraiture was fueled by the lack of a work by Copley, a gap in the collection recognized at least as far back as 1884 and cited as one of the collection's most glaring omissions in Goodyear's 1975 report. This century-long wish was fulfilled in 1984, when an endowment for acquisitions was established by the heirs and friends of board president Henry S. McNeil, who provided for the purchase of a fine portrait by Copley of the Massachusetts businessman Robert "King" Hooper (plate 4).

Not addressed in Goodyear's assessment is the overall strength of the Academy's collection of works on paper. Consisting of twelve thousand objects, the collection remains much less renowned than it should be, due in large part to limitations in exhibiting the works. For reasons of conservation, the building's skylights (a stipulated feature of the 1871 design competition) prevent prolonged

exposure outside the Academy's storage vaults. Considering the academic tradition of the school, it is reasonable that the collection is so rich in drawings, particularly figurative works by alumni or faculty artists such as Violet Oakley and Daniel Garber. The one hundred four meticulous figure drawings attributed to instructor Christian Schussele (see fig. 23) and the seventy-one evocative, looser drawings of figures and casts executed by Anshutz (possibly as classroom demonstrations) are emblematic of the Academy's pedagogical changes over time. The Academy's holdings in watercolors are as impressive, with glorious works by artists ranging from Winslow Homer, William Trost Richards, and Maxfield Parrish to Charles Demuth, John Marin, and Charles Burchfield (fig. 15) and beautiful pastels by Thomas Anshutz, Cecilia Beaux, Mary Cassatt, and Morton Schamberg.

The Academy's large collection of prints in all mediums includes striking examples from many of America's most important graphic artists, including James McNeill Whistler, Childe Hassam, Thomas Moran, John Sloan, George Bellows, Dox Thrash, Leonard Baskin, Andy Warhol, and Barbara Kruger. Of particular interest are large bodies of work by outstanding Philadelphia printmakers such as Joseph Pennell (66 prints), Daniel Garber (100), Herbert Pullinger (202; fig. 16), George Biddle (96), Julius T. Bloch (32), Benton Spruance (72; plate 155), and Stella Drabkin (20). The largest body of work in the collection by a Philadelphia printmaker is that by John Sartain (1808–1897): more than a thousand mezzotints, engravings, and etchings (plate 52), mostly gifts of his great-grandson Dr. Paul Judd Sartain. Vigorous and active in the public life of Philadelphia, John Sartain served on the Academy's board for twenty-two years, from 1855 to 1877. Much like Charles Willson Peale, the great Philadelphia artist of a generation earlier, Sartain was the patriarch of an artistic dynasty. He trained his children as artists, and the Academy owns a number of works by his sons Samuel and William and his daughter Emily.

The depth and breadth of the Academy's collection is further revealed in several "study collections," holdings of numerous oil studies, preparatory drawings, and sketchbooks by artists, many former Academy students or faculty. In 1950, forty oil studies by Beaux were donated by her nephew

Fig. 15

Charles Burchfield, *End of the Day*, 1938. Watercolor over graphite and charcoal on white paper, 28 x 48 inches (71.1 x 121.9 cm). Joseph E. Temple Fund, 1940.3.

Henry Sandwith Drinker, many painted during her studies in France. In addition to the drawings previously mentioned, Anshutz's daughter-in-law donated thirty-five oil studies and thirty-two watercolors, mostly landscapes, in 1971. The selection of exquisitely refined landscape studies by Charles Lewis Fussell, fifty-six in oil and twenty-eight in watercolor (plate 101), presents a striking contrast to the twenty-six jewel-like abstracted landscapes in watercolor and wax emulsion by Arthur G. Dove, donated by his son. A gift of more than two thousand objects by Violet Oakley, acquired

Fig. 16
Herbert Pullinger, *Pouring Huge Casting—Baldwins*, undated. Etching and soft ground on cream wove paper, sheet 13 x 14¾ inches (33 x 37.5 cm), plate 11⅛ x 12⅛ inches (28.3 x 30.8 cm). Gift of the artist, 1957.33.39.

after the death of her companion Edith Emerson in 1981, is the Academy's largest study collection. The core of this material consists of sketches and studies Oakley executed in preparation for portraits, illustrations, altarpieces, stained glass, and mural projects for which she is well known.

In 1985, the Academy was extremely fortunate to obtain, with funds from the Pew Charitable Trusts, a large selection of materials that had been retrieved from Thomas Eakins's home after his death, a unique and compelling collection that has been a boon to scholars of late-nineteenth-century art. Acquired by Charles Bregler, a former student of Eakins, the collection was purchased from Bregler's widow. The Bregler Collection contains more than two hundred sixty preparatory drawings, oil studies, perspective and anatomical studies, and juvenile works, plus ten small sculptures and casts, hundreds of pages of correspondence, and more than a thousand photographs and negatives by Eakins (plate 78 and see fig. 25). The collection also includes works by members of the artist's circle, including his wife Susan Macdowell Eakins.

As Goodyear noted in his 1975 report, one of the Academy's greatest difficulties in acquiring contemporary work is the long-standing belief that the institution has no interest in this area. The Academy made major strides in dispelling this incorrect notion when it founded its Morris Gallery program in 1978, a response to the extraordinary richness of contemporary visual arts in Philadelphia. Named for Harrison S. Morris and begun through a grant provided by his daughter, the artist Catherine Morris Wright, the gallery occupies former classroom space on the ground floor of the museum building. Initially designed as a gallery for local artists, the program has recently expanded to feature artists from across the country, and the nature of the space itself has inspired a number of stunning installation projects. In its nearly thirty-year history, the Morris Gallery program has also resulted in a number of additions to the Academy's collection.

The great convenience of purchasing contemporary works from the annual exhibitions ended in the late 1960s when the annuals were reluctantly halted due to growing logistical complexity and expense. While this may have briefly curtailed the Academy's efforts in collecting contemporary art, throughout the 1970s and 1980s funding from the National Endowment for the Arts, plus special Academy Contemporary Arts Purchase Funds and funds raised by the Pennsylvania Academy Women's Board, made possible the acquisition of works by Edwin Dickinson, Robert Motherwell, Alex Katz, Rackstraw Downes, William Bailey, George Segal, and Neil Welliver. And funds by the great benefactors of the past century—Phillips, Temple, Gilpin, Lambert, and others—continue to provide for new acquisitions.

Fig. 17

Benny Andrews (born 1930), *Oasis*, 1989. Oil and mixed media collage on canvas, 50 x 72 inches (127 x 182.8 cm). The Harold A. and Ann R. Sorgenti Collection of Contemporary African-American Art, 2004.20.1.

As the Academy strives to fill gaps in its holdings of abstract and conceptual art, it also maintains a commitment to its historical collections. Recent years have yielded extremely rich gifts. In 1979, David J. Grossman bequeathed eight works by the famed naive painter Horace Pippin, including one of Pippin's best-known works, *John Brown Going to His Hanging* (plate 160). Forty-three works on paper by Robert Motherwell, partial gifts of the Dedalus Foundation, came into the collection in 1994 (plate 216). A strong selection of works by African-American artists, notably Jacob Lawrence, Romare Bearden, Faith Ringgold, Sam Gilliam, Howardena Pindell, Raymond Saunders, and Benny Andrews (fig. 17), entered the Academy's collection in 1999, donated by collectors Harold A. and Ann R. Sorgenti.

The new millennium brought three unparalleled gifts. In 2001, the Academy acquired, again through the generosity of the Pew Charitable Trusts, the stunning favrile glass mosaic *The Dream Garden* (fig. 19), designed by alumnus Maxfield Parrish and executed by Louis Comfort Tiffany. The same year, longtime Academy supporters and noted collectors of American art Meyer P. and Vivian O. Potamkin bequeathed ten outstanding works by some of the most important artists in American history, with paintings by William Michael Harnett (plate 72), Childe Hassam (plate 95), John Twachtman, Maurice Prendergast, Marsden Hartley (plate 119), Arthur G. Dove (plate 147), Reginald Marsh, and Georgia O'Keeffe, a sculptural work by Elie Nadelman, and a pastel by Mary Cassatt.[19] And in 2002, a keenly felt gap in the collection was filled by Ann Stokes's donation of a painting by Whistler, *Rose and Gold: "Pretty Nellie Brown"* (plate 90).

One of the primary purposes of the Academy, as outlined in its 1805 Articles of Association, is the collection and exhibition of the best works by living artists. At its two-hundredth anniversary, the Academy continues to honor that pledge while simultaneously strengthening and displaying its important historical collection. Far from slowing down, the Academy at two hundred is seeing many exciting new changes. A 1999 American Collections Enhancement grant from the Henry Luce Foundation has supported an ongoing commitment to make the Academy's collections accessible via the Internet. With an ultimate goal of including two thousand works from the collection on its web-

site, this project makes possible the virtual "exhibition" of hundreds of works otherwise unavailable, especially delicate works on paper. With the acquisition of the adjoining Samuel M. V. Hamilton Building, the museum's exhibition space was effectively tripled. Plans include an "open storage" system for sculptural works, making them visible even when not featured in the galleries. Such unprecedented expansion will not only showcase the historic collections in a new light but also accelerate the Academy's drive to fill the gaps in its postwar collection, notably Abstract Expressionist and Pop works dismissed by an earlier generation of Academy decision makers. All of these changes, with more to come, will make the collection more accessible to the people of Philadelphia and to the wider world, as the Academy begins its third century of collecting.

Notes

Unless otherwise noted, the primary sources cited below are in the archives of the Pennsylvania Academy of the Fine Arts, Philadelphia.

1. Nicholas Biddle to the Pennsylvania Academy of the Fine Arts, Philadelphia, November 20, 1805.

2. Frank H. Goodyear, Jr., *Pennsylvania Academicians* (Philadelphia: Pennsylvania Academy of the Fine Arts, 1973), p. 5.

3. The casts currently owned and used by the Academy school are later replacements, purchased over many years. The June 2, 1851, *Annual Report* of the Academy reported, "scarcely a vestige remained" of the cast collection (pp. 6–7).

4. *Annual Report of the Pennsylvania Academy of the Fine Arts*, June 4, 1855, pp. 13–17.

5. *Annual Report of the Pennsylvania Academy of the Fine Arts*, June 2, 1851, p. 9.

6. In 1985 and 1986, the European works in the Phillips Collection were transferred to the Philadelphia Museum of Art in exchange for works of art and a monetary consideration.

7. Frank H. Goodyear, Jr., and Carolyn Diskant, "The Harrison Collection," in *The Beneficent Connoisseurs* (Philadelphia: Pennsylvania Academy of the Fine Arts, 1974), p. 1.

8. "Harrison Estate Sale," *American Art News*, March 12, 1912.

9. Goodyear and Diskant, 1974, p. 4. See also Susan Danly, "The Carey Collection at the Pennsylvania Academy of the Fine Arts," *The Magazine Antiques*, vol. 121, November 1991, pp. 838–45.

10. Goodyear and Diskant, "The Gibson Collection," 1974, p. 2.

11. *Resolutions of [the] Committee of Arrangements and Inspection [for the Annual Exhibition]*, April 22, 1811. Reproduced in *The Selected Papers of Charles Willson Peale and His Family*, 4 vols., ed. Lillian B. Miller (New Haven, Connecticut: Yale University Press, 1992), vol. 3, pp. 89–90.

12. *Annual Report of the Pennsylvania Academy of the Fine Arts*, February 1886 to February 1887, p. 5.

13. For an excellent overview of Whistler's acceptance, or lack thereof, in Philadelphia, see Sylvia Yount, "Whistler in Philadelphia: A Question of Character," in *After Whistler: The Artist and His Influence on American Painting* (Atlanta, Georgia: High Museum of Art, 2003), pp. 50–63.

14. Pennsylvania Academy of the Fine Arts Exhibition Sales Book, n.p.

15. Cheryl Leibold, "A History of the Annual Exhibitions of the Pennsylvania Academy of the Fine Arts: 1914–1968," in *The Annual Exhibition Record of the Pennsylvania Academy of the Fine Arts, 1914–1968*, ed. Peter Hastings Falk (Madison, Connecticut: Sound View Press, 1989), p. 25.

16. *Ibid.*

17. Frank H. Goodyear, Jr., *A Report on the Pennsylvania Academy's Collection*, 1975, p. 3.

18. *Annual Report of the Pennsylvania Academy of the Fine Arts*, June 1882 to February 1884, p. 13.

19. See *American Originals: Vivian O. and Meyer P. Potamkin–Collectors of American Art* (Philadelphia: Pennsylvania Academy of the Fine Arts, 2004).

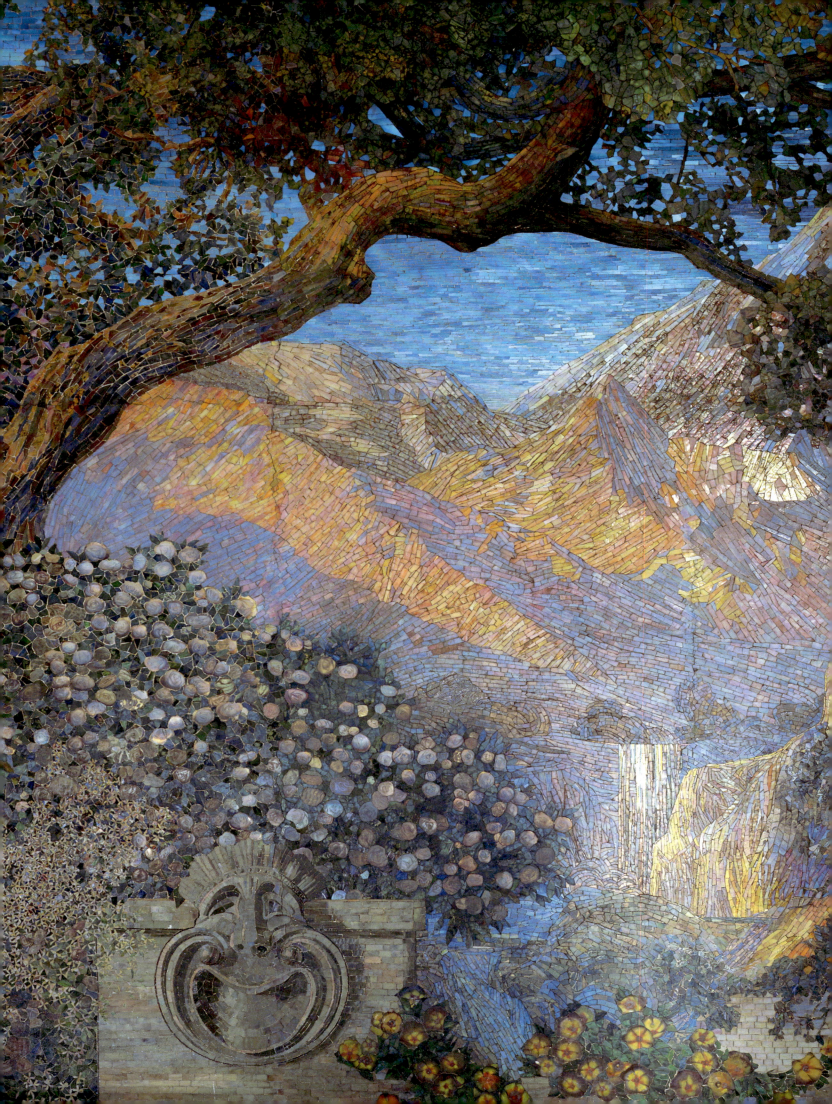

KIM SAJET

From Grove to Garden:
The Making of *The Dream Garden* Mosaic

*The Grove of Academe was to become a Dream Garden, but it was only
after six years of incessant effort, with obstacles and interventions almost
insurmountable, that the dream became true.*

—*Edward W. Bok*[1]

In the months before its final installation at the Curtis Publishing Company Building in
Philadelphia, *The Dream Garden* caused a sensation. Seven thousand people, attracted by reports
that they would see "the most wonderful favrile mosaic picture in America," visited the Tiffany
Studios in Corona, New York, in 1915 to preview the fifteen-by-forty-nine-foot fantasy (fig. 19).[2]
Weighing nearly four tons, *The Dream Garden* required the efforts of thirty artisans to execute over
the course of a year, in thousands of hand-cut pieces of favrile glass, a new type of material invented
by Louis Comfort Tiffany (1848–1933).[3] A derivation of the Old Saxon word for "handmade," favrile
dazzles with iridescent colors and a jewel-like patina.[4] As one leading critic of the day breathlessly
wrote: "Mere words are only aggravating in describing this amazing picture."[5]

 The making of *The Dream Garden*, however, was not without incident. From 1908 until 1914,
no fewer than ten artists were approached for the commission for the foyer of the new headquarters
of the Curtis Publishing Company. The project was fraught with so many setbacks that company
directors had to unveil their new building in 1910 without its central masterpiece. Instead of seeing a
"pivotal note," visitors to the empty foyer were greeted by strategically placed topiary trees (fig. 18).

 Over the span of six years, the original plans for the foyer commission changed substantially.
In place of a central panel painted by a single artist, *The Dream Garden* became a collaborative
undertaking that took its inspiration from a painting by Maxfield Parrish (1870–1966). Created to
champion the aspirations of a commercial publishing company that relied on advertising, sales, and
subscriptions for its livelihood, *The Dream Garden* also can be seen as representing a pivotal
moment at the turn of the nineteenth century, when aesthetic divisions between illustration, fine
arts, and the crafts were breaking down. The art-historical hierarchy that had placed painters and

sculptors above commercial illustrators and designers and had relegated craftsmen to the realm of skilled laborers was tested during the commission and manufacture of *The Dream Garden.*

The story of *The Dream Garden* began in 1908, when Edwin Austin Abbey was first approached to paint a large panel for the foyer of the Curtis Publishing Company's new building. Abbey, a native Philadelphian and an alumnus of the Pennsylvania Academy of the Fine Arts, also held the distinction of being a member of the Royal Academy of London—a singular achievement for an American-born painter. Abbey, who was not represented by a major work in the City of Philadelphia, was occupied with a series of murals for the Pennsylvania Capitol Building in Harrisburg when he signed on to submit a design for a thirteen-by-fifty-foot canvas for the Curtis foyer.[6] Abbey had been able to convince the Curtis Publishing Company directors that stretching a canvas of such enormous size was possible and agreed to begin it upon completion of the Harrisburg work.[7] His substantial

Fig. 18
Photographer unknown, Lobby of the Curtis Building in 1910 before installation of *The Dream Garden.* 3 x 5 ½ inch postcard. Courtesy of The Kevin F. Donohoe Company, Inc.

fee of fifty thousand pounds included expenses for a trip to Athens in January 1909, in order to research classical costumes and settings for the composition—one of his own choosing—*The Grove of Academe.*[8]

Surviving sketches and writings show that Abbey's *The Grove of Academe* pictured scholars and maidens, dressed in classical robes, assembled in a Garden of Knowledge. Abbey acknowledged thinking of an image of Plato surrounded by his disciples, in the spirit of Raphael's famous frescoes in the Vatican. Such instructional subjects, framed within the elevated spaces of classical architecture, were hallmarks of Abbey's monumental style and can be seen in *The Apotheosis of Pennsylvania* on the south wall of the Chamber of the House of Representatives in Harrisburg, Pennsylvania. His murals in other civic buildings, such as the Boston Public Library, were renowned; Abbey's work was well suited to grand public spaces and government commissions. The placement of *The Grove of Academe* in a commercial publishing house, therefore, signaled the aspirations of the Curtis Publishing Company, which sought to give Philadelphia a work that would "put good art within the comprehension of a large public."[9]

Heir through marriage to the Curtis publishing empire, Edward W. Bok (1863–1930) was responsible for commissioning all the decorations inside the company's new building, the exterior of which was fashioned from red brick with marble trimmings to enter into the spirit of its eighteenth-century surroundings.[10] Both professionally and socially ambitious, Bok had risen through the ranks of American publishing houses to become vice-president of the Curtis Publishing Company and managing editor of *The Ladies' Home Journal.* Under his management, the *Journal* had become the foremost women's magazine in the country, reaching a staggering one million subscriptions in 1902. The *Journal's* advice on clothes, food, home decoration, manners, and morals influenced an entire generation of middle-class women who, in Bok's opinion, had achieved "domestic statesmanship."[11]

In 1912, with the innovation of four-color presses, Bok began to focus on a "systematic plan for improving pictures on the walls of the American home" by producing in his magazine reproductions of paintings by Rembrandt, Velázquez, Turner, Van Dyck, Raphael, Frans Hals, Gainsborough,

Whistler, Corot, Vermeer, Botticelli, Titian, and other old masters.[12] The notion proved so success-ful that circulation rose to one-and-three-quarter-million copies, and more than seventy million reproductions of art were distributed nationally. In addition to fostering art appreciation, Bok was a proponent of the Arts and Crafts Movement, which, in the mid-1860s, had crossed the Atlantic from Britain. He had read John Ruskin and William Morris and supported the development of a distinctively American design aesthetic that avoided unnecessary embellishments and communicat-ed democratic ideals through the use of local materials. Whether he was championing the redesign of Pullman railway cars, calling for the elimination of billboard advertising, or criticizing the hap-hazard planning of America's cities, Bok enthusiastically supported the idea that superior design was linked to social reform. If the quality of the design was improved, the character of the individual producing the design would be improved, and hence society would be improved. Interestingly, in terms of *The Dream Garden*, Bok did not differentiate between the skills of the craftsman and the artist. To his way of thinking, "making decorations" was a communal concern, and no one member of the community was more important than another. Following John Ruskin's dictum: "Wherever you can rest, there decorate," *The Grove of Academe* fulfilled Bok's sense of responsibility to create serene places for reflection on the part of workers of the Machine Age.[13] The Curtis Publishing Company Building was, after all, a commercial enterprise, with printing presses housed in the base-ment and the upper floors filled with stenographers, typesetters, designers, and writers. Although the building was surrounded by history, inside, it was a model of American industrialization. Echoing William Morris, Bok envisioned Curtis Publishing as a place where art and labor would be reunited to mutual benefit.

The dimensions of the Curtis foyer—a thousand square feet, unobstructed by a single column—were established in 1908 by the building's architect, Edgar V. Seeler, in consultation with Edwin Austin Abbey. But Abbey suddenly died in early 1911, before work was begun. Throughout the search for another artist, Bok sought to transform the foyer into a space of social and self improvement. He wanted the commission to attract national attention, either by its construction, or by the stature of the artist (such as Edwin Austin Abbey, R.A.), or by its inspirational subject matter. The end result had to be conceptually and visually stupendous. *The Grove of Academe* had not only determined simply the size and shape of the foyer decoration, it had also set the standard against which all other artists approached for the commission would be measured.

The first artist to be approached after Abbey's death was John Singer Sargent (who had shared a studio with Abbey), then the most successful American painter living in Britain, but he declined the commission. Next in line came Howard Pyle, a well-known illustrator, who produced a study of Plato not unlike Abbey's. In November 1911, shortly before Curtis offered him the commission, Pyle died. George de Forest Brush, who like Pyle had produced illustrations for popular magazines such as *Harper's Magazine* and *Century Magazine*, worked for a number of months on designs with a Native American theme before he, too, declined the commission.[14] Next was Barry Faulkner, who submitted three sketches, which were all rejected. Subsequently, and in quick succession, came Andre Castaigne, Albert Herter, Richard Dana Marsh, and Boutet de Monvel. The work of the last was accepted by the judging panel for the Curtis foyer, despite some concerns expressed by Parrish, who sat on the panel, who said that the work was "a bit 'frenchy.' "[15] It must have been with signifi-cant dismay that Bok learned of de Monvel's untimely death in March 1913. An equally unsuccessful attempt was made by Frank du Mond, whose work Bok deemed "too inappropriate for the lobby."[16]

At this point, Bok was beginning to believe that "some fatal star" hung over his commission. When the building was complete, but there were still no concrete plans for the foyer, he wrote to Parrish: "The hoodoo that is following me in regard to that panel is simply amazing! Just think of the

Fig. 19

Maxfield Parrish and Louis
Comfort Tiffany, *The Dream
Garden*, 1915. Favrile glass mosaic,
15 x 49 feet (1493.5 x 457.2 cm).
Lobby of the Curtis Building,
Philadelphia. Partial bequest of
John W. Merriam; partial purchase
with funds provided by a grant
from The Pew Charitable Trusts;
partial gift of Bryn Mawr College,
The University of the Arts, and
The Trustees of the University of
Pennsylvania, 2001.15.
Photograph by Rick Echelmeyer

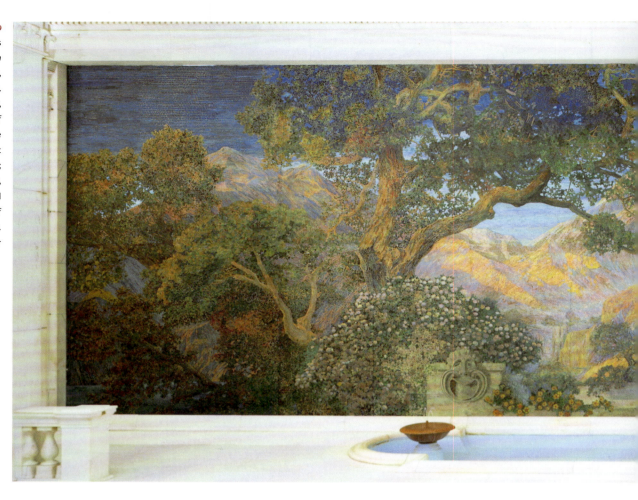

record: Abbey, Howard Pyle and de Monvel! You had better get a little anxious about your dealings with me, because the moment I have mural relations with a man he seems to run off the earth!"[17]

Parrish was indeed reluctant to become involved with Bok's project, since he was already working on eighteen murals for the Ladies' Dining Room on the top floor of the Curtis Publishing Company Building. The theme there centered on a "Florentine Fête"—a gathering of young boys and girls set within a classical loggia framed by lush gardens. It was Parrish's largest commission to date. Although Bok pressed to unify all the interior decorations for the Curtis Building with a single artistic vision, Parrish declined the commission at this time. Bok, who felt no nearer to a solution for the foyer, was forced to think about alternatives, such as bas-reliefs, fountains, or even an indoor garden.

Casting about for ideas, Bok recalled having seen, a few years earlier, a paneled glass tile theatrical curtain, which had been made for the National Theater in Mexico City by the Tiffany Studios in New York. Hailed as a marvel of modern engineering and design, the curtain was both visually striking and unerringly new. With great enthusiasm, Bok described favrile glass as "a new method in wall decoration, but one that was entirely practicable. Glass would not craze like tiles or mosaic; it would not crinkle as will canvas; it needed no varnish. It would retain its color, freshness, and beauty, and water would readily cleanse it from dust."[18]

At the Tiffany Studios glass blowing was treated as an art, and workers were encouraged to become artisans, developing the skills to hand make objects.[19] At a time when the glass industry was undergoing mechanization, Tiffany employed more than a hundred workers, including a Venetian glassblower named Andrea Boldini and several English craftsmen such as Arthur J. Nash, who was in charge of furnace operations. Tiffany apprenticed young men to carry out the various stages of furnace operations and women to prepare working drawings, to match colors, and to enamel pre-

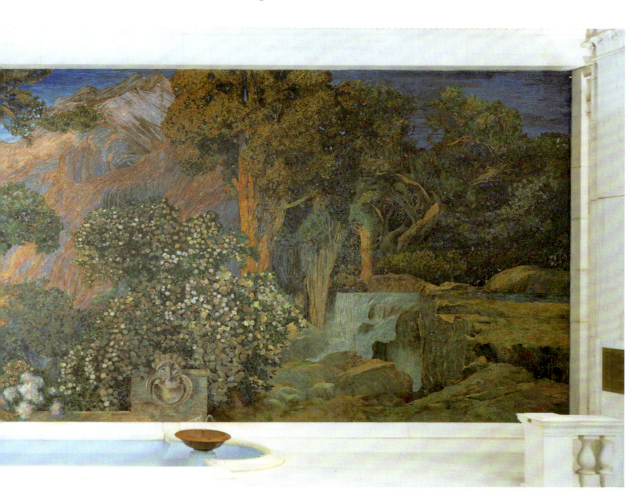

cious metals and jewelry. Aiming at the luxury interior-design market, Tiffany stated: "We are going after the money there is in art, but art is there all the same."[20]

Louis Comfort Tiffany had trained at the National Academy of Design and personally authored many of his studio's designs. By the turn of the century, he had assembled a group of experienced designers who were adept at designing windows with religious figures, to meet the enormous ecclesiastical market. This left Tiffany himself free to concentrate on domestic commissions for private clients, setting a new trend for nonfigurative allegorical windows that was considered quite modern. In 1913, for example, the Pittsburgh industrialist Andrew Carnegie commissioned a Tiffany window of a landscape with no figures in memory of his parents. This was deemed inappropriate by the church in Scotland where the window was to be installed. Carnegie defended his decision, stating: "I want something new, something American. I don't want these old style windows with the figures of bible prophets and crosses and that sort of thing. I want an outdoor scene. God is in that sunset. God is in all the great outdoors. I want a window just like that."[21]

Bok wanted a mosaic also, "just like that," but he did not want Tiffany to design it. While acknowledging the exciting possibilities of favrile glass, Bok agreed with contemporary critics that Tiffany's strength was in the realm of color, while he thought that his designs were either too traditional, too stilted, or overwhelmingly sentimental.[22] Tiffany submitted three designs to the Curtis Publishing Company, but they were all rejected. Later, in a telling letter of 1913, Bok wrote to Parrish: "I am delighted that the sketch goes so well, for it all depends on you—Tiffany's sketch is in, and is NIX: sad I think—still, it is about what I thought."[23] Despite the rejection of his designs, Tiffany nevertheless agreed to manufacture the mosaic by Christmas of 1915, for the princely sum of forty thousand dollars. Parrish, in turn, was paid two thousand dollars for his design.

On Bok's urging, Parrish visited the Tiffany Studios at Corona, New York, and was beguiled by the brilliant, shimmering colors of the glass. Parrish's biographer noted that: "He saw the depth of the cobalt blues emerging from the firing kilns, the oranges and the golden tones so essential to his signature pieces catching the light and bursting in cascades of color before him."[24] Upon his return to his studio, Parrish painted a three-by-nine-foot panel for *The Dream Garden*. This "garden sketch" became the template that the Tiffany craftsmen used to create the final mosaic.

At the unveiling of the mosaic in the foyer of the Curtis Publishing Company Building in 1915, the responses of the main protagonists, Edward W. Bok, Maxfield Parrish, and Louis Comfort Tiffany, could not have been more revealing. Bok approached the end of the project with his customary marketing zeal; he reproduced Parrish's original painting (fig. 20) in a double-page color lift-out in *The Ladies' Home Journal* and printed a glowing editorial as well as a brochure. In press releases, Tiffany spoke of having created a "practically new art" for the benefit of mankind and, moreover, of having "improved" upon Parrish's original design to reveal the "real significance of [the] picture."[25] But from the moment of acceptance of his "garden sketch" in February 1914, until his death, Parrish always refused to discuss his design for the mosaic in all but the most perfunctory manner, stating that: "It's a dream garden, a genuine dream, not a real thing in it, [and] nothing will induce me to talk about it."[26]

Parrish's reluctance and, indeed, his absence at the unveiling and the dedication receptions in Philadelphia were not uncharacteristic. Parrish was a notoriously private man, and he often declined to be interviewed or photographed. And yet the distance he placed between himself and *The Dream Garden* commission seems to have gone beyond a wish to be out of the limelight. Only a few months earlier Parrish had produced a short explanation of the *Florentine Fête* and the seventeen other murals he completed for the Ladies' Dining Room, which Bok subsequently used for an editorial in *The Ladies' Home Journal*. The artist was not, however, willing to do the same for *The Dream Garden*, stating: "I could no more write about the garden sketch than I could be present at that reception in the fall. Absolutely beyond me. And really, even if I had any command over that medium, to write about my work in any way would give me exactly the same modest sensation as walking down Chestnut Street at noon stark naked."[27]

Parrish visited the Tiffany Studios only twice while *The Dream Garden* was being made. He visited once, for a few moments, in December 1914, at the start of the manufacturing process, and later in August of 1915, shortly before it was put on public display. At the second visit, Parrish wrote to his wife that Tiffany had set up stage lighting that changed the surface colors of the mosaic creating a "truly unusual" effect. According to his son, Maxfield Parrish, Jr., this was the only time his father saw the completed picture.[28] Between the lines of Parrish's correspondence however, can be detected a sense of supreme disappointment in the mosaic's color. Despite Tiffany having used two hundred sixty different shades of colored tesserae, carefully transcribed from Parrish's original painting, *The Dream Garden* mosaic did not achieve the visual illusion that the painter had wanted to convey.

The composition of *The Dream Garden* was, in fact, inspired by a real garden that Parrish had recreated at his summer home, The Oaks, in the artists' colony of Cornish, New Hampshire. There, Parrish envisioned the creation of fantastical spaces where a visitor would chance upon places of tremendous beauty and solitude, improved by careful placement of foliage and flowers, large classical urns and vases, reflecting pools and fountains, walkways and steps (fig. 21). During a visit to The Oaks, Parrish told Bok that what he had in his "mind's eye" was a dream garden—a passionate disclosure that Bok orchestrated into an artificial reality.

Rendering landscape had always held special significance for Parrish, who considered it the highest form of subject matter. He sought to make his paintings visually accurate by meticulously

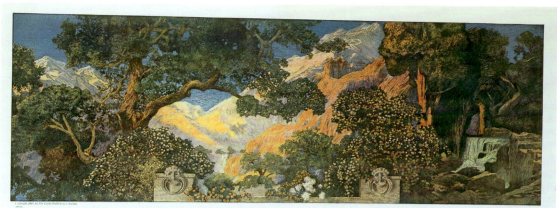

THE DREAM GARDEN: THE MOST WONDERFUL FAVRILE MOSAIC PICTURE IN AMERICA

Fig. 20

"The Dream Garden: The Most
Wonderful Favrile Mosaic Picture
in America." *The Ladies' Home
Journal*, December, 1915.

studying photographs, carefully establishing points of perspective, and using precise painting and glazing techniques. What Parrish sought for *The Dream Garden* was what he sought for all his paintings—an effect of illusion, where the viewer would be transported beyond the picture plane into a lifelike fantasy. *The Dream Garden* was extremely personal for Parrish. He considered it *his* garden. It was an extension of his heart's desire for The Oaks. It was, in fact, so personal that it has even been suggested that the *commedia dell'arte* masks the artist placed in the foreground are a form of self-portraiture. Did Parrish paint himself into his own fantastical world? [29]

The very nature of mosaic is, of course, fragmentation. Parrish's preparatory painting was reduced to two hundred sixty color tones, which could not compare to his original rendering. Tellingly, a number of years later, when asked for advice on furniture for the lobby, Parrish recommended that, in addition to the already extant reflecting pool, perhaps small fountains and carved balustrades placed in front of the mosaic and low pots filled with box plants on either side would suffice. Anything more delicate or flowery would "contrast unpleasantly with the formal artificial flowers of the glass." [30]

Since the moment of its unveiling there have been many who have disagreed with Parrish's personal assessment. In 1998, public affection for the mosaic rose to a peak when a spirited public campaign was mounted to halt the private sale and removal of *The Dream Garden* by the estate of the developer John W. Merriam. Ownership of the mosaic had transferred to Merriam with the purchase of the Curtis Building and most of the furnishings and contents of the Curtis Publishing Company in 1968. By then, popular magazines, which depended on low cost and high circulation, were faced with the competition of newer media such as photojournalism and television: *The Saturday Evening Post* ended publication in 1963, and *The Ladies' Home Journal* was acquired in 1986 by the Meredith Corporation. [31]

Merriam owned the Curtis Building from 1968 to 1984. However, the resale of the building to the Kevin F. Donohoe Company in August of 1984 did not include title to the mosaic itself. This complicated the ownership of *The Dream Garden* upon the death of Merriam in 1994, whose estate was divided among several beneficiaries: forty-one percent to his widow, Elizabeth C. L. Merriam, who was also the sole executor; and fifty-nine percent in the aggregate to four charitable institutions, the University of Pennsylvania, the University of the Arts, Bryn Mawr College and the Pennsylvania Academy of the Fine Arts. A public outcry ensued when it was learned that Mrs. Merriam, as Executor, had negotiated the mosaic's sale and removal to an unnamed buyer in 1998. Shortly thereafter, the Philadelphia Historical Commission, attempting to prevent its removal, designated *The Dream Garden* a "historic object." Media attention about the subsequent legal appeals

highlighted the importance of the mosaic to Philadelphians. *The Philadelphia Inquirer* went as far as to state: "To remove the Dream Garden would be an act of sacrilege, equivalent to selling off one of the Calder fountains on Benjamin Franklin Parkway, or perhaps tearing out the ceiling of the Sistine Chapel for sale to the highest bidder."[32]

The four charitable institutions stated publicly that they wanted a resolution which would retain the mosaic in a public venue in Philadelphia. Upon the death of Mrs. Merriam in March 2001, her previous position as sole executor was filled by two co-administrators, one of whom was appointed by Mrs. Merriam's estate, and the other by the four charitable beneficiaries. The matter was ultimately resolved in November 2001 when the Pew Charitable Trusts funded a purchase of Mrs. Merriam's estate's interest which was transferred to the Pennsylvania Academy of the Fine Arts, and the other three charitable institutions donated their respective interests to the Pennsylvania Academy. This generous and elegant solution resulted in full ownership of *The Dream Garden* by the Academy in trust for the people of the City of Philadelphia. "*The Dream Garden* is a celebration of artistic achievement that has been a renowned part of Philadelphia's history for eighty-five years," said Rebecca W. Rimel, the president of The Pew Charitable Trusts. "We are pleased to be able to work with area cultural and academic institutions and the Merriam estate to assure such a great masterpiece will remain on public display in Philadelphia for the benefit of all generations to come."[33]

Before the unveiling of *The Dream Garden* in the foyer of the Curtis Publishing Company Building, Parrish made the following statement, with some rancor, to Bok, whom he accused of orchestrating the entire process: "Tiffany and I are only instruments who helped carry out the dreams of a mastermind."[34] And yet, as the subsequent public support for the mosaic demonstrates, we can be grateful that Bok persevered to make Abbey's *Grove* into Parrish and Tiffany's *Garden*. From its inception, and many years after its completion, the fate of *The Dream Garden* was fraught with setbacks, artistic conflicts, and legal disputes. In the end, however, Tiffany's final words, which were printed in the brochure at the work's unveiling, ring true: "I trust it may stand in years to come …as something worthy [that] has been produced for the benefit of mankind, and may serve as an incentive to others to carry even farther the true mission of the mosaic."[35]

Notes

1. Edward Bok, *The Americanization of Edward Bok: The Autobiography of a Dutch Boy Fifty Years After* (New York: Charles Scribner's Sons, 1925), p. 265.

2. A double-page reproduction of the original painting by Maxfield Parrish was reproduced in the December 1915 issue of *The Ladies' Home Journal* (fig. 20). In capital letters below the image ran the text: "THE DREAM GARDEN: THE MOST WONDERFUL FAVRILE MOSAIC PICTURE IN AMERICA." The company Louis Comfort Tiffany first founded in 1883 was called Louis C. Tiffany and Company. In 1892, it became the Tiffany Glass and Decorating Company, and in 1898 its name was shortened to Tiffany Studios.

3. Estimates of the number of the mosaic's many tesserae vary from one hundred thousand to one million pieces of glass. In May 1999, the Cummings Stained Glass Studios, Inc., carried out a conservation assessment of *The Dream Garden* and placed the figure closer to the million-piece estimate. A circa 1915 photograph they uncovered shows twenty-three people working on the mosaic, but the exact number of craftsmen is unknown. A copy of the Cummings Report is on file in the registrar's office of the Pennsylvania Academy of the Fine Arts, Philadelphia.

4. Favrile glass is produced by exposing molten glass to a series of fumes and metallic oxides that infuse it with glowing colors.

5. Augustus Farnsworth's glowing description was reprinted in the editorial on page one of the November 1914 issue of *The Ladies' Home Journal.*

6. A mural is a painting executed on, or permanently affixed to, a wall. The canvas Abbey proposed for the Curtis commission would have been supported on large wooden stretchers, like an easel painting.

7. No doubt, it was expedient for Abbey to convince the Curtis Publishing Company directors that it was possible to produce such a large canvas, rather than a wall mural, since he intended to do the work in London, his adopted home since 1880, and ship it to Philadelphia.

8. The terms of the contract are set out in Bok's autobiography, *The Americanization of Edward Bok*, pp. 259–62, and E. V. Lucas, *Edwin Austin Abbey, Royal Academician: The Record of His Life and Work*, vol. 2, 1894–1911 (New York and London: Charles Scribner's Sons and Methuen and Company, Ltd., 1921), pp. 455–86.

9. Bok, 1925, p. 258.

10. Comprising an entire city block from Sixth Street to Seventh Street and from Walnut Street to Sansom Street, the Curtis Publishing Company Building faced Independence Square and the Old State House (now known as Independence Hall), built in 1731, on one side, and Washington Square on the other.

11. For further reading about *The Ladies' Home Journal*, see Helen Daemon-Moore, *Magazines for the Millions: Gender and Commerce in The Ladies' Home Journal and Saturday Evening Post, 1880–1910* (Albany, New York: State University of New York, 1994).

12. Bok, 1925, p. 245.

13. John Ruskin, *The Lamp of Beauty* (1849), reprinted in Isabelle Frank, ed., *The Theory of Decorative Art* (New Haven: Yale University Press, 2000), pp.42–46.

14. Apparently Parrish had suggested an "Indian subject" to George de Forest Brush. See Bok to Parrish, April 29, 1912. A reply from Parrish on May 3, 1912, mentions two letters from de Forest Brush, apparently of disgruntlement and about his resignation. Special Collections, Dartmouth College Library, Hanover, New Hampshire.

15. Parrish to Bok, May 3, 1912. Special Collections, Dartmouth College Library, Hanover, New Hampshire.

16. Jack W. Jacobsen, *Maxfield Parrish: The Man Behind the Make-Believe* (published by the author, 1995), p. 203.

17. Bok to Parrish, March 19, 1913. Special Collections, Dartmouth College Library, Hanover, New Hampshire.

18. Bok, 1925, p. 263.

19. Eileen Boris, *Ruskin, Morris, and the Craftsman Ideal in America* (Philadelphia: Temple University Press, 1986), p. 144.

20. *Ibid.*, p. 143.

21. Alastair Duncan et al., *Masterworks of Louis Comfort Tiffany* (London: Thames and Hudson, 1989), p. 139.

22. Herwin Schaefer summed it up when he wrote: "Even now, at the height of his fame, the beauty and richness of the glass did not blind the critics to the frequent inadequacy of Tiffany's designs, an inadequacy which was basically one of misusing decorative material for pictorial purposes." Alastair Duncan, *Tiffany Windows* (New York: Simon and Schuster, 1980), p. 41.

23. The letter, written on Hotel Belmont, New York, letterhead, is undated. Special Collections, Dartmouth College Library, Hanover, New Hampshire.

24. Parrish expert Alma Gilbert has deposited copies of her unpublished notes pertaining to Parrish and to *The Dream Garden* with the Pennsylvania Academy of the Fine Arts.

25. Tiffany's statements are recorded in both the Curtis Publishing Company brochure and the November 1915 issue of *The Ladies' Home Journal*, p. 1.

26. Jacobsen, 1995, p. 206.

27. *Ibid.*, p. 209.

28. *Ibid.*, p. 204.

29. This notion was suggested to me by Professor Steven Levine at a colloquium at Bryn Mawr College on *The Dream Garden* in 2001. The mask is the only sculpture Parrish ever made, shortly after returning from a trip to Europe in his youth. It was a motif that he used often in his illustrations. The original mask hung in the living room of his home.

30. Jacobsen, 1995, p. 210.

31. *The Saturday Evening Post* was also owned by the Curtis Publishing Company in Philadelphia. *The Ladies' Home Journal* is still published, but by a different owner.

32. Staff writer Stephen Salisbury quoted the architectural historian Richard Guy Wilson in *The Philadelphia Inquirer*, June 29, 1999.

33. *The Philadelphia Inquirer*, November 6, 2001, p. A1.

34. Jacobsen, 1995, p. 209.

35. Curtis Publishing Company brochure, produced in 1915 at the unveiling of *The Dream Garden* mosaic. A copy is held at the Free Library of Philadelphia, Rare Books and Manuscripts division.

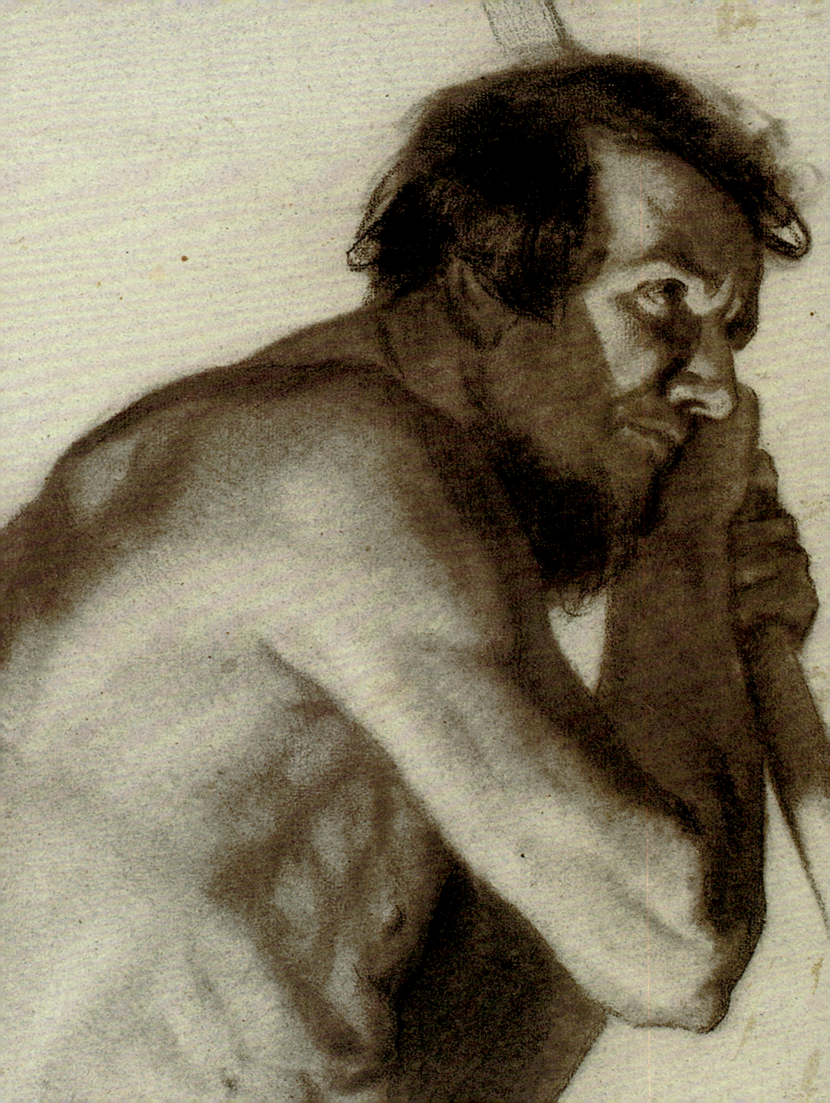

RONALD J. ONORATO

Christian Schussele,
Untitled (detail, fig. 23)

"Exciting the Efforts of the Artists": Art Instruction at the Pennsylvania Academy of the Fine Arts

Although the Pennsylvania Academy of the Fine Arts is often considered in terms of the pantheon of artists associated with it since its founding, the institution has reflected and influenced the course of American art history in another significant way: through its teaching methods. "Exciting the efforts of the artists" was explicitly stated as an aim of the founders of the Academy in 1805.[1] A broad overview of the theory and practice of art instruction at the Academy may be gleaned from the programmatic history of teaching at the Academy over the course of its history.

A rich and fascinating variety of materials for such a study are housed at the Academy. Manuscripts and printed documentation of classes taught as well as details of schedules and studio assignments are available. Analysis of the architectural spaces of the Academy reveals teaching methods and priorities. Student works produced under the influence of the Academy's programs can be interpreted, as can the experiences offered by the exhibitions and collections of the Academy over time. With all this information and, of course, background on instructors, administrators, and board members, a clear picture of the evolution of the Academy's teaching methods can be discerned.[2]

In its two-hundred-year history, several eras may be distinguished: the earliest formative years, when a European model prevailed; the later nineteenth century, when key individuals and new facilities had an impact on the teaching programs; and the twentieth century, when challenges presented by modernism and competing art institutions had to be faced. The most recent teaching programs have brought the Academy into the twenty-first century with a distinctive sense of an ever-evolving tradition.

As one of the earliest cultural institutions founded in America, the Pennsylvania Academy of the Fine Arts was inextricably linked to individuals, events, and ideals that flourished in the new

republic. The original Articles of Association, ratified in 1805, read like a mission statement, outlining the hopes and aims that its founders held for the new organization:

The object of this association is to promote the cultivation of the Fine Arts, in the United States of America, by introducing correct and elegant Copies, from works of the first Masters in Sculpture and Painting, and, by thus facilitating the access to such Standards, and also by occasionally conferring moderate but honorable premiums, and otherwise assisting the Studies and exciting the efforts of the artists, gradually to unfold, enlighten and invigorate the talents of our Countrymen.[3]

A few years later, lofty nationalistic goals were clearly on the mind of Joseph Hopkinson, the Academy president, in his *First Annual Discourse* in 1810, restating Benjamin West's 1805 comparison of Philadelphia to Athens and arguing that what America required to foster its visual arts were taste, spirit and patronage.[4] The vague notions of taste and spirit, supported by the somewhat mercenary concept of patronage, are qualities that any amateur of the day might have had: reflecting the belief that the education of artists through a specific curricular process was not a means of establishing culture. Enlightened amateurs were, indeed, the founders of the Academy: only three of the seventy-one founders were professional artists. The rest were doctors, publishers, authors, civic leaders, merchants, and members of the legal profession, the last comprising the biggest group of forty-one individuals. These founders bestowed a durable legacy of aspirations, theories, and collections that still inform its teaching programs after two centuries.

In addition to such heady goals, the Academy also had the advantage of being started in thriving, populous Philadelphia, the most cosmopolitan city in the new United States. This urbane context has been a significant but often unacknowledged influence upon the Academy's teaching methods. In the early nineteenth century, scores of plays were staged in the city every year, both in English and other languages, and musical concerts had been commonplace for decades. Other cultural institutions (founded earlier or about the same time), such as the University of Pennsylvania and the American Philosophical Society, added to the rich intellectual atmosphere of the city. Philadelphia was clearly a place where the arts and contemporary ideas about the arts could flourish.

Despite the country's political independence from Great Britain, the founders of the Pennsylvania Academy adhered, from the outset, to a tutorial model adopted from the Royal Academy of Arts in London as well as another, more short-lived Philadelphia organization called the Columbianum. The Columbianum was organized in 1794 by Charles Willson Peale (1741–1827), later to become the pivotal figure in the foundation of the Academy (see fig. 1), and drew its form from Peale's personal knowledge of the Royal Academy. In that model, students copied from antique casts, drew from life models, and received advice from master artists in independently arranged critiques. Peale himself called his Columbianum "an academy."[5] It was that and more: a combination arts center, gallery, museum, school, and artists' club all under one roof. In a place where none of these opportunities existed, the Columbianum would have fulfilled a variety of needs for the visual arts community in Philadelphia, not least of which would be as a place to meet with other like-minded professionals. Although the Columbianum failed after only a year, the more successful Pennsylvania Academy would be based on similar, mostly imported, ideas about art education.

Provision of the best examples of copies and casts of historical works for young artists to study, draw, and emulate constituted the most important of the primary offerings of the new Pennsylvania Academy (fig. 22). No formal classes, no structure of advancement from one level of ability to the next, not even the kind of artisanal techniques (such as mixing one's own paints or

stretching canvases) necessary to succeed as a professional artist were offered during the first decades of instructing at the Academy. Instead, the founders' efforts were put into building an appropriate place where artists could congregate and where a collection of plaster casts could be made available for study. Only a few artists among the founders transcended this agenda to include actual instruction in their goals. When Peale wrote to his friend Thomas Jefferson, he hoped that the founders could "begin a building for the reception of Casts of Statues, also for a display of Paintings, by the exhibition of which revenue may be had to defray the expence [sic] of a keeper who shall be capable to give instruction to the Pupels [sic]."[6]

The Academy collections have always been a major element of its teachings. In the Academy's initial era, when copying from master works was considered the primary component of learning how to be an artist, the focus was on amassing a strong collection of casts, paintings, and engravings. Early gifts, including the Joseph Allen Smith donation of casts and engravings and the gift through Emperor Napoleon Bonaparte of twenty-four volumes of Piranesi's engraved works, helped give the Academy its primary core of museum holdings. One contemporary explained that Smith gave his art works: "in the hopes that they might possibly be of some service to his countrymen when they should turn their thoughts to the study of Painting & Sculpture."[7] Other casts were purchased in Europe and added to this collection, including the *Laocoön*, the *Venus d'Medici*, and the torso Belvedere. By 1807, artists could draw from objects that included forty-two plaster casts, most after the antique, and, in addition, Jean-Antoine Houdon's *The First Set of Muscles in the Human Figure*, a standing écorché (or flayed human figure), used for representing human anatomy. This, then, was the current art teaching philosophy—primarily copying from Greek and Roman exemplars—and it became the mode of teaching for which the Academy became famous. Although much has changed in the visual arts over two centuries and the Academy's holdings have evolved into an important collection of American art, this traditional approach, with the addition of study from live models, continues to influence subsequent generations of students.

In 1810, due to urging by a group of prominent local artists, a formal teaching program was instituted in Philadelphia, although under a separate organization rather than under the impetus of the Academy. This organization, the Society of Artists of the United States, confirmed the prevalent thinking about art education as it outlined three branches of study: first rudiments, antique or cast drawing, and life study. For this artist-led enterprise, which failed after a few years, the Academy's only role was as a museum of casts from which artists could copy. Another artists' group, the Pennsylvania Academicians, was founded within the Academy in 1812. They functioned to some degree as the bridge between the outlook of the amateur stockholders and board members and the needs of the professional arts community. At their behest, the first semblance of regularized instruction began to be realized within the Academy's walls, including lectures on anatomy and a "life academy," where the human figure could be studied.[8]

Given the primacy of collecting art as a source of models from which to copy, one of the founders' primary considerations was the need for a permanent space to house such a collection. The first building, little more than an impressive facade attached to a large rotunda (see fig. 28),

Fig. 22

Permit to Copy a Picture (allowing Miss Corbin to copy a landscape by Thomas Doughty), ca. 1860.

served as an exhibition gallery with a few ancillary spaces used for a contributor lounge, a board-room, and a noncirculating library. As late as 1828, these smaller rooms were still known as the parlor, vestibule, and library—no room for classrooms, studios, or lecture halls was designated. Even though the Academy space had nearly doubled by 1835, almost all the increase was for exhibition space with little allotted for artists' needs or for teaching purposes. This lack of studio space and the particular model of art education that it implied would persist until the 1840s.

Starting in the late 1840s, the development of a structured curriculum began, as a number of artists either born in Europe or trained in its academies arrived in Philadelphia and became associated with the Academy. These included artists such as Peter Frederick Rothermel (1812–1895), Carl H. Schmolze (1823–1859), and Christian Schussele (1824–1879). Schussele, whose outlook and expertise

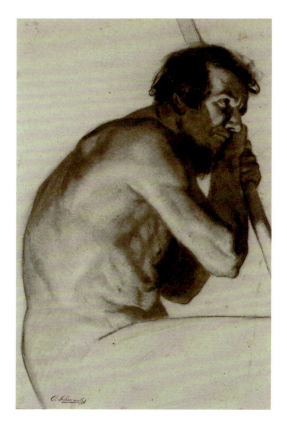

influenced the teaching programs from the 1850s well into the 1870s, was trained in Paris under noted painter Paul Delaroche. His popular genre scenes and large-scale historical themes represented the importation of a contemporary French idiom into the Academy world at mid-century (see plate 42). Based on some of his own preparatory drawings, known from an album in the Academy's collection (fig. 23), Schussele emphasized life study and the careful construction of multifigured narrative compositions. His was an analytical approach, typical of current French academic practice, that used drawings as a form of visual note-taking to better observe and understand his subjects.[9]

No doubt an artist like Schussele provided a role model for his students as someone who held contemporary academic ideas and standards: fundamental drawing from the antique, life study, and a demand for technical virtuosity. Elected president of the Academicians group in 1862, he had become a leader in the art life of the city. When Philadelphia artist John Sartain stated that prior to 1868 "there had never yet been in the Academy an organized school with regular paid instructors,"[10] he was technically correct, but there is evidence that students were already receiving instruction from Schussele. Besides copying from models in the Academy collection, by 1860 master classes were held with Schussele and Rothermel. One student, Eliza Haldeman, wrote: "I have commenced taking drawing lessons with Mr. Schuchselle [*sic*], that is, one of the young ladies at the Academy and myself go to his studio once a week, and have him criticize the drawings we made that week. Almost all the pupils at the Academy take lessons in this way."[11]

When in 1868 the Academy board appointed Schussele the superintendent of the Academy School, it was, in effect, officially updating its training methods by adding rigor to what was taught and structure to the extramural arrangements between student and master artists of previous decades.

Eliza Haldeman's letter reveals another important aspect of the Academy's mid-century teaching efforts, as it began to address the needs of women artists. As early as 1824, two women, Anna and Sarah Peale, had been appointed to the select Pennsylvania Academicians. Although such well-connected female artists could and probably did work with the Academy's collections since its beginning, the earliest documentation of women studying at the Academy occurred in 1844, when the "statue gallery" was set aside for the exclusive use of women at specific hours. By 1856, women constituted nearly fifteen percent of the Academy students in the formalized Antique Class; and they were permitted (after fig leaves were installed) to work side-by-side with their male counterparts in front of the casts of classical nudes.[12]

By 1860, the women artists were thoroughly incorporated into every aspect of the Academy program, except for the life class. A group of young women artists took matters into their own hands and set up an informal life class for themselves, albeit without nude models. By 1868, about a dozen women were regularly attending the Ladies' Life Class. A pattern of innovation that has always been part of curricular development at the Academy was established: artists helping to push the institution toward new ideas and practices.

Beyond the general excitement stirred by the American Centennial Exhibition of 1876 in Philadelphia, the curriculum of the Academy was directly affected by having a new, greatly enlarged facility in which faculty and students could utilize its resources (fig. 24 and see fig. 30). Just as the earlier building reflected the collections-oriented approach of the founders, its new home on Broad Street revealed the current state of pedagogic thinking in the Academy. In announcing their intentions for the new building, the board of directors reaffirmed how closely they still adhered to the original program of teaching young artists: "to provide the student, gratuitously, with the best instruction that can be had, and set before him proper examples for imitation and study, are the principal objects for which the academy was instituted."[13]

The specifications in the *Invitation for Proposals to Erect a Building for the Pennsylvania Academy of the Fine Arts*, published June 20, 1871, further demonstrate how thoughtfully the directors planned to accommodate and facilitate newer educational needs. They wanted their new building:

to contain 1st, a Library (having a fire-proof closet), which room will serve also as a Director's room. 2nd, A Lecture Room, 3rd, Galleries for casts from antique sculpture Connected with the galleries of casts, must be a room for storage of drawing stands, easels, and chairs used by the students, and this will serve for both sexes indiscriminately. There must also be provided a lady students' dressing room 4th, A Life Class, or Painting Room, which should be about 40 feet square Within the Life Class Room must be washstands for the use of students. The window must be large, and the top of it as high as the ceiling There must be a modelling room, and also a students' entrance on Cherry Street, between the Life School Room and Antique Galleries.[14]

With the realization of these goals, the ensemble for a real teaching school would now be complete. After more than seventy years of existence, the Academy had a professional staff, a fully equipped building that could accommodate both a public collection and student needs, and perhaps, most importantly, a board willing to encourage the day-to-day teaching of art under its auspices.

The ties to Parisian models of art instruction were strengthened in the decade immediately following the 1876 Centennial Exhibition, when Thomas Eakins (1844–1916) began teaching and eventually led the Academy in its new curricular developments (see fig. 5). Eakins, like his mentor Schussele, had trained in Paris at the Ecole des Beaux Arts. As others have noted, the interruption in instruction at the Academy while the new building was under construction allowed for the fresh beginning of "a new and more vital era of art education."[15] When Eakins started teaching, he reinvigorated the

Fig. 24
Frederick Gutekunst, *The Pennsylvania Academy of the Fine Arts Cast Studio*, ca. 1876. Albumen print, 3¾ x 3¼ inches.

training by adopting the rigorous academic perspectives of his Paris experience and adding to them his own ideas about how to train young artists. Eakins held numerous positions in the Academy instructional programs: as assistant to his old teacher Schussele, instructing an evening life class, as a demonstrator in the anatomy lectures, and after the death of Schussele in 1879, as Professor of Painting and Drawing. His success in this position led to his appointment as the Director of the Academy Schools in 1882. In all of these, he brought a commitment to the study of the human figure by emphasizing and refining anatomy study with lectures and dissection of human and animal cadavers. His innovations also included intensive color and spatial studies and the introduction of photography as a vital tool for artists working in a realist idiom. Difficult assignments, such as representing a sailboat under way, allowed him to challenge his students to think in terms of pictorial space and volumetric accuracy. Eakins himself was personally involved with trying to establish these new methodologies for his students in his own version of a Parisian atelier. Regardless of the novelty of his teaching methods, every aspect of his approach underscored his insistence on representational veracity.

Fig. 25
Circle of Thomas Eakins, *Naked Series: Joseph Smith, poses 1-7*, ca. 1883. Seven albumen prints mounted on blue board, each approximately 3 ⅞ x 1 ³⁄₁₆ inches. Charles Bregler's Thomas Eakins Collection. Purchased with the partial support of the Pew Memorial Trust, 1985.68.2.348.

An unpublished manuscript written by Eakins outlines his primary interests in art instruction. It is, in fact, the rough draft for a multichapter book analogous to his class lectures at the Academy. The table of contents reads like a course prospectus for the Academy schools during Eakins's tenure: Linear Perspective, Mechanical Drawing, Isometric Drawing, Refraction, Reflections in Water, Shadows, Laws of Sculptured Relief, and Notes on Construction of a Camera. His lectures are transcribed as if he were arguing a scientific theorem. He begins each chapter with a stated argument and then demonstrates how the desired effect can be achieved. This rational precision and clarity of cause and effect is a powerful teaching method and stands out from the broader, more generalized notions of art training of earlier eras.[16] While much has been made of his innovative approaches and the crisis they precipitated in his own teaching career, Eakins was, in essence, an artist connected to the same traditions that the Academy has always espoused—the realism of figural compositions. Two key factors caused conflict with the traditionalists in the Academy community. One was his readiness to adopt any productive technique or tool through which his students could better realize this realist approach. Even more troubling to his critics was the strength of his personal involvement with students in his interpretation of the French atelier system: he literally incorporated his pupils into his studio sessions, his nude studies, and his photography (fig. 25). Eakins's openness, coupled with his passionate insistence that seeing and understanding took precedence over propriety and social mores, was more than some could tolerate. This approach was in part the cause of his being driven from his position at the Academy.

While Eakins himself was no longer present at the Academy after 1886, many of his ideas and methods were maintained by the artists promoted or imported to fill the gap left by his departure.

Wary of granting any single individual the power and influence that had been Eakins's, the board divided his tutorial responsibilities between two artists, Thomas Anshutz (1851–1912) and James P. Kelly (1854–1893). Both had been friends of Eakins and had worked with him as students and assistants since 1876, so ironically many of his ideas continued to be presented to the Academy's student body.

Anshutz was the primary full-time professor until 1911 and represented the traditions of nineteenth-century academic training strongly grounded in drawing (a discipline still of primary importance to the Academy's philosophy). Although in the 1890s other artists were hired to teach, including Thomas Hovenden (1840–1895), Cecilia Beaux (1855–1942), William Merritt Chase (1849–1916), and briefly Robert Vonnoh (1858–1933), none seemed interested in day-to-day teaching methods at the Academy and instead relied on the conventional methods of individual critiques and the example of their own work.

Every era brings its own challenges to cultural institutions. The twentieth century was no different as the focus shifted away from the fundamental concerns of the previous century. New ideas and new programs in other institutions would compete with the weight of traditions at the Academy. Like only a few other large American cities, twentieth-century Philadelphia had a critical mass of artists, art students, collectors, curators, critics, and organizations interested in fostering a dynamic community of art and ideas. Art instruction in the modern era would no longer be a matter of what was taught in class but would incorporate what was experienced in and around Philadelphia as well.

In the first part of the century, the advent of modernism was not ignored by the Academy or its staff. Chase, who taught until 1909, pressed students toward a more modern approach by discouraging study from casts and encouraging his students to work directly from life to retain the immediacy of a sketch in their finished works. Instructors such as Arthur B. Carles (1882–1952), Henry McCarter (1864–1942), and Hugh Breckenridge (1870–1937) were instrumental in exposing the Academy students to various aspects of modernist practice in their own work, in their teaching, and in several specially curated exhibitions of modern art. The curriculum was simultaneously expanding with new classes established to address novel ideas (Open Studio), popular formats (Mural Painting), and even applied arts (Illustration). Some of these new courses were probably seen as vocationally directed as young artists began to seek paid employment in their chosen fields, and other art schools offered more and more of these courses.

While some of these artists' tenures were lengthy (McCarter was on staff for more than forty years), their teaching must be viewed against the backdrop of the powerful realist traditions that had been dominant at the Academy for well over a century. While less is known about exactly how and to what extent Carles and McCarter incorporated their own ideas about modernism into what they taught, there is no doubt that some students followed their lead and produced works that evinced abstract and expressionist values. Some of the changes in teaching during these years were based on the informal, open tone of their critiques, on the fresh voice of their own work and on the impact of the modernist exhibitions between 1920 and 1923, organized in part by Carles (fig. 26). "Carles was famous for his articulate defense of modernism and its critical importance to meaningful painting. His well-attended and memorable Saturday morning sketch classes were forums for promoting his beliefs among Academy students."[17] While these instructors exposed students to modernism, a backlash was raised among others who insisted upon the established realist traditions. Exposure to and adoption of new ideas are two different things, and for the next three or four decades the teaching philosophy at the Academy remained strongly conservative. From 1936 to 1969, the Academy was under the direction of Joseph T. Fraser, and although the school flourished, those years are marked by stability and continuity more than by curricular change.

The century also saw the rise of a visual arts culture in America that fostered more programs and competing institutions in Philadelphia. Institutions of higher education as well as specialized art schools and technical institutes offered studio training and built extensive facilities. What had been a near monopoly for the Academy in its earlier years had become, by the late twentieth century, a diverse field filled with competitors, some with offerings or opportunities against which the Academy was not equipped to compete. Academy responses to this new, institutionally crowded landscape included establishing undergraduate degree options (in collaboration with the University of Pennsylvania), introducing an M.F.A. degree, and attracting a diverse faculty with many professional perspectives. In addition, the curriculum was updated with options for work in mixed media, newer sculpture techniques (fig. 27), and experimental methods.

What might typical late-twentieth-century students expect in instruction at the Academy? They would pursue a four-year course with the first year devoted to fundamentals, particularly drawing and painting from live models, supplemented by cast drawing, anatomy, color, perspective, and art history. Later, they would choose a specific track of painting, sculpture, or printmaking and then proceed to work in individual studios where critique sessions are held with selected faculty and guest artists. Exhibitions in the museum and the annual student exhibition in the spring, guest lectures, and awards and travel scholarships offer different ways to inspire and engage artists in their formative years. The format of graduated training, moving from rudimentary skills to independent studio work and public engagement, can trace its roots back to the Academy's earliest days and has evolved as it has been informed and elaborated upon by scores of subsequent professionals.

Even with the addition of state-of-the-art facilities and more private studios in the new Samuel M. V. Hamilton Building (see fig. 40), one could surmise that recent changes to the teaching programs at the Academy have been extensions of the values and beliefs inherited from the developments of its first two centuries. Artists have always been the agents of important change in the Academy curriculum, and their roles as instructors and students remain at the core of the Academy's motivation. Today's Academy believes not just in teaching techniques, formulas, and standards. It acknowledges, in this era of shifting boundaries and constantly changing technologies, that students need to understand and be committed to their own values. As longtime Academy

Fig. 26
Photographer unknown,
Arthur B. Carles, ca. 1915.
Copy photograph, location of
original unknown.

Fig. 27
Academy sculpture class in
foundry techniques, 1990.
(Michael Pilla Photography).

teacher Dan Miller clearly stated, the faculty "want to get the students to know who *they* are" in order to realize their own creative vision.[18] Dean of Academic Affairs Jeffrey Carr knows that "an artist's work has the personal authority that comes out of long struggles in the studio."[19] Based on individual attention and hard work, the Academy curriculum, with its inheritance of long-standing academic traditions, the accumulated knowledge of generations of artists, the primacy of its collection, and its openness to change, is poised to continue teaching young artists for many years to come.

Notes

Unless otherwise noted, the primary sources cited below are in the archives of the Pennsylvania Academy of the Fine Arts, Philadelphia.

1. *Articles of Association, Dec. 26, 1805, of the Pennsylvania Academy of the Fine Arts.*

2. This essay is based, in part, on previous research, including the author's doctoral dissertation, "The Pennsylvania Academy of the Fine Arts and the Development of an Academic Curriculum in the Nineteenth Century" (Brown University, Providence, Rhode Island, 1977), and on other publications, including "Photography and Teaching: Eakins at the Academy," *American Art Review*, vol. 3, July–August 1976, pp. 127–40; and "The Context of the Pennsylvania Academy: Thomas Eakins' Assistantship to Christian Schuessele," *Arts Magazine*, vol. 53, no. 9 (May 1979), pp. 121–29.

3. *Articles of Association, Dec. 26, 1805, of the Pennsylvania Academy of the Fine Arts.*

4. Joseph Hopkinson, *The First Annual Discourse*, 1810, pp. 28–34.

5. See Rembrandt Peale, "Reminiscences—Exhibitions and Academies," *The Crayon*, May 1855, pp. 290–91; and Edward Nygren, "The First Arts Schools at the Pennsylvania Academy of the Fine Arts," *The Pennsylvania Magazine of History and Biography*, vol. 95, no. 2 (April 1971), p. 221. Another 1802 effort at establishing a school for artists, The New York Academy of the Fine Arts, was also an inspiration for the Philadelphians. See Frank H. Goodyear, Jr., "A History of the Pennsylvania Academy of the Fine Arts, 1805–1976," in *In This Academy: The Pennsylvania Academy of the Fine Arts, 1805–1976* (Philadelphia: Pennsylvania Academy of the Fine Arts, 1976), p.15; and Doreen Bolger, "The Education of the American Artist," *ibid.*, pp. 51–52.

6. Charles Willson Peale to Thomas Jefferson, June 13, 1805, in *The Selected Papers of Charles Willson Peale and His Family*, 4 vols., ed. Lillian B. Miller (New Haven, Connecticut: Yale University Press, 1992), vol. 2, part 2, pp. 850–52.

7. Quoted in E. P. Richardson, "[Joseph] Allen Smith Collector and Benefactor," *The American Art Journal*, vol. 1, no. 2 (Fall 1969), p. 10.

8. For more on this group, see Goodyear, 1976, p. 18; and Frank H. Goodyear, Jr., *Pennsylvania Academicians* (Philadelphia: Pennsylvania Academy of the Fine Arts, 1973).

9. A fuller discussion of these artists is found in Onorato, 1977, pp. 49–65 and 71–103; and Onorato, 1979, pp. 121–25. For Rothermel, see Mark Thistlethwaite, *Painting in the Grand Manner: The Art of Peter Frederick Rothermel* (Chadds Ford, Pennsylvania: The Brandywine River Museum, 1995), pp. 11–29.

10. John Sartain, *Reminiscences of a Very Old Man, 1808–1897* (New York: D. Appleton and Co., 1899), p. 250.

11. Eliza Haldeman Collection, letter dated February 4, 1860.

12. A fuller discussion of the role of the Academy and its relationship to women artists is found in Christine Jones Huber, *The Pennsylvania Academy and Its Women, 1850–1920* (Philadelphia: The Pennsylvania Academy of the Fine Arts, 1973).

13. Broadside, February 11, 1871.

14. *Invitation for Proposals to Erect a Building for the Pennsylvania Academy of the Fine Arts*, June 20, 1871, paragraph 5. For a fuller discussion of how the buildings reflect curriculum, see Onorato, 1977, pp. 25–26, 45–48, and 90–94.

15. Bolger, 1976, p. 62. For Eakins and the influence of his Parisian teachers, see Gerald M. Ackerman, "Thomas Eakins and His Parisian Masters Gérôme and Bonnat," *Gazette des Beaux Arts*, vol. 73, no. 1,203 (April 1969), pp. 235–56.

16. The manuscript (to be published in 2005) is held by the Philadelphia Museum of Art. For Eakin's use of photography, see Susan Danly and Cheryl Leibold, *Eakins and the Photograph: Works by Thomas Eakins and His Circle in the Collection of the Pennsylvania Academy of the Fine Arts* (Washington, D. C. : Smithsonian Institution Press, 1994).

17. Cheryl Leibold, "To Assist and Excite—Art Education at the Pennsylvania Academy of the Fine Arts," in *The Unbroken Line: A Suite of Exhibitions Celebrating the Centennial of the Fellowship of the Pennsylvania Academy of the Fine Arts* (Philadelphia: Pennsylvania Academy of the Fine Arts, 1997), p. 15.

18. Dan Miller, voiceover on promotional videotape, *The Unbroken Line*, 1987.

19. Jeffrey Carr, "Dean's Letter," Pennsylvania Academy website.

MICHAEL J. LEWIS

The Pennsylvania Academy of the Fine Arts as Building and as Idea

A great building is always a happy accident, in which luck counts for more than talent, and timing most of all. A brilliant architect may tackle a knotty problem, enlightened patronage may exert itself with vision and self-sacrifice, a capable builder may work conscientiously, but all this can only guarantee excellence, never greatness. Genuine greatness occurs when a building transcends the purely local and specific to confront the broad social and cultural forces of its age, and to embody them in physical form. This happens rarely, but it did so in Frank Furness and George W. Hewitt's building of the Pennsylvania Academy of the Fine Arts.[1]

The Academy, both building and institution, was vitally engaged with the chief currents of American culture—scientific, industrial, philosophical—in the turbulent decade after the Civil War. Its physical structure is as much an intellectual as an aesthetic creation, in which the cultural energy of nineteenth-century America aligned with the industrial resources of Gilded Age capitalism to create a building of complex and layered richness. It is easily America's most important High Victorian building.

The present Academy of the Fine Arts, on the southwest corner of North Broad and Cherry Streets, is the institution's third home. The first building was designed in 1805 by John Dorsey (1759–1821), a director of the Academy as well as an amateur architect of precocious but erratic gifts.[2] The Academy design shows him at his best (fig. 28). Fronted by a generous courtyard, the building stood on a large lot on the north side of Chestnut Street, between Tenth and Eleventh Streets. Dorsey designed a taut Neoclassical box, which he fronted with a pair of Ionic columns in antis and surmounted with a shallow dome. Guarded by carved sphinxes and watched over by an eagle in the pediment, grasping paintbrushes and an artist's palette in its talons, it conveyed that most Neoclassical of qualities: aloof, monumental dignity. This was America's first building built

in exotic romanticism. Of the two, Furness was the dominant personality, so dominant, in fact, that Hewitt's contribution is often overlooked. But both were essential to the Academy, whose synthetic, additive nature was peculiarly congenial to collaboration, even between architects of strikingly different temperament and training.

Furness was the product of an exceptionally intellectual household, headed by the Reverend William Henry Furness, the Unitarian minister and celebrated abolitionist. The elder Furness was a

transplanted Bostonian who graduated from Harvard Divinity School and was a lifelong friend of Ralph Waldo Emerson. Through Emerson and his father's wide circle of friends, the young architect grew up near the epicenter of American cultural life at a moment when transcendentalism, abolitionism, and Darwinism were its central preoccupations.

Furness was a protégé of Richard Morris Hunt, the first American architect to study at the celebrated Ecole des Beaux Arts in Paris. Hunt passed on to Furness the Ecole's disciplined classicism and its methodical planning, in which the floor plan was fundamental and was treated as an exquisitely logical diagram of axial movement. Furness learned Hunt's elegant classicism, but his wayward sense of form soon led him to quirkier solutions, tending toward caricature. The conspicuously mechanistic and top-heavy forms of his mature work sometimes seem exaggerated to the point of violence. Perhaps they owe at least as much to his brutal experience in the Civil War— where he was a captain in the Sixth Pennsylvania Cavalry and won the Congressional Medal of Honor—as they do to Hunt.

George Hewitt was cut from a different mold. A churchly and bookish Anglophile and a devout Episcopalian, he was a champion of the Gothic. He trained in the office of John Notman, which specialized in designing Gothic churches, lovely archaeological fictions meant to look six centuries old on the day they were consecrated. Hewitt's taste tended to the romantic. If Furness's favorite book was Viollet-le-Duc's *Dictionnaire raisonné de l'architecture française* (1854–68), that manifesto of rational structure, Hewitt poured over Owen Jones's sumptuous portfolio on the Alhambra, with its dream world of Islamic color and fantasy.[11] The Academy's more exotic passages should be credited to Hewitt.

Nepotism and favoritism notwithstanding, Furness & Hewitt eminently deserved their victory. Their design was an aesthetic and functional triumph, and displayed a confident spatial imagination. Its basic form was a basilica—a central nave flanked by two lower side aisles—an ecclesiastical building type that was ingeniously reconfigured to serve as an art gallery.[12] The north-facing studios were placed on the ground level and lighted by a shed roof of glass and iron, serving as a kind of clerestory (fig. 31). The second story, containing the painting galleries, was set back from this, its massive blank walls seemingly carried by the glass roof beneath, a feat of daring structural panache. In fact, these walls were suspended on a row of mighty iron girders, studded with rivets and boldly exposed to view. Never before had structural iron been exposed in a civic building, and certainly not for aesthetic pleasure.

The facade was equally daring. Unlike its predecessor, this was no stately sanctuary of the arts, but an executive summary of the history of architecture, which proclaimed the building a repository of all art. It brought together architecture's two great lineages, the classical and the medieval, as did the firm of Furness & Hewitt, that Anglo-French architectural hybrid. In massing, the Academy was thoroughly conventional: a tripartite arrangement of a taller block shouldered

between two lower wings, each capped with a mansard roof. This arrangement was the solution of the contemporary Corcoran Gallery in Washington, D.C. (1859–61). But below this classical roofline was a wall of agitated High Victorian color: rugged bluestone for the foundation and piers; vivid red brick outlined by black mortar joints for the walls; bright yellow sandstone for the trim; and polished red granite for the columns.[13] The hot chromatic intensity was Venetian in character, recalling the much more literal Venetian style of New York's National Academy of Design (1862–64).

The principal openings of the facade were headed by Gothic arches, carried on banded granite columns. But the building was hardly Gothic, and Greek and Islamic forms jostled gregariously. The large main arch was encased within by a projecting frontispiece whose cornice of merlons suggests the portal of a North African mosque.[14] The blank walls to each side, however, were treated as an abstraction of a Greek Doric temple, in which the metopes and triglyphs, which alternate in a proper Doric entablature, were pried apart and stacked above one another. The metopes, or sculptural panels, were carved with scenes from Paul Delaroche's *Hemicycle of the Beaux Arts*, which graced the Paris Ecole; beneath these came the sharply incised triglyphs.[15] The Greek theme culminated at the facade's midpoint with an actual work of ancient sculpture, a Hellenistic statue of Ceres, carried on a plinth that bisected the stilted arch of the entrance. To each side were to be sculpted panels of Phidias and Apelles, the principal figures of Greek sculpture and painting (fig. 32). Here classical idealism and nineteenth-century notions about progress and development were synthesized to form a dynamic diagram of the sources of all art, with Greece at the center.

The building's cornerstone was laid on December 7, 1872, but already a crucial change had taken place on the building committee. During the planning phase, Sartain played the dominant role, serving as chairman and personally revising Furness & Hewitt's plans for the classrooms and galleries.[16] But once the construction phase began, power devolved upon Rogers, whose grasp of technical processes and materials was exceptional. He reviewed the specifications during every step of the building process and was instrumental in bringing innovative construction techniques and materials to the building. He soon made a fateful decision.

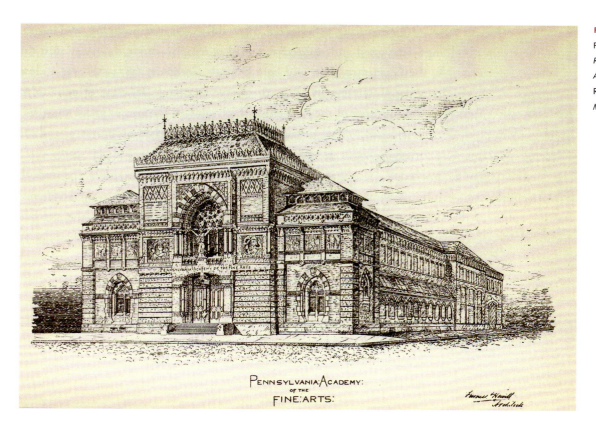

Fig. 32
Furness & Hewitt, *Perspective Rendering of the Pennsylvania Academy of the Fine Arts*, 1872. Reproduced in *Lippincott's Magazine*, March, 1872.

PENNSYLVANIA ACADEMY:
OF THE
FINE ARTS:

and history.[25] A few weeks later, Furness and Hewitt considered their position. Their contract with the Academy guaranteed them a fee of six thousand dollars—a cost-saving measure by the frugal Academy board, which preferred a fixed fee rather than the customary fee of five percent of the cost of the building. The architects recognized that the building was far from finished: its walls had been carried up to the height of the second story, and the iron truss above was in place, but it was still an empty shell, with several more years of work remaining.[26] Unfortunately, they had received all but five hundred dollars of their fee. They now wrote a very carefully formulated letter to the Academy. They discreetly pointed out that the system of working by separate contracts had, indeed, given the Academy a far better building than would otherwise have been the case, but it also cost the architects considerably more time and effort. They proposed now that they be placed on a salary until the end of construction; they suggested three thousand dollars.[27]

Of course, the request was out of the question. The donors were in as bad straits as the architects. A number of changes the building underwent in the winter of 1873–74 seem to be cost-cutting measures. The biggest casualty was the ceiling of the grand stairhall, which was to have been a lively essay in colored brick but was built instead in cheaper plaster and paint. But as the depression righted itself and funds flowed once again, work resumed a steady tempo.

The situation was bright enough in early 1874 for Fairman Rogers to approve the building of the stair balusters in costly solid bronze.[28] These were perverse in form, with diagonal railings intersecting the vertical balusters in an angled cog that bore a weird resemblance to an engineer's universal joint. Surely this witty detail was the invention of George's brother William Hewitt, who not only was chief draftsman but also a trained mechanical engineer. In a building saturated with industrial details, these mechanistic balusters were the most literal, and the most playful—an affectionate salute to Rogers and Matthew Baird, those building committee members whose fortunes were made by machines using these very joints.

The fourth and final year of construction came in 1875. While the roof received its cladding of slate, attention shifted to the interior and its decoration. The crowning feature, and the last to be finished, was the mighty coved ceiling above the stairhall. For this the architects turned to a Moorish technique, described in Owen Jones's monograph on the Alhambra. The walls were built of plaster that was stamped from a mold, making a diagonal pattern of raised lozenges, each bearing a decorative flower. Like the decorative sandblasting below, mass production and repetition produced an effect of baffling intricacy.

Furness & Hewitt had originally wanted the stairhall (fig. 35) to be colored by the building materials themselves; this was the imperative of structural polychromy, the moralistic doctrine so central to the High Victorian Gothic, which despised all sham. Such buildings were limited to the palette available by geology itself. For John Ruskin, the arbiter of Gothic Revival morality, this was an unequivocal good, relating the building to the natural world, the standard of all beauty. But even as Ruskin was writing, a color revolution was unfolding, and the Academy is marked by the effects of that revolution.

Until roughly the middle of the nineteenth century, artists were restricted to the earth palette, the same pigments used by Rembrandt, comprising pulverized rocks and plants. Mixed with impurities, these pigments could not approach the intensity of pure color, which is produced by light itself when split by a prism. But during the middle decades of the century, a number of artificial pigments were invented, such as cadmium yellow and magenta, which approached the intensity of pure light. A rainbow of colors became commercially available by the 1860s—and in short order the public's tolerance for intense color increased. Impressionism is one of the consequences of that chromatic revolution, but so is High Victorian Gothic architecture.

As the Academy was built, Furness & Hewitt moved from the geological palette advocated by Ruskin to the spectral color of the new chemical pigments. Industry and chemistry, rather than nature, were now the source of color. Most inventive was the decorative frieze under the cornice, where the architects invented a system for creating architectural color of a wonderful iridescence. Glass panels were painted on the reverse with transparent hues that were in turn backed with gold foil, which produced "a peculiarly beautiful luster."[29] The glass sealed the color, making it indelible, permanent, and safe against soot—a poignant acknowledgment that even as factories made possible the new vivid hues, their emissions also constantly blackened them.

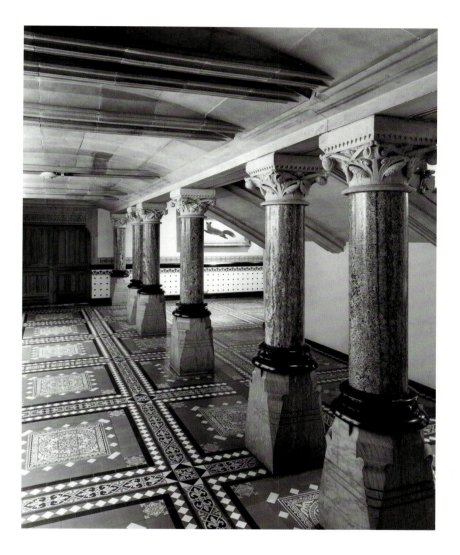

Like the exterior, the interior of the Academy is a color essay of great sophistication—as is appropriate for a building devoted to the language of paint. In the galleries surrounding the central stair, the colors are mixed secondary and tertiary hues, like the ochers and plums of the galleries. The essential colors, the three primary colors that are the source of all color, are placed appropriately at the center atop the stairhall, where they are bathed in light. Moreover, the primary colors appear in roughly the proportions recommended by Jones to produce a color chord of absolute harmony: a ratio of blue, red, and yellow, of approximately eight to five to three.[30] This triad is the eye of the color storm, a sleek cage of spindly granite colonettes supporting a sumptuous fabric of gold flowers on a field of red, and atop this wall, the blue of the heavens, a radiant and light-crowned sky picked out with gold stars.

Fig. 35
Furness & Hewitt, *Ground Floor beneath the Grand Stair*, (Ralph Lieberman Photography).

To appreciate this startling chromatic effect, one should experience it as the culminating point of a dynamic sequence, as the Beaux-Arts prescribed. The visitor first encounters the vestibule, a low and dark space, before the vertical release of the stairhall. Gracing the cornice of the vestibule is a peculiar frieze of bulbous mushrooms—a plant that grows in the dark—which is the counterpoint to the color jubilee of the stairhall, evoking movement through the building as a procession from darkness to light.

The Academy was dedicated at noon on Saturday, April 22, 1876. Its highlight was an address by the Reverend William Henry Furness, who had spoken at the cornerstone ceremony and who now spoke again. His son had dissolved his partnership with Hewitt the preceding fall, ambitious to work on his own, but the two architects set aside their estrangement to march together in the ceremony.[31]

One element of the building remained incomplete. Up to the eve of the dedication, Furness was negotiating with his sculptor, Alexander Kemp, about carving the great sandstone panels of Apelles and Phidias on the facade. But to the tapped-out donors, the building looked fine without

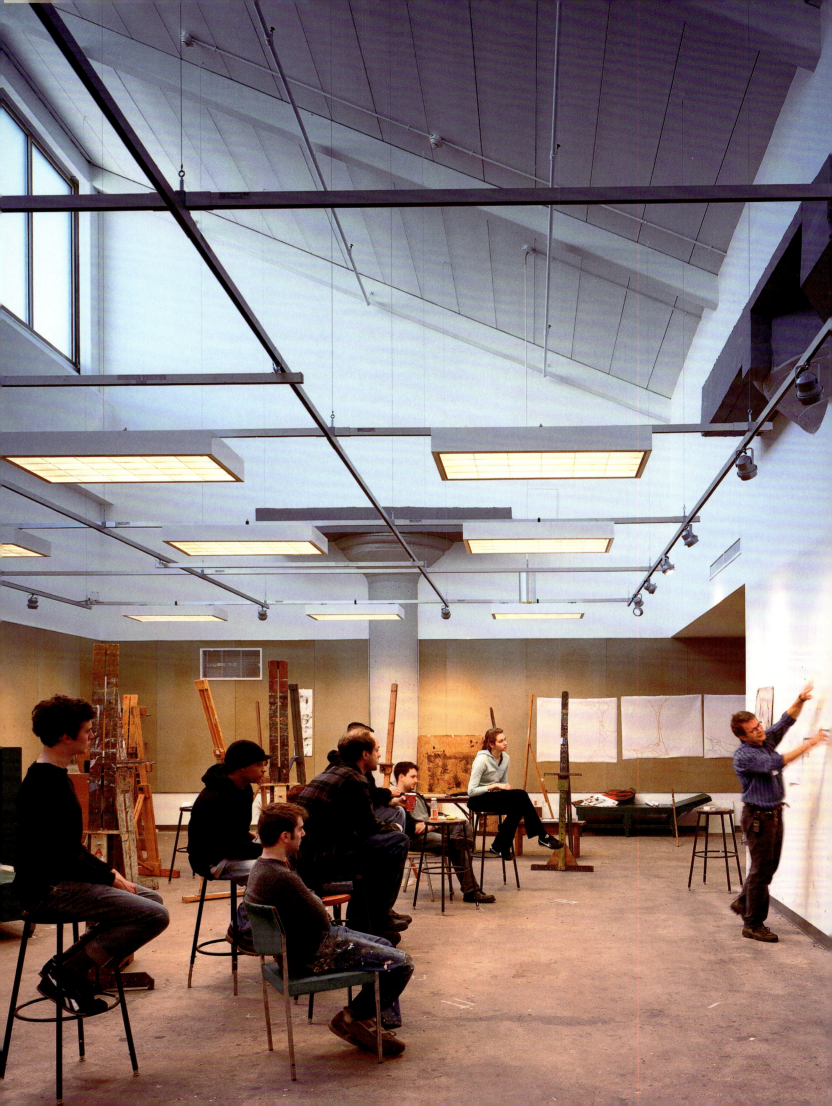

PETER M. SAYLOR, FAIA

Hamilton Building, Painting
Studio, Ron Wyffels instructing,
2003 (Tom Crane Photography)

The Samuel M. Hamilton Building:
Autos to Art

*In April of 1916, a newspaper article quoting Harrison S. Morris, a former
director of the Pennsylvania Academy of the Fine Arts, carried the headline
"Says Art Academy Must Go." Harrison specifically stated: "Plans for the
erection of a ten-story business building at the northwest corner of the
Broad and Cherry Streets permanently dooms the schools at the Pennsyl-
vania Academy. . . . The studios where many of the ablest American artists
were trained will be without adequate light when the new building goes up."* [1]

It is especially ironic today that the prophecy of doom predicted upon the construction of the
Gomery-Schwartz Motor Car Company has, over the course of ninety years and through several
transformations, turned out to be the source of future growth for the Academy, becoming a
campus anchor with the Landmark Building designed by Furness & Hewitt. The early and cur-
rent life of the structure, now known as the Samuel M. V. Hamilton Building, has influenced
the Pennsylvania Academy of the Fine Arts for more than nine decades, and its history has
become an integral part of the institution.

Looking back to the early part of the twentieth century, the section along North Broad
Street next to the Academy was home to a remarkable group of automobile manufacturers, includ-
ing the still extant Packard Building and the adjacent Peerless Cadillac Building. Other motor-car
companies dominating the area after the departure of the Baldwin Locomotive Works included
General Motors, Ford, Bergdoll, Krit, Overland Merion, Oldsmobile, Hupmobile, Keystone,
Studebaker, and White Motor. [2] It was into this heavy industrial environment that the Gomery-
Schwartz Motor Company announced, in 1916, its intentions to erect a ten-story building to serve
as an automobile showroom and "car storage" facility. Given the nature of the custom-automobile
business and the number of floors required for storage, a more likely use was for the assembly of
partially completed automobiles from parts manufactured two blocks north at the Gomery-
Schwartz plant located at Broad and Wood Streets.

would be contrasted with the Hamilton Building's transparent and welcoming "showroom" for art (fig. 38).

Public program elements that formed the Hamilton Building's first floor openness include a lobby, gift shop, galleries, café, and student entrance. The design expresses many of the same elements found in the Furness & Hewitt building, such as each having a main entry on Broad Street, a student entrance on Cherry Street to the west, and a grand stair to link galleries to lobbies. The Hamilton Building offers a much more open and airy interior compared to the celebrated exuberant polychrome treatment by Furness. The Hamilton design avoids mimicking the Furness details to achieve its clarity and crisp atmosphere and does so with a lobby fully exposed to Broad Street as a welcoming "billboard" to display the art on the inside. The Hamilton's grand stair, positioned somewhat teasingly behind a column (see illustration to the Foreword), strikes its own assertiveness in clear contemporary terms while recalling that of Furness with its celebrated grandeur and tension.

The new special exhibition gallery is named the Fisher Brooks Gallery, in honor of board member Marguerite Lenfest's mother, Leonie Brooks, and her grandfather, James R. Fisher, who attended the Pennsylvania Academy in the late 1880s and participated in several annual exhibitions. The Fisher Brooks Gallery provides an elegance of simplicity that offers optimum flexibility for traveling shows and, given the height achieved by the removal of the Gomery-Schwartz mezzanine, is ideal for the display of large contemporary paintings (fig. 39). Coupled with the extensive new galleries on the second floor and the unique Sculpture Study Center, the overall gallery additions significantly increase the Academy's ability to showcase its collection in full depth. All gallery areas are climate controlled to meet museum standards for temperature and humidity.

A benefit gained by the transformation of the ground floor, in exchange for the lost historic interior, is the fully restored exterior facade of the Hamilton Building. Adaptive design of fenestration on the lower levels recalls the showroom character of the automotive history of the site, while full replacement of the noncompliant aluminum window alterations now portrays the original site lines of its historic 1916 appearance. Brickwork has been cleaned and repointed with (researched)

Fig. 38
Elevation of the Landmark Building and the Hamilton Building, 2003.

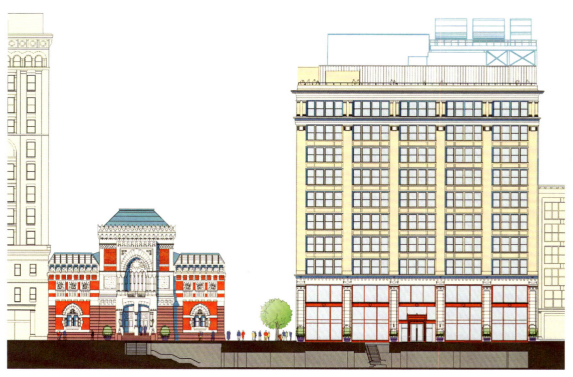

Fig. 39
Hamilton Building,
Fisher Brooks Gallery, 2003
(Tom Crane Photography).

mortar color and raked joints to provide the building with delineating shadow lines and a warm, creamy glow. A long-term deficiency in wheelchair access at the Academy has been resolved with the restoration and adaptation of the Hamilton Building main entrance. The creation of a dramatic interpretation of the old cast-iron doorway at grade level welcomes people into the new lobby. When connected to the Landmark Building by elevators down to and up from lower-level galleries under Cherry Street, the Hamilton Building will provide a resolution of the imposing steps at the Furness entrance without eliminating that historic procession.

Of equal importance to the expansion of museum programs are the significant advances in space allocation and environmental controls for the studio and teaching areas for the Academy. With the desire to increase enrollment to four hundred students, the Academy addressed program elements. A consolidated administration area permits the Academy to assimilate staff, faculty, and curators in one location. Expansion of the library brings vast improvement for students to study and research the Academy's collections. Major advances in equipment and environmental controls of hazardous areas in sculpture, painting, and printmaking studios bring the Academy to the fore-front of technology and safety for dealing with toxic climates. All these improvements were made without sacrificing the Academy's traditional program priority to provide senior students with individual studios for the pursuit of their talents.

The design of the upper floors in the Hamilton Building restores the historic character of the Gomery-Schwartz Motor Car Company by the removal of layers of office intrusions and by the return to loft-like floors, where the original mushroom-slab structure is once again celebrated. The open floors of 1916 are now considerably denser, but the spirit of the historic architectural character of workplace is expressed once again. Mechanical systems are fully exposed in an industrial manner, and light penetrates to inner floor areas, providing an environment conducive to the pursuit of creative art. On the tenth floor, large skylights light painting studios (fig. 40), taking advantage of the one place on the site where north light can be introduced in the same quality originally captured by

Peter M. Saylor, FAIA

Furness in 1876 in the studios of the Landmark Building (see fig. 24). A major improvement, never before available to the students of the Academy, is fulfilled by generous areas at elevator lounges on each floor set aside for casual relaxation and conversation. A student center on the partial eleventh floor, complete with a terrace on the roof, crowns the building with spectacular city views for social activities and painting.

Instead of dooming the institution, the construction and ultimate acquisition of the Gomery-Schwartz Motor Car Company has enabled the Pennsylvania Academy of the Fine Arts to reach its two-hundredth anniversary in its most advanced state since the opening of its 1876 Landmark Building at America's Centennial Exhibition. With its construction process conceived to evolve over several more phases, the Academy enters its third century having achieved the creation of an arts campus that is united, expanded, and provided with the latest in technology, flexibility, and design. The history of the Samuel M. V. Hamilton Building has come full circle by joining together two historically certified structures into arguably the most distinctive school and museum in the country for the creation and exhibition of American art.

Notes

1. "Says Art Academy Must Go," unidentified newspaper clipping, April 16, 1916. Pennsylvania Academy Archives.

2. George E. Thomas Associates, Inc., "A Brief Overview of the Gomery-Schwartz Motor Car Company Building, Broad and Cherry Street, Philadelphia." Prepared for Dagit • Saylor Architects, November 2000, p. 2.

3. *Ibid.*, p. 4.

Masterpieces from the Collection of the Pennsylvania Academy of the Fine Arts

For each artist, affiliations with the Pennsylvania Academy of the Fine Arts are indicated below the name.

Texts for the works in this section were produced by Alex Baker, Mark Hain, Cheryl Leibold, Lynn Marsden-Atlass, Kevin Richards, William Rudolph, and Kim Sajet, as well as several former Academy staff members.

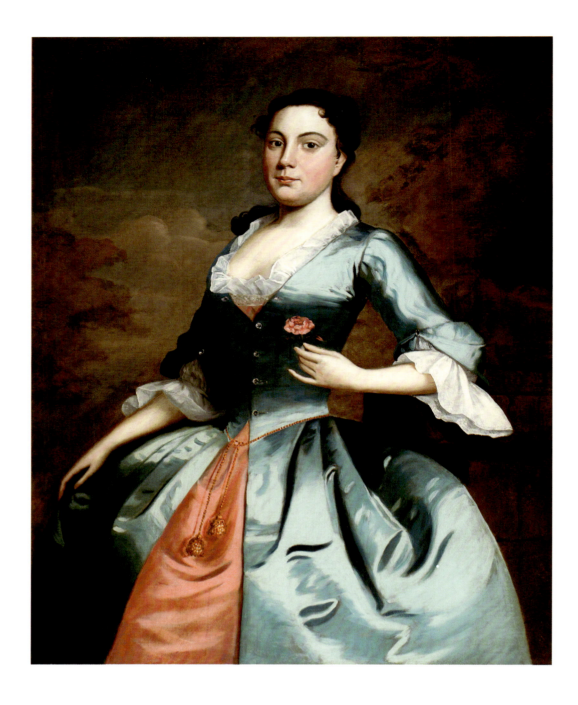

PLATE I
Robert Feke
ca. 1707–ca. 1751

Mary McCall (1725–1799),
ca. 1746
Oil on canvas
50¼ x 40¼ inches
(127.6 x 102.2 cm)
Bequest of Helen Ross Scheetz,
1891.3

Robert Feke is considered the first important artist born in America. Although his portraits are rather naive, Feke developed a style that was distinct from the prevalent English technique practiced in the Colonies. This "native style" became popular, and Feke earned a living as an itinerant portraitist, traveling between Boston, Philadelphia, and Newport, Rhode Island. Little is known of Feke. His later life is particularly mysterious: after sailing from Newport in 1750, possibly bound for commissions in Barbados, he was never heard from again.

Mary McCall was a member of the Philadelphia Dancing Assembly, which hosted dances every two weeks and was a vital part of the social life of colonial Philadelphia. She holds a single flower—a device common in Feke's portraits—in this case possibly symbolic of her availability for marriage. Seven years after this portrait is thought to have been painted, McCall married the merchant William Plumstead, who served as mayor of Philadelphia in the mid-1750s.

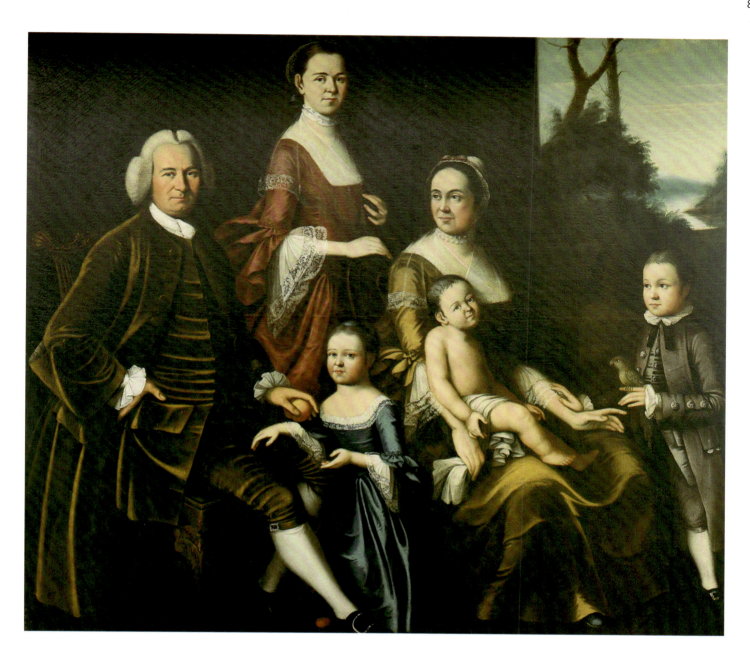

PLATE 2
Henry Benbridge
1743–1812
EXHIBITOR 1814

The Gordon Family (Thomas Gordon, the artist's stepfather, 1712–1772; possibly Ann, b. 1756, and Dolley Gordon; Mary Clark Benbridge Gordon, the artist's mother, possibly with Frances Gordon, b. 1761; and Thomas, b. 1758, or James Gordon), ca. 1762
Oil on canvas
66 x 78 inches (167.6 x 198.1 cm)
Henry S. McNeil Fund, 1987.8

Born and raised in Philadelphia, Henry Benbridge obtained his first artistic instruction from an itinerant English painter, John Wollaston. Before Benbridge left for Rome in 1765 in search of further training, he honed his craft through several ambitious copies after Peter Paul Rubens. He also embarked upon several family portraits, of which this large portrait of his mother, stepfather, and step- and half-siblings is the finest (the identities of the children have been debated by scholars). The complicated composition, showing the Gordons interlocked through a web of poses,

gestures, and glances, was more sophisticated than other group portraits executed in Philadelphia at the time. Benbridge represented his large family as prosperous and affectionate. In fact, that they wanted to document their status may be inferred from the later addition, by another artist, of the family's African servant Caesar behind the boy. This overpainting was removed when the painting was cleaned in the twentieth century but is still faintly visible.

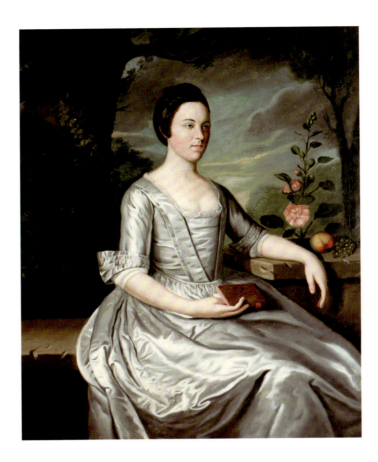

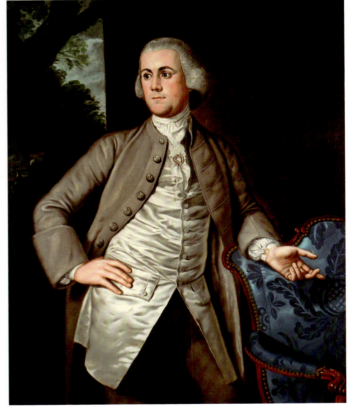

PLATE 3
James Claypoole, Jr.
ca. 1743–before 1815

Mrs. Joseph Pemberton (née Ann Galloway, 1750–1798), ca. 1767
Oil on canvas
50½ x 40½ inches (128.3 x 102.9 cm)
Gift of Henry R. Pemberton, 1968.6

Joseph Pemberton (1745–1782), ca. 1767
Oil on canvas
50½ x 41 inches (128.3 x 104.1 cm)
Gift of Henry R. Pemberton, 1967.15

Although he seems to have been a prominent painter in his own time, James Claypoole, Jr., is relatively unknown today. Probably born in Philadelphia, he was the son of James Claypoole, an even lesser-known artisan and painter, and probably trained under his father. Some time between 1769 and 1771 Claypoole, Jr., departed Philadelphia for London, intending to study with Benjamin West (1738–1820), as did many colonial artists. During the journey, a storm forced Claypoole's ship to stop at Jamaica. Claypoole settled there, married, and continued to work as a portraitist, miniaturist, and coach painter. It is unknown whether he ever returned to America.

The pendant portraits of Joseph Pemberton and his young wife, Ann, were most likely painted in honor of their marriage in 1767. Joseph Pemberton was the son of Israel Pemberton, a prominent Quaker and one of the richest merchants in Philadelphia. Venturing south to court a potential wife, Joseph visited relatives in New River, Maryland; after meeting Ann Galloway, he traveled no further. These lavish portraits display not only the artist's desire to showcase

his painting skill in the elegant mode popular in England, but also Joseph Pemberton's extravagant tastes. The graceful yet casual poses are typical of fashionable European portraits, while the clothing and other accoutrements indicate the sitters' wealth and social status.

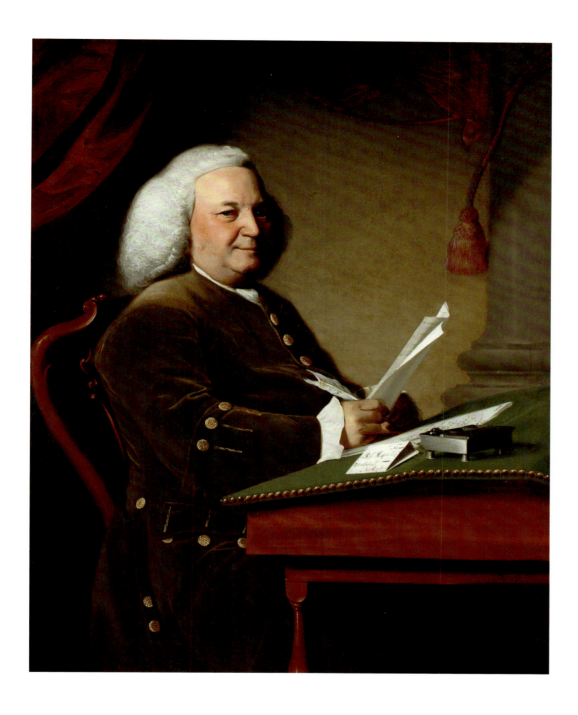

PLATE 4
John Singleton Copley
1738–1815
PENNSYLVANIA ACADEMICIAN 1812
EXHIBITOR 1817

Robert "King" Hooper
(1709–1790), 1767
Oil on canvas
50 x 39 ¾ inches (127 x 101 cm)
Henry S. McNeil Fund. Given
in loving memory of her husband by Lois F. McNeil and
in honor of their parents by
Barbara and Henry A. Jordan,
Marjorie M. Findlay, and
Robert D. McNeil, 1984.13

After the death of his stepfather,
a mezzotint engraver named Peter
Pelham (ca. 1697–1751), the teenage
John Singleton Copley was left with
a rudimentary artistic education,
a collection of engravings, and a
mother and half-brother to support.
This he did with a great deal of
competence, bravery, and native
talent, beginning a career as a portraitist that would ultimately take
him to the heights of Boston society.
Nevertheless, Copley yearned after
Europe, establishing a correspondence with his contemporary
Benjamin West and sending canvases
abroad for exhibition. When family

ties conflicted with local politics
(Copley's father-in-law, Richard
Clarke, was the merchant targeted
during the Boston Tea Party), the
artist eventually emigrated to
Europe on the eve of the American
Revolution, settling in London.

 This portrait of Hooper,
a successful businessman from
Marblehead, Massachusetts, is both
imposing and intimate. Copley's
keen powers of observation and
extraordinary facility in manipulating oil paint to mimic different
materials and textures are on vivid
display in the sweep of the drapery,
the glint of light off the inkwell, and

the fine penmanship on the letter
Hooper is writing. All these
qualities made Copley the most
sought-after artist in Boston—with
sitters as far away as New York
eagerly seeking his work.

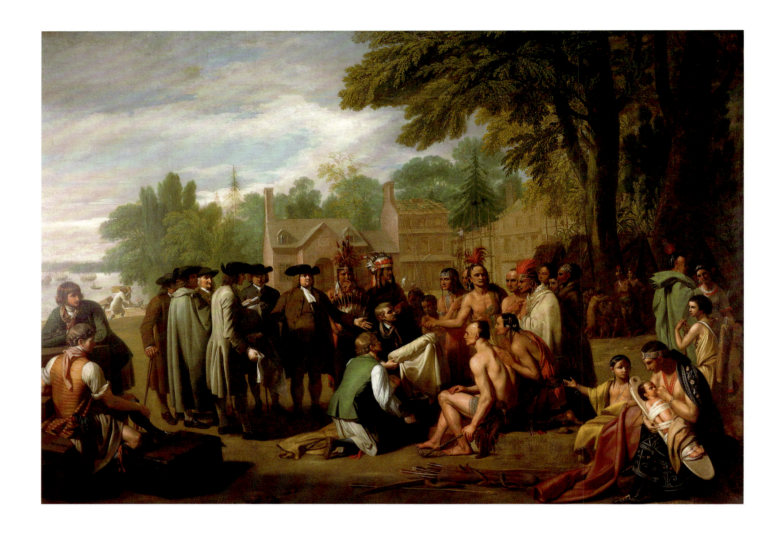

PLATE 5
Benjamin West
1738–1820
HONORARY MEMBER 1805
PENNSYLVANIA ACADEMICIAN 1812
EXHIBITOR 1811–64

Penn's Treaty with the Indians,
1771–72
Oil on canvas
75 ½ x 107 ¾ inches
(191.8 x 273.7 cm)
Gift of Mrs. Sarah Harrison (The
Joseph Harrison, Jr. Collection),
1878.1.10

Commissioned by Thomas Penn, son of Pennsylvania's founder, this painting depicts a legendary meeting between William Penn and members of the Lenni Lenape tribe at Shackamaxon on the Delaware River. Honoring his patron's and his own Quaker heritage, West employed a Neoclassical style to suggest both visual and political harmony. By depicting the three factions that shaped Pennsylvania for most of the eighteenth century—Native Americans, Quakers, and merchants—united in the act of settlement, West created a powerful symbol of peace. Although the scene is allegorical rather than historical, the image has become an icon of American history.

Benjamin West was the first American-born artist to earn acclaim outside his homeland. West was born in Springfield (now Swarthmore), Pennsylvania, and his early artistic promise encouraged Philadelphia's leading citizens to finance his training in Rome. Subsequently, in 1763 West traveled to London and never returned to the Colonies. His acclaim as a painter of historical scenes attracted the attention of King George III. West was appointed official history painter to the king and was a founder and later was elected president of the Royal Academy. Well aware that, as an American, he was a novelty, West used this mystique to his advantage, claiming that he had learned color mixing from Native Americans. He greatly contributed to American art in his role as teacher and advisor to the many early American artists who came to London to study with him.

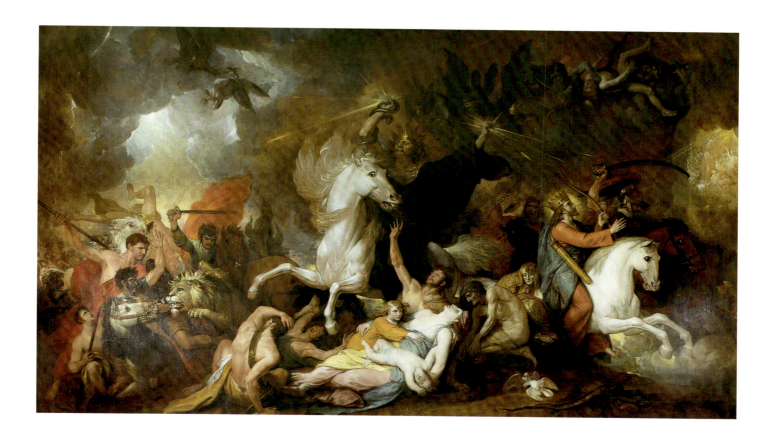

PLATE 6
Benjamin West

Death on the Pale Horse, 1817
Oil on canvas
176 x 301 inches (447 x 764.5 cm)
Pennsylvania Academy purchase,
1836.1

Although West had been elected the Pennsylvania Academy's first honorary member in 1805, the museum did not acquire a work by the artist until 1836, when it purchased this painting. To raise the necessary seven thousand dollars, the institution had to mortgage its building. Less than ten years later, a disastrous fire damaged the Academy's first home and much of its collection. *Death on the Pale Horse* was heroically saved by intrepid volunteer firemen, who cut the huge painting from its singed stretcher.

West based this work on the Book of Revelations 6:8, in which the Four Horsemen of the Apocalypse—Death, War, Famine, and Pestilence—ravage the earth. The biblical narrative of the painting was considered to be so complex that it was originally exhibited with an explanatory pamphlet, and even inspired a 114-page analysis by William Carey in 1836. While West had established his reputation as a Neoclassical painter, this late work shows him turning toward the newer romantic movement, and mindful of Edmund Burke's artistic philosophy of "the Sublime," a quality in art that is meant to evoke intense feelings of awe in the viewer. The monumental scale and packed composition also recall such populist art forms as dioramas and panoramas, spectacular images that toured galleries and lecture halls across the country. This version of *Death on the Pale Horse* is thought to be the artist's final major work.

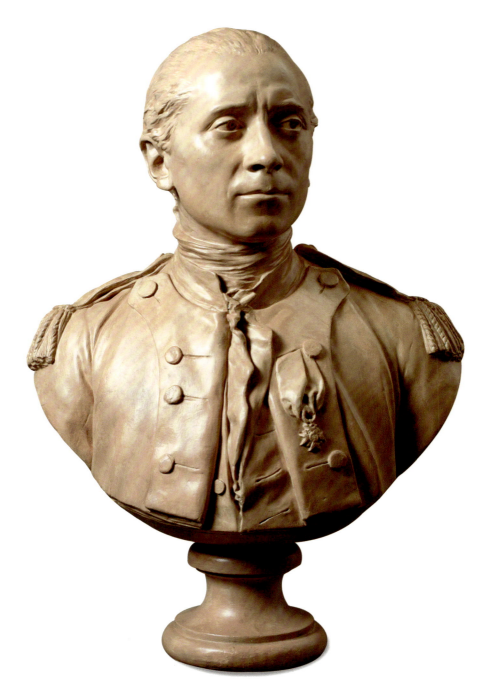

PLATE 7
Jean-Antoine Houdon
1741–1828
EXHIBITOR 1807–12

John Paul Jones (1747–1792),
1780
Painted plaster
27 ¾ x 19 ⅛ x 12 inches
(70.5 x 48.6 x 30.5 cm)
Provenance unknown, 1864.3

A staunch realist, Houdon was the foremost French sculptor of the eighteenth century. He was a superb portraitist, sculpting numerous busts of French nobles, wealthy bourgeoisie, and foreign royalty, all of which display the strikingly life-like quality he was known for. He is primarily remembered today for his series of the great men of the Enlightenment including Voltaire and Diderot and Americans such as Benjamin Franklin and George Washington. He is also remembered for his *écorché* (1767), a detailed anatomical figure of a flayed man, a work that became a staple tool in European and American art schools. A cast of it was acquired by the Pennsylvania Academy in 1805, the only contemporary work in the group of casts selected in Paris for the Academy by Nicholas Biddle and Houdon. John Paul Jones, the popular naval hero of the American Revolution, visited Paris in 1780, where he was widely fêted, and where a Masonic lodge commis-sioned Houdon to make this portrait. Jones was so pleased with it that he ordered at least twenty copies for his friends. The Academy's plaster bust was given to Major General William Irvine, then a Pennsylvania delegate to the Continental Congress, about 1790. On display at the Pennsylvania Academy by 1832, it was probably a gift of the sitter.

PLATE 8
Joseph Wright
1756–1793

The Wright Family (Joseph and his wife, Sarah, d. 1793, with their children, Sarah, Harriet, and Joseph), 1793, unfinished
Oil on canvas
37 ⁵⁄₁₆ x 32 inches (94.8 x 81.3 cm)
Gift of Edward S. Clarke, 1886.5

During his brief life, Joseph Wright became the first American-born student to study at the Royal Academy Schools in London, made the first sculptural likeness of George Washington (whom he also painted from life), caroused while studying in Paris, and survived a shipwreck off the coast of Maine. He was assisted in many of these adventures by his mother, Patience Lovell Wright, a flamboyant modeler in wax and the first known American sculptress, who had emigrated to Europe in search of famous clients. The Academy's painting is Wright's final work, begun in the summer of

1793 while the artist and his family were living at 21 Sassafras Street (now Race Street), awaiting his confirmation as first engraver to the U.S. Mint. Its composition, featuring Wright gesturing toward his growing family, reveals its indebtedness to the English conversation piece, as does its rather grandiose (and improbable) vaulted architecture and drapery swag. Yet for all that, the tenderness of the artist for his family is apparent in the sweetness of expression with which Sarah Wright regards her youngest daughter as well as in the directly curious gaze of little Joseph Wright, Jr.

Tragically, both Sarah and Joseph Wright perished in a yellow fever epidemic during 1793, leaving the portrait unfinished and their young children orphaned.

PLATE 9

Charles Willson Peale
1741–1827
PENNSYLVANIA ACADEMICIAN 1812
BOARD 1806–11
EXHIBITOR 1811–28

George Washington at Princeton
(1732–1799), 1779
Oil on canvas
93 x 58 ½ inches (236.2 x 148.6 cm)
Gift of Maria McKean Allen and
Phebe Warren Downes through
the bequest of their mother,
Elizabeth Wharton McKean,
1943.16.2

Among his numerous accomplish-
ments—artist, inventor, naturalist,
museum proprietor, co-founder of
the Pennsylvania Academy, and
patriarch of an artistic dynasty—
Peale was also a soldier in the War of
Independence. In spite of his abhor-
rence of violence, Peale's desire for a
free America compelled him to
enlist. He rose to the rank of captain,
striving to ease his troops' hardships
during the severe winter at Valley
Forge. Intelligent and energetic,
Peale even managed to further his
nascent painting career during the
war, executing miniature portraits,
including one of General George
Washington; it would be the first of
at least four more portrait sittings
with the future first president.

 This work is the third of Peale's
portraits of Washington from life,
commissioned by the Supreme
Executive Council of Philadelphia to
commemorate victory in the battles
of Princeton and Trenton. Here,
midway through the Revolution,
Washington is portrayed as com-
mander-in-chief, signified by the
blue sash he wears, with prisoners
of war and Princeton College visible
in the background. The commission
was a tremendous coup for Peale,
and replicas were in demand even
before the portrait was finished; this
painting is known to be the original
work. *George Washington at Princeton*
originally hung in the State House
(now Independence Hall), but
eventually came to hang in Peale's
Museum, and later the Academy.

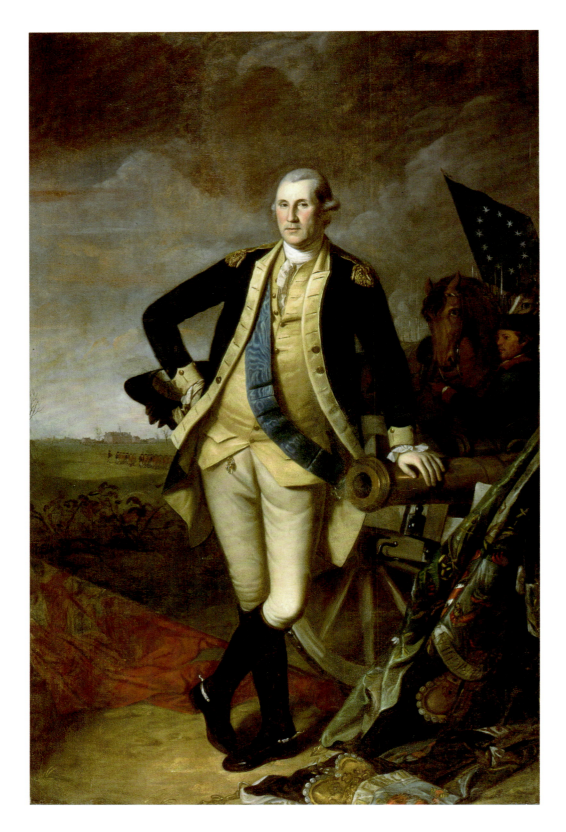

PLATE 10
Gilbert Stuart
1755–1828
HONORARY MEMBER 1807
PENNSYLVANIA ACADEMICIAN 1812
EXHIBITOR 1811–66

George Washington (The Lansdowne Portrait) (1732–1799), 1796
Oil on canvas
96 x 60 inches (243.8 x 152.4 cm)
Bequest of William Bingham, 1811.2

America's image of its first president is largely based on a sequence of enduring portraits by Gilbert Stuart. Washington's sittings for Stuart in Philadelphia, between 1795 and 1796, resulted in three distinctive images: the "Vaughan" type; the "Athenaeum" head, familiar as the image on the dollar bill; and the "Lansdowne" portrait, named for the Marquis of Lansdowne, former British Prime Minister and recipient of the work. With demand for the images high, Stuart painted many copies of these works; the Academy's *Lansdowne Portrait* is the original. In this work, Stuart painted only Washington's head from life, substituting a stand-in to complete the figure.

Washington was troubled at the time of this sitting. Besides a new set of badly fitted false teeth, differences in policy between the President and his cabinet over relations with England had become significant, and elements of the press were portraying Washington as a despotic monarch on par with the King of France. Ironically, Stuart, employing the continental Grand Manner he had learned from Benjamin West, honored Washington by emulating aristocratic portraiture such as Hyacinthe Rigaud's *Louis XIV* (1701). Stuart loaded the portrait with allegorical weight, including the rainbow symbolizing peace and prosperity after the storm of the Revolution, multiple references to Republican Rome, and the popular depiction of Washington as a new Cincinnatus, the Roman warrior who laid down his arms after establishing peace.

James Peale
1749–1831
EXHIBITOR 1811–1835

The Artist and His Family, 1795
Oil on canvas
31 ¼ x 32 ¾ inches (79.4 x 83.2 cm)
Gift of John Frederick Lewis,
1922.1.1

This painting is indebted to the example of the conversation piece, the small-scale group portraits popular among eighteenth-century English landed gentry. Such paintings, popularized by Arthur Devis and William Hogarth, typically featured well-to-do families on their estates, surrounded by possessions and enjoying refined pastimes. Unlike the English models, with their emphasis on property and possession, James Peale shows his young family in public, along the banks of the Schuylkill River. The depiction of Mary Claypoole on the same scale as her husband—indeed, partially obscuring him—suggests an equitable, affectionate relationship thirteen years into the marriage, while the happy play of the couple's five children celebrates family life. Peale was no doubt influenced by French philosopher Jean-Jacques Rousseau, whose writings on the education of children and advocacy of natural feeling were enormously popular in eighteenth-century Europe and America.

James Peale was trained by his older brother, Charles, who recorded the instructional process in a large group portrait (*The Peale Family,* 1771–73, New York Historical Society). James Peale himself carried on the tradition of familial instruction, teaching four of his children to paint. Besides this work, he is best known for his still lifes, some of the earliest American examples of this genre.

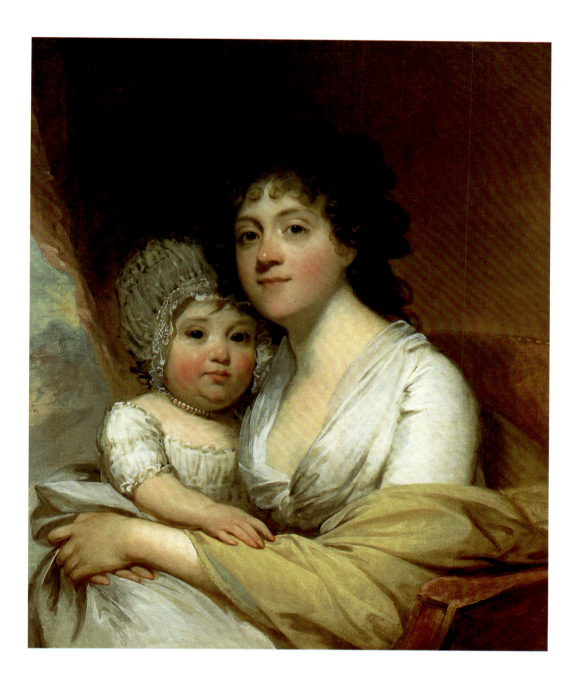

Gilbert Stuart

1755–1828

HONORARY MEMBER 1807

PENNSYLVANIA ACADEMICIAN 1812

EXHIBITOR 1811–66

Mrs. Samuel Gatliff and Her Daughter Elizabeth (Mrs. Gatliff, 1779–1853), ca. 1798
Oil on canvas
29 ¼ x 24 inches (74.3 x 61 cm)
Bequest of Dr. Ferdinand Campbell Stewart, 1899.9.2

Gilbert Stuart's portraiture represents a watershed moment in American art—-a transition to a more technically and psychologically sophisticated way of painting. A native of Rhode Island, Stuart began painting in the mannered, linear colonial style. In 1775, he sailed for London, becoming an assistant to Benjamin West. It was there that Stuart's mature style developed, emulating the soft, feathery technique of English masters Joshua Reynolds and Thomas Gainsborough; Stuart's fluidity with the brush was heightened by his keen sensitivity to color. In spite of his success, Stuart's unpredictability and fiscal irresponsibility forced him to flee creditors in London and subsequently Dublin. He returned to the United States in 1793, working in New York, Philadelphia, Washington, and Boston, and becoming a major influence to a new generation of artists.

Stuart's almost exclusive focus on the face resulted in portraits of great intimacy and insight. Here, Mrs. Gatliff holds her eldest child Elizabeth and looks out at the viewer with a radiant expression of maternal love. Elizabeth Gatliff married the English merchant Samuel Gatliff when she was seventeen, but, before she was thirty, was a widow with four children. The painting's glowing flesh tones and vigorous treatment of fabric are hallmarks of Stuart's technique. The Academy also owns a portrait of Samuel Gatliff, plus twenty-seven other portraits by Stuart.

PLATE 13
William Rush
1756–1833
PENNSYLVANIA ACADEMICIAN 1812
BOARD 1806–33
EXHIBITOR 1811–32

Head of the Nymph (fragment
from *Allegory of the Schuylkill
River*), 1809
Pine
10 x 9 ½ x 10 inches
(25.4 x 24.1 x 25.4 cm)
Henry S. McNeil Fund, 1990.8

One of three artists to sign the
Pennsylvania Academy's founding
charter, William Rush also served on
its board until his death. He began
carving figureheads and ships' orna-
ments about 1774. Usually carving
American subjects, such as Indians
or heroes like George Washington,
his figureheads were admired at
home and abroad for their masterful
carving and poses. Rush was one of
the earliest American sculptors to
create busts of soldiers, statesmen,
and scientists for the libraries of
middle class gentlemen, six of which
are in the Academy collection. His
wooden sculptures, painted white to
simulate antique marbles, anticipat-
ed the Neoclassical style soon to
prevail in America. After 1807, Rush
turned to architectural ornaments
such as the statues of *Comedy* and
Tragedy (Philadelphia Museum of
Art) or the Academy's *Eagle*. While
serving on the City Council's
Watering Committee, which built
a civic waterworks at Philadelphia's
Centre Square (the site of City
Hall), he carved the *Allegory of the
Schuylkill River*, a fountain depict-
ing a female figure and bittern for
its grounds (see John Lewis
Krimmel's *Fourth of July in Centre
Square*, Plate 14). *Head of the Nymph*
is all that remains of the original
wooden sculpture. Carved from a
live model, Louisa Vanuxem, the
work exhibits typical Rush details
such as carved-out pupils surround-
ed by an incised line and deeply
carved curls and topknot.

PLATE 14
John Lewis Krimmel
1786–1821
EXHIBITOR 1811–61

Fourth of July in Centre Square,
by 1812
Oil on canvas
22 ¾ x 29 inches (57.8 x 73.7 cm)
Pennsylvania Academy purchase
(from the estate of Paul Beck,
Jr.), 1845.3.1

Likely the earliest American artist
to specialize in genre scenes, or
depictions of everyday life, John
Lewis Krimmel has sometimes
been referred to as the "American
Hogarth" for his humorous and
lightly satirical paintings. The
German-born Krimmel emigrated
to Philadelphia in 1810. While sup-
porting himself as a portraitist and
drawing instructor, he began to
paint images of Philadelphia life.
A popular artist, Krimmel was
actively involved with the
Pennsylvania Academy until his
untimely drowning while swim-
ming in the Schuylkill River.

Fourth of July in Centre Square
surveys a broad range of the city's
population, including fashionable
ladies and gentlemen, plainly dressed
Quakers, and African-American citi-
zens. With its variety of narrative
incident, this summertime scene of
the park at Centre Square (now the
site of City Hall) captures much of
what was "new" in the city. To the
left, the Philadelphia Water Works,
housed in a classically inspired
structure by Benjamin Latrobe, was
considered an engineering marvel
and a godsend in a city long ravaged
by yellow fever (then thought to be
water-borne). The clean water

provided by its steam-driven
pumping station also made possible
America's first public fountain,
the centerpiece of which was *Water
Nymph and Bittern* (Plate 13), a
wooden sculpture by William
Rush, intended as an allegory of
the Schuylkill.

PLATE 15
John Vanderlyn
1775–1852
PENNSYLVANIA ACADEMICIAN 1812
EXHIBITOR 1823–50

Ariadne Asleep on the Island of Naxos, 1809–14
Oil on canvas
68½ x 87 inches (174 x 221 cm)
Gift of Mrs. Sarah Harrison
(The Joseph Harrison, Jr.
Collection), 1878.1.11

Unlike his contemporaries, John Vanderlyn chose Paris over London, becoming the first American artist to study in France—and the first to exhibit at the Salon, where he won a medal in 1804 for *The Death of Jane McCrea* (Wadsworth Athenaeum, Hartford, Connecticut). Nevertheless, Vanderlyn had deep native artistic roots: his grandfather, Pieter Vanderlyn was a prominent portraitist in the Hudson River Valley. He also briefly studied with Gilbert Stuart, the finest portraitist in the young United States.

The artist's masterpiece, *Ariadne* was one of the most advanced paintings of its day—not to mention being one of the first nudes ever exhibited in this country. The sensual portrayal of a recumbent female recalls the High Renaissance Venuses of Giorgione and Titian. The accomplished sculptural treatment of the body and the precise, tightly finished brushwork also show Vanderlyn's mastery of the French academic tradition. Daughter of King Minos of Crete, Ariadne betrayed her family to help the Athenian prince Theseus slay the Minotaur, only to be abandoned by her faithless lover on the island of Naxos. Although Vanderlyn represents Ariadne before she became aware of her plight, educated viewers would know the story had a happy ending: captivated by the beauty of the sleeping princess, Dionysus, god of wine, made her his bride.

Washington Allston
1779–1843
HONORARY MEMBER 1818
PENNSYLVANIA ACADEMICIAN 1812
EXHIBITOR 1816–42

The Dead Man Restored to Life by
Touching the Bones of the Prophet
Elisha, 1811–13
Oil on canvas
156 x 122 inches (396.2 x 309.9 cm)
Pennsylvania Academy purchase,
by subscription, 1816.1

One of the most ambitious paintings attempted by an early American artist, this monumental work depicts an episode from II Kings 13:21 in which accidental contact with the bones of the prophet Elisha resurrects a dead Israelite. South Carolinian Washington Allston was one of the best-educated and well-traveled painters of his day, graduating from Harvard College and spending several years in Europe, where the friendship of Romantic poet Samuel Taylor Coleridge and his exposure to British, French, and particularly Italian art exerted strong influences on his style and subject matter. The painting borrows compositional devices from Neoclassical tomb sculpture by Louis-François Roubillac and a High Renaissance altarpiece by the Venetian painter Sebastiano del Piombo, as well as the newly discovered sculptural groups from the pediments of the Parthenon then on view in London—all a testament to Allston's voracious visual appetite. The dramatic scene, with its mélange of quotations from high art, won a prize from the British Institution, a commercial gallery offering twice-yearly exhibitions of contemporary painting and old masters, in 1814. The painting was such a popular success when exhibited in Philadelphia that the directors of the Academy mortgaged the building to pay for its purchase. Allston's highly expressive, evocative landscapes and subject paintings inspired young artists throughout the nineteenth century.

PLATE 18
Charles Robert Leslie
1794–1859
HONORARY MEMBER 1818
EXHIBITOR 1811–65

The Murder of Rutland by Lord Clifford, 1815
Oil on canvas
96 ¾ x 79 ½ inches
(245.7 x 202 cm)
Gift of the Leslie family, 1831.1

Charles Leslie began his career as an apprentice to a local bookseller. This experience, which instilled in him a strong interest in literature, contributed to his later fame as a painter of subjects from Shakespeare and other English writers. Although he produced most of his work in London, Leslie found a receptive market for his small-scale "cabinet" pictures in Philadelphia, a city renowned for its theatrical culture. Leslie was also a favorite artist (and brother-in-law) of the Philadelphia art collector and patron Edward L. Carey, who bequeathed his notable collection to the Academy.

While studying with Benjamin West at Britain's Royal Academy, Leslie pursued his love for Shakespearean theater as both an entertainment and a subject for his art. This painting of a dramatic scene from *Henry VI* (Part III) was Leslie's first important painting made in England. It depicts the death of the young Rutland, son of the Duke of York, at the hands of his father's enemy during the War of the Roses. The painting's exaggerated emotionalism is typical of English romantic painting of the period, also apparent in the work of West and Washington Allston, another

of Leslie's mentors. The Academy owns two other Shakespearean paintings by Leslie: *Olivia in "Twelfth Night,"* and *Touchstone, Audrey, and the Clown in "As You Like It."*

PLATE 19
Bass Otis
1784–1861
PENNSYLVANIA ACADEMICIAN 1812
EXHIBITOR 1812–59

Interior of a Smithy, by 1815
Oil on canvas
50 ⅝ x 80 ½ inches
(128.6 x 204.5 cm)
Gift of the artist, 1845.2

Exhibited at the Academy in 1815, *Interior of a Smithy* is a rare painting in American art. It is the only known genre scene by Bass Otis, a Massachusetts-born and New York-trained portraitist and engraver who worked in Philadelphia between 1812 and 1845. It is, furthermore, one of the earliest, if not the only, known depiction of industrialization in the United States at that time. Scholars have long maintained that the moonlit interior is reminiscent of the nocturnal factory scenes of the British painter Joseph Wright of Derby, which Otis doubtless knew through engravings. The moody lighting and dramatic scale of the architecture and carefully observed implements in relation to the much smaller workers suggest the grandeur, importance, and mystery of industry, at a moment when a new country full of raw materials was coming into its own as a manufacturing power. The artist presented this painting to the Academy in 1845, roughly thirty years after he created it, suggesting that it held particular importance for him. Otis actively participated in the artistic life of Philadelphia, producing what is most likely the first published lithograph in the United States (*Reverend Abner Kneeland*, 1818), as well as teaching young artists Henry Inman and John Neagle, both of whom are represented in the Academy's collections.

Thomas Sully

1783–1872

PENNSYLVANIA ACADEMICIAN 1812

HONORARY MEMBER 1812

BOARD 1816–32

FACULTY 1812–16

EXHIBITOR 1811–70

Major Thomas Biddle
(1790–1831), 1818
Oil on canvas
36½ x 28 1/16 inches
(92.7 x 71.3 cm)
Bequest of Ann E. Biddle,
1925.8

Thomas Sully was one of the greatest painters in American art, second only to Gilbert Stuart in his influence on portraiture. Born into a family of actors in Lancashire, England, Sully was raised in South Carolina, where he initially took lessons from his older brother Lawrence. His hunger for improvement took him first to the elderly Stuart in Boston, then to London, where he studied with Sir Thomas Lawrence, third president of the Royal Academy, whose painterly flash and exquisite coloration marked Sully's own mature work. In Philadelphia, Sully became the city's most sought-after portraitist, enjoying a long and successful career as an artist and teacher.

A member of one of Philadelphia's most prominent families, Major Thomas Biddle distinguished himself as an artilleryman during the War of 1812. This portrait was commissioned from Sully by Biddle's father, when the twenty-eight-year-old was commander of Fort Mifflin. All of Sully's bravura handling is on view, from the dramatic sky to the glistening epaulets to Biddle's assured expression—which may owe something to artistic license, as the sitter was notably nearsighted. Biddle later explored the West and became an Army paymaster and banker in Saint Louis, where he was killed in a duel in 1831 arising from a political dispute.

PLATE 25
Thomas Sully

Frances Anne Kemble as Beatrice
(1809–1893), 1833
Oil on canvas
30 x 25 inches (76.2 x 63.5 cm)
Bequest of Henry C. Carey
(The Carey Collection),
1879.8.24

Undeniably Sully's masterpiece, this portrait exemplifies the artist's technique at its best, from the creamy flesh tones to the spark of the subject's vivacious personality to the sketchy background that adds to the sense of freshness and immediacy. The work records the abiding friendship between the painter and Frances Anne ("Fanny") Kemble, a British actress who debuted on the London stage as Juliet while a teenager. She first came to the United States on a two-year tour in 1832, where she was successfully courted by Pierce Butler, a Georgian planter. Both Kemble and Sully were members of extended theatrical families, which no doubt accounts for the great sympathy with which Sully depicted Fanny as various Shakespearean heroines (the Academy owns two other such portraits). When Sully journeyed to England in 1837–38 to try to paint Queen Victoria's portrait for a Philadelphia charitable organization, he took this painting along as advertisement of his skill. In fact, the painting's charm—as well as the young queen's fondness for Kemble—resulted in Sully finally obtaining a sitting with Victoria, who had been besieged by portrait requests since ascending to the throne. Sully remained friends with Kemble all his life, long after her 1849 divorce from Butler and return to the stage.

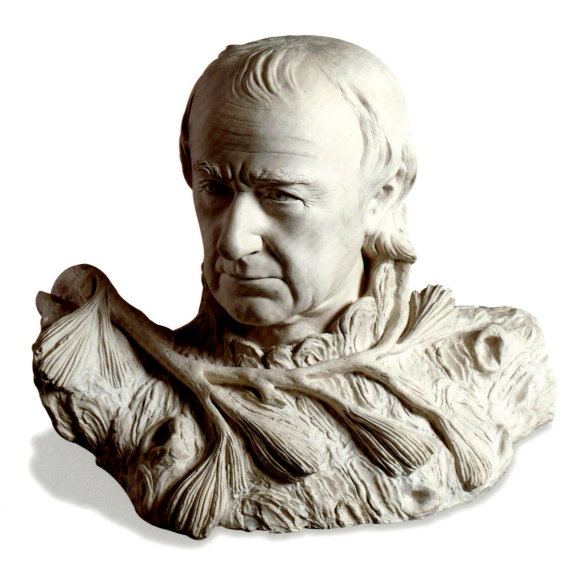

PLATE 26
William Rush
1756–1833
PENNSYLVANIA ACADEMICIAN 1812
BOARD 1806–33
EXHIBITOR 1811–32

Self-Portrait, ca. 1822
Terracotta
15½ x 18 x 11 inches
(39.4 x 45.7 x 27.9 cm)
Provenance unknown, 1849.1

Although William Rush never went abroad for study or travel, and rarely left Philadelphia, he emerged as an extremely gifted craftsman and self-taught artist whose career flourished in a critical period in American history. His principal medium was wood (see his *Head of the Nymph,* Plate 13) which, when painted white, simulated more expensive marble sculptures. In *Self-Portrait,* a rare terracotta work, Rush depicted himself as if emerging from a pine tree knot, perhaps as a kind of homage to his principal medium. At the back, which is as carefully finished as the front, Rush's hair is fused with the needle-shaped leaves of the pine branch in a stunning display of technical skill. No known plaster replicas survive, but several bronzes were cast posthumously. First exhibited at the Academy in 1822 and first recorded as a part of the permanent collection in 1849, it was conserved in 1988, at which time four layers of paint were removed to reveal the artist's intended original surface.

PLATE 27
Charles Willson Peale
1756–1833
PENNSYLVANIA ACADEMICIAN 1812
BOARD 1806–11
EXHIBITOR 1811–28

The Artist in His Museum, 1822
Oil on canvas
103 ¾ x 79 ⅞ inches
(263.5 x 202.9 cm)
Gift of Mrs. Sarah Harrison
(The Joseph Harrison, Jr.
Collection), 1878.1.2

Throughout his long life, Charles
Willson Peale continually strove to
improve the civic and artistic life
both of his adopted city and the
young republic. Besides founding
two art academies—including the
Pennsylvania Academy—and the
nation's first museum, he was the
patriarch of an artistic dynasty that
carried on his ideals. Peale thus dis-
seminated culture both within the
family sphere and in the wider
world. Nowhere is this more appar-
ent than in the remarkable self-
portrait he executed at the age of
eighty-one. With more than a touch
of the showman, Peale literally raises
the curtain to reveal the wonders of
his collection, then located in the
long gallery of Independence Hall.
Peale's Museum offered a cabinet of
curiosities to instruct and entertain
the spectators, from the wild turkey
at the lower left, to the skeleton of
the mastodon he had exhumed and
brought to Philadelphia at the right.
Cages in the background display
natural history specimens, while
above them portraits of American
worthies celebrate the heroes of
the new country. Significantly,
the visitors are in family groups,
echoing Peale's commitment to
education. Part advertisement,
part philosophical statement, *The
Artist in His Museum* stands as a
triumphant artistic and historical
accomplishment.

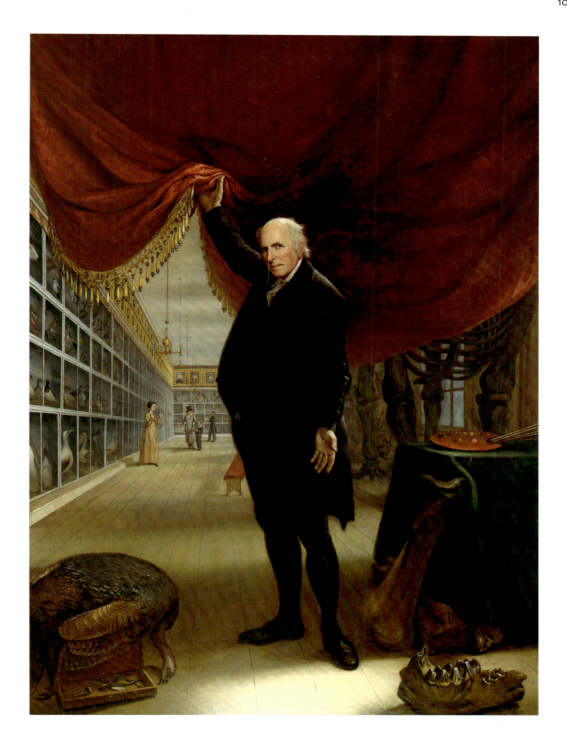

Thomas Birch
1779–1851
PENNSYLVANIA ACADEMICIAN 1812
EXHIBITOR 1811–62

Fairmount Water Works, 1821
Oil on canvas
20 ⅛ x 30 ¹⁄₁₆ inches
(51.1 x 76.4 cm)
Bequest of Charles Graff, 1845.1

Born in London, Thomas Birch came to Pennsylvania in 1794 and settled at Neshaminy Bridge, Bucks County. Along with his father William, who was also an artist, he produced a well-known set of engravings – *Views of Philadelphia* (1798–1800). Soon afterward, the younger Birch became interested in landscape painting. He is said to have walked along the banks of the Schuylkill River with other artists, including Thomas Sully, selecting picturesque views to paint. This view records Philadelphia's major engineering feat of the nineteenth century, the celebrated Fairmount

Water Works. Located near present-day Boat House Row, the water-works buildings have recently undergone restoration. Here they are seen in the days when the *Norristown* was the first steamboat to navigate the Schuylkill.

Trained as an artist by his English-born father, who was an engraver, Birch may have seen such images in European prints, readily available in Philadelphia in the early nineteenth century. Birch and his father first worked together to produce scenes of Philadelphia, but gradually Thomas began to specialize in marine views.

PLATE 29
Thomas Doughty
1793–1856
PENNSYLVANIA ACADEMICIAN 1824
EXHIBITOR 1816–64

Morning Among the Hills,
1829–30
Oil on canvas
15 ¼ x 21 ¹⁄₁₆ inches
(38.7 x 53.5 cm)
Bequest of Henry C. Carey
(The Carey Collection), 1879.8.4

Largely self-taught, Philadelphia-born Thomas Doughty trained as a leather currier before beginning to paint seriously around 1816 (by 1820, he had completely abandoned craft for art). He was deeply influenced by ideas of the Sublime and Picturesque, as derived from English art theory. According to this literary and artistic tradition, the drama and force of nature have the power to evoke feelings of awe in the viewer, who accordingly becomes aware of the divine force that has made all things. Doughty also responded to the balanced classical landscape tradition of the seventeenth-century French painter Claude Lorrain, whose works he knew from engravings. The abundant landscape of the young United States offered the artist numerous opportunities for inspiration and reflection—particularly the scenery of the Hudson River Valley, as is evident in *Morning Among the Hills*, painted five years after Doughty was elected an Academician of the Pennsylvania Academy. The dramatic scale of the riverbanks and distant hills just beginning to be haloed by the morning sun instills feelings of grandeur in the spectator, while a majestic bevy of swans regally glides through the foreground, undisturbed by activity save the rushing water itself. Such quiet, moving visions of the new American landscape garnered Doughty much acclaim early in his career.

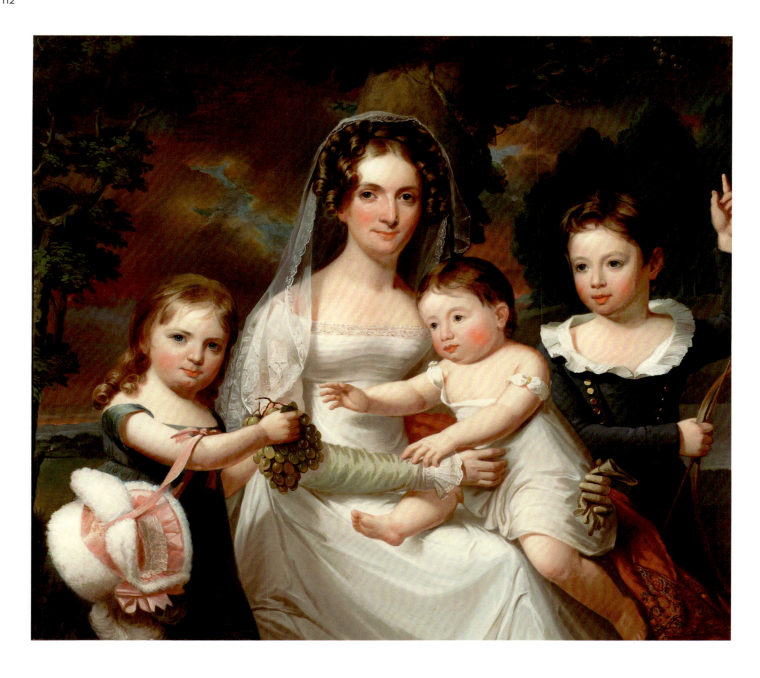

PLATE 30
Jacob Eichholtz
1776–1842
PENNSYLVANIA ACADEMICIAN 1824
EXHIBITOR 1811–66

Mrs. Elizabeth Wurtz Elder and Her Three Children (Mrs. Elder, d. 1852; William Smith Elder; Rebekah Heaton Elder; and Henry Lentz Elder), 1825
Oil on canvas
42 ½ x 47 ½ inches
(108 x 120.7 cm)
Bequest of Mrs. Blanche Elder Howell, 1923.12

The career of portraitist Jacob Eichholtz exemplifies the flexibility and determination required by artists of the young Republic. Although originally a metalworker in his native Lancaster, Pennsylvania, Eichholtz was encouraged to pursue painting by his contemporary Thomas Sully, who was on the verge of his own long career in Philadelphia. Eichholtz sought out the elderly Gilbert Stuart, then dean of portraiture and the most famous artist in America. While Stuart took no formal pupils, he generously shared his experience with aspiring young artists such as Eichholtz and Sully who visited him in Boston. Such mentoring was critical at a time when formal art training in the United States was still in its infancy. The freshness and quickness of this portrait of a lovely young mother and her children reveal that Eichholtz learned his lessons well. The light palette with its silvery accents and sketchy background landscape testifies to the continuing influence of the English school of portraiture. At the same time, the gestural interplay among the figures, as well as their variety of poses, shows Eichholtz's confidence as a mature painter, three years into a successful Philadelphia residency. Eichholtz enjoyed a prosperous career in Philadelphia, Baltimore, and Lancaster, where he returned in the early 1840s.

PLATE 31
John Neagle
1796–1865

PENNSYLVANIA ACADEMICIAN 1824
BOARD 1830–31
EXHIBITOR 1821–70

Pat Lyon at the Forge, 1829
Oil on canvas
94 ½ x 68 ½ inches
(240 x 174 cm)
Gift of the Lyon family, 1842.1

During the weekend of August
31–September 1, 1798, a bank
robbery occurred in which $162,821
was stolen from the Bank of
Pennsylvania. Although he had been
in Lewiston (now Lewes), Delaware,
at the time, trying to avoid yellow
fever in the city, British-born black-
smith Pat Lyon (1779–1829) was
arrested for the crime. Because he
had made the locks for the vault's
doors, Lyon was the prime suspect.
After three months in jail, Lyon was
released when the real culprit, Isaac
Davis, confessed. Lyon not only
wrote a best-selling book about the
incident, he went on to sue the bank
and police for false imprisonment—
a landmark case in U.S. legal history.
Lyon was eventually awarded twelve
thousand dollars in damages.

When he commissioned his
portrait in 1825, Lyon chose to be
represented not as the gentleman
he'd become, but in his apron, at
work. The red-headed blacksmith is
imposing, yet accessible, command-
ing the viewer's attention as surely
as he does his admiring apprentice.
The cupola in the left background
represents the Walnut Street Jail,
where Lyon had unjustly languished
nearly thirty years before. The
Academy's portrait is one of six
versions of the subject executed by
Neagle, a former coach painter who
later studied with Bass Otis and his
own future father-in-law Thomas
Sully, before embarking upon a
long and successful portrait practice
in Philadelphia.

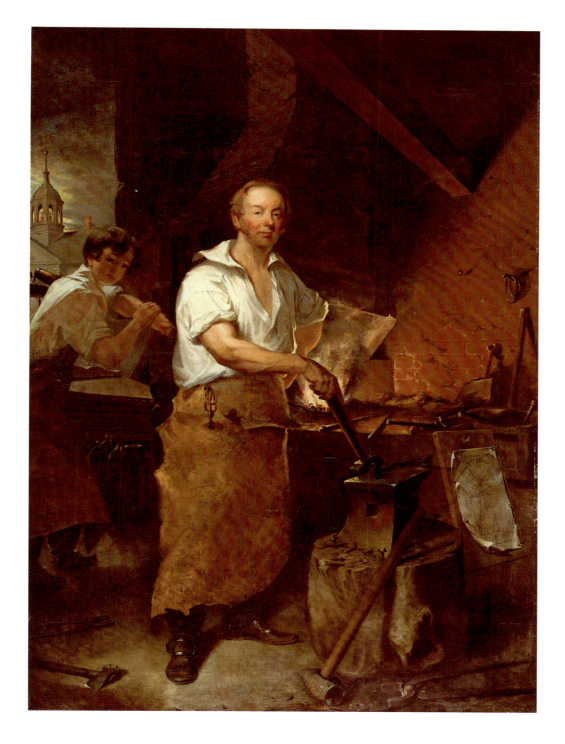

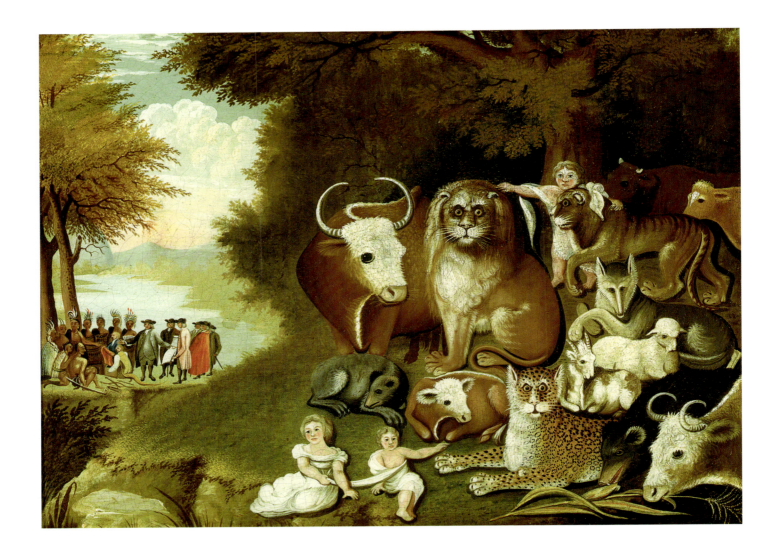

PLATE 32
Edward Hicks
1780–1849

The Peaceable Kingdom, ca. 1833
Oil on canvas
17 7/8 x 23 15/16 inches
(45.4 x 60.8 cm)
John S. Phillips bequest, by
exchange (acquired from the
Philadelphia Museum of Art,
originally the 1950 bequest of
Lisa Norris Elkins), 1985.17

Between 1820 and 1849, during
the last thirty years of his life, the
Quaker sign painter-turned-preacher
Edward Hicks created more than
one hundred versions of this sub-
ject, an allegory of spiritual and
earthly harmony based on Isaiah
11:6–9: "The wolf also shall dwell
with the lamb, and the leopard shall
lie down with the kid; and the calf
and the young lion and the fatling
together; and a little child shall lead
them. And the cow and the bear
shall feed; their young ones shall lie
down together: and the lion shall
eat straw like the ox. And the suck-
ling child shall play on the hole of

the asp, and the weaned child shall
put his hand on the cockatrice's
den." In the multiple versions of
his composition, Hicks both closely
followed the scriptural description
and also added imagery symbolic of
Quaker belief and Pennsylvania his-
tory. In the background at left, for
example, William Penn enacts his
treaty with the commonwealth's
native inhabitants in a composition
appropriated from Benjamin West's
painting of the scene (Plate 5).
While originally produced as visual
sermons for Hicks's family and
friends, the painting's technical
simplicity and deep-felt message

of unity have charmed generations
of viewers of all ages since the
painter's rediscovery during the
early twentieth century.

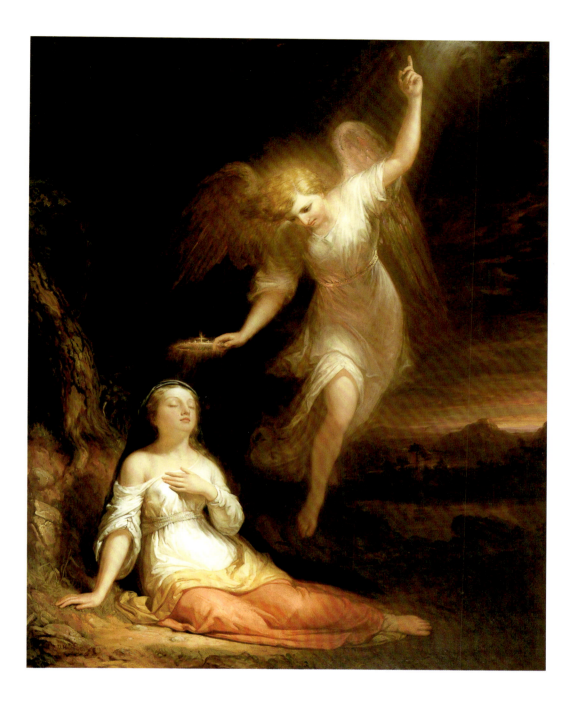

PLATE 33
Daniel Huntington
1816–1906
HONORARY MEMBER 1854
EXHIBITOR 1842–81

Mercy's Dream, 1841
Oil on canvas
84 ½ x 66 ½ inches
(214.6 x 168.9 cm)
Bequest of Henry C. Carey
(The Carey Collection),
1879.8.10

Mercy's Dream was the first great success of Daniel Huntington's career. In its large scale, the painting utilized the vocabulary of the old masters that Huntington had seen while studying in Europe. The sweetness of the figure of Mercy is reminiscent of a Raphael Madonna, while the elegant curve of the angel's body and upraised hand recall the *figura serpentinata* of Michelangelo. The subject matter, however, was one that held strong appeal for an American audience: John Bunyan's *The Pilgrim's Progress,* the epic religious allegory of the seventeenth century that was the best-selling book in the United States in the eighteenth and early nineteenth centuries, after the Bible.

In Part II, the character of Mercy experiences a dream that inspires her fellow pilgrims to continue their quest. Alone and downcast, Mercy is comforted by an angel, who blesses her, adorns her in jewelry, and transports her to a golden gateway, where she is brought into the presence of God. Huntington's composition closely follows the narrative, from Mercy's sumptuous clothes to the crown the angel bestows upon her. This vision of salvation struck a chord with the public, appearing as a popular print. Huntington made three other versions of the subject.

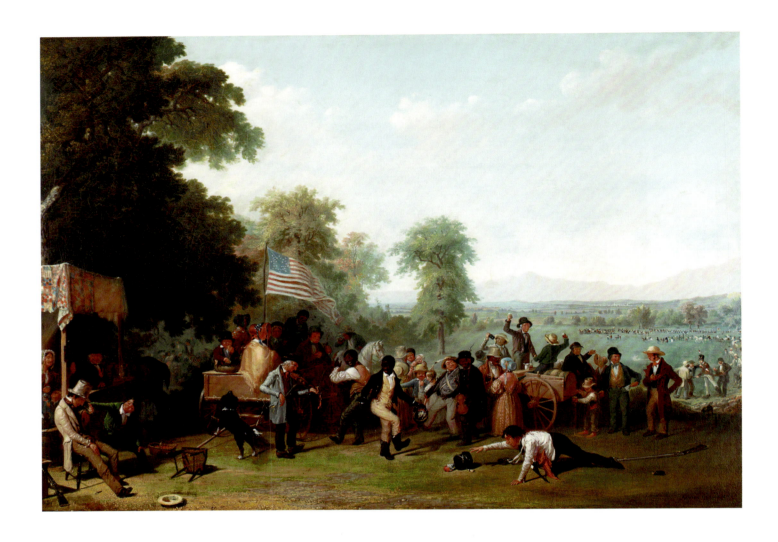

PLATE 34
James Goodwyn Clonney
1812–1867
EXHIBITOR 1845–47

Militia Training, 1841
Oil on canvas
28 x 40 inches (71.1 x 101.6 cm)
Bequest of Henry C. Carey
(The Carey Collection), 1879.8.1

Most likely born in Liverpool, England, James G. Clonney arrived in New York around 1830, where he began a career as a lithographer of urban scenes and depictions of animals. His precision and eye for narrative detail served him well when, probably around 1838, he turned to genre painting. *Militia Training*, his most ambitious work, showcases the noise, confusion, celebratory moods, and varying degrees of skill of the young nation's volunteer troops, who regularly came together for defensive maneuvers, and to socialize as well. Although indebted to British models, particularly the popular genre scenes of the Scots painter Sir David Wilkie, Clonney included elements that make this painting recognizably an American scene, from the patchwork quilt thrown over the beer stand to the prominently displayed American flag and cavorting African Americans at front. The activities occurring in this lively scene were closely observed—numerous preparatory drawings exist for the composition. The painting later appeared as an engraving in the illustrated annual *The Gift* in 1843, where it accompanied a sentimental story about two friends.

PLATE 35
William Sidney Mount
1807–1868
HONORARY MEMBER 1854
EXHIBITOR 1840–53

The Painter's Triumph, 1838
Oil on wood
19 ½ x 23 ½ inches
(49.5 x 59.7 cm)
Bequest of Henry C. Carey
(The Carey Collection),
1879.8.18

One of the greatest of all American genre painters—indeed, with George Caleb Bingham, the best known—the Long Island-based William Sidney Mount painted affectionately humorous depictions of everyday life as well as subtler explorations of political, class, and even racial issues facing the young country. Both levels are at work in *The Painter's Triumph,* painted when the artist was thirty-one. Marked by his characteristic warm, golden tonality, Mount depicted himself amazing a spectator with the magic of mimesis. If Mount's characterization of the gap-toothed,

awestruck farmer is comical, he also pokes fun at himself. The artist's dramatic expression, showman-like pose and agitated hair may spoof the artistic personality. Meanwhile, the drawing tacked to the wall of the bust of the *Apollo Belvedere*— one of the exemplars of antique art—alludes to the lofty ideals that Mount would have learned at the recently founded National Academy of Design. But have those ideals been shunted into a corner or do they still act as an inspiration? Is the painter's triumph the power of art to reach the masses or is it an ironic commentary on what the public

wants? It is a measure of Mount's accomplishment that the viewer may agree with both interpretations.

PLATE 36
Henry Inman
1801–1846
PENNSYLVANIA ACADEMICIAN 1831
BOARD 1833–35
EXHIBITOR 1825–62

Mumble-the-Peg, 1842
Oil on canvas
24 ⅛ x 20 1/16 inches
(61.3 x 51 cm)
Bequest of Henry C. Carey
(The Carey Collection),
1879.8.13

Painted four years before Henry Inman's early death at age forty-five, this genre painting depicts "Mumble the Peg," a knife-pitching contest, in which the weakest thrower must use his teeth to "mumble" or pull out a wooden peg inserted into the earth. In a peaceful, yet prosperous coastal landscape, two boys of different classes enjoy this game of skill. The cast-aside hat and schoolbooks suggest that rank and education do not affect this game. Meanwhile, the union of the players speaks to the possibility of friendship across classes—potentially an important message when the United States was rapidly growing in population and landmass. Certainly the painting enjoyed great popular success. Not only was it engraved for the magazine *The Gift* in 1844, but it also became the basis for "The Story of Nick Ten Vlyck," a supernatural tale by Charles Fenno Hoffman.

Trained by the eccentric New York portraitist, John Wesley Jarvis, Inman helped found the National Academy of Design. Like his Philadelphia contemporary Thomas Sully, Inman was often favorably compared to Sir Thomas Lawrence, the third president of the Royal Academy and the greatest English portraitist of the early nineteenth century. Inman lived in Philadelphia between 1832 and 1835, where he worked as an engraver and served on the board of the Academy.

PLATE 37
Jasper F. Cropsey
1823–1900
HONORARY MEMBER 1854
EXHIBITOR 1845–68, 1876–88

*Landscape with Figures near
Rome,* 1847
Oil on canvas
27 ⁵⁄₁₆ x 40 ³⁄₁₆ inches
(69.4 x 102.1 cm)
Gift of John Frederick Lewis,
Jr., 1954.22.1

When twenty-four-year-old Jasper
Cropsey journeyed to Italy from his
native New York State in 1847, he
was already working as an architect
and landscape painter. This canvas,
painted during his first year there, is
indebted to art historical precedent.
The carefully arranged composition,
with distinct zones of fore-, middle-
and background, framing foliage
and picturesque ruins, evokes the
idealized seventeenth-century scenes
of the Roman Campagna by Claude
Lorrain, who was still revered by
aspiring landscape painters of all
nationalities. The precise delin-
eation of scenery also hints at

Cropsey's mature work, realized
after a seven-year residency in
England during the late 1850s and
early 1860s. There, under the influ-
ence of both theorist John Ruskin,
who famously advocated truth to
nature, and the Pre-Raphaelites,
whose strong colors and abundant
detail had galvanized contemporary
British painting, the artist adopted
an atmospheric, yet highly particu-
larized style. Returning to America
in 1863, Cropsey enjoyed public
acclaim, particularly for his studies
of the effects of light on water. He
also continued his career as an
architect, notably designing the

now-destroyed train stations for the
Sixth Avenue Elevated Railway in
New York City.

PLATE 40
Hiram Powers
1805–1873
HONORARY MEMBER 1848
EXHIBITOR 1848–65

Proserpine, 1843
Marble; carved ca. 1860
25 x 19 x 10 inches
(63.5 x 48.2 x 25.4 cm)
Gift of John Livezey, 1864.5

In the mid-1820s Hiram Powers learned to model clay and make plaster casts under the sculptor Frederick Eckstein in Cincinnati, Ohio. From 1834 to 1836 Powers was in Washington, D.C., where he created busts of several American political figures including Andrew Jackson. He then moved to Florence where his talent was quickly recognized and where his studio became a major attraction for American tourists making the Grand Tour. About 1839 Powers began to create ideal sculpture of heroic or mythological themes. His most famous

work, *The Greek Slave* (1842), was shown in England and America where it garnered great acclaim as well as notoriety for its nudity. The plaster model for *Proserpine*—the name is the Roman variant of Persephone, the Greek goddess of spring—was completed in 1843. In the first marble replica, Proserpine's breasts and shoulders emerge from an elaborate basket of flowers. Later marbles such as this version have simpler terminations as a result of the high cost incurred when the Italian carvers executed the basket and flowers in the replicas.

Proserpine was Powers's most popular ideal bust; he produced nearly two hundred marble replicas of it in full and reduced scale.

PLATE 41
Thomas Crawford
1813–1857
HONORARY MEMBER 1854

Peri at the Gates of Paradise,
1854–56
Marble; carved in 1856–57
69 ¾ x 27 ¾ x 24 inches
(177.2 x 70.5 x 62 cm)
Bequest of Clarissa A. Burt,
1917.9

Thomas Crawford began carving architectural ornaments and funerary monuments about 1832 for the firm of Frazee and Launitz in New York. In 1835 he traveled to Rome, where he spent virtually the rest of his life. Initially, he modeled portrait busts of Americans on the Grand Tour and studied under the Neoclassical sculptor Bertel Thorwaldsen. His first major work, *Orpheus and Cerberus* (1843), was exhibited to great acclaim in Boston. For the next decade, before his life was cut short by a brain tumor, Crawford's ideal, classically inspired figures were sought after by patrons in Europe and America. He produced major sculpture groups for the city of Richmond, Virginia, and for the U. S. Capitol. *Peri* is a variant of the angelic theme popular with American sculptors of the midnineteenth century. In this piece, the story of the *peri*, a fallen angel derived from Persian religious belief, was inspired by an 1817 poem by the Irish writer Thomas Moore. Although in Crawford's marble, she appears calm and restful, in the poem she is disconsolate after repeated attempts to regain entrance to paradise. She succeeds only after offering the tears of a repentant sinner to God. The work, completed by Crawford's studio assistants, was commissioned by the Philadelphian Arthur A. Burt.

PLATE 44
Severin Roesen
1815/16–1872 or after
EXHIBITOR 1863

Still Life with Fruit, ca. 1855
Oil on canvas
30 x 40 inches (76.5 x 101.9 cm)
Gift of William C. Williamson,
by exchange, and Henry S.
McNeil and the Henry D.
Gilpin Fund, 1976.4

Trained as a china- and enamel painter in his native Germany, Severin Roesen emigrated to the United States during the 1848 Revolution. He settled first in New York before moving to Williamsport, Pennsylvania. Located in the north central part of the state, Williamsport was a wealthy city in nineteenth-century America because of its abundance of lumber. Around the middle of the century, the city boasted more millionaires per capita than any other locale, making it a lucrative market for an enterprising artist. This painting, executed three years after Roesen came to Pennsylvania, displays the characteristics that made Roesen a success in his adopted country. The warm tones and profusion of meticulously rendered fruits spilling forth from wicker baskets recall the grand still life tradition of seventeenth-century Dutch painting, a genre always popular with collectors, both in Europe and America. But while such paintings often contained symbolic messages warning of the transience of life, Roesen's updated composition is a richly detailed celebration of the bounty and variety of nature. The two-tier arrangement and bird's nest appear in several of Roesen's other paintings, while its large scale (over three feet in length) lent itself to the grand interiors of the luxurious homes being built in the prosperous city.

PLATE 45
Joseph Alexis Bailly
1825–1883
PENNSYLVANIA ACADEMICIAN 1860
FACULTY 1876
EXHIBITOR 1851–68

Paradise Lost, 1863–68
Marble
61 x 37 ½ x 42 inches
(155 x 94 x 106.8 cm)
Bequest of Henry C. Gibson,
1892.6.2

Born in Paris, Bailly fled his home-
land during the 1848 Revolution
and after a brief period of sculpture
study in London, settled in
Philadelphia. The son of a furniture
manufacturer, he initially worked in
wood, wax, and cameos. In 1854,
Bailly and a partner opened a sculp-
ture studio and, by 1860, was one of
the city's leading sculptors, specializ-
ing in public and funerary monu-
ments as well as portrait busts. He
was a member of the Pennsylvania
Academicians, a group of artists
who advised the Academy on exhi-
bitions and instruction. He also
taught at the institution in the late

1860s and in the 1870s. *Paradise
Lost,* inspired by John Milton's epic
poem, and its companion piece,
First Prayer (also in the collection),
depict the aftermath of Adam and
Eve's banishment from Eden and
the moral instruction of their sons,
Cain and Abel. Although Bailly's
handling of the figures appears overly
sentimental to the modern viewer,
the obvious religious and moral
narrative is precisely what appealed
to Victorian Americans. The carv-
ing of the bodies is quite sensuous,
but Bailly concealed enough of the
nudity to keep them within the
range of contemporary acceptability.

PLATE 48
Martin Johnson Heade
1819–1904
EXHIBITOR 1841–81

Sunset Harbor at Rio, 1864
Oil on canvas
20 ⅛ x 35 inches (51.1 x 88.9 cm)
Henry C. Gibson Fund, 1985.10

In 1863, Heade, who was born in Lumberville, Pennsylvania, set off for Brazil on the recommendation of his fellow artist Frederic Edwin Church, a trip which also allowed him to pursue his interests in ornithology and botany. Accompanying the naturalist Reverend J. C. Fletcher, Heade hoped to provide illustrations for Fletcher's study of South American hummingbirds, but this project was never published. Regardless, in Rio de Janeiro he exhibited a group of bird paintings, botanical studies, and landscapes, and was honored with the Order of the Rose by Emperor Don Pedro II.

In this painting, Heade, who studied with Edward Hicks, demonstrates a masterful use of light and composition, as our eye is led by the reflection of sunlight on the water to the city of Rio. The activity of the harbor is set against an exotic landscape filled with an array of flora. Heade is most commonly associated with Luminism, an art historical term coined in 1954 by John I. H. Bauer to signify a diverse range of American landscape painters who followed the Transcendentalist thought of Ralph Waldo Emerson. While there is no evidence to suggest that Heade read

Emerson, his work does fit into a larger cultural context that viewed South America as both a new Eden and an area to be exploited for natural resources.

PLATE 49
Sanford Robinson Gifford
1823–1880
EXHIBITOR 1856–80

Saint Peter's from Pincian Hill,
1865
Oil on canvas
9 ¹³⁄₁₆ x 15 ⁵⁄₁₆ inches
(24.9 x 39.5 cm)
Gift of Mr. and Mrs. Edward
Kesler, 1975.20.3

Rome has loomed large in the imagination of artists for centuries, and continued to do so in the middle of the nineteenth century. Nine years after he first visited Italy, Sanford Gifford recalled his European travels in this small, meditative landscape painted from memory. North of the Quirinal Hill, and one of the fabled seven hills that marked the boundaries of Ancient Rome, the Pincian Hill was celebrated for its public gardens. From just such a spot, Gifford's lone friar regards St. Peter's Cathedral, one of the enduring symbols of the Eternal City.

Gifford dedicated himself to landscape painting at age twenty-five after seeing the works of Thomas Cole, the leader of the Hudson River School. Rather than using landscape as a vehicle for grand moral and historical narratives, Gifford's depictions are evocative and marked by a strong interest in the effects of light. Until his death in 1880, Gifford continued to explore nature, venturing as far as the Rocky mountains with fellow artists Worthington Whitteridge and John Frederick Kensett in 1880, and exploring the Pacific Coast of Alaska in 1874.

John Sartain

1808–1897

Christ Rejected
(after Benjamin West), 1870
Mezzotint and stipple engraving
on cream wove paper
Plate 22 ¾ x 28 inches
(57.8 x 71.1 cm)
Image 18 x 25 inches
(45.7 x 63.5 cm)
The John S. Phillips Collection,
1984.x.340

The work of John Sartain, an engraver, painter, and designer, enjoyed high repute in the nineteenth century. His pioneering use of pictorial illustration in American periodicals changed the world of publishing. Trained in England, he arrived in the United States in 1830, already a master of mezzotint engraving. His reproductive engravings, after famous portraits or historical paintings, were extremely popular, especially with America's new middle class. Technically brilliant, they were produced as large framing prints or available in various magazines, including one owned by

Sartain, who understood both popular taste and business practice. Sartain was the patriarch of one of Philadelphia's most famous and significant artistic dynasties, and also one of the Academy's most important board members. He was a major presence at several other local institutions and served as art director of the 1876 Centennial Exhibition.

Christ Rejected, after Benjamin West's famed monumental work of 1814, also in the Academy's collection, and itself an icon of American painting, is one of the largest and most accomplished of Sartain's

engravings. Panorama-like canvases such as West's often toured the country to wide acclaim. The appearance of *Christ Rejected* at the Academy in 1862 created a "blockbuster" event that drew large crowds. The print, capturing the painting's drama and complexity, was widely disseminated to audiences eager for an image of it.

PLATE 53
Kenyon Cox
1856–1919
EXHIBITOR 1882–1917

Life Class: Masked Female Nude,
1876
Pencil on cream paper
17 ⅝ x 11 ⅜ inches
(44.8 x 28.9 cm)
Purchased with funds from the
H. J. Heinz II Charitable and
Family Trust, 1982.8.5

A staunch supporter of classical realism during the early twentieth century's move toward abstract experimentation, Cox was born in Warren, Ohio, receiving his initial art education at the McMicken Institute of Arts and Design in Cincinnati. In 1876, he enrolled at the Pennsylvania Academy, but, finding the instruction too rigid, he left for Paris the following year. He studied with Charles Carolus-Duran before entering the studio of Jean-Léon Gérôme at the Ecole des Beaux Arts. Upon returning to America, Cox established a reputation for his mural paintings, high-

lighted by his grand mural for the 1893 World's Columbian Exposition in Chicago.

This academic nude was executed during Cox's time as a student of Thomas Eakins at the Pennsylvania Academy. Cox's excellent draftsmanship is revealed in this drawing whose energy is accentuated by the free handling of the background. The inclusion of the mask on the model's face, concealing her identity, indicates the still controversial nature of studying from the nude model during this era in America. Cox had a distinguished teaching career at both the

Art Students League of New York and the National Academy of Design. He also was an art critic for *The Nation* and *Scribner's*. An outspoken critic of the 1913 Armory Show, he decried the encroachment of European modernism into American art.

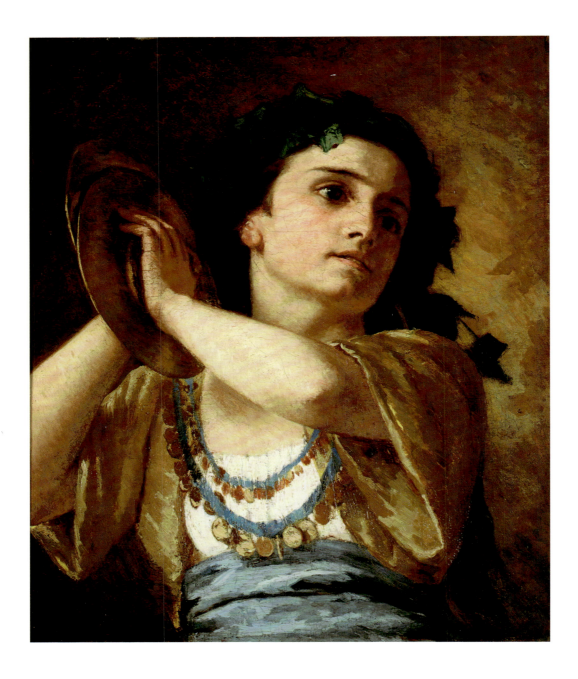

PLATE 54
Mary Cassatt
1844–1926
STUDENT 1860
EXHIBITOR 1876–1917
MEDAL 1914

Bacchante, 1872
Oil on canvas
24 x 19 ¹⁵⁄₁₆ inches (61 x 50.6 cm)
Gift of John Frederick Lewis,
1932.13.1

Painted for exhibition at the Esposizione di belle arti in Milan, this early work shows the influence of the young Mary Cassatt's extended European tour between 1871 and 1874. After a year and a half spent back in Philadelphia, Cassatt returned to Europe, visiting Rome, Madrid, Seville, Antwerp, and Parma. The choice of subject matter—a celebrant in Dionysian rituals swept up in religious mysteries—testifies to Cassatt's interest in classical culture. More significantly, the painting reveals the influence of the High Renaissance Northern

Italian painter Correggio, whose works Cassatt had been commissioned to copy by the Archdiocese of Pittsburgh. The bacchante's pose echoes a figure of the Madonna by Correggio and was painted in his native region. Yet, for all its Italian references, the painting also evokes the warm tonality of Spanish Baroque painting, which Cassatt and other young artists—such as her Philadelphia compatriot Thomas Eakins two years earlier, not to mention many of her eventual French colleagues—were also discovering in large numbers

during the second half of the nineteenth century. Cassatt moved to Paris in 1874, where she proceeded to abandon academic exercises such as this work in favor of scenes of modern life.

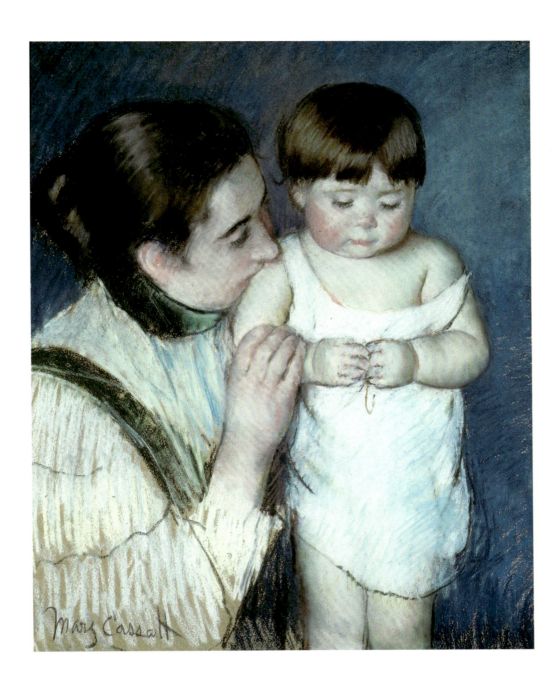

PLATE 55
Mary Cassatt
Young Thomas and His Mother,
ca. 1893
Pastel on thick wove paper
23 ⅝ x 19 ¾ inches
(60 x 50.2 cm)
Deposited by Mrs. Clement
Newbold, 1904.10

Mary Cassatt entered the Pennsylvania Academy at age sixteen. Six years later, with full family support, the artist went to Europe for further study, beginning the career that would ultimately result in her being claimed equally by European and American art history. Cassatt's spatial experimentation, bold handling, and interest in contemporary subject matter, as well as her extraordinary facility with the rapid medium of pastel, led to her invitation to exhibit with the Impressionists beginning in 1879. *Young Thomas and His Mother* belongs to themes of mothers and

children that Cassatt began to investigate in the 1880s. It is one of several pastels to feature these particular models. In an intensely intimate, tightly cropped scene, the portrait oscillates between areas of closely observed naturalism and sketchy, abstracted passages, imbuing it with both lyricism and dynamic tension.

The world of Cassatt's subjects is often mistakenly regarded as a cloistered one, but it is only one of the many spheres that she inhabited. She actively participated in the artistic life of both France and the United States. Cassatt tirelessly promoted advanced painting to

wealthy American patrons, who made purchases largely on her recommendation. Many of these collections formed the nuclei of the great treasure troves of Impressionist art now in United States museums.

PLATE 64
John Singer Sargent
1856–1925
EXHIBITOR 1891–1926

Mr. and Mrs. John White Field,
1882
Oil on canvas
44 ⅞ x 32 inches (114 x 81.3 cm)
Gift of Mr. and Mrs. John
White Field, 1891.10

As the leading expatriate portrait painter of his day, John Singer Sargent had a reputation for depicting the elegance and aloofness of his upper class sitters. In this portrait, however, he concentrated on the personal relationship between his subjects rather than the social trappings of their class. When this work was shown in a 1924 exhibition of Sargent's work, a critic praised it as a masterful interpretation of old age. The reviewer noted how convincingly Sargent had captured the nature of the couple's long marriage in their clasped hands and the subtle inclination of their heads toward one another.

John White Field and his wife, Eliza Peters Field, were wealthy members of an international social set that included some of the most noted writers and artists of the late nineteenth century. Among their acquaintances were literary figures such as Robert Browning, Charles Eliot Norton, and James Russell Lowell, and the sculptor William Wetmore Story. The couple were avid art collectors and acquired works by both European and American artists. In addition to this work, the Fields donated family portraits by Rembrandt Peale, Gilbert Stuart and Thomas Sully to the Academy collection.

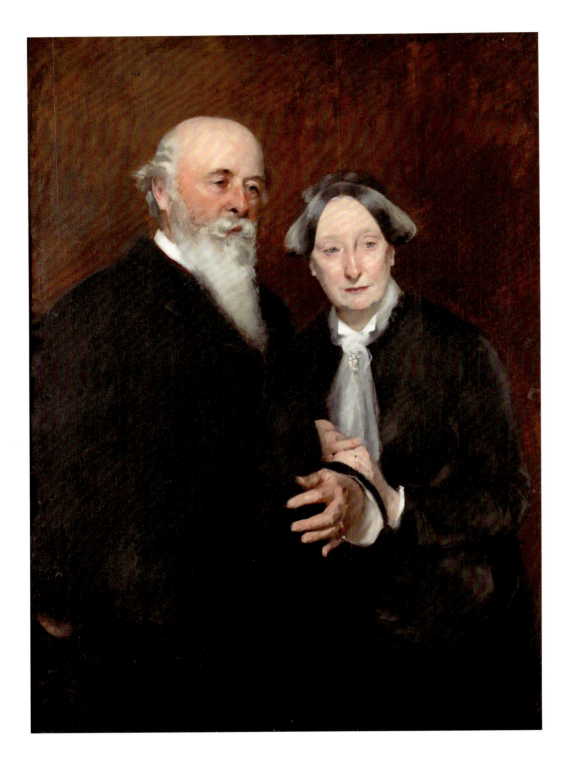

PLATE 65
Gari Melchers
1860–1932
EXHIBITOR 1883–1932

Skaters, early 1890s
Oil on canvas
43 3/16 x 27 1/2 inches
(111.7 x 69.8 cm)
Joseph E. Temple Fund, 1901.1

Born in Detroit of German ances-
try, Julius Garibaldi (Gari) Melchers
studied in Düsseldorf and at the
Académie Julian in Paris. In 1884,
he settled in Holland and founded,
along with another American
painter George Hitchcock, a school
of art in the picturesque village of
Egmond aan Zee, on the coast of
the North Sea. Initially the school
functioned only during the summer,
attracting young American artists
living and studying in Paris. By
1903, however, Egmond and other
Dutch regions became thriving
artists' colonies where influential
American artists and painting
instructors took groups of students.

Melchers's early work showed
the influence of his German train-
ing and his appreciation for Dutch
seventeenth-century masters such
as Frans Hals, by depicting genre
scenes of fishing folk set in dark
interiors. By the 1890s, however, he
began to experiment with bolder
color combinations and a sophisti-
cated handling of light and shadow
that echoed the concerns of the
French Impressionists. *Skaters*, a
Dutch scene with a long artistic tra-
dition, provided romantic visions of
a rural life that became popular with
an American public nostalgic for the
pre-industrial past. The painting
was exhibited at the 1893 World's
Columbian Exposition in Chicago
to critical acclaim.

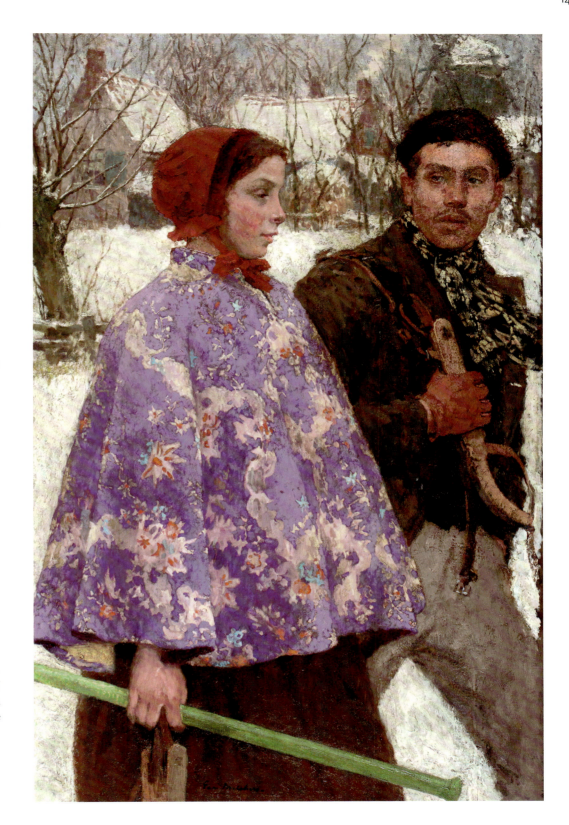

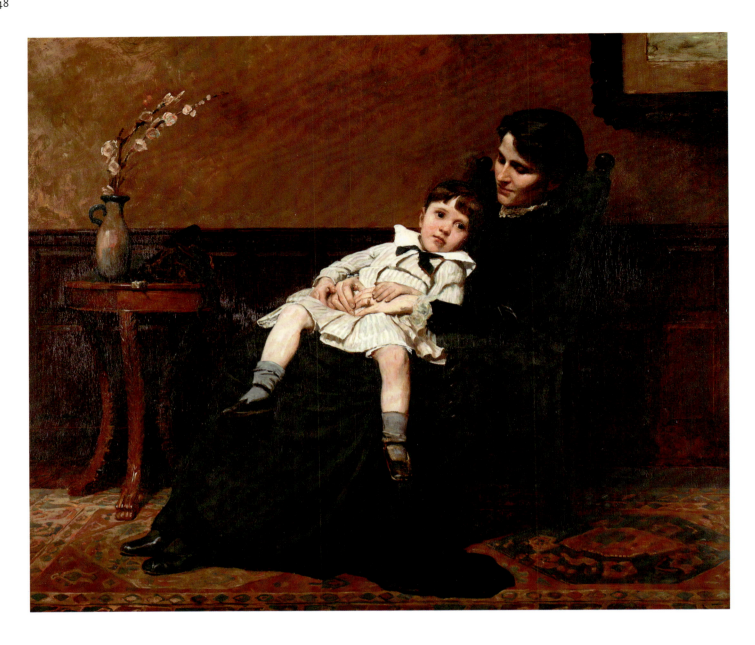

While under-recognized today, in her lifetime Cecilia Beaux was regarded as America's preeminent woman artist, and one of the most skillful portraitists of her generation. She studied at the Pennsylvania Academy in the late 1870s but claimed that her only important artistic training had been two years of private study under the painter William Sartain from 1881 to 1883. It was probably under Sartain's direction that she began this intimate portrait of her sister and nephew, a work that marked her debut as a painter. At the Academy's 1885 annual exhibition, the picture

received the Mary Smith Prize for the best work by a local woman. It was also accepted into the 1887 Paris Salon, a coup Beaux deemed a turning point in her career. Grounded in the muted palette of realism, the work reflects her Academy training. Although Beaux denied the influence, the subject and composition strongly suggest James McNeill Whistler's *Arrangement in Grey and Black: Portrait of the Artist's Mother*, a work Beaux surely saw when it was exhibited at the Academy in 1881. Beaux painted dozens of closely observed, touching portraits of women and children, for which she

achieved wide fame. Later in her career, her sitters included a distinguished array of international figures. The Academy holds a significant body of work by Beaux, including thirteen oils, numerous sketches (given by the nephew depicted in this work), and significant study materials.

PLATE 67
Cecilia Beaux

New England Woman (Mrs.
Jedediah H. Richards, née Julia
Leavitt), 1895
Oil on canvas
43 x 24¼ inches
(109.2 x 61.6 cm)
Joseph E. Temple Fund, 1896.1

After the success of *Les Derniers
jours d'enfance*, Cecilia Beaux spent
several years in France studying
at the Académie Julian and the
Académie Colorossi. Besides her
formal instruction, the artist spent
a good deal of time working in
Brittany, where she became increas-
ingly interested in atmospheric
effects. Upon returning to the
United States, Beaux became one of
the most sought-after portraitists in
Philadelphia and New York. Painted
the same year that she began teach-
ing at the Academy, this portrait of
Cecilia Beaux's second cousin Julia
is an outstanding example of the
artist's technique, reflecting both
her facility with the figure and an
atmospheric evocation of setting.
Rather than a traditional portrait,
the sitter's period costume evokes
the idea of colonial America when
nostalgia for the country's past was
fashionable. But if Beaux pays trib-
ute to the values of earlier days, the
formal characteristics of the paint-
ing are up-to-the-minute. The
flattened, dramatic diagonal com-
position, bold passages of paint,
and exploration of white tones
are reminiscent of the highly
decorative paintings of the Aesthetic
Movement, particularly James
McNeill Whistler. Like *New
England Woman*, some of Beaux's
most compelling portraits are of
relatives, whose familiarity doubt-
less allowed her more freedom to
experiment than would a commis-
sioned work.

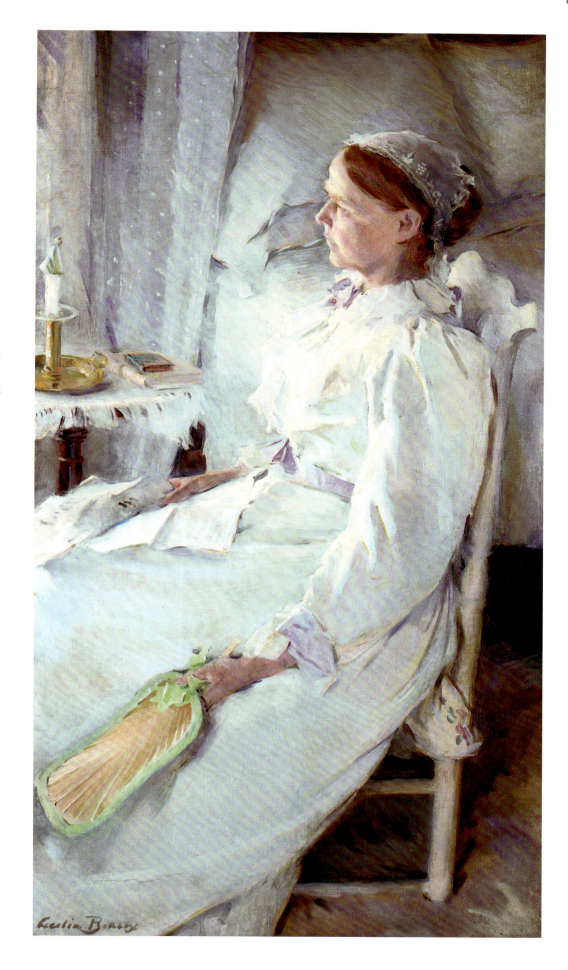

PLATE 68
Alexander Harrison
1853–1930
HONORARY MEMBER 1885
EXHIBITOR 1882–1916
MEDAL 1894

The Wave, ca. 1885
Oil on canvas
39¼ x 118 inches
(99.7 x 299.7 cm)
Joseph E. Temple Fund, 1891.5

The Philadelphia-born Harrison studied at the Pennsylvania Academy before his 1879 departure for France, where he would spend the rest of his life, dividing his time between Paris and Brittany. In Paris he trained in the atelier of Jules Bastien-Lepage and at the Ecole des Beaux Arts with Jean-Léon Gérôme, an academic painter of oriental scenes who also trained Thomas Eakins and Mary Cassatt. Harrison became an important figure in the artists' colony at Concarneau in Brittany, and Cecilia Beaux, also connected with the colony, reported

that his earlier training as an engineer influenced his analytical method of painting.

Painted on the Breton coast, this work is one of many serial depictions of gently breaking waves Harrison produced, a concept probably derived from the French Impressionists. Although Harrison was acclaimed for his skill as a *plein-air* painter, it is thought that this work was painted from memory after a series of quick sketches. The work was exhibited to great acclaim in Paris at the 1885 Salon and the 1889 Universal Exposition. Since its

purchase *The Wave* has been one of the most popular paintings in the Pennsylvania Academy collection.

PLATE 69
Dwight W. Tryon
1849–1925
EXHIBITOR 1879–1915

Evening, 1886
Oil on canvas
16 x 24 1/16 inches
(40.6 x 61.1 cm)
Henry D. Gilpin Fund, 1899.5

After amassing a comfortable sum in business, the largely self-taught Dwight W. Tryon turned full-time to art at age twenty-four. He studied in Paris from 1876 to 1879 under Jacquesson de la Chevreuse, a pupil of Jean-Auguste-Dominique Ingres, but responded much more strongly to the influence of painters of the Barbizon School, rather than the highly finished, linear style of the academic tradition. Upon returning to the United States, Tryon's mature work linked him with other young Americans who were interested in exploring the subtle variations of color, light, and atmosphere in landscape—a movement christened Tonalism in the early twentieth century, when these works were exhibited together. Small in scale, the Massachusetts landscape of *Evening* is a magnificent example of the Tonalist style. Careful gradations of color lead the viewer through the canvas, while the foreground and middle ground dissolve into a dewy haze, thanks to Tryon's soft, sketchy brushstrokes. Such meditative, absorbing landscapes proved immensely popular with collectors, particularly Charles Lang Freer, who eventually acquired six dozen of Tryon's works. As a major collector of Asian artifacts, Freer no doubt responded strongly to the subtle harmonies within Tryon's landscapes, which are reminiscent of Japanese painting.

PLATE 72
William Michael Harnett
1848–1892
STUDENT 1866
EXHIBITOR 1877–81

Still Life, 1887
Oil on canvas
24 ¼ x 20 inches
(61.6 x 50.8 cm)
The Vivian O. and Meyer P.
Potamkin Collection, bequest of
Vivian O. Potamkin, 2003.1.3

Harnett first studied art at the Pennsylvania Academy and later at Cooper Union and the National Academy of Design. Too poor to afford live models, Harnett turned to still-life painting, becoming one of the leading *trompe l'oeil* painters in America. Between 1880 and 1886 Harnett also studied in Munich and later in Paris. When he returned to America he settled in New York City, where he resided until his premature death at the age of forty-four.

This still life is characteristic of his later work in the tightness of its execution and rather luxurious collection of tabletop objects. He acquired many of these props while in Europe, and upon his return to America, used them constantly. The sheet music and violin reflect Harnett's interest in music, while the worn books, tattered oriental carpet and chipped vase suggest the contemporary fascination with the past and its comforting values. The careful arrangement of objects on a tabletop recalls the seventeenth-century Dutch antecedents of American still-life painting. His

illusionism was so convincing that Harnett was arrested in 1886 on a counterfeiting charge after exhibiting one of his paintings of a five-dollar bill.

PLATE 73
De Scott Evans
1847–1898

A New Variety, Try One,
ca. 1887–90
Oil on canvas
12 x 10 inches (30.5 x 25.4 cm)
Purchased with funds from the
daughters of Mary W. F. Howe,
1989.2

The *trompe l'oeil* painting of De
Scott Evans holds a unique place
in American still life. More than
twenty variations on the theme of
cupboard paintings by his hand
have been identified, typically fea-
turing either almonds or peanuts.
A New Variety, Try One is one of
eight pictures that depict almonds
set behind splintered glass in a faux
wooden cupboard box. A hand-
written card placed just behind
the glass invites the viewer to
"try one," and the shattered glass
implies that a visitor has indeed
succumbed to the temptation.

Evans's skill at rendering wood
grain, glass, and the nuts is bril-
liantly convincing. The painted
wood grain extends beyond the
stretcher to the sides, creating the
illusion of a hand-hewn box.

Evans is thought to have
been born "David Scott Evans" in
Boston, Indiana. He seems to have
used several pseudonyms, one of
which, S. S. Davis, is the signature
on this work. Evans, who trained in
Indiana and then studied briefly in
Paris, began painting still lifes after
moving to New York City in 1887.
He also specialized in scenes of

Victorian women and rural life,
artistic genres that brought patron-
age and greater acclaim to late
nineteenth-century painters.

PLATE 74
William Trost Richards
1833–1905
PENNSYLVANIA ACADEMICIAN 1860
EXHIBITOR 1852–1905

February, 1887
Oil on canvas, mounted on
wood
40 ¼ x 72 inches
(102.2 x 182.9 cm)
Gift of Mrs. Edward H. Coates
(The Edward H. Coates
Memorial Collection), 1923.9.5

Born and raised in Philadelphia, William Trost Richards took lessons with the German immigrant painter Paul Weber, as well as at the Pennsylvania Academy, before journeying to Europe in 1855–56, where he briefly studied in Düsseldorf, at that time a center for young American artists. After his return to the United States, Richards began to work directly from nature, sketching in the mountains of both New York State and Pennsylvania, as well as along the East Coast.

February is an exception to the marine paintings that began to pre-occupy Richards after the late 1860s. In this landscape, painted near the artist's farm in Coatesville, Pennsylvania, Richards evokes the chill and stillness of winter through the lowering gray sky, barren trees in the foreground, and his characteristic silvery tones. The artist manages to convey a dual sense of the truth-to-nature advocated by John Ruskin's *Modern Painters* and the Pre-Raphaelite artists he admired: not only accurate topography but also the experience of place, so vivid that the viewer can almost hear the crunch of footsteps across the frost-covered grass. The Academy owns eight canvases and ten watercolors by Richards—a testament to his popularity with Philadelphia collectors.

PLATE 75
Daniel Ridgway Knight
1839–1924
PENNSYLVANIA ACADEMICIAN 1864
STUDENT 1858
EXHIBITOR 1858–1912
MEDAL 1893

Hailing the Ferry, 1888
Oil on canvas
64 ½ x 83 ⅛ inches
(163.8 x 211.1 cm)
Gift of John H. Converse, 1891.7

Born in Philadelphia and educated at the Pennsylvania Academy, Daniel Ridgway Knight joined the wave of young American artists who flocked to Paris in the late nineteenth century in search of advanced instruction. He studied with Charles Gleyre in the early 1860s and Jean Louis Ernest Meissonier in the 1870s, from whom he obtained the crisp precision and highly finished handling that characterize *Hailing the Ferry*. His friendships with then-radical painters Alfred Sisley and Pierre-Auguste Renoir also instilled a love of working *en plein-air*. Academic

craftsmanship and truth-to-nature are both on display to great effect in this painting. Although Knight carefully arranged the scene according to traditional compositional principles, the realism of the costumes and the landscape testify to close study of the physical world. Meanwhile, the atmospheric handling also evokes the feeling of being in nature.

Paintings of rural life were popular in late nineteenth-century France and America, as urbanization changed traditional ways of living. Although based on conventional principles of art-making, Knight's

depictions of French peasant life share common ground with the 1880s explorations of rural Brittany by Paul Gauguin and the Nabi artists. Purchased by John H. Converse soon after its 1888 exhibition in Philadelphia, *Hailing the Ferry* was widely reproduced as a popular print and textile design.

158

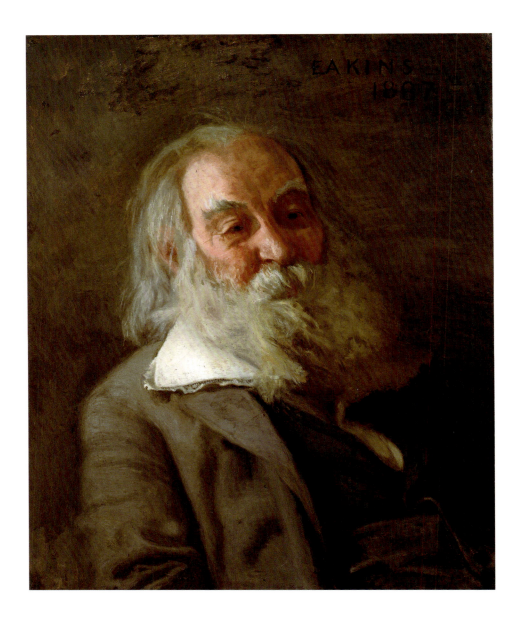

PLATE 76
Thomas Eakins
1844–1916
STUDENT 1862–65
FACULTY 1876–86
EXHIBITOR 1876–1917

Walt Whitman (1819–1892), 1888
Oil on canvas
30 ⅛ x 24 ¼ inches
(76.5 x 61.6 cm)
General Fund, 1917.1

Thomas Eakins, considered by many to be the greatest realist painter America produced, spent his career in Philadelphia, rarely leaving the city. His training in France in the 1860s grounded his work in the academic method of the French Ecole, a tradition he never abandoned during his more than forty-year career as a painter of Philadelphia scenes and portraits. Eakins's contemporary reputation as a radical lies more in his pedagogy, his use of photography, and his interest in the nude than in his approach to portraiture. While the Whitman portrait appears radically fresh in its simplicity, and the effect of the sitter captured in a casual moment, it relates easily to the rest of Eakins's oeuvre in its essentially straightforward quality and the sense of his having observed and captured the unvarnished, unadorned likeness of the sitter. Eakins succeeded best when he knew or respected his sitters and in this case, the canvas celebrates the well-documented mutual admiration of artist and subject. Considering their shared devotion to individualism, as well as to the body and the outdoor life, their friendship is not surprising. In fact, the work, painted at the poet's home in Camden, New Jersey, a popular destination for Philadelphia's cultural community, became Whitman's favorite among all the images produced of him.

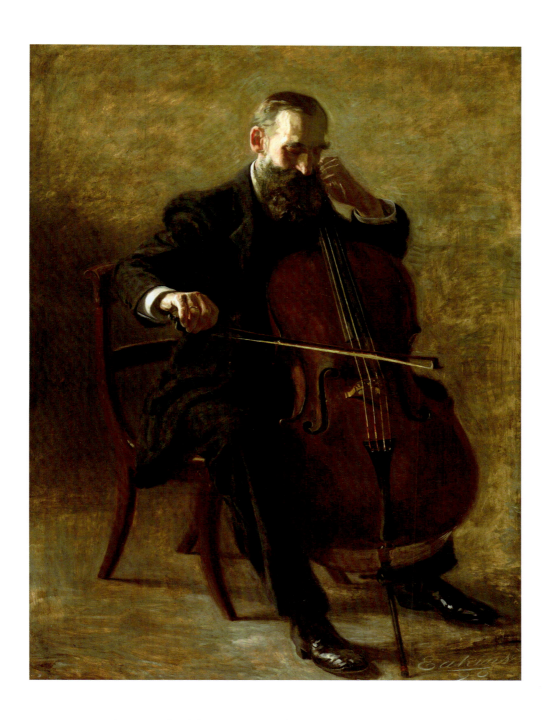

PLATE 77
Thomas Eakins

The Cello Player (Rudolph
Hennig, 1845–1904), 1896
Oil on canvas
64¼ x 48⅛ inches
(163.2 x 122.2 cm)
Joseph E. Temple Fund, 1897.3

The portrait of Rudolph Hennig
absorbed in his music making can
stand as a metaphor for Eakins's
entire career as a portraitist. A seri-
ous music lover, Eakins depicted
performers in numerous works
including *Home Ranch* and *Concert
Singer* (Philadelphia Museum of
Art). In fact, Eakins preferred to
paint musicians, scientists, doctors,
or fellow artists—-persons whose
qualities of mind or character
attracted him, and most of whom
posed at the artist's request. Like
many of Eakins's sitters, Hennig is
shown with attributes of his profes-
sion, in this case practicing private-

ly, serious and intent on the music,
with no listeners or audience. In
his more than two hundred fifty
portraits, Eakins's strongest skills
are the presentation of character
and the painting of the head and
hands. Hennig's right hand, lightly
holding the bow, and illuminated
from above, recalls the artist's
obsession with anatomy study
and pulls the viewer into the work.
Ten years after Eakins's stormy
departure from the Pennsylvania
Academy the work was purchased
out of the 1896 annual exhibition
and became the first Eakins oil to
enter the Academy collection.

Thomas Eakins

Woman in Laced-Bodice Dress,
ca. 1883
Albumen print
4 ½ x 3 ⅝ inches (11.4 x 9.2 cm)
Charles Bregler's Thomas
Eakins Collection, purchased
with the partial support of the
Pew Memorial Trust,
1985.68.2.264

Thomas Eakins, one of America's foremost painters, is less recognized as an important photographer. For approximately twenty years, between 1880 and 1900, he explored the medium, producing portraits, studies for paintings, some quasi-scientific images, many nude studies, as well as costumed figure pieces. In the latter, Eakins posed models in carefully planned settings so that costumes, props, and lighting work together to create a specific mood. Studies of women in historic costumes, from classical garb with casts of ancient statues, to women posing in eighteenth and early nineteenth-century dress, reflect the contemporary interest in historic recreations. Several of these photographs were made as preparatory studies for well-known paintings. *Woman in Laced-Bodice Dress,* and its companion piece in which the unidentified model is seated, are probably both photographic studies for Eakins's oil *The Artist's Wife and His Setter Dog* (ca. 1883, Metropolitan Museum of Art, New York). As in many of these photographic studies of pensive women in period settings, Eakins concentrated on the figure while ignoring the cluttered and busy background of his studio paraphernalia. This lack of compositional finish marks Eakins as essentially an amateur photographer who nevertheless responded to contemporary trends in artistic photography. The Academy holds hundreds of Eakins's photographic prints and negatives, an invaluable resource for scholarship on the artist.

PLATE 79
Robert W. Vonnoh
1858–1933
FACULTY 1892–95, 1918–19
EXHIBITOR 1915–34

November, 1890
Oil on canvas
32 x 39 ⅜ inches (81.3 x 100 cm)
Joseph E. Temple Fund, 1894.5

Robert Vonnoh was raised in Boston, where he initially took art lessons in the evening while working for a lithography firm during the day. After transferring to the Massachusetts Normal Art School and training to become an art teacher, Vonnoh enrolled at the Académie Julian in Paris from 1881 to 1883. *November* was painted during Vonnoh's second extended visit to France, between 1886 and 1891, after his marriage to the sculptor Bessie Potter. It was based on a study made on site in Grez-sur-Loing, a village near the Forest of Fontainebleau, about forty-five miles outside Paris that was popular with American and British artists in the late nineteenth century. Vonnoh himself returned numerous times to the village, as studies and finished canvases testify. For the final version of the painting, which the artist exhibited at the Salon of 1890, Vonnoh expanded the composition into a horizontal format and reversed the position of the solitary figure. The sparkling lavender and silver tones that add so much to the work's autumnal atmosphere result from Vonnoh's technique of using quick strokes of pigment applied directly from the tube over a thin white ground. Exhibited to great acclaim in several Northeastern cities—including an 1893 showing at the Academy—this painting was the first purchase by the Academy of an American Impressionist work.

162

PLATE 80
Elihu Vedder
1836–1923
EXHIBITOR 1880–85, 1893–99

The Sphinx, Egypt, 1890
Oil on canvas
20 ⅛ x 14 ¾ inches
(51.1 x 37.5 cm)
Bequest of Edgar P. Richardson,
1985.44

In 1889 Elihu Vedder was invited by collector and patron George F. Corliss to accompany him on an extended trip to Egypt. Upon seeing the Sphinx at Giza for the first time Vedder wrote to his wife: "I was simply struck dumb. I never saw nor shall I ever see such a thing again." The artist had been interested in the image of the sphinx for almost thirty years and had painted several depictions of it. This version emphasizes the fragile and ephemeral nature of man's existence by contrasting the tiny figure huddling on the body of the sphinx with the

huge scale of the sculpture and the vast desert beyond.

Born in New York City, Vedder was one of the last American expatriates to live and work in Rome, before Paris became the focus for American artists abroad. Known as a painter of esoteric subjects, his visionary works combine *plein-air* painting with a strong personal symbolism drawn from the imagination. In 1884 he published his major work, more than fifty illustrations for "The Rubaiyat" by the twelfth-century Persian poet Omar Khayyam. Vedder also exe-

cuted important mural commissions in this country, including the *Government* series at the Library of Congress in Washington, D.C.

PLATE 81
Augustus Saint-Gaudens
1848–1907
EXHIBITOR 1914–30

William Tecumseh Sherman
(1820–1891), 1888
Plaster; cast ca. 1892
29 ½ x 21 ¾ x 12 ¾ inches
(74.9 x 55.2 x 32.3 cm)
Deposited by Mrs. Alexander
M. Thackara, 1.1897

When he sat for Saint-Gaudens, three years before the end of his life, William Tecumseh Sherman had been a soldier in the Mexican War, a banker, a military academy administrator, and the commander of the United States Army under President Ulysses S. Grant from 1869 to 1883. Most famously, during the American Civil War, Sherman conducted the infamous "March to the Sea" through Tennessee and Georgia in 1864–65. This bloody but effective campaign cut the Confederacy in half and enabled a Union victory, becoming the stuff of military, historical, and cultural legend.

Sherman's notoriously irascible personality, as well as his strong will, is apparent in this vividly carved bust, modeled by Saint-Gaudens in about eighteen sittings lasting two hours each. The artist, an acclaimed late nineteenth-century sculptor, had studied and lived in Europe, particularly Rome, before triumphantly returning to the United States. At almost the same moment he was completing Sherman's bust, Saint-Gaudens was embarking upon several of the public memorials in New York and Boston that would earn him lasting fame. Saint-Gaudens later designed a memorial to

Sherman in New York's Grand Army Plaza, completed in 1903. The Academy's plaster bust was made for one of the general's daughters.

PLATE 82
John H. Twachtman
1853–1902
EXHIBITOR 1879–1909

Sailing in the Mist, 1890s
Oil on canvas
30 3/16 x 30 1/8 inches
(76.7 x 76.5 cm)
Joseph E. Temple Fund, 1906.1

One of the most poetic and abstract of John H. Twachtman's Impressionist paintings, *Sailing in the Mist* epitomizes his ability to fuse color and light. This seascape, which is nearly square, lacks a traditional horizon line. It is only with subtle shifts in brushwork and white highlights that Twachtman hints at recessional space. Thinly applied layers of paint merge with the white ground to flatten the surface further. This emphasis on two-dimensionality is characteristic of Twachtman's best work and distinguishes it from that of other American Impressionists, who more often relied on line,

brighter colors, and thickly impastoed surfaces to convey their imagery.

Early in his career, Twachtman employed the dark palette and the figural subjects advocated by the Munich Academy, where he had studied in the late 1870s. By 1883, however, after seeing the work of James McNeill Whistler and that of the French Impressionists, Twachtman had lightened his palette and turned his attention to landscape subjects. He pursued this direction in his art in the many landscapes painted near his farm in Greenwich, Connecticut, which he purchased in 1899. His role as one of

the leading American Impressionist painters was acknowledged early on, when the Pennsylvania Academy awarded him a Temple Gold Medal in 1895. Twachtman's works were regularly exhibited at the annual exhibitions from 1893 until 1909, seven years after his premature death.

PLATE 83
George Inness
1825–1894
EXHIBITOR 1879–1895

Woodland Scene, 1891
Oil on canvas
30 x 45 inches (76.2 x 114.3 cm)
Gift of John Frederick Lewis,
Jr., 1954.22.3

One of the most significant artists of the late nineteenth century, Inness was an important transitional figure in the history of American landscape painting. Born near Newburgh, New York, Inness lived most of his life around New York City, settling late in life in Montclair, New Jersey. Inness had very little formal training, partially because he feared his epilepsy would prevent extended study. On a trip to France in 1854, he was deeply affected by the intimate, moody work of the Barbizon School painters. Seeking to depict the "reality of the unseen," Inness veered away from panoramic paintings of Hudson River School-type realism. By the late 1880s, he had adopted a more painterly, even abstract approach to his imagery, infusing his landscapes with a sense of quiet awe, suggesting a "correspondence" between the physical world and the spiritual, a response resulting from his adherence to the philosophy of the eighteenth-century Christian mystic Emanuel Swedenborg.

This haunting late vision, with characteristic reverential atmosphere, emphasis on shadow, lack of detail, and limited palette, reveals the artist's interest in working increasingly from his imagination rather than from direct observation. According to Inness's friend and colleague Elliot Daingerfield, the artist's strongest work was "painted out of what people fondly call his imagination, his memory . . . without reference to any particular nature; for he himself was nature."

PLATE 84
Theodore Robinson
1852–1896
FACULTY 1894–95
EXHIBITOR 1882–95

Port Ben, Delaware and Hudson Canal, 1893
Oil on canvas
28¼ x 32¼ inches
(71.8 x 81.9 cm)
Gift of the Society of American Artists as a memorial to Theodore Robinson, 1900.5

In 1893, newly returned from France, where he had spent the last five summers painting at Giverny, Theodore Robinson sought additional income by teaching landscape painting at the Brooklyn School of Art in Naponach, New York. Located along the canal that connected the Delaware and Hudson rivers, the area surrounding this rural village presented him with an expansive pastoral landscape that differed markedly from the French terrain he had previously painted. In his diaries, Robinson noted especially the effects of clouds and the broad horizon, features that play an important role in the composition of this picture. The canal and towpaths provided him with ample perspectival devices, which he fully exploited to suggest deep recession into the distance. The following summer, Robinson painted along the Connecticut shore at Cos Cob. In the fall and winter, he replaced Robert W. Vonnoh as an instructor at the Pennsylvania Academy. He was hired by Harrison S. Morris, the secretary and managing director of the Academy. Morris, a strong proponent of American Impressionism, was the person most responsible for forming the Impressionist collection at the Academy, and he was behind the purchase of this work. It had previously been offered as a gift to the Metropolitan Museum of Art in New York and had been rejected. Morris noted wryly in his memoirs that the Metropolitan Museum "had not grown up yet to the lure of Impressionist painting; they held it, like even lesser critics, under suspicion."

J. Alden Weir
1852–1919
FACULTY 1912–13
EXHIBITOR 1879–1920
MEDAL 1916

Midday Rest in New England,
1897
Oil on canvas
39 ⅝ x 50 ⅜ inches
(100.6 x 128 cm)
Gift of Isaac H. Clothier,
Edward H. Coates, Dr. Francis
W. Lewis, Robert C. Ogden,
and Joseph G. Rosengarten,
1898.9

This large Impressionist landscape and figure painting is typical of the Salon-directed work that J. Alden Weir produced in the late 1890s. Originally painted for the Carnegie Institute's annual exhibition, *Midday Rest in New England* was purchased from the Pennsylvania Academy's annual exhibition in 1898 and later exhibited at the Paris Exposition of 1900, where Weir received a bronze medal. The painting combines a wealth of carefully drawn details in the rendering of animals and human figures, along with a traditional system of linear perspective in the receding tree trunks—pictorial elements that would have appealed to academic tastes.

J. Alden Weir began his career as a painter of figures and still lifes. He showed them at the Paris Salons from 1881 to 1883. It was not until the 1886 exhibition of French Impressionist work at the National Academy of Design and the American Art Association in New York, however, that Weir began to turn to landscape painting. During the summers of 1892 and 1893, he taught art classes with John Twachtman at Cos Cob, Connecticut. Between 1897 and 1901, Weir ran a summer school at his farm in Branchville, Connecticut, where this work was painted.

Bessie Potter Vonnoh
1872–1955
EXHIBITOR 1894–1931

Young Mother, 1896
Bronze with green-and-brown
patina; lost-wax cast in 1913
14 x 13 x 15 ½ inches
(35.6 x 33 x 39.4 cm)
Gift of Mrs. Edward H. Coates
in memory of Edward H.
Coates, 1923.9.8

Vonnoh, a native of Saint Louis,
was educated at the Chicago Art
Institute under Lorado Taft. She
enjoyed a successful forty-year
career making sculptures of upper-
class women at different stages of
life and engaged in everyday activi-
ties. During the 1920s and 1930s,
she executed a number of large
fountain and garden pieces. Both
these facets of her oeuvre reflect the
growing taste for bronze sculpture
to adorn private homes in early
twentieth-century America. After
her marriage to the painter and
Pennsylvania Academy instructor
Robert Vonnoh in 1899, the couple
moved to Rockland Lake, New
York. From 1900 onward, she exhib-
ited widely at national and interna-
tional exhibitions. *Young Mother*
was apparently the first of her works
to treat the theme of motherhood,
and it became her best-selling work,
reproduced in over thirty castings as
well as numerous plaster copies.
Vonnoh's impressionistic technique
is marked by extremely subtle sur-
face modulations. Facial features
are merely suggested and eyes are
indicated by shallow depressions,
producing an idealized, and thus
more symbolic, conception.

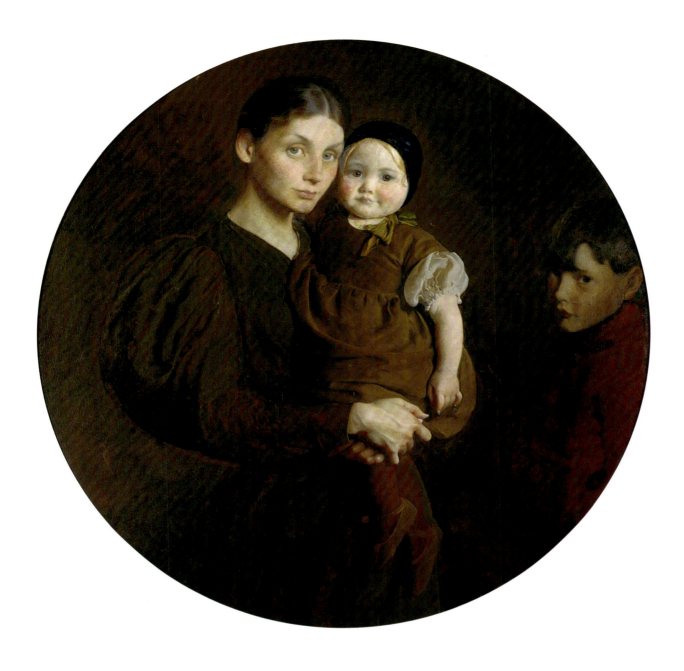

George de Forest Brush
1855–1941

Mother and Child, ca. 1897
Oil on canvas
Diameter 39¼ inches (99.7 cm)
Joseph E. Temple Fund, 1898.2

Active in the American Renaissance movement, George de Forest Brush is best known for portraits of his family that evoke images of the Madonna and Christ Child. The dozen or so paintings of his wife and children executed in the 1890s established his reputation. Art critics of his day frequently pointed out that Brush's paintings were not mere imitations of Italian religious art but realistic portraits that appealed to contemporary American audiences. Brush was praised for introducing "a modern note of painful seriousness" and avoiding sentimentality.

This portrait of the artist's wife, Mittie, with two of their children, is presented in a tondo, or round format that further emphasizes its relationship to Italian Renaissance paintings by artists such as Raphael and Andrea del Sarto. The portrait's limited range of color, the simple background, and the realistic depiction of facial features link Brush's work not only to Dutch art but also to such popular late nineteenth-century American portrait painters as William Merritt Chase and Thomas Eakins. Their work was often featured in the annual exhibitions at the

Pennsylvania Academy, where this painting was awarded a Temple Gold Medal in 1897.

PLATE 90
James Abbott McNeill Whistler
1834–1903
EXHIBITOR 1893–1907
MEDAL 1902

Rose and Gold: "Pretty Nellie Brown," 1895–1900
Oil on canvas
20 x 12 ¼ inches (50.8 x 31.1 cm)
Gift of Ann R. Stokes, 2002.5

Though he had resided in Paris and London since 1855, Massachusetts-born James McNeill Whistler became a household name in the United States, where the persona he created for himself as a witty and caustic aesthete in café society equaled his reputation as one of the most advanced painters of his time. His example lured many American artists to choose an expatriate life in the fashionable capitals of Europe. The title of this portrait of the daughter of one of Whistler's London patrons indicates that a pleasing arrangement of subtle color values, not a scrupulous like-ness of the sitter, was the artist's true aim. Such ambitions typically required considerable effort. Begun in late 1895, the painting had reached near completion, as *Rose and Brown*, by the summer of 1897. The artist continued, nevertheless, to work on the portrait until May 1900, when he wrote to his patron of the now-finished work, retitled *Little Nellie–Rose and Red*. The title was again changed for an exhibition in Boston in 1904.

PLATE 91
Henry Ossawa Tanner
1859–1937
STUDENT 1880–81
EXHIBITOR 1880–1909

Nicodemus, 1899
Oil on canvas
33 ¹¹⁄₁₆ x 39 ½ inches
(85.6 x 100.3 cm)
Joseph E. Temple Fund, 1900.1

The first African-American artist to achieve international prominence, Tanner was also one of the first African Americans to attend the Pennsylvania Academy, where he studied with Thomas Eakins before his 1891 departure for Paris to train at the Académie Julian. Feeling at home in France, Tanner spent most of the rest of his life there, successfully exhibiting at the Paris Salon and eventually becoming a member of the Legion of Honor. After his early focus on landscapes and African-American genre scenes showing Eakins's influence, Tanner achieved his greatest success with

evocative biblical paintings marked by dramatic, even supernatural, light effects (for example, *The Annunciation*, 1898, Philadelphia Museum of Art). Tanner's father was a bishop in the African Methodist Episcopal Church, and his own religious convictions instill these works with a contemplative quietude and a profoundly human sensitivity to his subject matter.

Painted during the artist's second trip to the Holy Land (sponsored by Tanner's Philadelphia patron Rodman Wanamaker), *Nicodemus* depicts a scene from the Gospel of John in which the

Pharisee and "ruler of the Jews" visits Jesus by night to receive his teachings. Tanner remarked that the six months he spent in Jerusalem lent an air of authenticity to this work, and he used local people as sitters. *Nicodemus* was shown at the Academy's 1899 annual, where it was awarded the Lippincott Prize for the best figurative work and purchased for the collection.

174

PLATE 92
Winslow Homer
1836–1910
EXHIBITOR 1888–1910
MEDAL 1896

North Road, Bermuda, 1900
Watercolor and graphite on
white wove paper
13 5/16 x 21 inches (35.4 x 53.3 cm)
Partial Gift and Bequest of
Bernice McIlhenny
Wintersteen, 1978.19

As he got older, in order to escape the
harsh conditions of Maine's winters,
Homer made frequent trips to Cuba,
Nassau, and Bermuda. In this water-
color, Homer juxtaposed the shade
of the island's trees with the intense
blue of the sea, while depicting a sin-
gle ocean liner in the distance to lead
our eye through the composition.
Homer did watercolors throughout
his career as a source of income, but
these works were a source of pride
for the artist. He once said, "In the
future, I will live by my watercolors,"
and indeed his works in this medium

are today among the most prized in
American art.

Homer was born in Boston,
receiving his first formal artistic
training as an apprentice to a lithog-
rapher. After additional private
study, Homer moved to New York
in 1859 to study at the National
Academy of Design, while working
as a freelance illustrator. He gained
national renown for the Civil War
scenes he illustrated for *Harper's
Weekly*. In 1866, Homer traveled
to Paris and exhibited in the Salon
of that year. He shared a studio in

Montmartre with Albert Warren
Kelsey, before returning to New
York. In 1872, Homer established a
studio in the famous Tenth Street
Studio Building, home to many
Hudson River School artists.

PLATE 93
Everett L. Warner
1877–1963
EXHIBITOR 1898–1931

February (also known as *A February Day, West 57th Street*),
1900
Pastel and black chalk on beige
sandpaper
18 ⅛ x 13 ¼ inches (46 x 33.7 cm)
Presented from the estate of
Francis M. Lewis, M.D.,
1902.3.2

Warner worked for four years as an art critic for the *Washington Evening Star* before enrolling at the Corcoran Art School in 1897. The following year, he moved to New York to study at the Art Students League. *February* is typical of Warner's early work, when he specialized in images of New York. In this work, he demonstrates his skill at conveying the turn-of-the-century urban environment as well as mastery of the difficult pastel technique. Against a snowy setting, several isolated figures and horse-drawn carriages make their way through the elements, dwarfed by the buildings that line the street.

In 1903, the sale of his early works enabled Warner to finance a trip to Europe, where he enrolled in the Académie Julian in Paris. There he befriended Leo Stein, Gertrude's brother, and was influenced by French Impressionism. In 1909, Warner became associated with the art colony at Old Lyme, Connecticut, where he joined other American Impressionist artists such as Childe Hassam. During World War I, Warner designed a system of camouflage for use on ships. After the war, he was offered a teaching position at the Carnegie Institute of Technology in Pittsburgh, and broadened his subject matter to include landscapes and scenes of rural life in addition to cityscapes.

PLATE 96
Alexander Stirling Calder
1870–1945
STUDENT 1885–90
FACULTY 1889–90
EXHIBITOR 1887–1943

Man Cub, 1901-02
Bronze with black patina; sand
cast in 1905-06
48 ¾ x 15 ¼ x 13 ¾ inches
(123.8 x 38.7 x 34.9 cm)
Cast by the Pennsylvania
Academy from the plaster pur-
chased by subscription, 1905.9

Alexander Stirling Calder was the
son of the Scottish–born sculptor
Alexander Milne Calder whose chief
legacy is the elaborate sculptural
decoration of Philadelphia's City
Hall, in which he was assisted by
his young son. After studies at the
Pennsylvania Academy, Calder trav-
eled to Europe in 1889 and 1890
with classmates from the Academy
school. Back in the United States in
1892, Calder plunged into his career
as a professional artist, executing
monuments for many major proj-
ects including, in Philadelphia, the
Witherspoon Building, the Swann
Memorial Fountain, and the
Shakespeare Memorial at Logan
Circle, as well as the sculptures for
the Panama Pacific International
Exposition (1915) and the War
Memorial Arch in Washington
Square in New York (1919). *Man
Cub,* modeled from life, depicts the
sculptor's son, Alexander ("Sandy"
Calder, the originator of the mobile,
see Plate 145) at the age of three.
The simple, playful treatment gives
the work the freshness of a sketch.
The plaster was shown in 1904 at
both the Academy annual and the
Louisiana Purchase Exposition in
Saint Louis. After purchasing it,
the Academy had the cast shown
here made. The plaster is now
lost. Another bronze cast is in the
Metropolitan Museum of Art in
New York.

PLATE 97
Charles Grafly
1862–1929
STUDENT 1883–88
FACULTY 1892–1929
EXHIBITOR 1885–1929
MEDAL 1899

In Much Wisdom, 1902
Bronze with black patina; sand
cast in 1902–03; mosaic inlay of
stone and gilded glass
63 ½ x 27 ¼ x 27 ¼ inches
(161.3 x 69.2 x 69.2 cm)
Henry D. Gilpin Fund, 1912.2

After studying at the Pennsylvania
Academy under Thomas Eakins and
Thomas Anshutz, Charles Grafly
traveled to Paris in 1888, where for
the next four years he worked under
several teachers and successfully
exhibited in the Paris Salons. Back
in Philadelphia after 1891, Grafly
taught at the Drexel Institute for
several years and at the Pennsylvania
Academy until his death. Grafly
designed a number of major public
monuments and also produced
uncommissioned allegorical pieces,
of which *In Much Wisdom* was the
last. Its subject, a symbol-laden god-
dess, stands on an ornate pedestal.
A serpent rises from the beautifully
modeled vegetation to her shoulders
and winds along her left arm. The
figure's sensuality recalls the work
of European Symbolist artists, who
may have been familiar to Grafly
from his years abroad. Applied
ornament of gilded glass and
turquoise mosaic on the lower,
square pedestal signals the sculptor's
growing interest in experimenta-
tion. *In Much Wisdom* is one of
nineteen works by Grafly in the
Academy's collection.

PLATE 98
Violet Oakley
1874–1961
STUDENT 1896
FACULTY 1912–17
EXHIBITOR 1896–1948

June, ca. 1902
Oil, charcoal, and graphite on
composition board
16 ³⁄₁₆ x 17 ¹⁄₁₆ inches
(41.1 x 43.3 cm)
Henry D. Gilpin Fund, 1903.4

Violet Oakley—illustrator, muralist, writer, and pacifist—played a prominent role in the artistic life of Philadelphia for almost half a century. Her illustrations for books, magazines and poems appeared in many popular publications. Born to an artistic family in New Jersey, Oakley studied at New York's Art Students League and later in Paris. She returned to America in 1896, settling in Philadelphia and enrolling briefly at the Pennsylvania Academy before entering Howard Pyle's illustration class at the Drexel Institute of Art, Science, and Industry. With Pyle's support, Oakley soon embarked on a lucrative career as a commercial illustrator and decorative artist. *June* was produced as a cover for a 1902 issue of *Everybody's Magazine,* a monthly periodical targeted at a female audience, published by the New York branch of John Wanamaker's merchandising empire. Oakley's composition of two women standing in front of a flower-covered wall was in keeping with what was considered at the time to be a natural subject for both women artists and women readers.

Edmund C. Tarbell
1862–1938
EXHIBITOR 1892–1938

The Breakfast Room, ca. 1903
Oil on canvas
25 x 30 inches (63.5 x 76.2 cm)
Gift of Clement B. Newbold,
1973.25.3

Tarbell received his first artistic training in his native Boston at the School of the Museum of Fine Arts before traveling to France. At the Académie Julian, Tarbell studied with the French Academicians Gustave Boulanger and J. J. Lefebvre while also being exposed to French Impressionism, a style he would begin to explore by 1891. Tarbell was a founding member of Ten American Painters, a group of Boston and New York artists who withdrew from the Society of American Artists and exhibited as an independent group until 1918.

Included in the 1903 annual exhibition at the Pennsylvania Academy, *The Breakfast Room* exhibits an astute awareness of innovative Impressionist techniques in the play of sunlight, the use of pastel colors, and the cropping of pictorial elements at the edges of the composition. These elements led a contemporary critic to compare this painting to the work of Edgar Degas. Unlike Tarbell's typically less charged images, a palpable tension exists between the couple seated at the table. They seem to avoid looking at one another, as if in isolation, lost in their own

thoughts. Framed by the open doorway, the servant in the background is further removed from their world. The painting of the nude on the back wall in this scene has been identified as a copy of Titian's *Venus and Dog with an Organist*, ca. 1550 (Prado Museum, Madrid).

Albert Laessle
1877–1954
STUDENT 1898–1904
FACULTY 1921–40
EXHIBITOR 1901–41

Turtle and Lizards, 1902–03
Bronze with brown patina;
lost-wax cast in 1903–04
17 ½ x 13 ¼ x 19 ½ inches
(44.5 x 33.7 x 49.5 cm)
Henry D. Gilpin Fund, 1904.4.1

Laessle, whose father was a German immigrant woodcarver, entered the Pennsylvania Academy in 1898, where he studied modeling with Charles Grafly for six years. In 1904, he was awarded the William Emlen Cresson Travel scholarship, and he departed for Paris. He received two extensions to the award, which enabled him to remain in Paris for three years. During this time he began sculpting animals and exhibited several works in the 1907 Paris Salon. Back in Philadelphia, he embarked on a forty-year career as a skilled *animalier*. He also taught

sculpture at the Academy's summer school at Chester Springs, Pennsylvania, from 1921 to 1939. Laessle's animal sculptures are in many public collections, including Rutgers University, the Metropolitan Museum of Art, and Brookgreen Gardens. Turtles and other small animals were his favorite subjects. An earlier composition, *Turtle and Crab* (plaster, now destroyed), was denied a medal in a 1901 exhibition when Laessle was accused of casting it from life. The Academy purchased the wax model for *Turtle and Lizards* in 1903 and cast it in both plaster

and bronze. The bronze version was exhibited at the Louisiana Purchase Exposition in Saint Louis in 1904, where it was well received.

PLATE 101
Charles Lewis Fussell
1840–1909
STUDENT 1864
EXHIBITOR 1863–1908

Young Girl at Forest Spring, 1903
Watercolor and gouache on
cream wove paper
14 x 23 ⅞ inches
(35.6 x 60.6 cm)
Gift of Mrs. Henry M. Fussell,
1974.8

Little known even in his lifetime, Fussell produced a body of stunning landscapes that make clear the artist's reverence for nature. Born in Chester County, Pennsylvania, Fussell lived and worked in the Philadelphia area for most of his life. As a young man he studied with the history painter Peter Frederick Rothermel and in 1864 enrolled in classes at the Pennsylvania Academy. It was there that he met Thomas Eakins, and the two remained lifelong friends. Fussell never married, and he lived with his parents until their death, supporting them, for a time, by farming in New Jersey. His attempts to gain fame as a painter of Rocky Mountain scenes went largely ignored, and Fussell had only slightly better luck making his name with landscapes of New York, New Jersey, and Pennsylvania.

Later in his life, Fussell settled in Philadelphia's western suburb of Media, where he lived with his sister and his aunt, the artist Graceanna Lewis. He worked largely in watercolor during this period, and his depictions of the groves and springs around Media combine an almost obsessive observation of stones, roots, and foliage with a brilliant palette of greens, a glowing quality of light, and a contemplative sense of quietude, as in this image of a solitary figure overwhelmed by natural grandeur.

PLATE 102

John Frederick Peto

1854–1907

STUDENT 1878

EXHIBITOR 1879–88

Toms River Yacht Club, 1904
Oil on canvas
20 x 16 inches (50.8 x 40.6 cm)
Purchased with funds from the
bequest of Henry C. Gibson,
1989.1

A masterful practitioner of *trompe l'oeil* painting—a still-life genre intended to "fool the eye" into perceiving an image as a three-dimensional arrangement—Peto received little attention in his lifetime. A native Philadelphian, Peto studied at the Pennsylvania Academy and became friends with the leading *trompe l'oeil* painter William Michael Harnett. Although the older artist strongly influenced him, Peto developed his own idiosyncratic, more subjective mode of illusionistic painting, softening the typically crisp edges, revealing rather than laboring to conceal brushstrokes, and showing great

sensitivity to the play of light on different objects. Peto also favored worn, shabby objects for his still lifes, which were evocative but unpopular with buyers who wanted pretty images. In spite of this, dealers sometimes forged Harnett's signature on Peto's work, knowing the value of the more successful artist's name.

Peto began his artistic career as a portrait photographer and divided his time between Philadelphia and Island Heights, New Jersey, where he eventually settled. Peto specialized in "rack pictures" such as this, images of photos, scraps of paper, and other detritus seemingly pinned

to boards. *Toms River Yacht Club* was probably commissioned by J. H. Stoutenburgh, a wealthy Philadelphian who was the commodore of the local sailing and social club. By including carved initials referring to Stoutenburgh and the club, personal memorabilia, and a *carte-de-visite* photograph of Stoutenburgh, Peto transformed the work from a still life into a conceptual portrait.

PLATE 103
Edward W. Redfield
1869–1965
STUDENT 1887–89
EXHIBITOR 1888–1946

The Old Elm, 1906
Oil on canvas
32 ¼ x 40 ⅜ inches
(81.9 x 102.6 cm)
Joseph E. Temple Fund, 1907.2

Specializing in wintry landscapes, Redfield established himself as one of the leading American Impressionists through his depictions of Bucks County and the Delaware River Valley. Born in Bridgeville, Delaware, Redfield received his artistic training initially at the Pennsylvania Academy, where he studied with Thomas Anshutz and Thomas Hovenden. Along with his classmate Robert Henri, Redfield traveled to France to study with William Bouguereau and Tony-Robert Fleury. While studying in France, Redfield abandoned his pursuit of portrait painting and took to painting outdoors, like the French Impressionists, traveling to rural sites historically associated with *plein-air* painting such as Barbizon and Pont-Aven in Normandy. A proponent of directly observing nature, he scorned artists whose works were executed within the studio. Redfield attracted younger artists who traveled to Bucks County to learn from his example.

The Old Elm reveals Redfield's rapid working process through the quickly applied brushwork that defines the trees in the upper left portion of the painting. A contemporary critic characterized Redfield's work as a synthesis of Courbet's realism and the "independence of air and light" of Impressionism. This combination can be seen in the trees in the foreground, where the heavily impastoed paint and distinctly colored brushstrokes create a three-dimensional surface that imitates the texture of tree bark.

PLATE 104
Thomas P. Anshutz
1851–1912
STUDENT 1876–82
FACULTY 1881–1911
EXHIBITOR 1879–1913
MEDAL 1909

Becky Sharp, ca. 1905
Pastel on prepared linen
42 x 33 ¾ inches
(106.7 x 85.7 cm)
Joseph E. Temple Fund, 1906.3

In his lifetime, Anshutz was better known nationally as a teacher than as an exhibiting artist, yet he maintained a position of authority and respect in the Philadelphia art world throughout his career. Influenced by the stylistic tradition of Thomas Eakins, his former mentor and predecessor at the Pennsylvania Academy, Anshutz did not flatter his sitters but sought to convey personality as well as outward appearance. Such attention to temperament is apparent even in this "literary portrait," a study of a model in the guise of Becky Sharp, the scheming, social-climbing anti-heroine of

William Makepeace Thackery's satirical novel *Vanity Fair*. The model was, at one time, identified as Virginia Henderson, sister of Helen Henderson, an Academy alumna who wrote the first published history of the institution and is the subject of both a pastel and an oil portrait by Anshutz in the Academy's collection. Later assessments agree that the model was more likely Katherine Rice.

This piece displays Anshutz's great affinity for the pastel medium, which he adopted late in his career. He even made his own colors in order to achieve desired effects.

The work was exhibited in the Academy's third watercolor annual, in 1906, where it won the Temple Prize and was purchased for the collection. In 2001, the Academy acquired a pastel study for this work, likely executed by Anshutz as a classroom demonstration.

PLATE 105
Thomas P. Anshutz

The Tanagra
(Rebecca H. Whelan), by 1909
Oil on canvas
80 x 40 inches
(203.2 x 101.6 cm)
Gift of friends and admirers of
the artist, 1912.1

The Tanagra is one of Thomas
Anshutz's most spectacular late
works, in which the solid anatomy
for which he was known vies with
increasingly abstracted space,
painterly flourishes, and the model's
own intense presence. The daughter
of a former president of the
Academy, Rebecca Whelan was
both a student and a favorite subject
for Thomas Anshutz, who painted
her at least five times, in a variety of
attitudes. Here, she contemplates a
tanagra figurine, the Attic Greek
clay statuettes that were in demand
in Europe and America in the late
nineteenth and early twentieth cen-
turies. In 1909, this painting won
the Gold Medal of Honor, the
Academy's greatest honor.

The Kentucky-born Anshutz
began his career at the National
Academy of Design, but soon
migrated to Philadelphia, where
Thomas Eakins's emphasis on draw-
ing from life greatly impressed the
young artist. Anshutz rose through
the ranks of the Academy, eventual-
ly succeeding Eakins as Professor
of Painting and Drawing after the
older artist's forced resignation
(a development Anshutz supported,
much to the regret of later art histo-
rians). A gifted teacher, Anshutz
inspired many of the artists who
would form the Ashcan School of
realism after moving to New York.

PLATE 108
Ernest Lawson
1873–1939
EXHIBITOR 1894–1940

The Broken Fence: Spring Flood,
by 1907
Oil on canvas
30 3/16 x 24 1/16 inches
(76.7 x 61.1 cm)
Gift of Bertha Schwacke,
1937.15.1

Hailed by the art dealer Frederic Newlin-Price as a "painter of crushed jewels," Lawson's landscapes shimmer with light and color. Born in Halifax, Nova Scotia, Lawson studied with and was profoundly influenced by John Twachtman. He also studied briefly at the Académie Julian in Paris, where he was struck by the work of Alfred Sisley, but he felt that too much exposure to Impressionism might compromise his individuality. From 1898 to about 1908, Lawson lived and painted in the Washington Heights section of Upper Manhattan. Like many other American artists influenced by

Impressionism, Lawson's response to the landscape was highly personal, an exploration of intimacy and mood. In *The Broken Fence*, Lawson painted in a very characteristic manner, layering pigment to an almost woven effect, with underlayers of color gleaming through. Around the time this painting was made, Lawson was introduced by his friend William Glackens to the other artists who would comprise The Eight, a group of artists who espoused an urban realist style. Lawson's association with The Eight and their commitment to innovative art also led to his participation in

the Armory Show in 1913. Despite great acclaim from certain critics, Lawson remained under-appreciated in his lifetime, and was often depressed and struggling financially. Late in life, he moved to Florida; his body was found on a deserted beach in Miami, where he was thought to have died of a heart attack after being robbed.

PLATE 109
Willard L. Metcalf
1858–1925
EXHIBITOR 1883–1924
MEDAL 1911

The Twin Birches, 1908
Oil on canvas
40 ⅛ x 39 inches
(101.9 x 99.1 cm)
Joseph E. Temple Fund, 1909.4

Willard L. Metcalf was one of the earliest American artists to embrace the Impressionist mode. While studying at the Académie Julian in Paris in 1884, Metcalf painted landscapes in a lightened palette. The following summer, at Grez-sur-Loing, he worked with other Americans who were also painting *en plein-air* in the French manner. Between 1886 and 1888, Metcalf stayed at various times in Giverny, where Claude Monet resided and which had become a center for young American artists interested in landscape. In 1898, Metcalf was a founding member of Ten American

Painters, a group of artists who withdrew from the Society of American Artists to exhibit independently.

Metcalf moved to New York in 1890 and earned a living as an illustrator. In 1895, he turned again to landscape painting and from that point forward specialized in landscapes. *Twin Birches* was executed in 1908, while Metcalf was staying on Leete's Island near Guilford, Connecticut. It was first shown at the Pennsylvania Academy's annual exhibition in 1909, at which time it was purchased for the permanent collection. This painting and others done on Leete's Island convey the

regenerative and comforting powers of nature, which underlie much of the appeal of Impressionist landscape painting.

PLATE 112
Philip Leslie Hale
1865–1931
FACULTY 1912–28
EXHIBITOR 1895–1931

The Crimson Rambler, ca. 1908
Oil on canvas
25 ¼ x 30 ³⁄₁₆ inches
(64.1 x 76.7 cm)
Joseph E. Temple Fund, 1909.12

Born into a prominent Boston family, Hale studied at Boston's School of the Museum of Fine Arts and New York's Art Students League before attending the Ecole des Beaux Arts and the Académie Julian in Paris. Although both French schools trained artists in the academic tradition, Hale was drawn to Impressionism. His experimentation with this new mode of painting was strengthened by his friendship with a fellow American painter, Theodore Butler, who was Claude Monet's son-in-law. Hale returned to Boston in 1890 and developed a reputation as a highly influential art critic, author, and

teacher, regarded as the de facto leader of the "Boston School" of Impressionists. Hale was a member of the Pennsylvania Academy's faculty and played a critical role in introducing Impressionism to Philadelphia.

The Crimson Rambler, purchased after its exhibition in the 1909 Pennsylvania Academy annual, is typical of Hale's impressionist style, with its linear treatment of the figure in a freely brushed setting of light and color. Hale's specialization in visions of idle, decorative women of fragile, "floral" beauty has been interpreted as a visual response to his objection to the women's suffrage

movement. *The Crimson Rambler* was painted at the home Hale shared with his wife, the painter Lilian Westcott Hale, in the Boston suburb of Dedham; the couple's daughter Nancy has identified the sitter as Rose Zeffler.

PLATE 113
William Sergeant Kendall
1869–1938
STUDENT 1885–86
FACULTY 1906–08
EXHIBITOR 1893–1937

Quest, 1910
Polychromed wood on wood
pedestal
34 x 14 ½ x 17 inches
(86.5 x 36.8 x 43.2 cm)
Gift of Mrs. William Sergeant
Kendall, 1956.8

Better known as a painter specializing in subjects of children (his *Beatrice* of 1906 is in the Academy's collection), Kendall may have been encouraged to model in clay by Thomas Eakins while studying in the 1880s at the Brooklyn Art Association and at the Pennsylvania Academy. Subsequently Kendall went to Paris, where he attended the Académie Julian and the Ecole des Beaux Arts. During his years in France, Kendall spent many summer months in the art colonies on the coast of Brittany. The hardworking Breton peasants provided the subject matter for many of his early paintings and at least two sculptures. One of the latter, *Quest* evokes the spiritual searching of a Breton peasant. Here the artist used the medium of painted wood, which was unusual for his era but appropriately reminiscent of church carvings of previous centuries. The dramatic and unusual *Quest* caused a sensation when it was exhibited, winning a silver medal at the Panama Pacific Exposition in 1915 in San Francisco. Kendall's first cousin, Ann Saunders, served as the model for the piece.

Arthur B. Davies
1862–1928

Isle of Destiny, ca. 1910
Oil on canvas, mounted on
wood
18 1/16 x 40 1/4 inches
(45.9 x 102.2 cm)
Gift of Mr. and Mrs. Alfred G.
B. Steel, 1943.17

New York-born Davies trained in
Chicago at the Academy of Design
and the Art Institute of Chicago,
before further study in New York at
the Art Students League. While ini-
tially committed to realistic land-
scape, Davies's style underwent a
dramatic change around 1900.
Influenced by the stylized Symbolist
landscapes of the French painter
Pierre Puvis de Chavannes, Davies
began to create evocative pastoral
dreamscapes. *Isle of Destiny* is a fine
example of Davies's mature style.
With its figures of all ages disporting
themselves in an idyllic landscape,
the painting pays tribute not only to
the Symbolist movement but also to
the Arcadian past as enshrined in
classical painting and verse. Never-
theless, the work also is marked by
modernist developments. The
painter greatly admired the dancer
Isadora Duncan, whose revolutionary
changes to the physical language of
dance may have echoes in the varied
rhythms of the figures' postures.
Davies had been connected nomi-
nally, if not stylistically, with the
revolutionary group of artists
known as The Eight, and shortly
after this painting was completed,
he helped organize the 1913 Armory
Show. That landmark exhibition
was the first exposure for many
Americans to European modern art.

PLATE 115
Maurice Brazil Prendergast
1858–1924
EXHIBITOR 1896–1922

Bathers in a Cove, ca. 1912
Oil on canvas
20 ⅜ x 26 ½ inches
(51.8 x 67.3 cm)
John S. Phillips bequest, by
exchange (acquired from the
Philadelphia Museum of Art),
1985.18

A participant in both the 1908 exhibition by The Eight and the 1913 International Exhibition of Modern Art (known as the Armory Show), two landmark events that introduced and promoted modern art in the United States, Prendergast was one of the most daring American artists of the early twentieth century. He studied in Paris at the Académie Colarossi and the Académie Julian from 1891 to 1895. Shortly after his return to the United States, he exhibited both oil paintings and watercolors at the Pennsylvania Academy. He went on to specialize in leisure subjects, particularly scenes along the coast of Massachusetts near Boston, where he lived.

Showing the influence of European movements such as Impressionism and Post-Impressionism, especially the work of Edouard Vuillard, Prendergast's paintings have often been compared to tapestries, mosaics, and stained glass because of the artist's brilliance in handling color and textures. He often depicted parks, beaches, and other public spaces, shimmering with sunlight and populated by elegantly dressed crowds, reflective of America's growing leisure time thanks to turn of the century indus-

trialization. In *Bathers in a Cove,* Prendergast characteristically built his jewel-like colors through softly textured layerings of paint, achieving a vivacity that stands in contrast with the decoratively still, almost sculptural poses of his figures.

PLATE 116
William McGregor Paxton
(1869–1941)
EXHIBITOR 1898–1941

Girl Sweeping, 1912
Oil on canvas
40 ¼ x 30 ⅜ inches
(102.2 x 77.2 cm)
Joseph E. Temple Fund, 1912.4

After training in Boston, Baltimore-born William McGregor Paxton studied in Paris at the Académie Julian and with the acclaimed painter Jean-Léon Gérôme at the Ecole des Beaux Arts in the late 1880s and early 1890s. His residency coincided with a renewed enthusiasm for the work of the Dutch painter Jan Vermeer, whose newly popularized paintings were increasingly prized by European and American museums, scholars, and collectors. After returning to Boston, Paxton developed his signature subject matter of solitary women engaged in meditative interior activities. *Girl Sweeping*, however, is rare among Paxton's works, since its subject is a servant rather than the mistress of the house.

In the absorption of his sitters and the lavishness of their settings, Paxton's scenes are not only indebted to the example of Vermeer but also echo contemporary examples by fellow Bostonians Edmund C. Tarbell (Plate 99), Frank W. Benson, and Joseph De Camp, who likewise frequently depicted women in domestic activities. Recent scholarship has suggested that such depictions soothed conservative social anxieties at a time when women fought for larger roles outside the home. Whatever the politics, paintings such as this pleased cultivated tastes by offering exquisitely painted old-master traditions in accessibly contemporary settings.

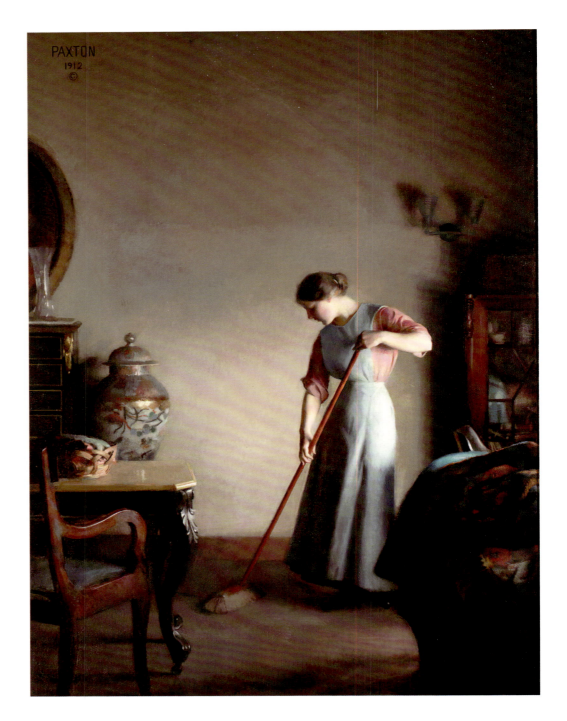

PLATE 117
Margaret Foster Richardson
1881–ca. 1945
EXHIBITOR 1908–30

A Motion Picture, 1912
Oil on canvas
40 ⅜ x 23 ⅛ inches
(102.6 x 58.7 cm)
Henry D. Gilpin Fund, 1913.13

This unique self-portrait reflects
changing attitudes toward women
in the early twentieth century as
well as an expansion of opportunities
clearly embraced by the artist.
Depicting herself as a working artist
with paintbrushes in each hand,
Richardson strides forward into the
light, hardly slowing to meet the eye
of the viewer. Richardson's direct
gaze, knowing smile, and the work's
sense of movement and vitality
convey a self-confidence and profes-
sionalism associated with the era's
so-called New Woman. In contrast
to the Gibson Girl, the more
decorative symbol of contemporary
femininity, Richardson chose to
depict herself with eyeglasses, a
no-nonsense hairstyle, a painter's
smock, and rather masculine collar
and tie.

A native of Winnetka, Illinois,
Richardson came to Boston for
artistic training, studying with
"Boston School" Impressionists
Joseph De Camp and Edmund C.
Tarbell. Primarily a portraitist, she
found early success and won a num-
ber of awards. Not following the
lead of her famous teachers, who
tended to paint women as gauzy,
vapid beauties, Richardson favored
strong, active female sitters, includ-
ing fellow artist Laura Coombs
Hills and Mary Baker Eddy,
founder of the Christian Science
Church. As *A Motion Picture* may
imply, Richardson was known for
painting her sitters so truthfully that
many felt her portraits were unflat-
tering. Unfortunately, Richardson's
commissions dwindled with the
Depression, and she closed her
studio in 1943.

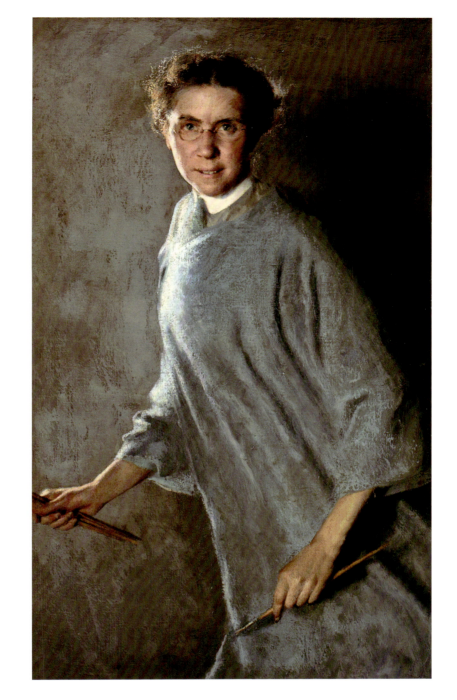

PLATE 118
Morton Livingston Schamberg
1881–1918
STUDENT 1903–06
EXHIBITOR 1904–10

View from the Side Boxes (Opera), ca. 1910–11
Oil pastel on paperboard
5 3/8 x 7 5/16 inches
(13.7 x 18.6 cm)
Purchased with funds from the Joseph E. Temple Fund, Mrs. Robert P. Levy, Mrs. Kenneth W. Gemmill, and Frank and Betsy Goodyear, 1982.4

Schamberg studied architecture at the University of Pennsylvania before enrolling at the Pennsylvania Academy, where he studied with William Merritt Chase. He took up residence in Paris for three years, where he came under the influence of Cézanne, Picasso, and Matisse. He was joined in Europe by fellow Academy student Charles Sheeler, and when they returned to Philadelphia in 1910, they shared studio space in the same Chestnut Street building, as well as a farmhouse in Doylestown.

The intensity of the yellows and oranges in *View from the Side Boxes* reveals the influence of Fauvism on Shamberg's work during this period. He dated few pieces from 1909 to 1912 and, as a result, there is uncertainty about the location depicted, but it may be a view from Philadelphia's Academy of Music. Schamberg helped to organize Philadelphia's earliest modern art exhibitions, and he had works included in the 1913 Armory Show. He became involved with several members of the artistic avant-garde, including Marcel Duchamp, Francis Picabia, and Alfred Stieglitz, who recommended that he also take up photography. Becoming affiliated with the New York Dada movement, he collaborated with the Baroness Elsa von Freytag-Loringhoven on the first American Dada "Readymade," an assemblage of plumbing pipes in a meter box entitled *God*. Tragically, Schamberg died at age thirty-seven from the Spanish influenza epidemic that swept through the nation in 1918.

PLATE 119
Marsden Hartley
1877–1943
EXHIBITOR 1933–43

Flower Abstraction, 1914
Oil on canvas, with painted
wood frame
42 ⅜ x 34 ⅞ inches
(exclusive of frame)
(107.6 x 88.5 cm)
The Vivian O. and Meyer P.
Potamkin Collection, bequest of
Vivian O. Potamkin, 2003.1.4

Poet, critic, and artistic rebel, Hartley became associated with Alfred Stieglitz's 291 gallery, where he had his first solo show in 1909. While in New York, he became familiar with other American avant-garde artists such as Arthur G. Dove and John Marin. It was Stieglitz who arranged for Hartley to spend a year in Paris, where he befriended avant-garde writer and art collector Gertrude Stein. Hartley admired the writings of Emerson, Thoreau, and Whitman, writers in whom he found a shared focus on the importance of nature to human existence.

Flower Abstraction is a prime example of the paintings Hartley executed in Berlin between late winter of 1914 and the end of 1915. During this period, his well-known *War Motifs* combined symbols from flags and military insignia, such as bars, medals, and stripes, into flat decorative patterns. The bold, brightly colored forms reflect the influence of the French painter Robert Delaunay, whose work Hartley saw in Berlin, as well as the overlapping and intersecting planes of Picasso's Synthetic Cubism. In *Flower Abstraction*, which was painted

at the end of his Berlin period, Hartley moved beyond literal military motifs to a more abstract and independent arrangement. The brilliant colors and jagged forms seem to burst forth out of the canvas, spilling across the colorful border onto the narrow inner frame, which incorporates motifs from the main composition.

PLATE 120
Arthur B. Carles, Jr.
1882–1952
STUDENT 1900–07
FACULTY 1917–25
EXHIBITOR 1905–46

An Actress as Cleopatra
(Mercedes de Cordoba), 1914
Oil on canvas
30 3/16 x 25 1/8 inches
(76.7 x 63.8 cm)
John Lambert Fund, 1915.3

Indissolubly linked with the Pennsylvania Academy, Arthur B. Carles, Jr., is one of the most important, if underrated, figures in modern American painting—and certainly in the history of Philadelphia art. His travels in France between 1907 and 1910, as well as subsequent visits in 1912, 1921, and 1929, exposed him to artistic experiments in spatial arrangement, form, and color. Friendships with Edward Steichen, Alfred Stieglitz, and John Marin kept him abreast of American developments—as did his participation in the 1913 Armory Show, the exhibition that introduced mod-

ernism to America. Carles's own expressive color and abstract forms proclaimed his allegiance to progressive principles. His teaching, both at the Academy from 1917 to 1925 and in private arrangements, encouraged a generation of young artists to develop their own cutting-edge styles.

When Mercedes de Cordoba met Carles in New York in 1904, she had already modeled for Steichen. They renewed their friendship in France, where de Cordoba worked as an illustrator and correspondent for *Vogue*. After their marriage in 1909, she became the subject of

several of her husband's paintings. This work shows de Cordoba attired in an elaborate, vaguely Egyptian costume. The title of "actress," although merely descriptive then, proved prophetic: de Cordoba had a role in a Broadway production of *As You Like It* in 1923, one year after the couple's divorce.

PLATE 121
Arthur B. Carles, Jr.

Composition No. 6, 1936
Oil on canvas
40 ¾ x 51 ¼ inches
(103.5 x 130.2 cm)
Gift of Joseph Wood, Jr., 1957.25

Executed in 1936, in the last years of his career, this painting represents Arthur B. Carles's continuing explorations of the expressive power of color, for which the artist had long been noted. Reds, violets, and greens set up a forceful counterplay of primary, secondary, and tertiary colors. Carles was greatly influenced by the vivid coloristic effects of Matisse and Cézanne, whose work he certainly could have seen in his French residency of 1907–10, not to mention in three separate group exhibitions featuring Cézanne during Carles's extended visit to Paris in 1912. The jagged, interpenetrating

forms of the composition, however, represent a new area of interest for Carles that had begun to solidify in the previous decade, also based on his European experiences. The spatial investigations of Cubism, developed initially by Picasso and Braque, were widely disseminated by other artists such as the so-called Puteaux Group. The 1912 Salon d'Automne—where Carles himself exhibited a still life—featured the Maison Cubiste, an installation of Cubist paintings by the Puteaux Group. *Composition No. 6* is a triumphant union of twin strands of modernist interest by a painter who

continually responded to his era's dramatic artistic changes.

204

PLATE 122
Henry McCarter
1864–1942
STUDENT 1879–82
FACULTY 1900–42
EXHIBITOR 1890–1943

Symphony, by 1915
Oil on canvas
103 ⅜ x 100 ⅜ inches
(262.6 x 255 cm)
Gift of Mrs. Henry Clifford,
1944.33

One of the earliest faculty members to reflect a modernist sensibility, Henry McCarter was affiliated with the Pennsylvania Academy for almost forty-five years. As an Academy student, he studied under Thomas Eakins, but Eakins's emphasis on realism alienated the dreamy McCarter. More influential was McCarter's study in Paris in the late 1880s with such artists as Pierre Puvis de Chavannes and Léon Bonnat, and his apprenticeship in the lithography workshop of Henri de Toulouse-Lautrec. McCarter was fascinated by myth and mysticism and spent nine months at Trinity College in Dublin studying Irish folklore and the ninth-century illuminated Book of Kells. Returning to America, he became one of New York's most sought-after magazine illustrators. In 1900, McCarter was asked by Harrison Morris to teach an illustration class at the Academy, and he remained as an instructor until his death forty years later.

Many of McCarter's foremost artistic concerns—experimentation with nonliteral color, attention to light effects, desire to visually represent sound—are evidence of his modernist mindset. His openness to new ideas influenced his students, who included important American modernists Arthur B. Carles and Charles Demuth. McCarter's beautiful draftsmanship, his love of the fantastic, his regard for the vibrant colors of Gauguin and Matisse, and his study of illuminated manuscripts can all be seen clearly in *Symphony*.

Gaston Lachaise
1882–1935

Peacocks, 1918
Bronze with gilding on stone
base; lost-wax cast in 1922
22 ¼ x 55 ¾ x 9 inches
(56.5 x 141.5 x 22.9 cm)
Gift of Mr. and Mrs. Lawrence
Katz, 1985.8

Lachaise entered the Ecole des
Beaux Arts at age sixteen, where he
began a promising career as a classi-
cally trained sculptor. He showed
annually at the Paris Salon and twice
finished second in the *Prix de Rome*
competition. In 1905, however, he
abandoned this path to pursue his
future wife, Isabel Dutaud Nagle,
who had moved to Boston. To fund
his trip, Lachaise worked for a year
in the studio of the Art Nouveau
designer René Lalique. In 1912, he
moved to New York, where he began
working as an assistant in the studio
of Paul Manship, while also becom-
ing acquainted with the New York

avant-garde. In the 1920s, Lachaise
became a contributing artist to the
journal *The Dial*, which featured the
writings of T. S. Eliot, e.e. cum-
mings, and Henry McBride, and art
by Pablo Picasso, John Marin, and
Charles Demuth.

While best known for his figu-
rative abstractions depicting his
wife, throughout his career Lachaise
executed a wide range of animal
sculptures in which he aspired to
"translate spiritual forces." The pea-
cock has been a favorite subject in
Western art since Roman antiquity
and was particularly popular during
the early twentieth century as a

motif in Art Nouveau imagery.
Peacocks reveals Manship's influence
in its frontal orientation, emphasis
on silhouette, simplification of
forms, and use of gilding.

PLATE 124
Mahonri Young
1877–1957
EXHIBITOR 1906–25, 1940–41

Man with a Pick, 1915
Bronze with black patina;
lost-wax cast in 1918
28 ¼ x 8 x 10 inches
(71.7 x 20.3 x 25.4 cm)
Gift of Mrs. John Wintersteen,
1982.11

A grandson of the Mormon leader
Brigham Young, Mahonri Young
was born in Utah and in 1899 went
to New York and Paris for his train-
ing. Best known as a sculptor, he
also enjoyed success as a painter and
printmaker. His subjects reflected
the wide range of his experience:
from the Native Americans, cow-
boys, and animals of the Southwest
to the boxers and construction
workers of New York and Paris.
Modeled in 1915, *Man with a Pick* is
one of Young's many sculptures
depicting workingmen. Aesthetic
considerations rather than social
comment drove his choice of sub-
jects. He delighted in the balance
and poise of working people and in
the rhythmic nature of their tasks.
For the most part, American art
patrons found these subjects unin-
teresting, although Young's series of
boxers of the mid- to late 1920s
found some buyers. During his
Paris studies, Young assimilated the
Beaux-Arts style, which is character-
ized by actively worked surfaces.
The result can be seen here in the
profusion of broken planes that
reflect light and create a sense of
movement.

PLATE 125
Walker Hancock
1901–1998
STUDENT 1920–24
FACULTY 1926–67
EXHIBITOR 1922–62
MEDAL 1953

Head of a Finnish Boy, 1939
Terracotta
15 ¾ x 8 ¼ x 8 ½ inches
(40 x 21 x 21.6 cm)
Gift of James P. and Ruth
Marshall Magill, 1957.15.11

Walker Hancock was educated at
Washington University in his native
Saint Louis between 1918 and 1920,
and at the Pennsylvania Academy
under Charles Grafly, from 1920 to
1924. After four years of study at the
American Academy in Rome, he
became Grafly's hand-picked succes-
sor, heading the sculpture program
at the Academy for thirty-eight
years. From 1930 until his death,
Hancock maintained a residence
and studio in Gloucester,
Massachusetts, and frequently used
as his models members of the large
Finnish community there. The sitter
for the sensitively modeled *Head of
a Finnish Boy* was Alwin Jussila from
the nearby town of Lanesville.
Grafly's influence can be seen in the
handling of forms and the strong
sense of anatomy. During his teach-
ing career, Hancock also executed
commissions for commemorative
sculptures, medals, and war memo-
rials. His most famous work, the
Pennsylvania Railroad War
Memorial (1952), a monumental
figure of an angel lifting up a fallen
soldier, dominates the waiting room
of Philadelphia's Thirtieth Street
Station. Considered by many to be
the dean of American figurative
sculpture, Hancock won numerous
awards and important commissions
during his seven-decade career.

Daniel Garber
1880–1958
STUDENT 1899–1905
FACULTY 1909–58
EXHIBITOR 1902–56
MEDAL 1929

Quarry, 1917
Oil on canvas
50 x 60 inches (127 x 152.4 cm)
Joseph E. Temple Fund, 1918.3

Despite the Impressionist color and light that give a sense of *plein-air* immediacy to this work, *Quarry* was executed in the studio from a preparatory drawing and notes. The carefully constructed composition, with horizontal bands of sky, land, and water, is overlaid with a unifying surface of small, delicate brush strokes, characteristic of Garber's work. The scene depicted is on the Delaware River across from Limeport, Pennsylvania, not far from New Hope, where many of Pennsylvania's Impressionist painters gathered in the early decades of the twentieth century. Garber, one of the leading members of the group, was trained at the Pennsylvania Academy by Thomas Anshutz and shared with his teacher an understanding of traditional realist drawing and a love of bright pastel colors and sunlit landscapes, here showing the scarred landscape of industrial America.

PLATE 127
Daniel Garber

Portrait of Walter H. Gardner,
1922–23
Charcoal on buff laid paper
24 ½ x 18 inches (62.2 x 45.7 cm)
Gift of Walter H. Gardner,
1988.1

In melding the seemingly antithetical styles of the academic mode and Impressionism, Garber combined skillful technique, exacting compositional strategy, and a sensitivity to color in his light-filled canvases. As an instructor at the Academy for more than forty years, he represented the conservative faction, which stressed rigorous technical training over experimentation. Garber was one of the pioneering artists among the American Impressionists who found inspiration in the landscape around New Hope, in Pennsylvania's Delaware Valley. While he is best known as a painter, Garber was also an extremely skillful graphic artist. His drawings and prints equal his work in oil. Garber acquired his love for charcoal drawing while he was a student at the Academy, a pursuit encouraged by his teacher Thomas Anshutz.

Walter Gardner was a student of Garber's from 1921 to 1928 and on occasion teacher and student spent evenings sketching or posing for one another. This image of Gardner is characteristic of Garber's portrait drawings: a tightly rendered figure bathed in dramatic light, set against a sketchy, shadowy background.

PLATE 128
Florine Stettheimer
1871–1944
EXHIBITOR 1944

Picnic at Bedford Hills, 1918
Oil on canvas
40 5⁄16 x 50 ¼ inches
(102.4 x 127.6 cm)
Gift of Ettie Stettheimer, 1950.21

Born into a wealthy New York fami-
ly, Stettheimer studied at the Art
Students League of New York before
obtaining further training in
Munich and Paris during a fifteen-
year European sojourn. Upon the
outbreak of World War I, her family
returned to New York and quickly
came to dominate the city's progres-
sive art circles. The Stettheimer
salon drew the major avant-garde
figures in the twenties and thirties,
including Marcel Duchamp, Elie
Nadelman, and Carl Van Vechten.

At this time, Stettheimer
moved away from conventional
academic practice to develop her
own self-consciously "naive" mod-
ernism of simple forms and vivid
colors, derived from both European
and Asian sources. In a series of
conversation-piece portraits,
Stettheimer depicted her friends and
family with a wry intimacy and
warmth. *Picnic at Bedford Hills* por-
trays the Stettheimer sisters relaxing
with Nadelman and Duchamp in a
vibrant landscape, while laborers
plow the neighboring field.

PLATE 129
Elie Nadelman
1882–1946
EXHIBITOR 1921

Chanteuse, ca. 1918
Painted cherry wood
36 x 17 x 10 inches
(91.4 x 43.2 x 25.4 cm)
The Vivian O. and Meyer P.
Potamkin Collection, bequest of
Vivian O. Potamkin, 2003.1.7

Already an established artist and a
member of the Parisian avant-garde,
Warsaw-born Nadelman emigrated
to America in 1914 with the advent
of World War I. While his previous
sculptural work had evinced influ-
ences as diverse as classical antiquity
and Cubism (which he later claimed
to have invented), soon after arriving
in the United States, Nadelman's
work began to reflect his fascination
with American folk art. "I employ
no other line than the curve, which
possesses freshness and force,"
Nadelman stated, explaining that he
sought to create harmony through
the interplay of concave and convex
forms. Certainly the graceful curves
of *Chanteuse* embody this notion,
from the lyrical arc of the singer's
arms as she stands poised to perform
to the rhythmic cascade of her hair
and the fluted folds of her skirt. In
emulation of the wooden folk art
pieces he admired, Nadelman delib-
erately "weathered" his pieces,
resulting in the haunting face of this
figure which suggests the ravages of
time and the elements.

PLATE 132
Robert Henri
1865–1929
STUDENT 1886–94
EXHIBITOR 1892–1929

Ruth St. Denis in the Peacock Dance (1878–1968), 1919
Oil on canvas
85 x 49 inches (215.9 x 124.5 cm)
Gift of the Sameric Corporation in memory of Eric Shapiro, 1976.1

The driving force behind the formation of The Eight and the de facto leader of the so-called Ashcan School, Henri trained at the Pennsylvania Academy under Thomas Hovenden and Thomas Anshutz before seeking further study in Europe. Henri returned to Philadelphia in 1891 and embarked on his influential teaching career. While his crusading "art spirit" championed his students' freedom and experimentation, Henri's own work strayed little from his realist training. His greatest innovation was in painting contemporary scenes with an unflinching eye, even scenes considered ugly.

As with many of his compatriots among the Ashcan painters, Henri had an avid interest in the theater, evidenced by this striking full-length portrait of the celebrated modern dance pioneer Ruth St. Denis. Captivated by St. Denis's soon-to-be-legendary performance at New York's Palace vaudeville house, Henri asked the dancer to pose for what he called "a mighty propaganda." St. Denis's choreography was frequently inspired by non-Western sources, and she based this role on an Indian legend of a woman who is turned into a peacock because of her extreme vanity. Henri painted St. Denis in her exotic costume of shimmering violet and green, her sinuous pose reflective of the dance's graceful movement.

PLATE 133
Robert Henri

Wee Maureen, 1926
Oil on canvas
24 x 20 inches (61 x 50.8 cm)
Gift of Mrs. Herbert Cameron
Morris, 1962.17.1

Ohio-born, Nebraska-raised Robert Henri studied at the Academy before studying and traveling in Europe, where the expressive brushwork of Velázquez and Hals influenced his work. After settling in New York, Henri adapted this style to modern-day subjects and portraits. With a cadre of students and friends—some of whom had also studied at the Academy—Henri organized an independent group exhibition in 1908 at the Macbeth Gallery in New York to protest the conservative exhibition policies of the National Academy of Design.

Although described as The Eight, the artists were later dubbed the Ashcan School because of their attention to scenes of modern life. After 1909, Henri began to experiment with an increasingly vibrant palette based on advanced color theory, an approach vividly apparent in *Wee Maureen*, the portrait of a child from the Irish village of Dooagh, which Henri visited yearly. The grave but charming painting triumphantly unites Henri's interest in color with the thick impasto and bold handling that had marked his entire career—as well as remaining a testament to the

artist's empathy with his subjects. An influential teacher, Henri published his lectures on art in 1923 in *The Art Spirit*.

PLATE 134
John Sloan
1871–1951
STUDENT 1893–94
EXHIBITOR 1901–51

Jefferson Market, 1917,
retouched 1922
Oil on canvas
32 x 26 ⅛ inches (81.3 x 66.4 cm)
Henry D. Gilpin Fund, 1944.10

A keen observer of modern life, Sloan was influenced by the charismatic Robert Henri but quickly developed into a highly original artist and major figure connected with The Eight and the Ashcan School of realist painters. Born in Lock Haven, Pennsylvania, Sloan had to support his family from a young age but managed to study briefly at the Pennsylvania Academy with Thomas Anshutz. Of the four newspaper reporter-illustrators inspired by Henri to turn to painting, Sloan was the last, after William Glackens, George Luks, and Everett Shinn, to move from Philadelphia to New York. Intimidated by the city initially, he soon acclimated to his new home, finding that New York inspired his strongest paintings and prints. The proximity of his studio to the seedy Tenderloin District particularly affected Sloan, who was fascinated by the life around him, both the action on the streets as well as furtive glimpses into tenement windows.

This image shows the view out of Sloan's Washington Place studio onto Jefferson Market, dominated by the police court tower, also the subject of a number of etchings Sloan executed around the same time. *Jefferson Market* demonstrates Sloan's increasing concern with geometrical composition, involving a complex interplay of verticals, diagonals, and triangles that stemmed from his study of modern painting and shows the impact of the 1913 Armory Show on his work.

PLATE 135
George Luks
1866–1933
STUDENT 1884
EXHIBITOR 1900–33

Polish Dancer, ca. 1927
Oil on canvas, mounted on
masonite
66 ⁵⁄₁₆ x 48 inches
(168.4 x 121.9 cm)
Gift of the Locust Club,
Philadelphia, 1955.1.2

Like his artist comrades in the group influenced by Robert Henri, Luks rejected traditional academic painting in favor of stark realism and modern subject matter. Of the group dubbed the Ashcan School, Luks hewed closest to Henri's model of capturing quickly the vitality of the urban environment in all its grit and gleam. A boisterous, earthy personality and something of a blowhard, Luks briefly studied at the Academy in 1884. After early careers as a newspaper illustrator and comic artist, he became an established painter who participated in both the landmark 1908 exhibi-tion by The Eight and the equally historic Armory Show of 1913.

Luks is widely regarded as the most insightful portraitist among The Eight. He grew up in small Pennsylvania towns where industry attracted immigrants, and his paint-ings reveal sympathy for marginal-ized people. Luks is particularly known for his portraits of New York street characters, affectionate render-ings of distinct personalities and appearances. *Polish Dancer* seems to be an extension of this affinity, with possible antecedents in a series of paintings Luks made in 1918 after meeting a group of Czech émigrés

while visiting his friend Gutzon Borglum, the sculptor of Mount Rushmore. In 1927, *Polish Dancer* was awarded a gold medal by the Locust Club, a men's social organi-zation in Philadelphia.

PLATE 138
Georgia O'Keeffe
1887–1986
EXHIBITOR 1945–62

Red Canna, 1923
Oil on canvas
12 x 9 ⅞ inches (30.5 x 25.1 cm)
The Vivian O. and Meyer P.
Potamkin Collection, bequest of
Vivian O. Potamkin, 2003.1.8

Noted for her sensual abstractions of flowers and southwestern motifs, O'Keeffe is one of the most recognized twentieth-century American artists. Raised in a family that stressed education for women, O'Keeffe attended the Art Institute of Chicago before going to New York to study at the Art Students League. After working as a commercial artist, she accepted a teaching position at Columbia College in South Carolina. In 1916 her paintings came to the attention of Alfred Stieglitz, whose gallery was a venue for European and American avant-garde art, featuring artists such as

Marcel Duchamp, Francis Picabia, Arthur Dove, and Marsden Hartley. Stieglitz's gallery hosted O'Keeffe's first solo show, and he became her most vigorous promoter until his death in 1946. O'Keeffe and Stieglitz married in 1924.

Red Canna is among the earliest of her enlarged, abstracted flower paintings and, despite its small size, demonstrates her interest in imbuing natural phenomena with monumental impact. O'Keeffe loved gardening and was often inspired by a specific flower that she then painted in a consistent color through a series of a dozen or more paintings. In

these extreme close-ups she established a new kind of modern still life with no references to atmospheric effects or realistic details, reflecting her statement, "I paint because color is significant."

Hugh H. Breckenridge

1870–1937
STUDENT 1887–92
FACULTY 1894–1937
EXHIBITOR 1889–1938
MEDAL 1919

The Tree of Life, by 1929
Oil on canvas
37 x 43 inches (94 x 109.2 cm)
Gift of the Fellowship of the
Pennsylvania Academy, 1934.14

Breckenridge's varied body of work is exemplary of the dilemma many artists face. A skillful academic realist painter, Breckenridge saw his many portrait commissions merely as a way of making money. His personal work grew increasingly bold and expressive, particularly in the 1920s, until his engagement with light, mood, and intense color brought him to pure abstraction. *Tree of Life* shows Breckenridge's departure from his earlier Impressionist and Pointillist technique and pastel palette, composing instead with vivid color and an understanding of Cézanne's analysis of form. Structured as if one were looking out from the mouth of a cave into a paradise of light and color, the work relates to other allegorical tree images Breckenridge painted in this period, including a series of studies in which his experimental impulses are particularly energetic and vivid.

Breckenridge began his long association with the Pennsylvania Academy at age seventeen, when he finally overcame his family's objections to his art studies. Within a short time of his 1893 return from European training (made possible by winning the Academy's prestigious Cresson Travel Scholarship), Breckenridge was offered a position at the Academy, serving as a dedicated painting instructor for more than forty years. Along with Henry McCarter and the younger artist Arthur B. Carles, Breckenridge was one of three Academy instructors who brought a modernist spirit to the school in the early twentieth century.

PLATE 140
Earl Horter
1880–1940
EXHIBITOR 1915–40

Toledo, 1924
Gouache on cream watercolor
paper
Sheet 15¼ x 12⅛ inches
(38.7 x 30.8 cm)
Image 13½ x 10⁹⁄₁₆ inches
(34.3 x 26.8 cm)
Gift of Mrs. Thomas E. Drake,
from the collection of her aunt
Margaretta Hinchman, 1955.15.6

As a painter and printmaker, com-
mercial artist, teacher, and collector,
Earl (also spelled Earle) Horter
helped to introduce modern art to
Philadelphia. This brilliant drafts-
man received a silver medal for his
prints at the 1915 Panama-Pacific
International Exposition in San
Francisco. During the 1920s he
began to paint, showing his oils and
watercolors at the Pennsylvania
Academy's annual exhibitions.
His knowledge of modernism was
enhanced by his own activity as a
collector; in 1934 his collection
included seventeen Picassos, as well

as works by Brancusi, Duchamp,
Braque and Matisse.

Horter painted several images
of the Spanish medieval city of
Toledo in oils and watercolor. Like
the Spanish Baroque master El
Greco, Horter exaggerated the
height and thinness of the city's
fortifications; darker tones draw
our eyes to the central towers at
the river's edge and in the distance.
However, Horter's watercolor also
reveals his interest in Cubism,
notably in the spare planes and sim-
plified forms and volumes. Horter's
incomplete edges allow one plane to

merge with another and complicate
the spatial relationships among the
buildings and the stark landscape.
Through these techniques Horter
analyzed the city as a play of form
and space represented on the flat
picture plane.

Lyonel Feininger
1871–1956
EXHIBITOR 1939–56

Possendorf, 1929
Oil on canvas
30 ⅝ x 38 ⅝ inches
(77.8 x 98.1 cm)
Henry D. Gilpin Fund, 1951.5

The son of German immigrants, Feininger returned to Europe to study music and art, supporting himself as a political cartoonist for various German newspapers. After studying at the Berlin Academy he traveled to France in 1906 thanks to the money he earned doing one of the earliest American comic strips, "The Kin-der-Kids" for the *Chicago Tribune.* In Paris, Feininger fell under the influence of Robert Delaunay's Orphic Cubism, a style marked by contrasting colors and abstract forms. Returning to Germany, he exhibited with the *Blaue Reiter* group, and his friend-ship with Paul Klee and Wassily Kandinsky led to his becoming one of the founding members of the Bauhaus School in 1919, led by the architect Walter Gropius. Feininger contributed a woodcut for the cover of the first Bauhaus manifesto.

Possendorf depicts a small village near Weimar, the original home of the Bauhaus School. Feininger used geometric planes of greens, browns, and oranges to articulate the structures and space of this image, concentrating a band of light on the church tower. In 1937, Feininger's paintings were included in the infamous "Degenerate Art" show held by the Nazi party to highlight the "corruptness" of avant-garde art. That same year Feininger and his Jewish wife fled Germany to seek safety in America, where they spent the rest of their lives.

PLATE 142
Oscar Bluemner
1867–1938

Ascension, 1927
Watercolor, gouache, and
Chinese white on wove paper
mounted on board
10 ¼ x 15 ⁵⁄₁₆ inches
(26 x 38.9 cm)
John S. Phillips Fund, 1988.5

Trained as an architect in Berlin, German-born Bluemner emigrated to the United States in 1892 and began painting the landscapes of New York and New Jersey around 1910. He returned briefly to Europe in 1912, where exposure to various new and daring modes of painting invigorated his own work. Bluemner's significance to the burgeoning modernist movement was marked by his participation in the historic Armory Show of 1913, the event that introduced avant-garde art to American audiences. Bluemner also contributed to the equally groundbreaking Forum Exhibition in 1916, which was vetted by Alfred Stieglitz, the New York gallery owner and tastemaker who championed modernism.

Influenced to a degree by movements such as Cubism, Expressionism, and Orphism, Bluemner's work shows more kinship with artists such as Arthur G. Dove and Charles Burchfield, figures independent of specific movements who regarded landscape painting as a profoundly spiritual exploration. Deeply affected by German Romanticism, especially Goethe, and American writers Emerson and Whitman, Bluemner saw his landscapes as deeply personal visions of external reality. As in many of Bluemner's mature works, *Ascension* assembles geometric divisions of intense color into simple architectonic forms within a fantastic landscape, all bathed in a mystical glow.

PLATE 143
Guy Pène du Bois
1884–1958
EXHIBITOR 1906, 1917–49

People, 1927
Oil on canvas
45 ⅛ x 57 ⅞ inches
(114.6 x 147 cm)
Joseph E. Temple Fund, 1943.12

Although painted in France, where Guy Pène du Bois and his family lived from 1924 to 1929, *People* explores the artist's continuing fascination with contemporary American society, both at home and abroad. Du Bois frequently explored themes of the loneliness of the crowd through the representation of upper-class sitters who are active in the world, yet still solitary. In this large painting, the artist literally widened his scope. A group of fashionably dressed men and women stand at the edge of an enigmatic, semicircular space. But for all the

sense of community that such a gathering entails, the obliqueness of the narrative, combined with the painter's characteristic sculptural modeling that renders their features indistinct, gives the scene an impersonal, potentially disturbing aura. Raised in an old Louisiana Creole family transplanted to New York, du Bois studied with William Merritt Chase and Robert Henri, an experience that committed him to representational art. Although hostile toward abstraction, du Bois's works, with their hard edges and massive forms, nevertheless flirt with

modernist styles. A teacher himself, notably at his own school in Stonington, Connecticut from 1932 to 1950, du Bois was also an active art critic, as well as a memoirist.

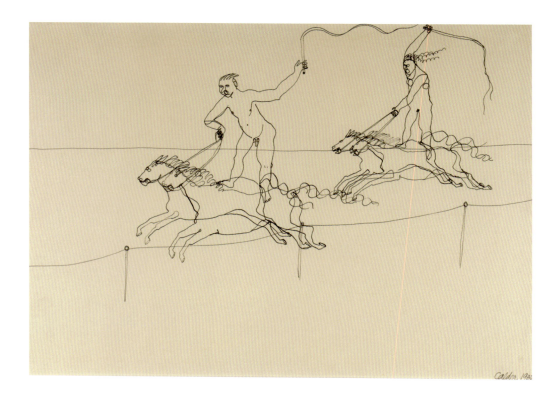

Alexander Calder
1898–1976
EXHIBITOR 1944–66

Equestrians (Circus Riders), 1932
Pen and ink on off-white wove
paper
14 x 19 ⅛ inches (35.6 x 48.6 cm)
Presented by Carl Zigrosser as a
memorial to Leo Asbell,
1961.16.1

Alexander ("Sandy") Calder was a native Philadelphian, the son and grandson of famous sculptors associated with the city (Plate 96). Calder was also one of the first American sculptors to gain recognition in Europe, where he spent much of his time after 1926. His signature sculptural invention was dubbed the "mobile" by the artist Marcel Duchamp. It became one of the most famous icons in twentieth-century art. While studying at the Art Students League in New York in the mid-1920s he discovered the circus world and thus began his lifelong fascination with that milieu. In 1926 in Paris, he created a complex, movable, miniature *Circus* in wire, and in the early 1930s produced more than one hundred drawings of circus subjects. *Equestrians* is typical of the works in this whimsical series, exhibiting Calder's brilliant continuity of line and his subtle economy of means. The first of three Calder works to enter the Academy collection, it would be followed by *Route Barrée* in 1962 (Plate 145), and his six *Bicentennial Tapestries* in 1976.

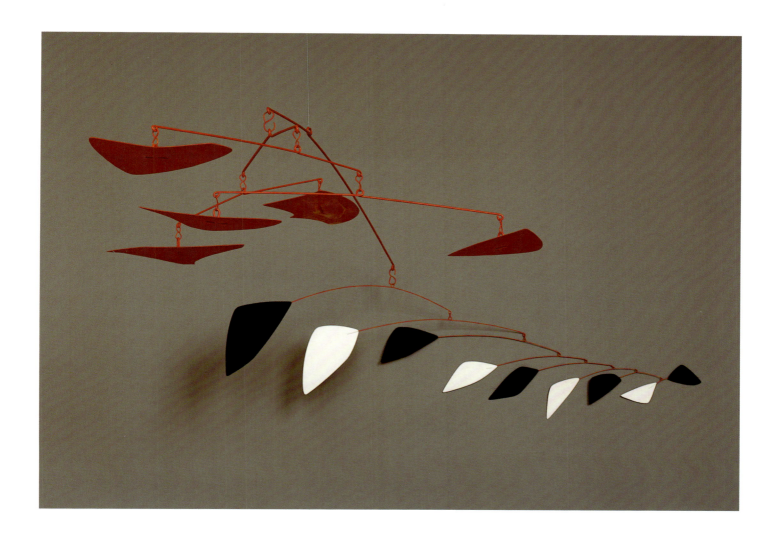

PLATE 145
Alexander Calder

Route Barrée, 1962
Painted sheet metal and steel wire
28 x 130 x 51 inches
(71.1 x 330.2 x 129.5 cm)
Henry D. Gilpin Fund, 1962.16

Alexander Calder departed for Paris in 1926, having earned a degree in mechanical engineering from the Stevens Institute of Technology in Hoboken, New Jersey, and having spent some time studying at New York's Art Students League. A 1930 visit to the studio of the painter Piet Mondrian sparked Calder's interest in strong color and abstraction. At about the same time, he met the Surrealists Joan Miró and Hans Arp, whose organic imagery and interest in compositions determined by the laws of chance fascinated him. His

motorized and hand-cranked sculptures of the next forty years drew from these sources and were developed in increasingly sophisticated depth and size. Sculptures such as *Route Barrée* move in response to natural air currents and thus depend on random action. After 1950, his mobiles, as well as his stationary sculptures (named "stabiles" by Arp), became larger and more monumental. Many have been commissioned for outdoor installations worldwide. In addition to sculpture, Calder fashioned jewelry, illustrated books,

stage sets, and even some industrial and household goods during his long career as one of the most well-known and innovative sculptors of the twentieth century.

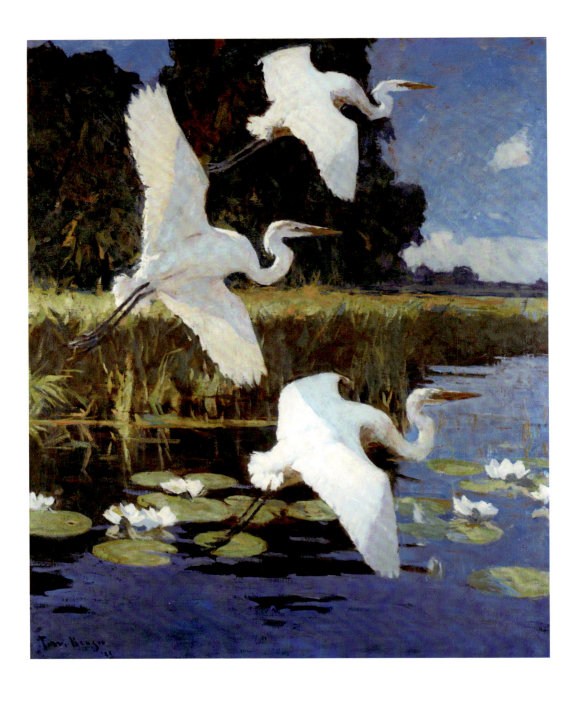

PLATE 146
Frank W. Benson
1862–1951
EXHIBITOR 1885–1950
MEDAL 1926

Great White Herons, 1933
Oil on canvas
44 x 36 ⅛ inches
(111.8 x 91.8 cm)
Joseph E. Temple Fund, 1934.2

Frank W. Benson was a founding member of Ten American Painters, a group of artists who broke away from the juried Society of American Artists exhibitions in order to control the manner in which their works were displayed. This they did through artist-organized, noncompetitive group shows in New York, Boston, and other cities between 1898 and 1918 that paid careful attention to the arrangement of works, down to the colors of gallery walls. With his great friend Edmund C. Tarbell, a classmate, colleague, and fellow member of the Ten,

Benson was one of the leading painters in Boston in the late nineteenth and early twentieth centuries. Skilled in oil, watercolor, and etching, the artist taught for many years at the National Academy of Design. His 1896 murals for the Library of Congress remain some of his most acclaimed work. Although best known for his Impressionist-influenced depictions of women and children, Benson was equally adept as a painter of wildlife, as this late painting amply displays. The realism of the herons in flight testifies to the studies of nature informing all of

Benson's works. At the same time, the deep colors and shallow space of the lily pads and marshy landscape behind the birds create a highly decorative pattern in a synthesis of realism and artifice.

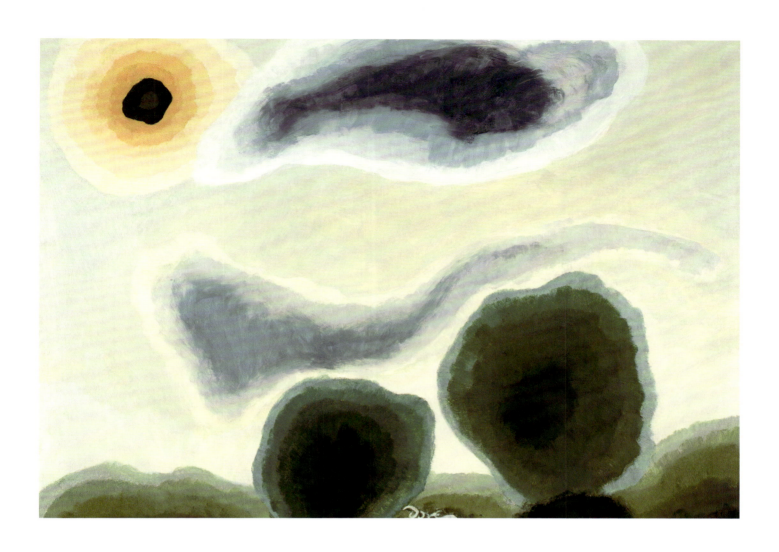

PLATE 147
Arthur Garfield Dove
1880–1946
EXHIBITOR 1944–45

Naples Yellow Morning, 1935
Oil on linen
25 ⅛ x 35 inches (63.8 x 88.9 cm)
The Vivian O. and Meyer P.
Potamkin Collection, bequest of
Vivian O. Potamkin, 2003.1.2

Shortly before Dove moved to Geneva, New York in 1933 he abandoned his experiments with collage and committed himself "to let go of everything and just try to make oil painting beautiful in itself." An avid reader of painting manuals, he studied mediums compatible with oil, and in the fall of 1935 he devoured Max Doerner's *Materials of the Artist* (1934). Propelled by his reading, he began to experiment with resin oil color and oil over tempera, "fat over lean," as Doerner recommended. In so doing, Dove discovered that he could create new clarity and brightness as well as texture and depth to his colors, and that his paintings, in turn seemed almost to pulsate with energy and vitality. *Naples Yellow Morning* derives its title from the color used by the old masters and praised by Doerner for its purity. By placing short, thinned, almost translucent brushstrokes over underlying hues of different intensity, Dove discovered that he could create the impression that the thick warmth of the sun was literally impregnating the forms in his composition.

Arthur Dove is acknowledged as one of the first artists to work in this modern manner. Like his friends John Marin and Georgia O'Keeffe, Dove revitalized American landscape painting by transcribing his responses to natural motifs through increasingly personal, simplified, and witty paintings and drawings.

PLATE 148
William J. Glackens
1870–1938
STUDENT 1894–95
EXHIBITOR 1894–1938

The Soda Fountain, 1935
Oil on canvas
48 x 36 inches (121.9 x 91.4 cm)
Joseph E. Temple and Henry D.
Gilpin Funds, 1955.3

One of the artists connected with the rebellious group known as The Eight, and by extension a prominent member of the Ashcan School, Glackens attended night classes at the Pennsylvania Academy while working as an artist-reporter for various Philadelphia newspapers. Encouraged by Robert Henri, he traveled to Paris in 1895, where he developed an enthusiasm for the paintings of the French Impressionists, especially Pierre-Auguste Renoir. He later purchased works by Renoir and other French modernists while serving as an art advisor to his high school friend the noted collector Albert C. Barnes.

Glackens is known as a painter of genre scenes of middle-class life. Although his early genre images were characterized by their sketchy effects, *The Soda Fountain* was painted in a more academic style typical of his later work. The model for the soda clerk was the artist's son Ira, who stated that his father had assembled a rough approximation of a soda fountain in his studio for this painting. Renoir's influence on Glackens, from the feathery brushstrokes to the strident edge of the pastel palette, is emphatic in this work.

PLATE 149
Charles Sheeler
1883–1965
STUDENT 1903–06
EXHIBITOR 1907–58

Clapboards, 1936
Oil on canvas
21 ⅛ x 19 ¼ inches (53.7 x 48.9 cm)
Gift of W. Griffin Gribbel, R. Sturgis Ingersoll, John Frederick Lewis, Jr., William Clarke Mason, Henry T. McIlhenny, Lessing J. Rosenwald, Alfred G. B. Steel, Mrs. George F. Tyler, William L. Van Alen, and Joseph E. Widener, 1939.19

Capturing the rise of industry through a meticulous realism, Sheeler was a prominent figure in American modernism before World War II. Born in Philadelphia, he studied art at the Pennsylvania Academy with William Merritt Chase. Early in his career, Sheeler supported himself as an architectural photographer in order to maintain his studio. From 1910 to 1919, he traveled to Bucks County on the weekends, photographing and painting subjects such as barns, farmhouses, and factories. During the 1920s, Sheeler became associated with artists now called the

Precisionists, a term used to describe individuals who painted in a realistic style emphasizing a precise depiction of industrial subjects.

By 1929, Sheeler began to more overtly base his paintings on photography through a technique that combined the visual crispness of photographs with painterly effects. *Clapboards* reveals these concerns in the numerous parallel lines that carefully order this vision of suburban rooftops framed by the branches of two trees. The regularity of the forms displays Sheeler's interest in the underlying geometry and rational order that define the man-made

world. While better known for his representations of industry and machinery, *Clapboards* shows Sheeler's continued interest in vernacular architecture.

Julius T. Bloch
1888–1966
STUDENT 1908–13
FACULTY 1947–62
EXHIBITOR 1913–62

Lynching, 1936
Oil over egg tempera on gessoed
board
25 1/16 x 16 inches
(63.7 x 40.6 cm)
Gift of the Free Library of
Philadelphia, 1958.5

With the thoughtful insight of an outsider, Bloch expressed through his paintings and graphic works the divide between idealism and the reality of social injustice. The only son of a German-Jewish family, Bloch emigrated to Philadelphia at age five. He studied at the Pennsylvania Academy, responding particularly to the lingering influence of former instructor Thomas Eakins. Bloch was drafted into service during World War I and never fully recovered from the horrors he witnessed. His leftist politics dovetailed with the humanitarian aspects of the Works Progress Administration (WPA), the Depression-era government program for artists, for which Bloch created empathetic works hailing the dignity of the individual. Bloch joined the Academy faculty in 1947.

Beginning in the 1930s, Bloch increasingly turned to African-American subject matter in his work. In 1935 he played an instrumental role in organizing the NAACP's exhibition *An Art Commentary on Lynching*, protesting this atrocity that had come to be viewed as a prime symbol of racism in America. He explored the disturbing theme in a number of works, including *The Lynching*, 1932, now in the Whitney Museum of American Art, a work that significantly enhanced Bloch's reputation.

PLATE 151
Robert Gwathmey
1903–1988
STUDENT 1926–30
EXHIBITOR 1934–66

Street Scene, 1938
Oil on canvas
36 3/16 x 30 1/16 inches
(91.9 x 76.4 cm)
Joseph E. Temple Fund, 1942.4

A Virginian from Richmond, Gwathmey was a social activist deeply engaged with issues of racism, political injustice, and militarism. Educated at the Pennsylvania Academy, he became involved with several radical organizations in Philadelphia concerned with the plight of the working class. In 1942, these activities led the FBI to put Gwathmey under surveillance for the next twenty-two years. He was an active participant in the Civil Rights movement and opposed the United States participation in the Vietnam War. Gwathmey formed close relationships with other socially conscious artists, such as Phillip Evergood, Jacob Lawrence, and Ben Shahn.

In 1938, Gwathmey destroyed many of his early paintings, feeling they were too heavily influenced by his teachers. *Street Scene* shows the subject matter and visual language that would preoccupy him for the next two decades: scenes of African-American life in the rural South, executed in a simplified visual language rooted in folk art. Twenty figures partake in a range of early-evening activities, including resting, conversation, playing checkers, and carrying laundry. The town's roofs form an abstract pattern of triangles, and three churches loom in the distance. Gwathmey's wife Rosalie was a photographer who took images of the rural South that often became the basis for his compositions.

PLATE 152
Reginald Marsh
1898–1954
EXHIBITOR 1932–52

*End of 14th Street Crosstown
Line*, 1936
Egg tempera on composition
board
24 x 36⅛ inches (61 x 91.8 cm)
Henry D. Gilpin Fund, 1942.7

A highly educated and sophisticated man, Marsh cultivated a populist reputation as an urban realist during the 1930s. The son of artists, Marsh studied at Yale and the Art Students League as a young man. Like the artists of the Ashcan School in the previous generation, he worked as an illustrator for various New York newspapers and magazines, an experience that influenced his choice of subject matter when he turned to painting. Later associated with the "Fourteenth Street School"—a group named after a busy crosstown street in Lower Manhattan that also included Isabel Bishop and Raphael Soyer—Marsh specialized in scenes of pulsating street life around New York's Union Square.

Despite his privileged origins in an upper-class family, Marsh was deeply affected by the plight of the common man, and portrayed scenes of New York life from Depression-era breadlines to the beaches at Coney Island. Painted during an era of labor unrest in Union Square, *End of 14th Street Crosstown Line* juxtaposes construction workers tearing up old trolley car lines with picketers demonstrating against Ohrbach's, a store that had refused to allow its workers to unionize.

Masterfully painted in egg tempera, a demanding technique he had been using since the late 1920s, the work exhibits Marsh's use of signs and other graphics to enhance meaning.

PLATE 153
Isabel Bishop
1902–1988
EXHIBITOR 1930–69

Young Woman, 1937
Oil and egg tempera on
masonite
30 x 21¼ inches (76.2 x 54 cm)
Henry D. Gilpin Fund, 1938.2

Isabel Bishop was born in
Cincinnati but moved East in 1918,
where she enrolled at the New York
School of Applied Design for
Women and then the Art Students
League, beginning in 1920. In the
city—especially in the area around
Union Square—Bishop was inspired
by the bustle of urban life, particu-
larly by the young women of New
York, who were entering the work
force in ever increasing numbers. In
paintings and prints, Bishop explored
both the women and the men of
New York, as they interacted with
their jobs, each other, and the city.

Although Bishop's subject may
be modern, the technique she chose
for this painting recalled those of the
old masters, whose work she discov-
ered after a trip to Europe in 1931.
The use of egg tempera (the combi-
nation of pigments dissolved in egg
yolk) was employed in European
painting before the widespread
dominance of oil-based pigments in
the seventeenth century. Not only
did the exacting process account for
the delicate glazes visible in the
painting, it also demanded an
extraordinary amount of time.
Bishop sometimes spent nearly an

entire year working on a single
painting, belying the simple and
often ephemeral quality of the
finished work.

PLATE 154
Dox Thrash
1893–1965
EXHIBITOR 1933, 1946

Second Thought (also known as
My Neighbor), recto, 1939
Carborundum, aquatint, and
mezzotint on wove paper
Sheet 12 ⅞ x 10 inches
(32.7 x 25.4 cm)
Image 8 ⅞ x 6 ⅞ inches
(22.5 x 17.5 cm)

East Side, verso, 1939
Carborundum, aquatint, and
mezzotint on wove paper
Sheet 12 ⅞ x 10 inches
(32.7 x 25.4 cm)
Image 9 ⅞ x 7 ⅞ inches
(25.1 x 20 cm)
Pennsylvania Academy Purchase
Fund, 1999.21a, b

Thrash headed the Graphic Arts
division of the Works Progress
Administration (WPA) in
Philadelphia from 1935 to 1942,
during which time he invented the
Carborundum printmaking process.
Carborundum is the trade name of a
coarse, granular industrial product
made of carbon and silicone, tradi-
tionally used for grinding and pol-
ishing. Thrash used the material to
clean lithographic stones and subse-
quently discovered its ability to pit
the surface of copper etching plates
in subtle gradations. By burnishing
areas of the pitted plate where he
did not want ink to hold, the artist

defined his imagery. The overall
effect is related to the mezzotint,
which is typically characterized by
rich intaglio impressions.

Thrash made this rare double-
sided print during his tenure at the
Philadelphia WPA. The dual
images—one a dignified portrait of
an African American in reverie
(*Second Thought*) and the other a
scene of the Philadelphia waterfront
with a worker, railroad, and skyline
(*East Side*) represent the two major
focuses of Thrash's work: portraiture
and urban/industrial landscapes.

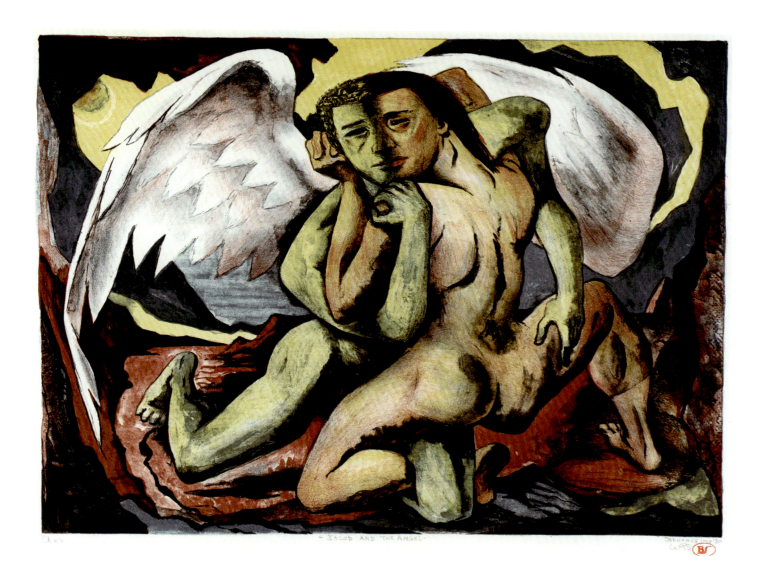

PLATE 155

Benton Murdoch Spruance

1904–1967

STUDENT 1925–29

EXHIBITOR 1932–67

Vanities II: Jacob and the Angel,
1950
Four-color lithograph on
off-white wove paper
Sheet 16 (irr.) x 22 ¾ inches
(40.6 x 57.8 cm)
Image 13 ⅞ x 18 ⁹⁄₁₆ (irr.) inches
(35.2 x 47.2 cm)
Gift of Mrs. Benton Murdoch
Spruance, 1975.5.21

A seminal figure in twentieth-century graphic arts, Benton Spruance did much to elevate printmaking's status. Spruance won a scholarship to the Pennsylvania Academy in 1925, where he was awarded the prestigious Cresson Travel Scholarship two years in a row. He was first introduced to lithography in 1928 while in Paris on the first scholarship, and over the course of his lifetime Spruance broadened the possibilities of the medium, particularly in the use of color. A native Philadelphian, Spruance was an idealist and activist crucial to the city's mid-century renaissance, notably a program whereby

one percent of the cost of a public building is allocated for art. Spruance was also a gifted instructor of both studio practice and art history who taught widely in Philadelphia.

Spruance's ethical concerns meshed particularly well with lithography, long established as a forum for political and satirical messages, and he was committed to creating art that, while personal and expressive, communicated a message. He frequently turned to mythological, religious, and biblical themes in his work, as in this image, the first of his depictions of Jacob wrestling an angel (Genesis 32:22–32), a theme

and composition he revisited in 1952 and 1956. One in a series of five biblical images from the *Vanities II* series, *Jacob and the Angel* illustrates Spruance's deep admiration for William Blake, as well as several of his technical innovations in color lithography.

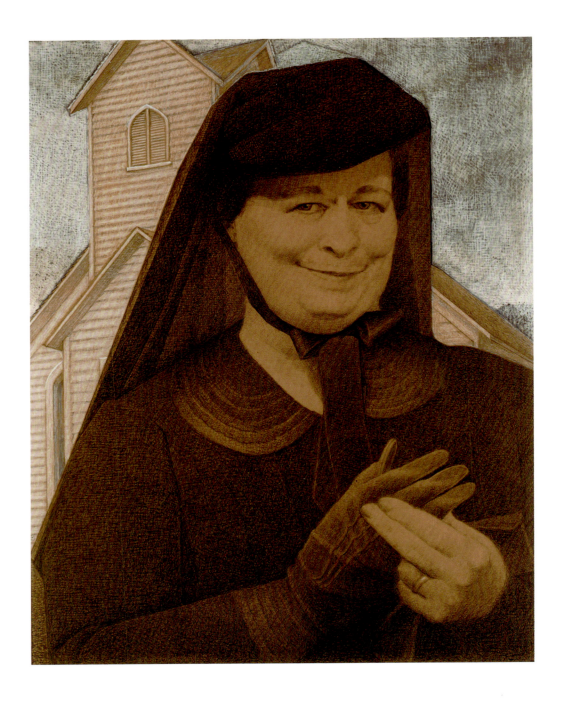

PLATE 156
Grant Wood
1892–1942
EXHIBITOR 1931, 1937

The Good Influence, 1936
Black carbon pencil, india ink,
and white gouache on tan wove
paper adhered to masonite
Sheet 30 ¾ x 24 ¼ inches
(78.1 x 61.3 cm)
Image 20 ½ x 16 ¼ inches
(52.1 x 41.3 cm)
Collections Fund, 1952.6.2

In 1930 Grant Wood painted his most famous work, the double portrait *American Gothic*, and instantly gained national recognition as a leader of the regionalist school. Trained as a painter at the Art Institute of Chicago and at the Académie Julian in Paris, Wood returned to his native Iowa where he taught art in the public schools of Cedar Rapids from 1919 to 1924, and subsequently as artist-in-residence at the University of Iowa from 1935 to 1942. His visions of the American heartland are stylized landscapes and penetrating portraits combining both irony and realism.

In 1936, New York publisher George Macy proposed a special edition of Sinclair Lewis's signature book, *Main Street*, illustrated with drawings by Wood to be offered by his Limited Editions Club. Wood produced nine illustrations for the book including *The Good Influence*. Lewis's character Mrs. Bogart is brilliantly satirized in Wood's depiction of a fashionable widow, an upstanding icon of her Midwestern community, prominently posed in front of the straight-edged architecture of her Baptist church. Yet her face, with its calculating eyes and self-satisfied smile, reveals her truer

nature as a sanctimonious gossip and morality judge of her town. Wood's model for this drawing was Mrs. Mollie Green, hostess at Iowa City's leading hotel.

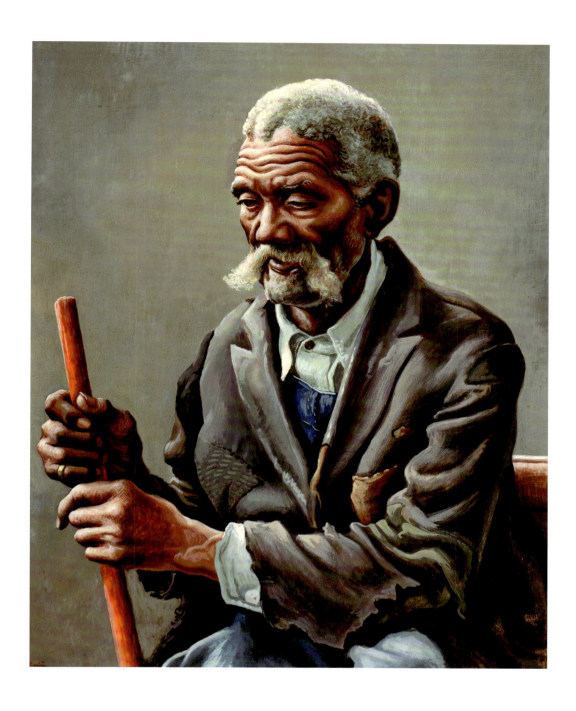

PLATE 157
Thomas Hart Benton
1889–1975
EXHIBITOR 1920–45

Aaron, 1941
Oil and egg tempera on canvas,
mounted on plywood
30 5/16 x 24 5/16 inches
(77 x 61.8 cm)
Joseph E. Temple Fund, 1943.3

Named after a great-uncle who had been an early United States senator, Benton was born in Neosho, Missouri. Benton traveled to Paris, where he absorbed the currents of European modernism. Returning to America in 1912, he was unable to sell his European-inspired canvases, leading him to temporarily abandon painting to work as an architectural draftsman during World War I. After the war he began traveling throughout the United States, capturing his vision of the country's different regions. Through his large murals, landscapes, and portraits, Benton gained national recognition, leading President Harry S Truman to call him: "The best damned painter in America." Benton taught for several years at the Art Students League, where he would influence a new generation of American artists, including Jackson Pollock.

Benton was the most prominent of the American Regionalists, a term that refers to a group of artists, including Grant Wood and John Steuart Curry, who depicted folk culture during the 1920s. In returning to his native roots, Benton developed an unpretentious realism, extolling the simple virtues of life in the American heartland. In *Aaron*, he depicted an elderly farmer with tattered clothes. Set against a neutral background, the subject's face reveals the wear and tear of agrarian life, while Benton's populist visual language defines this work as thoroughly American.

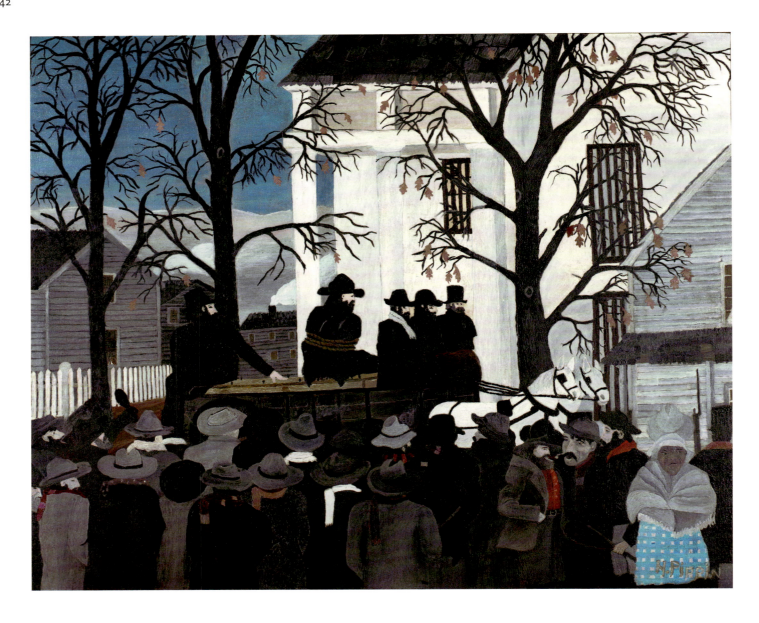

PLATE 160

Horace Pippin

1888–1946

EXHIBITOR 1943–47

John Brown Going to His Hanging, 1942
Oil on canvas
24 ⅛ x 30 ¼ inches
(61.3 x 76.8 cm)
John Lambert Fund, 1943.11

Pippin is recognized as one of the premier self-taught artists of this century. A native of West Chester, Pennsylvania, he depicted his local environment in numerous images. He also explored historical subjects, such as this homage to the fiery abolitionist John Brown. A white man who became a martyr for the anti-slavery cause, Brown occupied a special place in African-American memory throughout much of the twentieth century. Pippin depicted him as a quietly heroic figure in three separate paintings: *John Brown Reading His Bible, The Trial of John Brown,* and this image. One of the artist's most famous works, *John Brown Going to His Hanging* pictures the controversial figure on the way to his death. A crowd has gathered to watch (and presumably cheer) Brown's execution—with one notable exception, the black woman at lower right who, scowling, refuses to participate in the event. According to family legend, Pippin's grandmother was present at the hanging. By including her— the only black figure in any of the artist's history paintings—Pippin emphasized his personal connection to Brown's legacy of black liberation. This work was exhibited in and purchased from the Pennsylvania Academy's 1943 annual exhibition.

PLATE 161
Milton Avery
1885–1965
EXHIBITOR 1929–64

Oxcart–Blue Sea, 1943
Oil on canvas
32 1/8 x 44 inches
(81.6 x 111.8 cm)
Gift of Mrs. Herbert Cameron
Morris, 1952.16

Combining elements from folk art and European modernism, Avery is famous for his rural landscapes and seascapes featuring isolated individuals. He studied art at the Connecticut League of Art Students in Hartford, while working the night shift in a factory. At age forty, Avery moved to New York. There he encountered the work of Henri Matisse and the pre-Cubist works of Pablo Picasso, which transformed his approach to art. While his wife, Sally Michel, supported the family working as a freelance illustrator, Avery devoted himself solely to painting, developing a simplified visual language built around essential forms. During the late 1930s, their home became a meeting place for a group of young artists that included Mark Rothko, Barnett Newman, and Adolph Gottlieb.

Oxcart–Blue Sea is typical of Avery's mature style, as flattened areas of color define the painting's composition. The curve of the green hill echoes the curve of the purplish gray shore, creating a harmony that reveals Avery's debt to Matisse. Two oxcarts make their way along the shore, the individual riders isolated from the town seen in the distance. Quiet and humble, Avery himself was a loner, and while he would influence many abstract artists during the 1950s, he would neither become part of a group movement nor break from the representation of his fundamental subjects: landscape, seascape, still life, and the figure.

PLATE 162
George Copeland Ault
1891–1948
EXHIBITOR 1931–49

Black Night: Russell's Corners,
1943
Oil on canvas
18 x 24 1/16 inches (45.7 x 61.1 cm)
John Lambert Fund, 1946.3

Ohio-born George Ault painted the world around him with a quiet grace and an air of melancholy that may reflect his troubled, reclusive life. Often linked with Precisionist painters such as Charles Sheeler (Plate 149), Ault's geometric architectonic studies are more subjective, even mysterious, showing the influence of his most admired artist, Albert Pinkham Ryder. The stillness and sense of solitude in his work have led to comparisons with Edward Hopper (Plates 136–37) but seem more in line with the Surrealists, particularly Giorgio de Chirico, another of Ault's major influences.

Ault was equally informed by American folk painting, a style he explored despite his extensive formal training in London.

Beginning in the 1920s, when his work focused on urban architecture, Ault had been a presence in New York City art circles. He suddenly left this milieu behind in 1937, when he moved to the rural community of Woodstock, New York. *Black Night: Russell's Corners* is the first in a series of four contemplative nocturnes depicting an intersection near Ault's Woodstock studio. Ault often studied the interplay of the stable, blacksmith shop, barns, and overhead wires near

Russell's Corners. In *Black Night*, as with many of his works, the brilliant illumination of the darkness by a single light source speaks of Ault's ability to uncover the sublime in the most prosaic settings.

PLATE 163
Walt Kuhn
1877–1949
EXHIBITOR 1908–12, 1945–49

Clown with Folded Arms, 1944
Oil on canvas
30 x 25 ⅛ inches
(76.2 x 63.8 cm)
Joseph E. Temple Fund, 1945.8

After traveling in the American West and working as an illustrator for a San Francisco newspaper, the Brooklyn-born Kuhn made his way to Europe to further his art education by studying at the Royal Academy in Munich and the Académie Colarossi in Paris. Returning to America, Kuhn settled in New York to work as an illustrator for newspapers and magazines, including *Puck* and *Life*. With Arthur B. Davies, he helped form the American Association of Painters and Sculptors, serving as executive secretary and visiting Europe to select many of the works for the benchmark 1913 Armory Show.

Kuhn's dissatisfaction with the American art establishment may have led him to select works that would upset traditional sensibilities.

In the 1920s Kuhn, who possessed a love for popular theater all his life, designed and directed touring vaudeville stage shows. This element of popular entertainment became the subject matter for his mature art. Like European artists such as Daumier, Toulouse-Lautrec, and Cézanne, Kuhn rendered his subjects with a psychological insight that transforms them into sympathetic figures suggestive of the struggles of modern life. *Clown with*

Folded Arms represents an acrobat who worked in the Ringling Circus and on the vaudeville circuit. Set against a stark background, the contrast between his makeup and his serious facial expression elevates him above the transient world of entertainment and into the timelessness of artistic tradition.

PLATE 164
Stuart Davis
1892–1964
EXHIBITOR 1930–64

Ultra-Marine, 1943
Oil on canvas
20 x 40 ⅛ inches
(50.8 x 101.9 cm)
Joseph E. Temple Fund, 1952.11

Critical in bridging European modernism and American art, the Philadelphia-born Davis studied with Robert Henri in New York, but his experience with the 1913 Armory Show led to his abandonment of traditional realism. Influenced by the Cubist work of Fernand Léger, Davis lived in Paris during the late 1920s, where he studied with Jan Matulka and befriended fellow American artists Alexander Calder, Isamu Noguchi, and Morris Kantor. He returned to New York and began teaching at the Art Students League in the 1930s, while carrying out murals for the WPA.

Ultra-Marine is Davis's first work to put in practice his new concept of pictorial design called "configuration theory." Davis's theory combined abstract forms, an allover pictorial scheme with no singular focus, and Gestalt Theory. His abstract forms have roots in European modernism, especially in the work of Léger, Joan Miró, and Henri Matisse, while his interest in jazz music influenced his dispersed compositional structure. He learned about Gestalt Theory, the idea that visual images can be abstracted and retain their affiliation with reality, from psychologists working at the

New School for Social Research, where Davis was teaching by 1940. Davis carefully worked out the composition for *Ultra-Marine* through a series of studies, aspiring to give each part of the small painting equal emphasis. This interest in an allover pictorial scheme anticipates some of the concerns of the Abstract Expressionists.

Stuart Davis

Letter and His Ecol, 1962
Oil on canvas
24 x 30 inches (61 x 76.2 cm)
John Lambert Fund, 1964.2

Late in his career, Davis returned to distinctive motifs from his earlier compositions, often incorporating letters and cryptic fragments of words. In *Letter and His Ecol*, the allusive bilingual title may refer to the Ecole des Beaux Arts. In the top center of the composition, the letters "Ecol" and "Inst" appear, the latter suggesting the French word "Institut." (Davis had titled a 1925 gouache "Institut de France," after the institution that oversaw the Ecole des Beaux Arts.) In *Letter and His Ecol* he rhythmically ordered his composition through the use of red, green, yellow, and black, having worked out the placement of shapes through two black and white studies. In the lower right, the word "any" appears, while diagonally opposite, in the upper left, appears an "X," next to which Davis placed his signature.

Firmly established as a master of American art by the 1950s, Davis's ascent was largely overshadowed by the emergence of Abstract Expressionism. Nevertheless, the courageous experimentation of Davis's pioneering modernist imagery of the early 1940s paved the way for a younger generation of artists exploring not just abstraction, but also Pop Art and Minimalism. Davis also made a significant contribution as a writer, leaving behind more than fifteen thousand pages of notes on art.

A beloved teacher at the Pennsylvania Academy from 1952 to 1979, Morris Blackburn (or "Blackie," as he was affectionately known by students and colleagues) was himself a student at the Academy from 1925 to 1929. The influence of Arthur B. Carles, under whom he trained, is apparent in the love of vibrant colors and geometric forms shown here. From Daniel Garber, his other professor at the Academy, he developed a deep reverence for working outside—a practice he transmitted to his own students on sketching trips to the New Jersey shore, Pennsylvania fields, and New Mexico. Rather than representing a particular place, this dynamic composition pays tribute to the feelings evoked by music, specifically, the work of composer Aaron Copland. *Appalachian Spring*, Copland's innovative orchestral suite that had premiered in 1944, successfully wedded modern rhythms to traditional American folk songs, much as Blackburn's painting happily combines the hard-edged Cubist forms of European modernism with more organic, biomorphic forms. The recipient of numerous prizes and veteran of dozens of solo exhibitions, Blackburn also taught at the Philadelphia Museum of Art and Temple University's Tyler School of Art, leaving his mark on a generation of Philadelphia artists. A watercolor version of the composition is also in the Academy's collection.

PLATE 167
Loren MacIver
1909–1998
EXHIBITOR 1947–66

Oil Slick, 1949
Oil on canvas
34 x 25 inches (86.4 x 63.5 cm)
Gift of the Pierre and Maria-
Gaetana Matisse Foundation,
2003.16

A painter of semi-abstract, dreamlike canvases in a style reminiscent of both Paul Klee and American Magic Realist painters, Loren MacIver was always attuned to the uniqueness of place, whether it was the expanse of landscape or the minutia of the city street. Her work has been the subject of major one-person exhibitions at the Whitney Museum, the Phillips Collection, and the Orange County Museum of Art. In 1962 she represented the United States at the Venice Biennale.

While verging on abstraction, MacIver's paintings are very often grounded in reality. Though her paintings are reality-based, they are filtered through a poetic sensibility. She enjoyed evoking the subtleties of visual experience: the arcs of windshield wipers on a rainy night, a cracked window blind, her studio skylight. *Oil Slick* looks abstract, but the title and the context of MacIver's attention to the subtle details of the everyday experience tell us otherwise. MacIver's lifelong fascination with the way beauty emanates from the commonplace is fully articulated in this poetic work. Employing feathery brushstrokes, the artist renders the rainbow effect produced when motor oil encounters a curb-side puddle.

PLATE 168
Pavel Tchelitchew
1898–1957
EXHIBITOR 1944–56

Interior Landscape VII (Skull),
1949
Crayon, pencil, and watercolor
on beige paper
12 x 8½ inches (30.5 x 21.6 cm)
Gift of Richard A. Lee in honor
of Richard C. Friedman, M.D.,
2003.17

Pavel Tchelitchew enjoyed international attention from the mid-1920s until his death in the late 1950s. He was the subject of survey exhibitions at the Wadsworth Athenaeum, the Museum of Modern Art, and had three solo exhibitions at the renowned Julien Levy Gallery, New York. In 1926, Tchelitchew first became associated with a group of artists called the Neo-Romantics, which included Christian Berard, Kristian Tonny, and fellow Russian émigrés, the brothers Leonid and Eugene Berman. Reacting against what was sometimes considered the cold, impersonal quality of modern abstract art, the Neo-Romantics believed that art must return to the exploration of the human condition and emotions. Indeed, Tchelitchew looked back in art history for inspiration to important figures like Leonardo and Michelangelo. The symbolic landscapes he created also evoke the work of Bosch and Breughel. Tchelitchew has sometimes been categorized as a Surrealist, but he was never an official member of the group.

In the early 1940s, Tchelitchew became obsessed with human anatomy and the anatomical studies of Leonardo. Believing that the body mirrored the immensity and intensity of the universe, the artist depicted the human form as if it were possessed by an otherworldly light and energy. *Interior Landscape VII (Skull)* is part of this body of work. Here, an ethereal light emanates from strategic points on the skull.

PLATE 169

Morris Graves

1910–2001

EXHIBITOR 1934, 1945–63

Brooding, 1953
Tempera over bronze powder
paint over gray wash on laid
paper
19 ⁷⁄₈ x 30 ³⁄₁₆ inches
(50.5 x 76.7 cm)
John Lambert Fund, 1963.1

One of America's greatest mystical painters, Graves was primarily self-taught, although he studied briefly with like-minded artist Mark Tobey. Living and working in the Pacific Northwest, the isolation from artistic centers such as New York or Paris allowed their work to develop largely uninfluenced by dominant trends. Graves and Tobey marked the beginnings of a revival of American abstract art in the 1940s, creating deeply felt, introspective imagery infused with haunting suggestions of emotionality and spirituality.

Deeply influenced by Zen Buddhism and Asian mysticism, Graves's study of Chinese and Japanese scroll paintings had an even more profound effect on his work than his studies with Tobey. Often using animals, particularly birds, to allude to human psychological states, Graves's work traces a journey through consciousness, which may evoke contemplation, pathos, or a spiritual awakening. In this case, *Brooding* seems to refer not only to the nesting hen's activity, but also to describe her moody expression. In this painting, Graves displayed his

mastery of the brush technique of Asian ink painters, in which the simplest stroke of the brush eloquently conveys the maximum meaning. By moderating between wet, bleeding strokes and dry, scratchy marks, Graves added variety and visual meaning in the manner of Japanese master calligraphers.

PLATE 170
Andrew Wyeth
b. 1917
EXHIBITOR 1935–65
MEDAL 1966, 1998

Young America, 1950
Egg tempera on gessoed board
32 ½ x 45 ⁵⁄₁₆ inches
(82.6 x 115.1 cm)
Joseph E. Temple Fund, 1951.17

A painter of landscape and figure subjects in Pennsylvania and Maine, Andrew Wyeth is one of the best-known American artists of the twentieth century. His painting style is representational with dreamy overtones, which in the American context of the post–World War II period was often termed Magic Realism. Deeply rooted in depicting everyday reality, Magic Realist painters like Paul Cadmus, Ivan Albright, George Tooker, Philip Evergood, and Wyeth tempered their realism with fantasy and wonder. Wyeth worked primarily in tempera and watercolor, often using the drybrush technique.

Wyeth was trained by his father, the famous illustrator N. C. Wyeth, who taught the aspiring artist that depicting mood through the subtleties of changing light and shadow was the ultimate goal of artmaking. Aside from the home schooling provided by his parents, Wyeth was never formally educated in art. Like the artists mentioned above, Wyeth maintained a style strongly oriented toward realism during the heyday of Abstract Expressionism. Adhering to his convictions regarding the combination of realism and fantasy, Wyeth was snubbed by many prominent art

critics. His paintings suggest rural quietude, isolation, and a somber mood and are usually devoid of modern-day objects like automobiles. Wyeth formed close relationships with virtually all of the people he painted, and the subject of *Young America* was no different. The boy was a neighbor of the Wyeth family and a friend of Wyeth's children.

PLATE 171
Philip Evergood
1901–1973
EXHIBITOR 1934–69

Threshold to Success, 1955–57
Oil on gessoed Celotex board
67 ½ x 36 ¼ inches
(171.5 x 92.1 cm)
Joseph E. Temple Fund, 1958.10

Born in New York City as Philip
Blashki, Evergood's family moved to
London when he was a child. To
avoid prejudice there, his name was
legally changed to Evergood at the
age of thirteen. A musician in his
youth, he studied at Eton and
Cambridge University before begin-
ning his art education at the Slade
School with Henry Tonks and
Havard Thomas. Returning to New
York in 1923, Evergood's early work
engaged biblical themes, but with
the onset of the Depression he
shifted to social realism, focusing on
political oppression and racism in
several impressive murals painted
for the WPA. Politically active,
Evergood served as president of the
New York Artists Union.

 In the 1950s, Evergood turned
to images that combine fantasy with
biblical and mythological symbolism.
A prime example of this later style,
Threshold to Success started as a
demonstration for students in a
summer class but evolved into a
painting depicting the erotic dreams
of a young athlete-turned-scholar.
He holds a large book bearing the
title "Tome" that has a multitude of
names inscribed upon it. Most
prominent are the names of Old
Testament figures such as Adam,
Ham, and Noah, but these names
coexist with a great array of other
allusions, including Orphan Annie,
Piet Mondrian, Betsy Ross,
Hippocrates, and Edouard Vuillard.

PLATE 172
Jack Levine
b. 1915
FACULTY 1966–69
EXHIBITOR 1940–68

Medicine Show, 1955
Oil on canvas
40 ⅛ x 45 ¼ inches
(101.9 x 114.9 cm)
Henry D. Gilpin and John
Lambert Funds, 1956.2

Steeped in social realism, Levine's work is fueled by moral outrage at political and commercial corruption. Hailing from the South End of Boston, Levine was from an immigrant family and endured poverty in his youth. His artistic talent drew the notice of Denman Ross, a Harvard professor. Through Ross, Levine acquired an excellent knowledge of art history, becoming an admirer of Rembrandt, Daumier, Goya, and Grosz. One of the first American-born artists to explore Judaic themes, Levine increasingly turned toward Old Testament imagery in the 1980s, exploring his own identity as a Jew after several trips to Israel.

Medicine Show is one in a series of paintings that focus on a sideshow huckster, replete with a band and burlesque performers. Set against an urban landscape drawn from Levine's childhood neighborhood, this work combines direct observation with social commentary. As the artist explained, "I've always tried to make some point about charlatans—in this case, a medicine show. . . . I've always been trying to make a kind of indictment of mysticism, and people being fooled." Levine has had a distinguished pro-

fessional career, teaching at the Art Institute of Chicago and the Pennsylvania Academy, while also serving as president of the American Academy of Arts and Letters.

PLATE 173
Ben Shahn
1898–1969
EXHIBITOR 1931–69

Cat's Cradle in Blue, ca. 1959
Egg tempera on composition
board
39 ¾ x 25 ¾ inches
(101 x 65.4 cm)
Joseph E. Temple Fund, 1960.11

Although Ben Shahn is strongly identified as an artist committed to social and political causes, his work never reads as mere propaganda, but resounds with deeply felt humanitarian concerns for the individual in society, and the plight of the oppressed. Born in Kovno, Lithuania, Shahn's family emigrated to Brooklyn in 1906. At an early age, he apprenticed with a lithographer and later studied at the National Academy of Design and the Art Students League. His vigorous artwork was influenced by the European avant-garde, American naive painting, and the Mexican muralists. Shahn designed his own murals during the Depression working for government relief agencies, for which he also photographically documented rural poverty. Such experiences filtered into Shahn's art.

Not all of Shahn's artwork was overtly political. Later in his career he designed sets for theater and ballets. The strange "primitive" figure in *Cat's Cradle in Blue* derives from a mask of the devil Shahn designed in 1958 for the poet Archibald MacLeish's controversial Pulitzer Prize-winning verse drama *J.B.*, based on the Book of Job. The bizarre figure, with its double-pupil eyes, reappears in a later work, *Branches of Water or Desire* (1965). Likewise, Shahn explored the visually dazzling game of cat's cradle, both as simple play and with deeper symbolic meaning, in several drawings, prints, posters, and paintings throughout his career.

PLATE 174
Yves Tanguy
1900–1955
EXHIBITOR 1947–53

Suites Illimitées, 1951
Oil on canvas
39 ¹⁄₁₆ x 32 ³⁄₁₆ inches
(99.2 x 81.8 cm)
Henry D. Gilpin Fund, 1953.6

Born in Paris, Tanguy joined the French Merchant Marine and traveled the world before deciding to become an artist. Tanguy encountered the work of Giorgio de Chirico in 1923 and soon after began painting in a surrealist fashion. Within two years, André Breton welcomed him into the Surrealist group. Despite his lack of formal training, Tanguy's art developed quickly and his mature style emerged by the late 1920s—a style that changed very little during his more than thirty-year career. In 1939, he emigrated to the United States, where he lived the rest of his life, marrying the American Surrealist painter Kay Sage in 1940 and becoming an American citizen in 1948.

All of Tanguy's mature paintings depict a highly distinctive dreamscape—a kind of inner landscape of the unconscious where immense, unbounded space is occupied by scattered biomorphic shapes that seem both lunar and marine. Tanguy synthesized the Surrealist strategy of unpremeditated expressionism with an academic attention to meticulous rendering of subject matter. Surrealist painting can be divided into two general categories, the "abstract" and the "academic," and Tanguy belongs to the latter category, as do René Magritte and Salvador Dalí.

PLATE 175
Will Barnet
b. 1911
FACULTY 1967–92
EXHIBITOR 1947–68

Whiplash, 1959
Oil on canvas
62 ¼ x 41 ⅛ inches
(158.1 x 104.5 cm)
John Lambert Fund, 1962.3

Hailing from Beverly, Massachusetts, Will Barnet first studied art at the School of the Museum of Fine Arts in Boston. In 1930, he moved to New York, where he enrolled in the Art Students League, studying with Stuart Davis and becoming an instructor in printmaking in 1936. He quickly established his reputation through prints and paintings executed in a social realist style bearing influences from Jan Vermeer, Honoré Daumier, and José Clemente Oroszco. During the 1940s, Barnet developed an abstract pictorial language based on hard-edged geometric forms; this language dominated his work into the 1960s, before he returned to a figurative style. Noted for his etchings, woodcuts, and lithographs, Barnet has taught at Cooper Union, Cornell University, Yale University, and the Pennsylvania Academy.

Barnet's fascination with Native American art is evident in *Whiplash*'s forms and color scheme, an inspiration he shared with his New York colleagues Peter Busa and Steve Wheeler. The artists formed a movement known as Indian Space, named for their interest in the flattened space of Native American art, a visual paradigm shared by the contemporaneous Abstract Expressionist movement. Between 1959 and 1962, Barnet traveled to the Pacific Northwest to study Native American art, drawn to its totemic power and affected by the region's landscape.

PLATE 176
Franz Kline
1910–1962

Untitled, ca. 1953
Oil base black ink wash and
collage on cream paper
13 ⅞ x 18 ¾ inches
(35.2 x 47.6 cm)
Gift of Gerrish H. Milliken, Jr.,
1975.23

Through his signature style of broad
gestures of black paint set against a
white background, Kline became
one of the leading figures of the
Abstract Expressionist movement.
Born in Wilkes-Barre, Pennsylvania,
Kline studied art at the Boston Art
Students League and later at the
Heatherley School in London. In
1939, he moved to New York and
began painting cityscapes and land-
scapes of the Lehigh Valley region.
During the 1940s, Kline won several
awards at the annual exhibitions of
the National Academy of Design. In
1949, a friend used a projector to
enlarge some of Kline's small gestural
studies, and soon afterwards Kline
abandoned figurative painting to
focus on his black and white linear
abstractions.

This work displays Kline's
mature visual language translated
from enamel housepaint to ink
wash and reducing the scale of his
work to a more intimate size. The
spontaneity of ink wash helps bring
out the relation of Kline's art to
Japanese calligraphy and Zen paint-
ing. Kline's interest in Japanese art
dates to the mid-1940s, a period
that also saw the emergence of his
friendships with fellow Abstract
Expressionists Willem de Kooning
and Jackson Pollock, as well as his
exploration of existentialist philosophy.
This combination of influences pro-
vided the stimulus for Kline's radical
break from representational art.

PLATE 177
Richard Stankiewicz
1922–1983
EXHIBITOR 1954, 1966

Dark Mother, about 1955
Welded steel
50 x 31 x 26 inches
(127 x 78.7 x 66 cm)
Contemporary Arts Purchase
Fund, 1983.19

Associated with other found-object artists of the 1950s such as Robert Rauschenberg and Louise Nevelson, Stankiewicz developed his own aesthetic that combined the accumulative potentials of welding with a figurative sensibility permeated by great wit. Born in Philadelphia, Stankiewicz studied with Hans Hofmann at the Art Students League in New York before traveling to Paris in 1950 to study with Fernand Léger and later Ossip Zadkine. Upon returning to New York, Stankiewicz began making sculptures by welding together "junk," including scrap metal, tools,

machine parts, and household equipment. The sculptor Sidney Geist referred to Stankiewicz's work as "the miracle of the scrap heap."

In *Dark Mother*, Stankiewicz reveals his humor and sense of the absurd, welding together pieces from a barbecue grill, a bicycle, and various mechanical parts. The title in conjunction with the sculpture itself creates an unexpected association between maternal warmth and the barbecue hood. Stankiewicz's use of found objects was, in part, a reaction to the urban environment of New York where junk endlessly littered the streets. Stankiewicz discovered ways

to recycle this rubbish into elegant sculptures, transforming the discarded into compelling works of art. He taught sculpture at State University of New York in Albany and Amherst College.

Lee Bontecou
b. 1931
EXHIBITOR 1960, 1964

Grounded Bird, 1957
Bronze with green patina;
cast in 1958
17 ¼ x 62 x 15 inches
(43.8 x 157.5 x 38.1 cm)
Joseph E. Temple Fund, 1960.2

Lee Bontecou studied at the Art Students League in New York from 1952 to 1955 under William Zorach and John Hovannes. Shortly thereafter she began making fantastic and often semi-abstract bird and animal sculptures of terracotta formed over reinforced concrete. *Grounded Bird,* a massive, wingless creature, stands with splayed claws, displaying an aggressiveness shared with several of the artist's pieces from this period. The composition is balanced by legs that firmly ground the large body. Gaps between the edges of the slabs near the left leg and tail recall its origins in clay and add character to the surface by allowing glimpses into dark crevices. In subsequent decades, Bontecou produced the canvas and metal wall reliefs for which she is well known, many exhibiting the menacing, aggressive character perceptible in the bird sculptures. She has also worked with vacuum-formed plastic, clay modeling, and has produced a significant body of work in printmaking.

PLATE 179
Isamu Noguchi
1904–1988
EXHIBITOR 1926–27, 1960–68

Girl Torso, 1958
Marble with wood and steel
support
23 x 10 x 3 inches
(58.5 x 25.4 x 7.5 cm)
Henry D. Gilpin Fund, 1960.9

Isamu Noguchi's early education in
Japan and subsequent attendance at
an American high school grounded
him in two cultures that colored his
life and art. As a young man, Noguchi
apprenticed in Japan with a cabinet-
maker, where he first developed his
reverence for natural materials. Later,
he apprenticed with Gutzon Borglum,
the sculptor of Mount Rushmore.
After a brief sojourn in medical
school, Noguchi received a 1927
Guggenheim Fellowship that took
him to Paris, where he became a studio
assistant to Constantin Brancusi.
Noguchi responded to what he saw as
the Japanese aesthetic of his mentor's
work, and, like Brancusi, understood
abstraction as an investigation of a
subject's essence, as well as a revelation
of the "truth" of the materials with
which he created. Noguchi favored
working in stone, carving away rather
than artificially appending anything
to his material. *Girl Torso* was created
from a block of Pentelic marble and
the abstracted figure is reminiscent of
archaic Greek sculpture. Noguchi saw
little distinction between fine and
applied arts and was a designer of
everything from furniture and indus-
trial products to gardens, bridges, and
stage sets and costumes. His mulberry
paper and bamboo Akari lamps are an
icon of mid-twentieth-century design
and display the same harmonious
marriage of Asian aesthetics and
Western modernism as his organic-
abstract sculpture.

PLATE 180
Charles Burchfield
1893–1967
EXHIBITOR 1927–65

Purple Vetch and Buttercups, 1959
Watercolor over charcoal on
white wove paper
39 ¹³⁄₁₆ x 29 ¹³⁄₁₆ inches
(101.1 x 75.7 cm)
John Lambert Fund, 1961.1

Among the most visionary artists to
express reverence for nature through
paint, Charles Burchfield lived a
quiet life outside of the artistic
mainstream but nonetheless attract-
ed admiration with his exquisite
watercolors of meadows, forests, and
the changing seasons. Like George
Inness and author Henry David
Thoreau, Burchfield concentrated in
his work on speaking of the spiritual
revelation, even ecstasy, evoked by
nature. Based on the natural world,
Burchfield's work approaches the
fantastic, with visual devices meant
to replicate bird and insect sounds,
and halos pulsing from plants. In

Purple Vetch and Buttercups, the
landscape is activated by rhythmic
paint strokes, suggesting a radiant
energy invisible to the human eye.
Burchfield wrote that this work
"was the first 'out-door' picture that
I painted in almost two years. . . . I
could not have done it in the
studio. . . . If the golden archway
suggests the entrance of Paradise to
you, you would not be far off—In
fact, I don't know how the beauty
of Paradise could exceed the glory
of this visual world of ours!"

A native Ohioan, Burchfield
moved to New York City in 1913,
only to return home the next year.

After his marriage, Burchfield
moved to Buffalo to work for a wall-
paper company, while continuing to
produce some of America's greatest
modern watercolors. In addition to
landscapes, Burchfield also painted
grittier Depression-era scenes such
as *End of the Day* (fig. 15).

PLATE 181
Bob Thompson
1937–1966

*Untitled (Procession at
Aqueduct)*, 1961
Oil on wood panel
20 x 23⅜ inches (50.8 x 59.4 cm)
Funds provided by the
Collectors' Circle, 2000.9

Envisioning a fantastic world by
turns riotous, mysterious, or utopi-
an, Bob Thompson found inspira-
tion in the themes and compositions
of Renaissance paintings and the
works of the old masters. Equally
informed by the color and energy of
Paul Gauguin and the German
Expressionists, Thompson's deeply
personal responses to art historical
precedents are typically haunting
and complex. He often worked with
religious or classical themes, and the
inclusion of an aqueduct in this
work suggests an ancient Roman
setting, as does the interplay of
robed and nude figures, evocative of

a Roman mystery cult ritual. The
figure at lower left, however, with
his bright green hat, adds an
anachronistic air that threatens to
expose the entire scene as theatrical.

Thompson is now recognized
as one of the most important
African-American painters of the
post-war generation, and, indeed, he
broke through racial barriers in the
art world within his short lifetime.
A native Kentuckian, Thompson
briefly studied medicine at Boston
University before returning to
Louisville to study art. He moved to
New York in 1959, and became allied
with the avant-garde art scene,

befriending poets, jazz musicians,
and like-minded artists such as Jan
Müller, Red Grooms, and Alex Katz
who were reinvestigating figurative
painting in the wake of Abstract
Expressionism. Thompson's work
is acclaimed for its emotive colors
and interweaving of symbolism,
spirituality, and biography: the
isolated observer often found in
Thompson's work has been identi-
fied as self-portrait.

PLATE 184
Leon Golub
1922–2004
EXHIBITOR 1964, 1966

Seated Boxer II, 1960
Oil and lacquer on canvas
96 x 81 inches (243.8 x 205.7 cm)
Alexander Harrison Fund,
2004.10.1

Emerging into the art world in the wake of Abstract Expressionism, Leon Golub utilized similar techniques, but applied them to an invigorated figurative tradition passionately directed by the artist's political concerns. Initially a member of the Chicago-based figurative group known as the Monster Roster, which emulated German Expressionism's often violent depictions of the human condition, Golub developed a method of painting in layers and then stripping and scraping the canvas with solvents and sharp tools, creating a distressed, mottled surface suggestive of charred flesh. Much of Golub's early work addressed the brutalities committed against the human body and the extremes it could endure. *Seated Boxer II* is from a series of paintings influenced by the scale and physicality of Greek and Roman sculpture and the often tragic tales they represent. A monumental example of Golub's early work, in which figures emerge from and dissolve into the surface of the paint, *Seated Boxer II* bespeaks a spirit of human resistance in the face of overwhelming forces.

PLATE 185
David Smith
1906–1965
EXHIBITOR 1947–56

V.B. XXII, 1963
Welded steel
99 ⅝ x 14 ¼ x 13 inches
(253 x 36.2 x 33 cm)
Gift of Mr. and Mrs. David N.
Pincus, 1980.28

Translating the gestural spontaneity of Abstract Expressionist painting into three dimensions, Smith emerged as the leading sculptor of post–World War II America. Born in Decatur, Indiana, Smith moved to New York at the age of twenty-one and enrolled in the Art Students League, studying with the Czech abstractionist Jan Matulka. Upon seeing the welded sculptures of Pablo Picasso and Julio González, Smith purchased welding equipment and began experimenting with the possibilities of industrial parts and tools for making art. The connection to industry also held a personal significance for Smith, as he had worked in an automobile plant as a young man and also assembled tanks and locomotives during World War II.

In 1952, after winning Guggenheim awards in two consecutive years, Smith began working in series, a process that he would continue until his death. *V.B. XXII* is from a series utilizing materials that Smith had shipped over from Voltri, Italy, to his Bolton Landing studio in upstate New York. Smith had visited Voltri the previous year, producing a series of large sculptures in an abandoned steel factory. The work conveys Smith's interest in evoking the totemic power of objects from past civilizations through the materials and techniques of the industrial world.

268

PLATE 186
Richard Diebenkorn
1922–1993
EXHIBITOR 1962–68

Interior with Doorway, 1962
Oil on canvas
70 5/16 x 60 inches
(178.6 x 152.4 cm)
Henry D. Gilpin Fund, 1964.3

A cerebral artist who struggled with the issue of abstraction versus representation, Diebenkorn was educated at Stanford University, where he studied art, music, and literature. He later studied with Hans Hofmann at the University of California-Berkeley before traveling to New York where he fell under the sway of Robert Motherwell and William Baziotes. By the 1950s, Diebenkorn was recognized as the leading West Coast abstract painter, but he turned to figurative art under the influence of his friend and colleague David Park at the California School of Art. Along with Elmer

Bischoff, they led the Bay Area Figurative School that went against the currents of abstraction during the late 1950s and early 1960s.

Interior with Doorway presents a view from within Diebenkorn's studio, looking out onto a sunlit street with the Berkeley hills in the distance. While many of his interior scenes are filled with a single figure seated in a chair, here we encounter only an empty chair, heightening the elegiac mood of this work. Diebenkorn carefully constructed this interior through rectangular expanses of color purged of detail, revealing his debt to Matisse. An

encounter with Matisse's work in Russia a few years later pushed Diebenkorn back toward abstraction, leading to the defining paintings of his career, such as the enormous *Ocean Park* series.

PLATE 187
Elizabeth Osborne
b. 1936
STUDENT 1954–58
FACULTY from 1961–
EXHIBITOR 1962–68

Woman with Red, 1962
Oil on canvas
63 ⅛ x 46 inches
(160.3 x 116.8 cm)
Gift of the Ford Foundation,
1964.1.6

Born in Philadelphia, Osborne trained with Hobson Pittman (as a high school student) and Neil Welliver at the Philadelphia College of Art (now University of the Arts) before enrolling at the Pennsylvania Academy in the mid-1950s. In 1961, she joined the faculty at the Academy, where she continues to teach. She is represented in public collections including the Academy, the Philadelphia Museum of Art, and the Delaware Art Museum.

Woman with Red brings to mind the domestic scenes—contemplative yet intensely colorful—of the French artist Pierre Bonnard, whom Osborne greatly admired during her student years. An early work, this painting nonetheless showcases Osborne's trademark still in evidence today: a clever balance of realism and Color Field abstraction. Her approach is partially indebted to Richard Diebenkorn, whose painterly formalism exerted some influence on Osborne's work in the early sixties. Osborne has also explored the push and pull of representation and abstraction within the context of landscape painting, conveying hypnotic calm with colorful, undulating strokes created by combing paint across the canvas in wide, gestural swipes. From the beginning of her career to the present, Osborne has always incorporated and interpreted core issues of modern painting, from the staining of raw canvas to the flattening of planes, from a schematic stylization of forms to the pragmatic investigation of the medium of paint itself.

PLATE 188
**Zsissly
(Malvin Marr Albright)**
1897–1983
STUDENT 1923
EXHIBITOR 1927–49

The Trail of Time is Dust, 1962
Watercolor and gouache on
paper
27 ½ x 40 ½ inches
(69.9 x 102.9 cm)
Gift of the artist, 1966.12

Malvin Marr Albright adopted the
pseudonym Zsissly to distinguish
himself from his artist father, Adam
Emory Albright, and identical twin
brother Ivan. Zsissly's father had
studied with Thomas Eakins at the
Pennsylvania Academy, and he
instilled those teachings in Ivan and
Malvin. Zsissly worked primarily as
a sculptor, again to differentiate
himself from his brother, who is best
known for his grotesque figurative
paintings. Ivan and Zsissly worked
as part of the Federal Art Project in
Chicago during the 1930s, and in
1943–1944 they collaborated on the

paintings used for Albert Lewin's
film *The Picture of Dorian Gray*.
The brothers shared a studio in
Warrenville, Illinois, next to their
father's studio.

The Trail of Time is Dust is
filled with objects related to the life
of a fisherman, a subject explored by
both Zsissly and Ivan. Nets, pulleys,
ropes, lanterns, gloves, and other
utilitarian objects are rendered with
a meticulous realism and a nearly
monochromatic palette. The simul-
taneous feelings of nostalgia and
decay relate to childhood memories
of the Albright family's summers

spent in rural fishing villages.
In 1965, this work received the
Philadelphia Water Color Prize in
the Pennsylvania Academy's annual
exhibition.

PLATE 189
Robert Rauschenberg
b. 1925
EXHIBITOR 1967–69

Homage to Frederick Kiesler, 1966
Offset color lithograph on white wove paper
Sheet 34 ⅞ x 23 inches (88.6 x 58.4 cm)
Image 33 ⅞ x 22 inches (86 x 55.9 cm)
John Lambert Fund, 1969.8

A ground-breaking artist, Rauschenberg was an integral force in establishing Postmodern art. Coming to prominence in the 1950s, Rauschenberg appropriated some of the visual language of the Abstract Expressionists but insisted that his work was documentary rather than expressive. His innovative "combine paintings" used collage and assemblage to address the clamor of twentieth-century existence and incorporated not only traditional art forms but also performance, music, light, electronics, and a variety of found objects including garbage, bedding, and taxidermied animals.

Rauschenberg felt that such detritus, plus visual references to pop culture, was the only way to achieve "honest" commentary on modern life.

In the 1960s Rauschenberg began using more printmaking processes in his collages. He created this print shortly after the death of the influential Romanian-born architect, artist, and designer Frederick Kiesler. Rauschenberg depicted Kiesler turning to review the up-ended image of his most visionary monument, *The Shrine of the Book*, built in Jerusalem to house the Dead Sea Scrolls. The red and yellow concentric circles above the

shrine represent Kiesler's plan for the *Endless Theatre*, and the shadowy silhouette at the top-right corner shows the pod-like forms of his *Endless House*.

PLATE 190
Fairfield Porter
1907–1975
EXHIBITOR 1934, 1962–66

Jimmy and Liz, ca. 1963
Oil on canvas
45 x 40⅛ inches
(114.3 x 101.9 cm)
Henry D. Gilpin Fund, 1980.15

A painter and art critic, Fairfield Porter graduated from Harvard University, studying art history with Bernard Berenson. He moved to New York and enrolled in the Art Students League, where he studied with Thomas Hart Benton. Porter traveled extensively throughout Europe and visited Stalinist Russia. He became associated with many prominent artists, including Alfred Stieglitz, John Marin, and Willem de Kooning, as well as important literary figures, such as Kenneth Rexroth, Frank O'Hara, and James Schuyler. As a writer, Porter was an editorial associate for *ArtNews* and a critic for *The Nation*, while also writing poetry. In addition, he published a book on Thomas Eakins.

Jimmy and Liz presents a domestic scene typical of Porter's mature work. A portrait of his daughter Liz and his friend the poet James Schuyler, this work also situates itself in relation to the domestic scenes of Edouard Vuillard and Pierre Bonnard, two artists who greatly influenced Porter's work. This can be seen in the emphasis on effects of color and the lack of emotional connection between the two individuals. Porter navigates a space between abstraction and realism, creating a figurative scene that is as much about the act of painting as it is about the individuals depicted.

PLATE 191
Philip Pearlstein
b. 1924

Two Female Models on Hammock and Floor, 1974
Oil on canvas
72 x 72 inches (182.9 x 182.9 cm)
Gift of Betsy and Frank
Goodyear, Jr., 1983.21

Philip Pearlstein was born in Pittsburgh and graduated from the Carnegie Institute in 1949, before moving to New York with his classmate and friend Andy Warhol. He gained recognition in the late 1960s and early 1970s for his starkly idealized paintings of nude models in domestic settings. Pearlstein's pictures are often abruptly cropped and sport exaggerated perspectives. A classic example of the discrepancy between artistic intention and viewer reception, Pearlstein's paintings have been contextualized within European traditions of nude figure painting. Furthermore, his work has

often been interpreted in sexual and psychoanalytic terms, given his choice of subject matter. However, Pearlstein claims that his allegiances lie in abstraction and formalism, not realism and the psychosexual. He characterizes his use of the nude as a convenient way to describe surfaces, contours, and their relationship to other forms. Pearlstein counters the emotional and spiritual transcendence associated with art and offers instead a visual and material discipline based on a rigorous matter-of-fact attitude. For these reasons, he has perhaps more in common with Conceptual and Minimal artists

than with either Abstract Expressionists or fellow post war realists.

PLATE 192
Jacob Lawrence
1917–2000
EXHIBITOR 1948–67
MEDAL 1997

Dream Series #5: The Library,
1967
Tempera on board
24 x 35 ⅞ inches (61 x 91.1 cm)
Funds provided by the National
Endowment for the Arts, the
Collectors' Circle, and the
Henry D. Gilpin and John
Lambert Funds, 1987.34

Depicting activities ranging from introspection to animated discussion, Lawrence represented more than thirty-five figures in this vibrant library scene orchestrated through a refined palette of reds, greens, yellows, and blues. Public libraries appear frequently as a subject in Lawrence's paintings, embodying a space where African Americans can access their identity, culture, and history. For Lawrence, Harlem's Schomburg Library played a critical role in his development, providing a facility where he could research such heroes of the African-American community as John

Brown, Frederick Douglass, Harriet Tubman, and Toussaint L'Ouverture, all of whom became subjects for Lawrence's work.

Lawrence studied with Charles Alston at the American Artists School in New York and worked as part of the easel-painting project of the WPA during the Depression. Fellow Harlem artists Romare Bearden and Gwendolyn Knight, whom he married, were a source of inspiration, as were artists he became acquainted with at Edith Halpert's Downtown Gallery, including Horace Pippin, Stuart Davis, and Ben Shahn. Lawrence

maintained a figurative style even after the rise of Abstract Expressionism, using his representational language to communicate pride in African-American experience. He wrote, "My pictures express my life and experiences. I paint the things I know about and the things I have experienced. The things I have experienced extend into my national racial and class group."

PLATE 193
Raymond Saunders
b. 1934
STUDENT 1953–57
EXHIBITOR 1962–66

Jack Johnson (1878–1946), 1971
Oil on canvas
82 ⅜ x 63 ⅝ inches
(209.2 x 161.6 cm)
Funds provided by the National Endowment for the Arts, the Pennsylvania Academy Women's Committee, and an anonymous donor, 1974.9.1

Raymond Saunders has had a career-long fascination with graffiti, amateur signage, and the store-front church facades found in many urban communities across America. His juxtaposition of images, objects, and words using bright colors and collaged materials projects a sense of immediacy that encourages viewers to connect their everyday experiences with those of others. By extension, Saunders aims to confront the stereotypes found in contemporary culture and reinforce the point that America is a pluralistic and multiracial country.

This painting depicts Arthur John "Jack" Johnson, the son of a former slave who in 1908 became the first African-American boxer to win the Heavyweight Champion of the World title. Renowned for his personal charisma and his willingness to challenge racial stereotypes, Johnson retired from boxing and subsequently achieved fame as a jazz musician. Although Johnson faced virulent bigotry throughout his career, for Saunders the boxer served as an icon of African-American success and perseverance in the face of adversity. By incorporating the figure into an otherwise abstract field of colors, Saunders addressed contemporary artistic concerns as well as questions of racial identity.

PLATE 194
Mark Rothko
1903–1970
EXHIBITOR 1946

Untitled (Maroon over Red), 1968
Acrylic on paper mounted on
canvas
39 ⅛ x 26 inches (99.4 x 66 cm)
Bequest of Bernice McIlhenny
Wintersteen, 1986.31.5

One of the most significant artistic pioneers of the postwar period, the Russian-born Rothko is principally associated with Abstract Expressionism but is also considered a forerunner of the Color Field movement, which emerged from the former. Rothko sought to deny the illusion of three-dimensional space, instead making the flatness and physical presence of the canvas an integral component of his work. At the same time, his paintings have been interpreted as profound meditations on the emotive or even transcendent qualities of color. In this light, Rothko's work has been

called the most intensely personal of the New York School artists.

Rothko came to the United States as a child, studying briefly at Yale University and at the Art Students League with Max Weber. Rothko moved from representational painting into a period of biomorphic abstraction in the 1930s, informed by the automatic drawing exercises of the Surrealists, ancient myth, and the writings of Freud and Jung. As his work grew increasingly abstract throughout the 1940s, he still pursued a universal response through his work, based on the concept of the collective unconscious. Rothko

painted works on paper, such as this one, throughout his career. The translucent washes of paint on absorbent paper accomplish the same hazy, stained effects that are hallmarks of his paintings on unprimed canvas, his paint layering technique achieving a compelling luminosity.

PLATE 195
Jules Olitski
b. 1922

*Purple Mekle Lippis of Beauty
Mouth–2*, 1972
Acrylic on canvas
80 x 59 inches (203.2 x 149.9 cm)
Gift of Mr. and Mrs. J. Welles
Henderson, 1984.42

Citing influences from Rembrandt to Hans Hofmann, Olitski combines majestic scale with sensuous color, spraying and staining his large canvases with multiple evanescent layers of pigment. First discovering abstract art by painting blindfolded, Olitski developed his style by relinquishing any expectations for the end result, allowing his materials to be the primary expressive agents. In line with many other artists of his generation, Olitski eschewed figurative work in the belief that attempts to simulate three-dimensionality on a two-dimensional surface are unavoidably false, and that embrac-

ing a canvas's inherent flatness through abstraction achieves a more profound, universal response. The influential critic Clement Greenberg, who championed Olitski's career, considered him America's greatest living painter.

Olitski came to the United States from Gomel, Russia, as an infant. He studied at the Art Students League and the Beaux-Arts Institute of Design, both in New York, as well as in Paris on the G.I. Bill. Connected with the Color Field movement, which emerged from Abstract Expressionism, Olitski valued color over composition,

exploring subtle modulations of hue with increasingly innovative techniques. In *Purple Mekle Lippis of Beauty Mouth–2*, a title taken from a book on the African slave trade, Olitski saturated the canvas by rolling it through a trough of acrylic paint and then stapled it to his studio floor to squeegee and spray-gun the canvas with additional layers of color—his trademark technique.

PLATE 198
Janet Fish
b. 1938

Yellow Goblets, 1976
Pastel and wash on white wove
paper
31¼ x 22 ³⁄₁₆ inches
(79.4 x 56.4 cm)
Funds provided by the National
Endowment for the Arts, the
Charles E. Merrill Trust, and the
Crag Burn Fund, 1976.14.3

Often connected with the New
Realist movement of the 1970s,
Janet Fish is best known for her
lustrous still lifes incorporating fruit
jars, plates, vases, goblets, and other
glassware. Born in Boston, Fish was
raised in an artistic family. She spent
her childhood with her grandfather,
the landscape painter Clark Voorhees,
in Old Lyme, Connecticut, the
location of an art colony associated
with American Impressionism. Her
mother was a sculptor, and Fish
aspired to be a sculptor too, first
studying at Smith College with
Leonard Baskin before attending

Yale University, where she experi-
mented in abstract painting.

Fish's still lifes frequently show
an almost Pop Art playfulness in
their elevation of mundane house-
hold objects to shimmering treas-
ures, but her work is also influenced
by the highly personal vision of
Abstract Expressionism. Unlike the
idealized, classical still lifes of
William Bailey, Fish combined
meticulous observation with a sen-
suous application of paint, while
also offering personalized settings
for her everyday objects. The prop-
erties of glass provide Fish with

endless opportunities to explore
unique abstracted forms and a rich
and seemingly unlimited spectrum
of jewel-like color. *Yellow Goblets*
masterfully replicates the illusion
of overlapping transparent glass,
especially notable for the fact that
Fish created the image using chalk
pastel, the physical antithesis of the
hard, glaring surface of glass.

PLATE 199
William Bailey
b. 1930

Monte Migiana Still Life, 1979
Oil on linen
54¼ x 60³⁄₁₆ inches
(137.8 x 152.9 cm)
Funds provided by the National
Endowment for the Arts, the
Contemporary Arts Fund,
Bernice McIlhenny
Wintersteen, the Pennsylvania
Academy Women's Committee,
Marion B. Stroud, Mrs. H.
Gates Lloyd, and Theodore T.
Newbold, 1980.2

Noted for his architectonic still-life paintings bearing allusive Italian titles, Bailey studied with Josef Albers at Yale University after serving in the Korean War. Initially an abstract painter, he turned to the depiction of objects after a 1960 trip to Europe. His contemplative still lifes, with their quiet, somber colors, stand in marked contrast to the flamboyant still lifes of contemporary artists associated with the New Realist movement. While figures such as Janet Fish, Ralph Goings, Richard Estes, and Audrey Flack painted gleaming, photo-realist imagery that frequently doubled as commentary on the superficial, "plastic" aspects of contemporary life, Bailey used the still life to explore timelessness through unpretentious items that make no claim to a specific cultural era.

Consistently presented at eye level, Bailey purposefully rendered each object in his compositions with the same serene texture, thereby evoking a subtle sense of other-worldliness from familiar domestic objects. That Bailey painted his still lifes from imagination rather than observation enhances this uncanny idealization of form. In *Monte Migiana Still Life*, the stark, shallow background space focuses attention on the row of objects, arranged as carefully as actors on a stage. The painting becomes a small drama of coexisting objects, the physical tension of two forms nearly touching or the modification of space and tones as two forms overlap and cast shadows.

PLATE 200
Alex Katz
b. 1927
EXHIBITOR 1960

Night, 1976
Oil on canvas
72 ⅛ x 96 inches
(183.2 x 243.8 cm)
Funds provided by the National
Endowment for the Arts and the
Contemporary Arts Fund,
1981.13

Since 1962 Alex Katz has been recognized for his billboard-scale paintings, which focus on the human figure. His cool detachment in these monumental paintings is the culmination of his lengthy working process. He begins with preparatory drawings, then develops a small oil sketch, and then follows the sketch with a full-scale cartoon, which is later transferred to the large canvas. In the final stage Katz paints the entire canvas in oil in a single session. "The surface is kept wet, paint is painted into existing wet paint. That is, wet into wet. This enables me to get the finished surface I want," notes the artist.

Executed in New York in the winter of 1976, *Night* is a portrait of the artist's wife, Ada. A spot of light from a lamp near the couch highlights Ada's profile in the darkness. In the background a fragment of the painting *Vincent and Ada* (1976) is seen. Katz's aim in his night paintings is formal and complex. "The place doesn't matter," he noted in an interview with author Donald Kuspit. "It's the armature for the light." In 1981, *Night* was exhibited at the Marlborough Gallery and was subsequently acquired for the Academy's permanent collection.

PLATE 201
Alfred Leslie
b. 1927

James Tate and Liselotte Tate
(James, b. 1941; Liselotte,
b. 1946), 1976
Oil on canvas
84 x 60⅝ inches
(213.4 x 154 cm)
Funds provided by the Crag
Burn Fund, Marion B. Stroud,
and an anonymous donor,
1977.3

By the late 1950s, Alfred Leslie was
considered one of the leading figures
of the second wave of Abstract
Expressionism, explosively applying
paint to large canvases. Surprising
many, he turned to realistic figure
painting in 1964 but never aban-
doned his affinity for massive scale.
Leslie's larger-than-life portraits
confront the viewer through
dramatic devices such as low lighting
and a hard, precise manner whereby
all materials, including skin, look
like metal or vinyl. Relying on
realistic rendering, frontal poses,
enormous scale, and monochromatic
grounds, Leslie soon realized that
adroit realism was not enough.
David, Ingres, and Caravaggio—
and a general attention to classical
ideals—began to heavily influence
the artist by the mid-1970s. Like
these great masters, Leslie staged his
subjects and through distortion and
artifice achieved great dramatic
effects. Invoking Caravaggio in
particular, Leslie proclaimed his
intention of returning to art the
function of moral edification. He
purposefully borrowed composi-
tions from the Baroque master to
portray contemporary events.

PLATE 202
Neil G. Welliver
b. 1929
EXHIBITOR 1962–68

Cedar Breaks, 1976
Oil on canvas
96 x 96 inches
(243.8 x 243.8 cm)
Funds provided by the National
Endowment for the Arts and the
Charles E. Merrill Trust,
1976.14.2

Like his contemporary Philip Pearlstein (Plate 191), Neil Welliver made significant contributions to the reemergence of representational painting in the 1970s. Rarely panoramic, Welliver's paintings instead focus on intimate views of wooded scenes. His bold and articulate landscapes are derived from views of actual natural settings, but the manner of their depiction suggests a type of artifice one is likely to associate with a paint-by-numbers technique. Viewed closely, a Welliver painting appears as blobs of unmixed paint. But viewed from a short distance, the painting snaps into sharp focus. The push and pull between abstraction and representation is the cornerstone of Welliver's artistic method. While his style is rooted in the tradition of American landscape art, it is filtered through the color-theory ideas of his teacher and mentor at Yale University, Josef Albers, and the surface sensibilities of Jackson Pollock and the Abstract Expressionists.

Welliver grew up in the countryside of eastern Pennsylvania and earned a bachelor's degree from the Philadelphia Museum College of Art in 1953 (now University of the Arts), before heading off to Yale to study with Albers, where he received an M.F.A. in 1955. He taught painting at the University of Pennsylvania Graduate School of Fine Art for more than twenty years (1966–1989), commuting from his farmhouse in Maine. In Maine, he became part of a circle of outstanding realist painters that included Fairfield Porter, Alex Katz, Lois Dodd, Yvonne Jacquette, and Rackstraw Downes.

PLATE 203
Rackstraw Downes
b. 1939

Behind the Store at Prospect, 1979–80
Oil on canvas
18 ¾ x 46 ¹¹⁄₁₆ inches
(47.6 x 118.6 cm)
Funds provided by the National Endowment for the Arts and the Contemporary Arts Fund, 1981.5

An artist whose realist landscapes provide both subtle commentary on humanity's relation to nature and the larger tradition of landscape painting, the British-born Downes was educated at Cambridge University before coming to America to study at Yale University. He worked as an art critic before turning his energies to painting. Downes created meticulous landscapes of the rural Northeast, New Jersey, and Texas that reveal an interest in light and atmosphere. While influenced by Fairfield Porter, Downes's work engages with nineteenth-century landscape painting, particularly the work of John Constable.

Behind the Store at Prospect presents Downes's typical format, a long horizontal canvas that provides a panoramic view of a rural landscape devoid of people. While individuals do not populate his canvas, the subject of his work is the human presence in nature, an intervention in the environment that is marked by a wealth of visual signs. The railway tracks, telephone poles, road, house, and cars all bear witness to how humanity transforms the environment even within the rural setting. Downes's paintings usually take years to complete, leading to the exceptionally finished surface that provides their visual immediacy. He wrote, "My paintings are executed from start to finish on site in the landscape. . . . When you work outdoors, you surrender a lot of control over your subject and that is what I like about it, the interactive, experiential character of it."

PLATE 204
Sidney Goodman
b. 1936
FACULTY from 1978–
EXHIBITOR 1960–68

Nude on a Red Table, 1977–80
Oil on canvas
53½ x 77¾ inches
(135.9 x 197.5 cm)
Funds provided by the National
Endowment for the Arts, the
Contemporary Arts Fund, and
Mrs. H. Gates Lloyd, 1980.20

Over the past forty years, Goodman has produced a profound series of paintings that both figure and disfigure the body as a site of tradition and trauma. His work engages the history of art by referencing works from the past, while thoroughly confronting contemporary issues. Born in Philadelphia, Goodman received his art education at the Philadelphia College of Art. He has had a distinguished teaching career at institutions including the University of California–Davis, the University of Georgia–Athens, and at the Pennsylvania Academy.

Nude on a Red Table is an unsettling work that takes up a theme Goodman has depicted since the mid-1960s, a nude woman crowded onto a small table. Here, Goodman further elicits the themes of fragmentation implicit in the earlier images, the twisted body becoming a heap of heavy limbs, conjuring images of Géricault's paintings of severed body parts. Headless, the torso ends in streaks of red paint that spill over the table. Disrupting the viewer's expectations, Goodman questions the nature of representational art, as his painting

dissolves from meticulous realism to total abstraction. Through this shifting visual language, Goodman engages with issues surrounding the tradition of the nude, while demonstrating his mastery of the figure.

PLATE 205
Mary Frank
b. 1933

Woman Lying Down, 1980
Stoneware (ten sections) on
wood base with sand
11 ¾ x 39 x 84 inches
(29.8 x 99.1 x 213.4 cm)
Henry D. Gilpin Fund, 1981.1.14

Mary Frank is an essentially self-taught sculptor and printmaker. She worked in wax and wood in the 1950s, with plaster in the 1960s, and primarily in terracotta since 1970. The fragmented figure is a recurring theme in Frank's art and, in this work, she recreates a female body in ten jagged segments arranged on a bed of beach sand. The terracotta pieces suggest broken artifacts found in archaeological excavations or the victims of the volcanic destruction of ancient Pompeii. Frank modeled the terracotta directly, adding powdered metal-oxide that produces brilliant cobalt blue surface high-lights after firing. Details were applied to the wet clay by incising lines and patterns, and in some works, by imprinting images of natural forms such as fossils and ferns. Like much of her art, *Woman Lying Down* is ambiguous, simultaneously sensual and spiritual, calming and disturbing. The figure's pose could be one of repose, suffering or sexuality. Frank instills the same presence and physicality in her equally powerful monoprints and drawings.

PLATE 206
Louise Nevelson
1899–1988
EXHIBITOR 1944, 1953, 1964

Cascades Perpendiculars I,
1980–82
Painted wood
108½ x 34½ x 28 inches
(275.6 x 87.6 x 71.1 cm)
Gift of the friends of Bernice
McIlhenny Wintersteen in
honor of her 80th birthday, and
the Ware Trust Fund, 1983.4

Internationally known for her wood
constructions, Louise Nevelson was
one of the most renowned sculptors
of the twentieth century. Born in
Russia and brought up in Maine,
Nevelson studied painting at New
York's Art Students League before
turning to sculpture. Her interest in
so-called primitive art, as well as in
Cubism and Surrealism, led her to
experiment with found objects. She
assembled lumber, spindles, spools,
finials, columns, and dozens of plain
wood fragments in boxes, which
were then stacked in large wall-like
arrangements. These structures,
which the artist produced for almost
forty years, were painted a single
color, often black, and thus take on
the mysterious air of totemic forms.
Cascades Perpendiculars I is the first
in a series of sculptures constructed
from the decorative remnants of the
organ of Saint Mark's Church in the
Bowery in New York, which was
damaged by fire in 1978. While the
work shares with Nevelson's other
pieces the matte black surface and
abstract arrangement of various
components, the composition is less
self-contained and somber than
many of the artist's constructions.

Barbara Kruger
b. 1945

Untitled, #3719, 1984
Photograph
71½ x 45 inches (181.6 x 114.3 cm)
Gift of Mr. Henry S. McNeil, Jr.,
1984.19

One of the best known 1980s artists
to wed critical theory and photogra-
phy, Kruger began her professional
career as a graphic designer and
media critic. Her commercial back-
ground coupled with strong feminist
beliefs influenced her conceptual
and aesthetic approach to art making.
Kruger works from pre-existing
photographs, which are easily read
as archetypes of America's conflict
between consumerism and idealized
values. She enlarges, crops, and
recasts the images as monumental
provocations. The juxtaposed text,
suggestive of the confrontational
technique of advertising slogans,
directly addresses the viewer through
the use of shifting pronouns. Unlike
the clarity of advertising, however,
Kruger's montages are ambiguous,
the language fluid. Gender opposi-
tions are implied but never fixed and
thus, the images are open to multiple
interpretations. As a final flourish,
Kruger packages her photographs
in theatrical red frames, explicitly
highlighting the commodified
nature of art.

Kruger is often associated with
a group of artists including Cindy
Sherman, Sherrie Levine, and
Richard Prince who use appropria-
tion as the driving methodology in
producing photo-based work. They
came to be known as Postmodern
photographers, and their historical
roots lay in the Duchampian tradi-
tion of the Readymade as well as the
appropriative practice of the Pop
artists, like Andy Warhol and Robert
Rauschenberg, who incorporated
silk-screened photographs of media
and advertising in their art.

Romare Bearden

1911–1988

EXHIBITOR 1947, 1954

The Piano Lesson (Homage to Mary Lou), 1983
Color lithograph on paper
29 ⅓ x 20 ⁵⁄₁₆ inches
(74.5 x 51.6 cm)
The Harold A. and Ann R. Sorgenti Collection of Contemporary African-American Art, 1999.17.1

Inspired by the improvisational approach of jazz music, Bearden started creating collages in 1964 that depicted African-American life in the rural South and Harlem. In these images, Bearden appropriated a technique associated with Cubism and Dada art, drawing upon cryptic symbolism from Afro-Caribbean culture to address religion, mythology, history, literature, and everyday life. He also layered these works with autobiographical elements culled from his childhood memories. Born in Charlotte, North Carolina, Bearden moved with his family to Pittsburgh when he was still a child before set-

tling in New York. Bearden studied with George Grosz, beginning his artistic career as a social realist in the 1930s. He shifted to abstraction in the 1950s until arriving at his breakthrough collages that would establish his prominent reputation.

The Piano Lesson is one of a series of images rooted in Bearden's memories of Mecklenburg County in North Carolina. Visually, this print was inspired by two Henri Matisse paintings—*The Piano Lesson* (1916) and *The Music Lesson* (1917). Bearden depicted a music teacher and her student in a Southern parlor. He dedicated this

image to the great jazz pianist Mary Lou Williams, who, like Bearden, moved as a child from the South to Pittsburgh. *The Piano Lesson* also inspired Pittsburgh-native August Wilson's 1987 play of the same title.

PLATE 209
Red Grooms
b. 1937
MEDAL 1990

A Room in Connecticut, 1984
Oil on canvas and acrylic on
Plexiglas with aluminum frame
72 x 96 inches (182.9 x 243.8 cm)
John Lambert Fund, 1985.4

The work of Red Grooms resists
easy categorization. Blurring the
boundaries between high art and
popular culture, he fluidly moves
among the mediums of painting,
sculpture, printmaking, and film.
Along with Allan Kaprow, Jim Dine,
and Claes Oldenburg, Grooms
began experimenting in performance
art during 1958 after studying at
both the Chicago Art Institute and
the New School for Social Research.
In the 1960s, Grooms started creating
installations he termed "sculpto-pic-
toramas," immersing his audience in
carnival-like imagery based upon
the worlds of entertainment and art.

A Room in Connecticut belongs
to Grooms's continuing series of "art
about artists." This fanciful tribute
to the American avant-garde depicts
the artist Marcel Duchamp and his
patron the collector Katherine S.
Dreier—two of the founders of the
Société Anonyme, established in
1920 to promote American and
European modernism—conversing
in the art-filled library of Dreier's
West Redding, Connecticut, home.
Two works by Duchamp are recreated
by Grooms: above the bookcase, the
painting *Tu m'* (Yale University Art
Gallery), and at right, a three-
dimensional rendering in Plexiglas

and aluminum of *The Bride
Stripped Bare by Her Bachelors, Even*
(Philadelphia Museum of Art). As a
bonus, Grooms lets us spy another
two modernist figures through the
window: Baroness Hilla Rebay, the
first director of the Guggenheim
Museum, and the architect of the
Guggenheim's building, Frank
Lloyd Wright.

PLATE 212
Irving Petlin
b. 1934
FACULTY from 1992–

The Disappeared, 1985
Oil on canvas
78 x 108 inches
(198.1 x 274.3 cm)
Lewis S. Ware Fund and the Leo
Model Foundation, 1986.6

Irving Petlin studied art at the University of Chicago before attending Yale University to complete his graduate work with Josef Albers. He spent the early 1960s in France, exposed to the intellectual and artistic climate, where he developed two of his major influences, literature and politics. Upon returning to America, he founded the activist group Artists and Writers Against the Vietnam War and later participated in the Artists' Call Against U.S. Intervention in Central America. While Petlin, like his friend Leon Golub, often addresses issues of world conflict, politics is not the sole root of his work. He has shown a deep engagement with literature, working from the texts of writers as diverse as Bruno Shulz, Primo Levi, Paul Celan, Edmond Jabes, and the art historian Meyer Shapiro.

The Disappeared is from a series of images that confront the atrocities of Argentina's oppressive military regime of the 1970s and early 1980s, a period of terror when thousands of citizens "disappeared." Petlin created a painting that is filled with foreboding imagery, from the traces of a horse and carriage that appear in the ghostly forest on the left side to the screaming figure who occupies the right foreground. In its Pointillist styling, this work also reveals Petlin's interest in another politically conscious artist, the nineteenth-century anarchist Georges Seurat.

PLATE 213

Leon Golub

1922–2004

EXHIBITOR 1964, 1966

Threnody II, 1987
Acrylic on linen
120 x 152 inches
(304.8 x 386.1 cm)
Alexander Harrison Fund,
2004.10.2

One of the foremost contemporary figurative painters, Leon Golub painted visceral responses to atrocities committed as a result of dehumanizing political fanaticism. While his earlier work (Plate 184) was a dark meditation on suffering, the turmoil of the 1960s, culminating in the Vietnam War, urged Golub to make his work less allegorical and more explicitly responsive to current events. His subject matter increasingly became the violent, hidden side of the daily news and an indictment against the abuse of power. Golub has suggested that looking at his paintings is like looking into a mirror—that anyone, in certain circumstances, can revert to appalling violence.

Golub rose to artistic prominence in the 1980s with brutal series such as *Mercenaries* and *Interrogation*. Female figures, notably absent from his work until this point, became the focus of the *Threnody* (a song of lamentation) series. Veering from his often shocking depictions of torture and murder to a quieter yet still chilling pathos, Golub used the mourning women, aged and poor, as a symbol of powerlessness. In this work, the women gesture wildly in a ritualized mourning dance, and the flattened space and absence of shadows confine the figures in a "non-space" with nowhere to escape. The haunting strangeness of *Threnody II* transcends the conventions of protest art while still addressing the historical realities of oppression and exclusion.

PLATE 214
Nancy Graves
1940–1995
MEDAL 1987

Hay Fervor, 1985
Bronze and steel with poly-
chrome patina, baked enamel,
and polyurethane paint
95 ¾ x 87 x 38 ¼ inches
(243.2 x 221 x 97.2 cm)
Purchased with funds provided
by Dr. Luther W. Brady, Mr. and
Mrs. Daniel W. Dietrich II,
Mrs. Robert English, Mr. and
Mrs. Henry F. Harris, Mr. and
Mrs. J. Welles Henderson, Mr.
and Mrs. Leonard I. Korman,
Harvey S. Shipley Miller, Mr.
and Mrs. Allen J. Model, Mr.
and Mrs. Stewart Resnick, Mr.
and Mrs. George M. Ross, Mr.
and Mrs. Stanley C. Tuttleman,
and the Pennsylvania Academy
of the Fine Arts Women's
Committee, 1987.7

Drawing upon diverse influences, including natural history, cartography, non-Western art, and modernist sculpture, Graves produced a dynamic body of work encompassing many mediums. After studying at Vassar College and Yale University, Graves traveled through North Africa and the Near East, arriving at the subject for her breakthrough works, realistic sculptures of life-size Bactrian camels. First shown at New York's Graham Gallery in 1968, these pieces quickly established Graves's reputation. By the mid-1970s, she began experimenting with welding as a technique, utilizing a large repertoire of cast or fabricated forms to make sculptures intuitively, without preparatory drawings. While working within a tradition that includes Pablo Picasso and David Smith, Graves's playful application of color disrupts expectations and undermines the machismo sometimes associated with welded sculpture.

Hay Fervor comes from a series of works that incorporate pieces of farm machinery. Graves creates visual tensions through the juxtaposition of large, threatening mechanical forms with small, innocuous objects cast from life, such as leaves and pretzels. The vivid colors add to these striking contrasts, transforming everyday objects into abstract shapes. She also explores the sculptural issue of balance, establishing physical relationships that accentuate the humor of this vibrant piece. The Academy purchased the work in 1987, when Graves accepted the Award of American Art from the Pennsylvania Academy.

PLATE 215

Faith Ringgold

b. 1930

Tar Beach 2, 1990
Silkscreen on silk and pieced
printed cotton
65 ¾ x 65 ¼ inches
(167 x 165.7 cm)
The Harold A. and Ann R.
Sorgenti Collection of
Contemporary African-American
Art, 1999.17.2

An artist galvanized by the Civil
Rights movement and feminism,
Ringgold has transformed traditional
domestic crafts, primarily quilts, into
a medium through which to engage
issues surrounding race, gender,
identity, and politics. She gained
notoriety in 1970 when she was
arrested for her participation in the
People's Flag Show, an exhibition
challenging legislation against the use
of the American flag. The following
year, she helped form the group
Where We At, which decried the
exclusion of women in American and
African-American exhibitions.
During the 1970s, she explored racial

and gender themes through the
mediums of soft sculpture, perform-
ance art, and story quilts. Ringgold
began writing her autobiography in
1977, but, unable to find a publisher,
she began depicting her tale on quilts.
Subsequently, she has produced a
great number of narrative quilts based
on her fiction and autobiographical
accounts, all told from the perspec-
tive of a female protagonist. Typically,
these feature representational imagery
framed by a decorative quilt border.

Tar Beach 2 comes from
Ringgold's childhood memories of
summertime dinners atop the roof of
the Harlem, New York, apartment

building where she and her family
lived. Ringgold produced this
editioned silkscreened quilt at the
Fabric Workshop in Philadelphia.
The *Tar Beach* series of painted
quilts became a children's book,
which was later selected as a
Caldecott Honor Book.

Robert Motherwell
1915–1991

Barcelona Elegy for the Spanish Republic, 1991
Lift-ground etching and aquatint on cream wove paper
Sheet 32 ⅞ x 27 inches (83.5 x 68.6 cm)
Image 27 ½ x 21 ⅛ inches (69.9 x 53.7 cm)
Gift of The Dedalus Foundation and John Lambert Fund, 1994.6.36

The most intellectual and articulate of the Abstract Expressionists, Motherwell laid out the existentialist underpinnings of their artistic project, writing essays for the *Partisan Review* and collaborating on the journal *Possibilities* with the critic Harold Rosenberg. Motherwell pursued a doctorate in philosophy at Harvard University but abandoned his studies in 1940. He began to take classes at Columbia University with the art historian Meyer Shapiro, who suggested that Motherwell take up painting. Through Shapiro, he was introduced to the Surrealist artist Kurt Seligmann, and soon

Motherwell befriended Max Ernst, Marcel Duchamp, André Breton, and other members of the international avant-garde. In 1941, he moved to Greenwich Village and soon met William Baziotes, Jackson Pollock, and Lee Krasner, the future core of the Abstract Expressionists.

Barcelona Elegy for the Spanish Republic is from Motherwell's definitive series of works memorializing the Spanish Civil War of the 1930s. For more than forty years, Motherwell used the imagery of large black ovals and bars to commemorate the Spanish poet García Lorca, executed by Fascists during

the war. Inspired by Lorca's poem "Lament for Ignacio Sánchez Mejías," describing the death of a bullfighter, Motherwell utilized white to symbolize the radiance of life and black to signify death, touching on universal issues of mourning and remembrance.

PLATE 217
Donald Sultan
b. 1951

Red Poppies: April 14, 2003, 2003
Enamel, flocking, tar, and
spackle on tile over masonite
76 ½ x 38 inches
(194.3 x 96.5 cm)
Promised gift of Luther W.
Brady

Donald Sultan is recognized for his unusual painting techniques and his invigoration of the still-life genre, which he pushes in the direction of abstraction and Pop Art. Instead of canvas, Sultan works on masonite covered with vinyl floor tiles, which are assembled in grid-like fashion. The vinyl-tile surfaces are then covered with tar on which Sultan draws, in this case, a poppy image. The floral forms are excavated and then covered and filled with dry-wall spackle, which when cured, are painted with vividly hued enamels. Sultan then introduces a black rayon flocking, the texture of which suggests poppy pollen. He finally gouges and scrapes the area surrounding his subject, producing rhythmically obsessive vertical striations on the surface, and creating an abstract ground in the process.

Sultan's paintings resonate across several artistic contexts including Richard Serra's angular, deeply black, oil-stick drawings; Donald Judd's interest in the repetition of industrial materials; and Andy Warhol's focus on isolated images. His work also engages 1970s and 1980s painting, in which artists pushed the limits of what constituted the painted picture plane. Like Julian Schnabel or Anselm Kiefer, Sultan also found the need to reinforce the richness and depth of a painting's surface after the spartan attitudes of Minimalism and Conceptualism.

PLATE 218
Betye Saar
b. 1926

Blackbird, 2002
Mixed media assemblage and
collage (double sided)
22 ⅜ x 23 ¼ x 2 ¾ inches
(56.8 x 59.1 x 7 cm)
Henry D. Gilpin Fund, 2004.6

Although the term "blackbird" was
originally a racist epithet, with the
rise of the Civil Rights movement in
the 1960s and 1970s, the word was
appropriated and transformed into a
term of endearment. In this three-
dimensional assemblage, Betye Saar
addresses the fact that, while
enslaved, African Americans were
often forbidden to learn to read and
write. They taught themselves and
their children in secrecy and estab-
lished a rich cultural heritage com-
plete with linguistic associations. The
focal point of this work, mounted on
vintage blackboard, is a photograph
of a third-grade class taught by Saar's

great aunt Hattie in Missouri in
1911. Below, Saar placed symbols of
enslavement and racism into com-
partments. Watermelon slices, a
fruit that was credited with keeping
many slaves alive but later symboliz-
ing the broader denigration of black
people, are being eaten by small
children perched atop wooden letter
blocks—educational toys denied to
slave children.

Of African, Native American,
and Irish descent, Saar cuts across
cultural boundaries by emphasizing
the importance of keepsakes and
memories to create a sense of
belonging that is universally sought.

Influenced by Joseph Cornell's box
constructions, her work often uses
objects that narrate women's lives.
Saar's focus on women has con-
tributed to her reputation as one
of the foremost feminist art activists
of the twentieth century.

PLATE 219
Elizabeth Catlett
b. 1915

Naima, 2001
Black marble
15 ½ x 8 ½ x 15 inches
(39.3 x 21.5 x 38.1 cm)
Henry C. Gibson Fund, 2004.21

Based on a smaller terracotta head that was completed in Elizabeth Catlett's studio, *Naima* depicts one of the artist's twin granddaughters during a summer visit to her home in Cuernavaca, Mexico, when the girl was eighteen years of age. A quiet and classically inspired representation of a young woman, the bust is one and a half times life size. The eyes are inlaid with semiprecious stones in order to symbolically hint at what Catlett described as a "dramatic" personality. The precise incisions and clean lines recall the monumentalism of ancient Egyptian and African sculpture that reduced extraneous details into stylized, symbolic forms.

An activist for the rights of women and racial and social equality, Catlett took up printmaking in the mid-1940s as a means to make political statements. While works on paper naturally lent themselves to telling narratives that could speak to the moment, Catlett turned to sculpture as something more durable and timeless. Working with natural materials, Catlett aims to match the surface texture to the meaning of the object. Polished to a high finish, the white-veined marble and dramatic hair wrapping convey both a sense of Naima's physical strength—she was training to be a dancer—and the proud lineage of her ancestors.

PLATE 220
Vincent Desiderio
b. 1955
STUDENT 1979–84
FACULTY from 1995–

Pantocrator, 2002
Oil on linen
82 ⅞ x 193 ¾ inches (overall
triptych) (210.5 x 492.1 cm)
Herbert M. and Mary W. F.
Howe Fund, 2003.7a–c

Contemporary artist Vincent Desiderio often formats his work in large-scale diptychs or triptychs, relating his representational painting style to art historical precedents. Desiderio sees himself as a critic of a "modernist paradigm" marked by dysfunctional social relationships and the narcissistic pursuit of fame. His wish to "invigorate aesthetics with social responsibility" is reflected in his often painfully personal images of friends, family, and his disabled son, presented as visual juxtapositions laden with allegorical meaning. In 1996, Desiderio was the first American to win the prestigious International Prize of Contemporary Art given by the Prince Pierre Foundation of the Principality of Monaco.

The Greek word "pantocrator," translated as "ruler of all," is an art historical term that has been used to identify depictions of Christ enthroned, looking out at the viewer with a commanding gaze. In this work, Desiderio flanks a fantastic image of a space station with a voyeuristic glimpse of a woman showering and part of the facade of the famed cathedral in Florence known as the Duomo. These disparate images set up a conversation about seeing, involving Renaissance perspective, the psychological gaze, and the unblinking mechanical eye of the camera.

Pennsylvania Academy of the Fine Arts
Timeline of Important Events

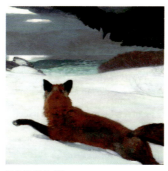

Detail, Plate 86

1896
Cecilia Beaux and William Merritt Chase begin teaching at the Academy.

1897
The Fellowship, the Academy's alumni organization, is founded.

Thomas Eakins's *Cello Player* is purchased.

Academy students and alumni, including John Sloan and William Glackens, paint a mural cycle for the auditorium walls.

1898
Architect Frank Miles Day is engaged to plan for the expansion of the building and the conversion of studios to galleries.

1898-1901
Important early photographic exhibitions, the *Philadelphia Photographic Salons*, are held.

1900
An illustration course is established. (It is discontinued in 1958.)

1902
The Cresson Travel Scholarship is first awarded.

1903
An architectural design course is established. (It is discontinued in 1908.)

1904
The Academy's first annual exhibition of watercolors, prints, and drawings is held in collaboration with the Philadelphia Water Color Club.

The Academy's Second Century, 1905–2005

1905
The one-hundredth anniversary of the Pennsylvania Academy is celebrated.

Charles Sheeler, Morton Schamberg, Arthur B. Carles, and Charles Demuth attend the Academy.

1908
An exhibition of the Eight introduces Philadelphia to these painters of contemporary urban subjects.

Detail, Plate 133

1917
The Academy opens it summer campus at Chester Springs, Pennsylvania.

The *Thomas Eakins Memorial Exhibition* is held.

1920
Paintings and Drawings by Representative Modern Masters, an exhibition organized by Arthur B. Carles and Carroll Tyson, shows works of European avant-garde artists.

1921
Paintings and Drawings Showing the Later Tendencies in Art, organized by Alfred Stieglitz, Arthur B. Carles, Joseph Stella, and Thomas Hart Benton, becomes the first museum exhibition of work by American modernists.

1923
Contemporary European Paintings and Sculpture displays recent additions to the collection of Albert C. Barnes.

Portraits by Charles Willson Peale, James Peale, and Rembrandt Peale are exhibited during the run of the Barnes Collection.

1928-33
The Chester Springs program holds winter school sessions.

1929
A cooperative program with the University of Pennsylvania is established.

1938
The Academy holds the exhibition *Lithographs of the Panama Canal* by Joseph Pennell.

The Ware Travel Scholarship is established.

1940
Paintings by Arthur B. Carles are exhibited.

1945
In the *Star Presentation* exhibition the Academy displays masterpieces after their return from wartime storage.

1948
The Schiedt Travel Scholarship is established.

1950
The *Contemporary British Painting* exhibition is held.

1952
The Academy closes its Chester Springs campus.

1955
The Academy celebrates its 150th anniversary.

The *150th Anniversary Exhibition* of 106 works from the Academy's collection travels to six European cities under the auspices of the U.S. Information Agency; 27,713 persons attend the exhibition at the Academy.

1964
The Academy school gains a second facility in the Peale House, the former Belgravia Hotel, on Chestnut Street.

The graphics (printmaking) major is established.

1965
The Peale Club (a dining club) is opened next to the Peale House.

1966

The Andrew Wyeth exhibition is attended by 173,000 visitors.

1969

The 164th annual exhibition closes this series, which began in 1811.

The museum shop is established and vault renovation commences.

The Jacob Eichholtz exhibition, with an accompanying catalogue by Edgar P. Richardson, marks a new era of scholarly exhibitions and publications. Ten paintings by Eichholtz are presented to the Academy by Mrs. James H. Beal.

1970

President and Mrs. Nixon attend the opening of the *To Save a Heritage* exhibition. Mrs. Nixon unveils restored paintings, and the Academy presents a souvenir portfolio of historical documents to its guests.

1971

The Academy opens its conservation laboratory. Funds for the laboratory are provided by Mrs. T. Carrick Jordan, Bertram O'Neil, and Henry S. McNeil.

A cooperative program with the Philadelphia College of Art (University of the Arts) is founded.

The Furness-Hewitt Building is placed on the National Register of Historic Places.

Academy Studio, Fig. 27

1972

Frank H. Goodyear Jr. becomes the Academy's first professional curator.

A conference of distinguished consultants considers the Academy's future.

1974

The Furness-Hewitt Building closes for a two-year restoration.

1975

The Furness-Hewitt Building is awarded National Landmark status.

1976

The restored building reopens for the celebration of the U.S. bicentennial.

1978

The Morris Gallery program is inaugurated to exhibit contemporary regional art.

1980

The Academy celebrates its 175th anniversary with a block party on Broad Street.

1981

The *Exhibition of Contemporary American Realism Since 1960* travels to three European venues.

1982

Antiques Magazine devotes its March issue to the Academy.

The school moves into the Peale House II, the former Oliver Bair building, on Chestnut Street.

1984

Philip Pearlstein is the five-hundredth special exhibition held since 1807.

1985

The Red Grooms exhibition brings 90,000 visitors to the Academy and travels to three American venues.

Charles Bregler's Thomas Eakins collection is purchased.

An endowment for acquisitions, established by the heirs of board president Henry S. McNeil, provides funds for the purchase of the Academy's first painting by John Singleton Copley.

1988

The school is moved into the new building at 1301 Cherry Street.

1989

The Academy publishes *Checklist of American Paintings* and *Writing About Eakins: The Manuscripts in Charles Bregler's Thomas Eakins Collection*.

Detail, Plate 209

1990

The *Thomas Eakins Rediscovered* exhibition displays artwork, photographs, and manuscripts from Charles Bregler's collection.

The museum director's position is endowed by Stanley C. and Edna S. Tuttleman.

The three-volume *Index to the Annual Exhibitions* is published.

1992

The Master of Fine Arts program is inaugurated.

1994

I Tell My Heart: The Art of Horace Pippin exhibition travels to four American venues.

The building is closed for six months for renovation.

Eakins and the Photograph is published, and an exhibition of Eakins's photographs is mounted.

1995

Forty works by Robert Motherwell are acquired.

To Be Modern: American Encounters with Cézanne and Company exhibits art of American modernists; museum attendance increases significantly.

The Academy's website is established.

1997

The Fellowship, the Academy's first alumni association, celebrates its one-hundredth anniversary.

The *Catalogue of American Sculpture* is published.

1999

The Maxfield Parrish exhibition brings 83,000 visitors to the galleries.

2000

The eleven-story building adjacent to the Furness-Hewitt Building is acquired, allowing the Academy to create a fine arts campus with the school and the museum in close proximity.

2001

The Dream Garden mosaic by Maxfield Parrish and Louis Comfort Tiffany, is acquired thanks to the generosity of the Pew Charitable Trusts.

2002

American Sublime, an exhibition of landscape paintings, brings 50,000 visitors to the Academy in sixty-two days.

With a gift of five million dollars from the Dorrance H. Hamilton 1999 Charitable Trust, the new building is formally named the Samuel M. V. Hamilton Building.

The Dream Garden, Detail, Fig. 19

2003

The Academy receives a gift of ten American masterpieces from the estate of Meyer P. and Vivian O. Potamkin and honors the gift with a specially designated gallery.

2004

The Academy receives the Harold A. and Anne R. Sorgenti Collection of Contemporary African-American Art.

2005

The Academy celebrates its two-hundredth anniversary with a variety of events, including the grand opening of its new Hamilton Building.

310